COLOR

 THE WILLIAM & BETTYE NOWLIN SERIES
in Art, History, and Culture of the Western Hemisphere

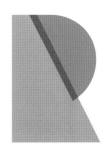

American Photography
TRANSFORMED

AMON CARTER MUSEUM OF AMERICAN ART

John Rohrbach
With an Essay by Sylvie Pénichon

UNIVERSITY OF TEXAS PRESS, AUSTIN

Printed in China
First edition, 2013

Requests for permission to reproduce material from
this work should be sent to:
 Permissions
 University of Texas Press
 P.O. Box 7819
 Austin, TX 78713-7819
 http://utpress.utexas.edu/index.php/rp-form

The paper used in this book meets the minimum
requirements of ANSI/NISO Z39.48-1992 (R1997)
(Permanence of Paper). ∞

Design by Lindsay Starr

Library of Congress Cataloging-in-Publication Data

Color (Amon Carter Museum of American Art)
 Color : American photography transformed / Amon
Carter Museum of American Art, John Rohrbach, Senior
Curator of Photographs; with an essay by Sylvie Pénichon,
Conservator of Photographs. — First edition.
 p. cm
 Includes bibliographical references and index.
 ISBN 978-0-292-75301-3 (cloth : alk. paper)
 1. Color photography—United States—History.
I. Rohrbach, John. II. Pénichon, Sylvie. III. Amon Carter
Museum of American Art. IV. Title.
 TR510.c536 2013
 778.6—dc23 2013000509

doi:10.7560/753013

Color! American Photography Transformed is organized by
the Amon Carter Museum of American Art. The exhibition
and publication are made possible in part by a grant from
the National Endowment for the Arts. The exhibition is
sponsored by Frost Bank.

Amon Carter Museum of American Art
Fort Worth, Texas
October 5, 2013, through January 5, 2014

Dixon Gallery and Gardens
Memphis, Tennessee
January 19, 2014, through March 23, 2014

The Amon Carter Museum of American Art was
established through the generosity of Amon G. Carter Sr.
(1879–1955) to house his collection of paintings and
sculpture by Frederic Remington and Charles M. Russell;
to collect, preserve, and exhibit the finest examples of
American art; and to serve an educational role through
exhibitions, publications, and programs devoted to the
study of American art.

Contents

Foreword

IT IS FITTING that a project of this scope and focus should originate with the Amon Carter Museum of American Art. From the beginning, this museum, now in its sixth decade of operation, has demonstrated an unwavering commitment to collecting, conserving, exhibiting, and publishing fine art photographs.

In the early 1960s, when photography still languished as a stepchild in the fine art world, the Amon Carter's first director, Mitchell A. Wilder (1913–1979), presciently understood that the medium would eventually bloom into a highly regarded and sought after fine art. Undervalued, photographs were then still sold mostly in lots, and Wilder eagerly snapped them up, adding photographs to the collection and exhibition program from the museum's earliest years. In 1967 alone, he acquired a 3,000-print collection of Native American portraits and scenes collected by the Bureau of American Ethnology and spearheaded three exhibitions of photography, including *Dorothea Lange Looks at the American Country Woman*. He also inaugurated the museum's acquisition of artist archives, winning the trust of photographer Laura Gilpin (1891–1979), who in 1978 bequeathed her body of work to the Amon Carter—some 27,000 objects in all. The following year, the year he died, Wilder commissioned Richard Avedon (1923–2004) to begin work on what would become *In the American West*, a masterwork of American portraiture.

The museum's focus on photography did not soften with Wilder's death. In 1990, the Amon Carter made an important commitment to color photography by accepting the archive of Eliot Porter (1901–1990), an early master of dye-imbibition color photography. That body of more than 100,000 works, including 7,000 color prints dating back to 1939, established the archetype for environmental color photography.

Beyond continuing to build and show its collection, the Amon Carter has published nearly forty volumes to date on the medium. This book is the museum's latest contribution. The story of color in American photography, which John Rohrbach, senior curator of photographs at the Amon Carter, relates in

these pages, is as old as the medium itself. From the moment Louis-Jacques-Mandé Daguerre (1787–1851) introduced his invention in 1839, scientists and photographers at all levels of expertise began striving to develop a practical way of making color photographs. Color became, in Rohrbach's words, the medium's holy grail. This passionate effort to achieve color did not successfully culminate until 1907, when the brothers Auguste Lumière (1862–1954) and Louis Lumière (1864–1948) introduced the Autochrome, the first commercially viable color photographic process.

The story does not end there, however. Color may have arrived, but artists and other serious students of the medium, who had long invested themselves in the lights and shadows of black-and-white, quickly found themselves ambivalent about it. Making prints was difficult and expensive. The medium was transitory, too, as the printed dyes tended to fade quickly, and photographic colors were difficult to control. As a result, most established artists and critics regarded color photography suitable for advertising but unworthy of the stage of fine art. Only in 1976, nearly 140 years after the daguerreotype was introduced, did color photography finally gain critical acceptance as a fine art medium. That year John Szarkowski (1925–2007), then curator at the Museum of Modern Art in New York, organized an exhibition of the color photographs of William Eggleston (b. 1939).

Szarkowski's celebration of Eggleston's color photographs opened the gates to color's broad acceptance. And yet, as this book articulates, this turn also initiated photography's fundamental transformation. Eggleston taught Szarkowski how, even in describing the world, color could separate and demand to be read as pure hue. As other photographers came to this same realization, they began to use color as an active tool for reflecting cultural ideas and emotions, as well as for engaging more directly with painting.

Photography did not lose its descriptive core, but that core increasingly succumbed to overt manipulation and sometimes even fabrication.

JOHN ROHRBACH'S history as a scholar of American photography parallels the history of the medium itself in a way. His early years as a student of the medium were rooted in its pre-color history, but he came to the Amon Carter in 1992 to delve into the newly acquired Eliot Porter archive, a massive body of color work. Now in his twenty-first year at the museum, Rohrbach is among the nation's leading voices in the evaluation and critique of American photography, and this book is a culmination of his many years of study.

Similarly, Sylvie Pénichon is a prominent voice in the world of photography conservation—a formidable profession, given the vast array of photographic processes that have come and gone over the decades. Beyond her essay in these pages on the technical history of color photography, she is in the final stages of publishing a comprehensive book with the Getty on color photographic processes.

Many people are recognized in the back pages of this book for helping bring this project to fruition. Here, I wish to thank Kevin Sharp, director of the Dixon Gallery and Gardens in Memphis, who responded enthusiastically to hosting at his institution the exhibition that accompanies this volume—serendipitous in that Memphis is the birthplace of William Eggleston. I also wish to thank Dave Hamrick, director of the University of Texas Press, who has proven himself a notable champion of producing fine art books on photography. *Color: American Photography Transformed* is the result of our collaboration, commitment, and passion.

Andrew J. Walker
Director, Amon Carter Museum of American Art
Fort Worth, Texas

COLOR

Introduction

Color photography is an accomplished fact. The seemingly everlasting question whether color would ever be within the reach of the photographer has been definitely answered.

ALFRED STIEGLITZ, 1907[1]

NEW YORKER Alfred Stieglitz had been lobbying hard for recognition of photography's artistic equality with painting through the decade leading up to the introduction of the Autochrome, the first commercially successful color photographic process, in 1907.[2] He had been arguing through examples of his own photographs, and those by others he deemed worthy, that sensitively constructed, framed, and printed photographs relayed just as much emotion and beauty as works in any other artistic medium. If the lack of photographic color undercut his arguments, its introduction now offered the potential of beating painting at its own game, of reflecting life more vividly and quickly, with just as much fulfillment—at least at first blush. Stieglitz immediately called the Autochrome "another dream come true," and he and his colleagues set out with great enthusiasm to master the process.

Their excitement would not last. Almost immediately, it became apparent that photographic color delivered a world that was simultaneously too real and not real enough. Discerning eyes found a surreal brittleness in the spot-on renderings delivered by most well-exposed color photographs, as if the air had just been sucked out of their subjects. They recognized that photographic colors would pull forward or recede, not fully adhering to the objects they described, especially if the colors were slightly off in hue or saturation. And if they were off a little more, they would simply look wrong. Additionally, color photographs exaggerated the color shifts of light as it changed over the course of a day; they inflated the reflection of color across forms; and they generally presented blocked-up shadows rather than project the deep-toned luminescence that made black-and-white photographs so appealing. In short, photographic color danced to its own peculiar rhythms. Add to this the higher expense of color materials, and it becomes easy to understand why Stieglitz and many of his closest associates turned their backs on the medium within a short period.

This book relates the story of artists' decades-long coming to terms with color photography, including their debates over how to, and even whether to, integrate color into their practices, their initial

Calvin and Hobbes © 1989 Watterson. Distributed by Universal
Uclick. Reprinted with permission. All rights reserved.

explorations of it, and their gradual embrace of it as a flexible tool for communicating their visions. The book reveals that this absorption of color instigated wide acceptance of a fundamentally new definition of photography, one that openly blends photography's documentary foundations with the creative flexibility of painting. In this shift, the book suggests, photography finally, once and for all, was delivered from its second-class artistic status. It also was repositioned to become today's dominant artistic form.

Color focuses on the United States, but it is by no means a comprehensive survey of American artists' use of color photography. It does not mention many important artists who have used the medium, and it only cursorily discusses many others. It covers technical advances, most directly in Sylvie Pénichon's discussion. Several recent books provide such broad discussions. Pamela Roberts's *A Century of Colour Photography: From the Autochrome to the Digital Age* (2007) and Nathelie Boulouch's *Le ciel est bleu* (2011) summarize the full history of color photography, integrating color use in Europe, America, and beyond. Kevin Moore's important book *Starburst: Color Photography in America, 1970–1980* (2010) effectively synopsizes artists' explorations of color photography over the years surrounding John Szarkowski's influential 1976 exhibition at the Museum of Modern Art (MoMA) of Memphis photographer William Eggleston's snapshot-inflected color photographs. Numerous other recent books delineate the use of color by specific artists, from Ansel Adams to Alex Webb; this book's bibliography points to many of these studies.

By focusing on what color brings to photography rather than on either the technical achievement of color photography or artist biography, this book shifts the conversation to the liaison between photography and human sight, to the connections between color and black-and-white photography, and to photography's bond with the other arts, particularly to painting. This book finds its roots in the core achievement and challenge of photographs: that we so quickly accept their optical mechanics as reflecting the world.

If black-and-white photographs deliver unparalleled detail, color photographs convey immediacy, at least when their hues approximate what we expect to see. This visceral connection to sight is what makes photographs so beguiling and useful, of course. It also explains why there was such consternation that the first photographs did not deliver color and why color immediately became the medium's holy grail—its last step to perfection.

However much we know that human sight has always conveyed the world's colors, our photographically driven memories suggest that the nineteenth century was essentially brown and that the first half of the twentieth century was largely gray, as Calvin's dad discusses in Bill Watterson's marvelous *Calvin and Hobbes* cartoon. When color did arrive, our memories tell us that the world became garish, projecting screaming reds and blues so solid that clear skies seem to jump forward as geometrical facets. Although we accept those saturated worlds as good enough, the hues all too often have now faded, taking on casts of pale magenta or cyan. In response, we have taught ourselves that good color marks the here and now, while bad color, or no color at all, means looking into the past. These memories have taught us to think of color photography as a recent phenomenon.

This book reveals that color photographs were produced in 1851—not very good ones, but ones that truly and directly rendered the world's colors. Chapter 1 tells the engaging tale of the great stir they induced. It is a story filled with enough exaggerated hope, promise, and confrontation to suggest a Hollywood melodrama. The chapter then relates the decades-long, nationalist-tinged race to produce a commercially viable system for making color photographs that led up to the introduction of the Autochrome in 1907, a story of great expectation mixed with skepticism, of intermittent joys and subsequent frustrations.

The Autochrome's introduction is where the heart of the book's tale takes hold. Technical issues certainly played a role in the quick rejection of color by Stieglitz and his colleagues. Autochromes are one-of-a-kind photographs on glass plates. They are difficult

to display, they do not translate well in print form, and their dyes fade when left for extended periods in bright light. Yet Stieglitz quit using the process not for these reasons but because color changed his conception of photography in ways that he neither expected nor was ready to explore.

Color brought photography into closer alignment with human sight and yet paradoxically away from the medium's descriptive roots. Chapter 2 examines this quandary, relating photographic artists' extended struggle to understand what color delivered and sharing their at times vociferous arguments over how to think about and use photographic color. For much of this time artists and critics alike focused on the dichotomy of close description versus abstraction. For many of them, straight depiction of the world undercut one of the key tenets of what made photographs artful, while abstraction seemed merely to project ideas already addressed in more fulfilling fashion through painting. However, in the face of these quandaries, the allure of color remained unabated. More photographers were taking it up each year, often with great finesse and creative expertise. Unfortunately, until photographers could figure out how to integrate color into black-and-white trends, color photography stubbornly remained a secondary tool, acceptable mainly for commercial work and hobby play. On those rare occasions when it gained respect, as in the work of Eliot Porter and Marie Cosindas, that support was begrudging and the work was framed as an offshoot of the main course of art-photographic practice.

Still, by the early 1970s, Chapter 3 explains, the use of color photography was becoming so pervasive among amateurs and young artists that critics started realizing that it would be only a matter of time before the medium would gain wide museum acceptance. The question now became under what terms color would find that critical embrace. The answer came quickly in the form of Szarkowski's presentation of Eggleston's color photographs at MoMA. That exhibition has come to be so universally viewed by historians as the marker of color photography's artistic and critical acceptance that it is difficult to remember

how controversial it was. Szarkowski's designation of Eggleston's color photographs as "perfect" created an uproar. His images were not traditionally beautiful. Nor were they visually challenging in subject or composition, at least at first glance. But the very existence of the show made it clear that color had finally gained a place within the artistic pantheon, and that straightforward looking at the world was the accepted path.

Yet this chapter makes clear that even Szarkowski did not fully understand Eggleston's achievement. By embracing color photography that was naturalistic yet forceful, where color competed with subject for attention, he inadvertently set in play the demise of photography in the traditional sense. When, later that decade, the fine art photography world absorbed semiotic appreciations of cultural meaning, the transition was completed. Eggleston's acceptance of color's active unpredictability, in tandem with semiotics, transformed photography from a tool for describing the world into an opportunity to blend description with cultural assertion; in other words, it became a means for shaping new worlds.

This shift fundamentally undercut photographers' and critics' longstanding location of photography's core in its unique ability to record light and physical detail with unparalleled exactitude. While we generally think of color as bringing added truth and immediacy to this foundational core, color photography actually freed the medium from its subservience to verisimilitude. Visceral connection to the world remains today the key to photography's graphic power, but now imaginative creation is equally important. The last part of Chapter 3 traces this momentous shift as it cut away the boundaries between photography and the other arts, bringing new artists into the field who had little interest in photography's traditions and who were more interested in using the medium not to record the world but to reflect ideas about the world.

By the early 1990s, color had become so absorbed into fine art photography that use of color materials was no longer a point of critical discussion; it was

taken for granted. This is too bad, because photographers were applying color in active ways. Chapter 4 relates the main line of this ongoing conversation. Now, photographers were conversing with painting—using the camera to question the semantics of color description and our expectations of the colors of things. They also were choosing colors in direct reference to the vocabulary of painting and installation art, Rembrandt's browns, Holbein's greens, and the color fields of James Turrell.

New digital technologies only enhanced these explorations. The easy erasure of the boundary between reality and fiction afforded by this technological change induced artists using the camera to embrace the longstanding notion that art is inherently theater. That embrace released photography from its artistic ghetto. Transforming photography from record to creation rooted in record saved the medium from itself, making it, at last, a full equal with painting. Color, this book argues, was essential to this transformation.

Yet all is still not resolved. The rapid shift from film to chip has recently caused a range of artists to look hard at the tools of their trade. As screens increasingly become the final presentation mode, some photographers are bringing explicit new attention to the physicality of the photographic print—not only the mutuality of light and white paper, but also the patterns created by the layers of color in film and printing papers. Although these shifts have incited critics and historians to call into question the very viability of photography, this text concludes that this change is merely another transition for this peculiar and beguiling art. ◆

1. Alfred Stieglitz, "The New Color Photography—A Bit of History," *Camera Work* 20 (1907): 20.
2. See William Innes Homer, *Alfred Stieglitz and the Photo-Secession* (Boston: Little, Brown and Company, 1983).

CHAPTER

Inventing Color Photography

Reproduce, by means of light, the beautiful colored image on the ground glass of your camera, and you will be ahead of all the painters.

ASHER B. DURAND, 1848[1]

IN JANUARY 1851 an obscure upstate New York photographer named Levi L. Hill published a pamphlet in which he made an astonishing claim:

> Several years experimentation have led us to the discovery of some remarkable facts, in reference to the process of daguerreotyping in the *colors of nature*. For instance, we can produce *red, blue, violet,* and *orange* on one plate, at one and the same time. We can also produce a landscape with these colors beautifully developed—and this we can do in only one-third more time than is required for daguerreotype. The great problem is fairly solved. In a short time it will be furnished to *all* who are willing to pay a moderate price for it.[2]

Although Hill used the royal "we," readers of his declaration understood that he, and he alone, was close to resolving one of the great problems of the day—how to make color photographs. There had been broad disappointment at the public introduction of photography in 1839 that neither the daguerreotype nor the competing salted paper print process could render the world's vast array of color.[3] Established scientists and tinkerers alike had been pressing to create color photographs since well before photography's introduction. Scientists had figured out how to photographically record the hues of spectral arrays, but they had not been able to advance beyond that elementary level.[4] To address customers' pressing desire for color, photography studios had developed a service of applying watercolor, pigments, and even gold leaf to key parts of their images (Plate 1.1), yet these efforts were a mere stopgap.[5] To push discussions along, New York City's main photographic newspaper, *The Daguerreian Journal*, had even taken to publishing a series of articles detailing the scientific properties of light and color.[6]

That a little-known backwoods photographer was now claiming to have resolved a problem that had stumped even leading international scientists like Sir John Herschel of England came as a shock. Immediately, Samuel Dwight Humphrey, the editor and owner of New York City's photographic newspaper,

The Daguerreian Journal, wrote to Hill asking for an explanation; and before seeing any of Hill's plates, he excitedly announced to his readers: "We are now called upon to notice the greatest and most valuable discovery since the announcement of the Daguerreotype by Daguerre, and the Telegraph by Morse. With these names we now add another of one whose great perseverance and energy has ranked him with the first discoverers in the world."[7] He christened Hill's color photographs "Hillotypes" in acknowledgement of Hill's explanation that they were entirely different from daguerreotypes. Like their predecessors, he noted, they were one-of-a-kind metallic plates; but rather than having the difficult-to-view mirrored surface of daguerreotypes, they presented the muted reflectivity of enamel. They also were apparently quite durable. Taking Hill at his word, Humphrey explained to his readers that placement of two plates for four months in a sunny window had done nothing to diminish their colors. He relayed Hill's continuing difficulty at achieving yellow but, caught up in the excitement, he predicted the quick adoption of Hillotypes and even imagined color photographic landscapes that were five feet across.[8]

Hill, it would turn out, was the epitome of an ambitious tinkerer. He had taken up photography two years earlier, when chronic bronchitis had forced him to quit his duties as minister to a small Baptist congregation in the Catskill Mountains town of Westkill, and had established a modest trade in portrait photography, selling detailed text instructions on making daguerreotypes and offering personal lessons in the mechanics of the medium. The first spring or summer of practicing his new profession, while drumming up portrait commissions in Dover Plains, he had sought out the acclaimed Hudson River School painter Asher B. Durand for advice on hand-coloring. In return, Durand had delivered the challenge at the top of this essay. The painter probably tossed it out as a casual remark, said half in jest, but the statement became Hill's obsession. Now, in a second letter back to Humphrey, Hill retold his tale about meeting Durand and how it had sparked him to experiment with

color. He drolly explained that it had all been in fun until one day he had unexpectedly produced a plate that recorded the bright ruby-red color of his sitter's dress. That surprise, which he admitted he had not been able to repeat, had caused him to experiment intensively for almost two years until one day, he said, he had happened upon "a singular compound" that worked. Already, he relayed, he had produced forty-five successful color plates and had even figured out how to reduce his exposures to less than that needed to make daguerreotypes. In closing, he asked for time to further "perfect" his discovery and to secure a "special patent" for it. With those achievements in hand, he promised, he would offer it for sale "on reasonable terms."[9]

Hill's latest letter only made Humphrey more effusive. Although he still had not seen any of Hill's plates, in the next issue of *The Daguerreian Journal* he exclaimed: "America can safely say she has presented to the world one of the most invaluable discoveries that has ever been imprinted upon the pages of history."[10] Hill subsequently sent a third letter proclaiming: "I have now fifty-five specimens. They all are equally perfect. It is quite remarkable that I have never yet made a *partial* failure."[11] He explained that his new color photographs had strong clear whites, deep reds, and none of the blue tonal reversal so common to overexposed daguerreotypes.

Through the spring and early summer months of 1851, photographers from across the United States badgered Hill with letters, and those who could made their way to Westkill to see the Hillotypes in person. Hill generously met with those who came, but coolly put them off, explaining that he would not show his plates to anyone until he had perfected his process. Such demurrals did not stop Humphrey from making Hill co-editor of his journal or from inflating the photographer's achievement by writing: "The Hillotype surpasses in magnificence any discovery appertaining to our art. . . . Could Raphael have looked upon a *Hillotype* just before completing his Transfiguration, the pallet and the brush would have fallen from his hand, and this picture would have remained

unfinished."[12] Yet impatience was spreading. With an increasing number of customers now holding off getting their portraits made until they could get them done in color, the photography market was in disarray. Some photographers began accusing Hill of lying. In response, citing the distraction of having to entertain so many visitors, and claiming deteriorating health, Hill announced that with regret he had been forced to close his doors to all visitors.[13]

Then word arrived that the Frenchman Claude Félix Abel Niépce de Saint-Victor had produced color daguerreotypes. Niépce freely showed his imperfect results to colleagues, openly describing his process and revealing its limitations.[14] His method required exposure times of one to three hours, and the colors faded almost immediately, but Hill now felt enough pressure to prove his priority that he immediately invited Humphrey and a small group of respected daguerreotypists including John Gurney, Charles Meade, and Myron Shew to his Westkill home to show them his color plates.

The visit was a disaster. Rather than perfect, full-color portraits and views, Hill pulled out plates documenting hand-colored French engravings. What's more, the plates showed indistinct greens, vague hints of blue and yellow, and in some cases a predominating cast of red or purple.[15] (Plate 1.2.) Hill explained to the group that these Hillotypes represented merely his experiments, and that he had other good plates in hand, yet he obstinately refused to present those better plates for inspection. He even rebuffed requests to bring out the original French engravings to allow his visitors to check the quality of the color translations. Feeling duped, Humphrey immediately dropped Hill from the masthead of *The Daguerreian Journal* and declared in the October issue that it was time for Hill to show not his experiments but his successes.[16] To make matters worse for Hill, that November the New York State Daguerreian Association sent a three-person delegation headed by one of his most vocal detractors, daguerreotypist D. D. T. Davie, to Westkill to investigate his claims. When Hill refused to receive them, the committee

acidly reported: "Mr. Hill has deluded himself, thoroughly and completely—the origin of the discovery was a delusion."[17]

Still, Hill obfuscated, pleading for patience. He invited other prominent photographers, including John A. Whipple and the influential daguerreotypist-painter-inventor Samuel F. D. Morse, to private viewings in exchange for written attestations of support, and he added a portrait of a child and a landscape view to the plates that he was willing to show his visitors. In response, Morse generously sent the press letters heralding Hill's plates while admitting their imperfections. When Humphrey conscientiously re-printed one of Morse's letters along with some of the other testimonials of support in what he now called *Humphrey's Journal*, readers inundated him with malicious hate mail directed at Hill.[18]

In late 1852, a committee of New York daguerreotypists publicly offered to raise one thousand subscriptions at $100 each for rights to Hill's process, only to have Hill reject the proposition, replying that he was closer than ever to success and wanted to complete the job himself.[19] When word got out the following spring that Hill had approached the U.S. Senate Committee on Patents, Humphrey was forced to publish a statement saying that there was no truth to the rumor that Hill was about to release his process to the public.[20]

Then came a long silence. It was as if Hill had disappeared. The daguerreian trade recovered and photographers shifted their concerns to the competition brought by the collodion process that, though also not offering color, at least allowed multiple prints of fine detail to be made from a single negative.

When Hill popped up again in early 1855 with a new circular and a letter to *Humphrey's Journal* announcing his imminent plans to publish instructions for producing color photographs, Humphrey noted the flow of incredulous letters that resulted, including one that sarcastically urged the formation of "a procession of believers . . . uniformly dressed in *chrome yellow breeches*" to march on Hill's Westkill home to celebrate the photographer's newfound ability to

render yellow.[21] Fed up with Hill's antics and willing to be publicly chastised, Humphrey opened the February 1, 1855, issue of his journal with an extraordinary six-page letter summarizing the situation.[22] The unidentified writer, who called himself "Helios," first established his neutrality and independence: "As one who has never seen the gentleman, I am free of all Sheridan-like influences." Noting how Humphrey's original announcement extolling Hill's success had turned the photography world "topsy-turvy," Helios then mused that at least the Westkill innkeeper must have gotten wealthy serving Hill's many visitors, and that Hill must have grown rich, despite his protestations to the contrary, through the sales of his books and many circulars proclaiming his discovery. Castigating Humphrey for his misplaced enthusiasm, the writer concluded that the whole affair was nothing more than a classic case of Barnum humbugging, and Hill's most recent letter and circular was nothing more than a "sublimely ridiculous 'Jeremy Diddler' trick":

> We have been led on, time after time . . . we have contributed liberally. Now let every one assume the position . . . that LEVI L. HILL *has not any discovery by which he can produce upon metallic plates the colors of Nature*, that can be at once *successfully applied*, and is not PRACTICAL! . . . Let every one . . . not contribute further . . . until he has provided satisfactory evidence that he has something of PRACTICAL WORTH."[23]

In a subsequent issue, Humphrey admitted that Helios's explication had unleashed enough anti-Hill letters to fill eight issues. There matters stood for another year.

Finally, in August 1856, more than five years after his initial announcement, Hill published his color recipe. Ambitiously priced at $25 (about $650 in today's dollars), *A Treatise on Heliochromy; or, The Production of Pictures by Means of Light, in Natural Colors* is a remarkable blend of hyperbole, tirade, self-celebration, and obfuscation. It opens with Hill's

lengthy self-aggrandizing tale of his transitions from young printer and bookseller to preacher and then photographer. The text then launches into an extended explication of the succession of problems he had encountered over his years of trying to achieve viable color photographs. The account makes it clear that Hill was not a methodical man, neither taking detailed notes nor controlling for the variables in each new experiment. Recounting the attempted visit in late 1851 of the three investigators sent by the New York State Daguerreian Association, Hill vituperatively accused Davie and his associates of attempting to break into his lab, steal his secrets, and even threaten his life, forcing him to buy a revolver, borrow a guard dog, and organize his neighbors into special defense committees. Only at the end of the book does the photographer offer his step-by-step recipe for making Hillotypes. Unfortunately, the recipe is so convoluted and filled with contradiction that even today it cannot be followed. Sick of the whole affair, Humphrey refused to even acknowledge the publication.

Hill well knew of his predicament. Within months of his text's publication he quit the photography business entirely, moved to New York City, and took up trying to create an economically viable gas for illumination by separating water into oxygen and hydrogen.[24] But Davie refused to let the matter drop. Embarrassed by Hill's characterization of his 1851 visit, Davie sued Hill for libel, and after getting a court order banning the sale of Hill's book he convinced Humphrey to publish a letter wherein he labeled Hill "a Judas; nay, a midnight assassin" who had skulked into hiding.[25] When Levi Hill died in February 1865 at age forty-nine, probably succumbing to the accumulated poisons of his various experiments, the new editor of *Humphrey's Journal of Photography*, John Towler, generously acknowledged his death with the summative declaration: "He always affirmed to the writer that he *did* take pictures in their natural colors, but it was done by an *accidental* combination of chemicals which he could not, for the life of him, again produce!"[26]

There the beginnings of color photography in America lay, dismissed and largely forgotten until almost seventy years later, when New Jersey physician Dr. John Boggs Garrison approached the Smithsonian Institution's National Museum of American History.[27] Claiming to be Hill's son-in-law, Garrison offered the museum sixty-two 8½" × 6½" photographs on copper plates that he called Hillotypes. The objects presented color records of hand-colored engravings, save for a view of an unidentified farmhouse. The museum took them in, not knowing quite what to think of them. Some of the plates were very glossy while others were almost matte in finish. Some gave off strong iridescent patterns when viewed under fluorescent light.[28] When the museum put one of the plates on display in the 1980s, its colors faded so quickly that it had to be immediately taken off view.[29] Only in 2007, with the help of scientists at the J. Paul Getty Conservation Institute in Los Angeles, did the museum undertake a full physical and

chemical analysis of the plates. They found that although Hill had apparently never solved his problem in getting clear yellows and blues, and had added or enhanced these colors by hand-painting some of his plates, he had apparently been able to directly record red and green. How he achieved those colors remains a mystery.[30]

HILL'S FAILURE did not stop Americans and Europeans alike from trying to produce color photographs; but rather than focus on directly recording the world's colors, as Hill had done, the most successful investigations over succeeding years followed an indirect route founded on burgeoning medical understanding of the human eye. This indirect route would provide the foundation for color photography as we know it today, but it would not come quickly or easily.

Three decades before photography's introduction in 1839, the English scientist Thomas Young had postulated that the human eye sees color by means of three types of retinal nerve fibers that respond roughly to the colors red, green, and blue. In 1850, just as Levi Hill was about to announce that he had produced color photographs, the German physicist Hermann von Helmholtz had hypothesized that the brain recombines those three colors into a full spectrum. It would take another eleven years for someone to successfully apply those surmises to photography, but on May 17, 1861, the Scottish physicist and mathematician James Clerk Maxwell demonstrated to his colleagues at London's Royal Photographic Society how one could create a full-color image of a tartan ribbon (Figure 1.1) by photographing it three times, once each through red, green, and blue filters, project a black-and-white positive version of each image through its corresponding color filter, and bring the four images together by superimposition.[31] This cumbersome projection proved that color photography was achievable in principle, but it delivered a very imperfect rendition of the ribbon's colors.[32] Seven years later the Frenchmen Louis Arthur Ducos du Hauron and Charles Cros each demonstrated separately conceived though similar ways of making color

FIGURE 1.1
James Clerk Maxwell (1831–1879), [Tartan ribbon], 1861. Reproduction of projected positive plates. © National Media Museum/Science and Society Picture Library, London.

photographic prints based on Maxwell's ideas—by layering in exact registration carbon tissues representing each primary color image. But here, too, the inability to render a full range of color adequately prevented commercial viability (Figures 1.2 and 1.3).[33] The problem was that photographic emulsions of the day captured blue very well but were far less sensitive to red and green. Through the remainder of the nineteenth century if one wanted a color photograph, one had to paint it with watercolor or other pigments. The matte surface of salted paper prints took watercolor quite well, extending the use of that type of paper well after the glossier albumen papers had come into vogue. Top-end studios were less likely to hand-color their works, arguing that the practice undermined photography's wonderful "unmediated" connection to the world, but many middle-level studios offered the service, often hiring women to complete the hand-coloring. Generally, they touched up just a few key details like jewelry or faces, but in some cases, especially with paper prints, the hand-coloring could be extensive, and subtly beautiful, blending the realism of photography with the lush beauty of painting (Plates 1.3, 1.4).

The lack of a panchromatic (sensitive to all colors) photographic emulsion did not stop people from trying to make color photographs though, and by the 1880s, announcements of success in achieving such photographs were popping up with regularity. Editors of newspapers and photography journals were cautious, however. Not wanting to miss out in case any of these reports were true, they faithfully printed these tales, though often with open skepticism.[34] For example, when the *Nebraska Herald* in Plattsmouth relayed a London report on August 18, 1881, describing production of a color photograph of a dog whose protruding tongue was said to captivatingly mirror the real thing, the paper's editor appended the text with a note stating that he would wait to see the results in person before commending them.[35]

The competition between Americans and Europeans over who would be the first to produce a practical form of color photography was so fierce that

when Philadelphian Frederic Ives suggested in a February 1888 lecture at the Franklin Institute that he was close to resolving the problem, he created quite a stir.[36] Ives was in the midst of a controversial career due to his tendency to assert his priority over inventions quite similar to those announced by others, but he had gained more than seventy patents and was clearly responsible for the substantive improvements that made halftone printing of photographs practical. He had developed a binocular microscope, an improved self-playing piano, and a means of using infrared and ultraviolet photography to detect counterfeit banknotes.[37] He was not to be dismissed lightly. Directly recording the world's colors was a dead end, he explained in that talk, because such processes required impractically long exposures and delivered only muted colors that were not permanent.[38] He argued that those investigating indirect color had also been taking the wrong track because they had been using filters of pure red, green, and blue. They should have been using color mixes, he

FIGURE 1.2
Louis Ducos du Hauron (1837–1920), [Rooster and budgerigar], 1869–1879. Tricolor carbon transparency on paper. Reproduction from George Eastman House International Museum of Photography and Film, Rochester, NY.

declared. To prove his point, he projected six color slides that used compound color screens. The results were not perfect, but they generated tremendous excitement.[39] Caught up in the race for personal and national priority, Ives suggested that he had been working on the problem of color for eleven years already and that he would have come forth earlier had a fire two years previously not destroyed most of his work. He claimed that he had made the slides he was then presenting six years earlier.

It would take Ives four more years to refine his system enough to make it more credible. When he finally demonstrated it in April 1892 at Philadelphia's Association Hall, the room was filled with people and bursting with high expectation. As his first photograph was projected, everyone broke into sustained applause. The device, which Ives called a "heliochromoscope," was cumbersome. It required the projection in meticulous alignment of three black-and-white, glass-plate positives, each through its own special color filter.[40] It was not for the weekend amateur or the faint of heart, but it delivered photographic images of remarkably nuanced color. Immediately, Ives set off on a European tour to triumphantly show off a portable version of the instrument that he called a photochromoscope. There, members of the photographic community met him with a mix of chagrin and skepticism. Once again, an American had supposedly solved a problem that still bedeviled them. At the Royal Society of Arts and Sciences in London, Ives set the object shown in the color photograph next to his machine so that attendees could judge for themselves the quality of the color rendition. But nationalist prejudices filled the room. The president of the London Camera Club, Sir William Abby, disdainfully refused to be introduced to him until after he had seen the display for himself. Ives later gleefully described the experience:

> Only one photochromoscope was on exhibition, surrounded by such a crowd that it was a long time before he could get to it. After the first glance, he straightened up as if galvanized, batted his eyes a few times and then took another look, this time a very long one, while others waited impatiently for their turn. He then pushed his way through the crowd to where I was standing, introduced himself, and invited me to be his guest at a dinner at the Camera Club. Thereafter he was my fast friend, endorsed all of my theories and claims, and never had a word of anything but the highest praise for what I had shown and accomplished.[41]

FIGURE 1.3
Charles Cros (1842–1888), *La Table, Nature Morte*, 1869. Tricolor carbon print. Courtesy of Sotheby's Picture Library.

By the fall of 1892, Ives was marketing a one-shot camera that he asserted would so ease the process for making the glass plates required for his color projectors that it would deliver color photography into the hands of the "press the button" class of amateurs. (The camera exposed the three black-and-white negatives simultaneously through color filters. One then transformed each negative into a positive through redevelopment.) Alluding to another major recent technical breakthrough, he suggested that his heliochromoscope could translate its three black-and-white plates into a full-color image "as readily as the sound record in the phonogram is translated into sound in the phonograph." The whole, he said, would make "color-photography a household affair."[42] To counter complaints about his viewer's bulkiness, he equated it to stereo photography, and predicted that it would soon become more popular than the stereoscope.

That November, however, when Ives presented his heliochromoscope at the Camera Club of New York, the drawbacks of his three-color projection system became clear. He had such difficulty achieving proper alignment that a reporter from *The New York Times* exclaimed that his color photograph of a gilt Chinese vase sitting on a cigar box looked like "a weak water color of the object, or like a piece of cheap Japanese decoration," and that his photographs of a bouquet of flowers and a chromolithograph delivered nothing better than crude saturated colors.[43] Although Americans rejected his projectors, Ives gained enough British investors to start selling them in 1899 under the name Krōmskōp (Figure 1.4). Unfortunately, even with further refinements the machines remained persnickety. They also were expensive. Sales were limited.[44]

If making one's own color photographs still remained a technical challenge in 1899, a new printing technology offered at least a partial solution. The same year that Ives started selling his Krōmskōps, the Detroit Photographic Company started marketing Photochroms, a blend of photography and lithography wherein printers could incorporate up

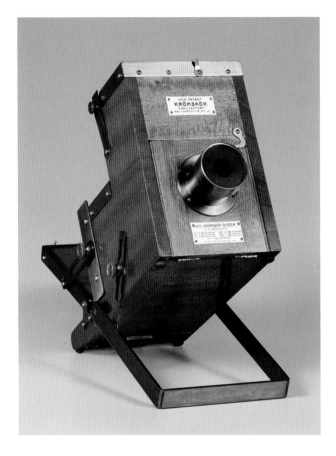

FIGURE 1.4
Frederic E. Ives (1856–1937), Krōmskōp viewer, ca. 1899. George Eastman House, International Museum of Photography and Film, Rochester, NY.

to fourteen colors into a photographic image.[45] The method, which allowed the company to produce credible color photographs in print form, was a hit (Figure 1.5). The Detroit Photographic Company found wide commercial success with the process by hiring the well-known photographer William Henry Jackson, and incorporating his extensive stock of images into its archive. Congress's authorization of penny postcards in 1898 provided another huge market for Photochroms.[46] But the process was more a pastiche than a true answer because it produced colors that seem to lie on the surface rather than come from the objects photographed.

Ives's Krōmskōps and the Detroit Photographic Company's Photochroms may have been the most successful means for producing color photographs as the nineteenth century closed, but they were by no means the only approaches to solving the problem of color. Over these same years, Americans and Europeans alike were working to refine the Cros/Ducos du

Hauron approach of layering colored carbon tissues.[47] Still others, drawing on painters' recognition of the mind's tendency to blend adjacent small spots of color into larger mixed tones, developed systems based on juxtaposing black-and-white negatives with screens of primary colors.[48] The lack of panchromatic emulsions rendered all of these efforts compromises, but by 1900 enough of these kinds of color photographs

FIGURE 1.5
William Henry Jackson (1843–1942), *Pulpit Rock, Echo Canyon, Utah*, ca. 1890–1900. Photochrom. Amon Carter Museum of American Art, Fort Worth, TX.

were working their way into public exhibitions that the leader of New York's fledgling community of artist-photographers, Alfred Stieglitz, felt the need to address the issue. Taking advantage of his position as editor of the Camera Club of New York's journal, *Camera Notes*, in July 1900 Stieglitz published poet-critic Sadakichi Hartmann's essay "Color and Texture in Photography." Here, Hartmann downplayed "color in photography as nothing but *contrast and arrangement of values*," and suggested that those interested in color should study the black-and-white photographs of the heralded artist-photographer Frank Eugene who had gained his artistic training at the Bayrische Akademie der Bildenden Künste (Bavarian Academy of Fine Arts).[49]

If Stieglitz and Hartmann were ambivalent about contemporary achievements in color photography, the man who would soon become Stieglitz's most influential supporter and assistant was on the cusp of embracing the medium. The young Milwaukee artist Edward Steichen had taken up both photography and painting in 1895 shortly after starting an apprenticeship in a commercial lithography studio. His painting lessons had led him to recognize the difference between recording an object, person, or scene before his camera and capturing its expressive character. He then had realized that he could inject an artful moodiness into his photographs by doing such quirky things as leaving raindrops on his lens or giving a slight kick to his tripod while photographing the changing light of woodlands at dusk. The results were so beguiling that in 1902 Stieglitz would select him to be part of an inaugural "Photo-Secession" group of the top American artist-photographers of the day.[50] At about this same time Steichen encountered an article describing the French photographer Robert Demachy's practice of gum bichromate printing, which allowed the artist to build up the tones and even add color to his photographic images through multiple printings.[51] Inspired to try the practice himself, he started creating evocative photographs of Rodin's sculpture, New York's famous Flatiron Building, and a rural "moonrise" incorporating subtle

yet distinct blues, greens, and browns (Figure 1.6). Intrigued by the potential of color, he also started experimenting with several of the new "repeating back" cameras that exposed three negatives quickly one after the other through red, green, and blue filters, photographing the autumnal color around the Stieglitz family summer house at Lake George, New York, and while visiting the critic Charles Caffin in Mamaroneck, New York.[52] Even though Stieglitz was skeptical about color, recognizing that the lack of panchromatic emulsions prevented these photographs from displaying satisfactory nuance, he liked

Steichen's work enough to display some of the results at the new gallery he had opened to promote the art of photography, and to publish several in his new independent art journal, *Camera Work*.[53]

Then, in 1905, the London firm of Wratten and Wainwright introduced a panchromatic photographic emulsion. Immediately, achieving good quality, easy to produce color photographs seemed not merely probable but inevitable. And the inevitable occurred a short two years later when on June 10, 1907, the French brothers Auguste and Louis Lumière triumphantly introduced what would become the first

FIGURE 1.6
Edward Steichen (1879–1973), *Moonrise, Mamaroneck, NY*, 1904. Platinum print and ferroprussiate. The Museum of Modern Art, New York. Gift of the photographer. Permission of the Estate of Edward Steichen. Digital image © The Museum of Modern Art/Licensed by SCALA/ Art Resource, NY.

commercially successful color photographic pro-
cess, unveiling their method to a specially invited
audience of six hundred artists, writers, politicians,
photographers, and press in the Parisian offices of
L'Illustration. Steichen was at the event, and Stieglitz
would have been there if he had not fallen ill that day
and been forced to remain at his hotel.[54]

The Lumière brothers had been working on the
problem of color for years. They had gained patents
for their new screen process in 1903, and now, finally,
had figured out how to produce their color photo-
graphic plates in commercial quantities. Their Auto-
chrome took the new panchromatic emulsion and
overlaid it with millions of tiny grains of randomly
distributed potato starch that had been dyed orange-
red, green, and blue-violet. The tiny dots fooled the
eye into reading the images as having a full range
of hues. The plates required long exposure times of
one to two seconds at around noon on a bright sunny
summer day, but they could be exposed in most stan-
dard cameras and mastered, the Lumières explained,
by any photographer with reasonable skills. (A busi-
ness would quickly develop offering folding mirror-
filled frames called diascopes that enabled easy
viewing of the plates.) Steichen came away not partic-
ularly impressed with the brothers' sample plates, but
he was intrigued enough by the demonstration to buy
plates for himself and Stieglitz. When he then tried
the process the next day, he was so captivated by the
results that he rushed over to Stieglitz's room to show
off his work and to teach the rudiments of the process
to the older man.[55] Stieglitz then travelled on to Ger-
many with his wife and daughter and Steichen took
off for London to show his plates to R. Child Bayley,
editor of the journal *Photography*. Bayley was so
impressed that he rushed to press with an interview
that saw Steichen proclaiming that the Autochrome
"copies with the same startling realism that a good
phonograph records a Caruso solo."[56] As Bayley trum-
peted Autochromes to his skeptical readers, Steichen
then proceeded to Tutzing, a resort near Munich, to
join Stieglitz and photographers Frank Eugene and
Heinrich Kühn.[57] There, working together, the men
refined their Autochrome technique. By late July,

Stieglitz was able to excitedly write Bayley that he too
was getting pictures that were "so startlingly true that
they surpass anyone's keenest expectations."[58] One
of these successful color photographs is an informal
portrait of a dapper Eugene in suit and fedora hold-
ing a half-empty stein of beer (Plate 1.5). The color of
the beer is so believable that it induces thirst, while
the blues and greens of Eugene's apparel seem spot-
on in their subtlety.[59] "For upwards of twenty years I
have been closely identified with color photography,"
Stieglitz declared in a letter sent for publication in
Bayley's journal. "I have paid much good coin before,"
concluding that color would remain "the *perpetual
motion* problem of photography." Now, he exulted:

> The possibilities of the process seem to be unlim-
> ited. Steichen's pictures are with me here in Mu-
> nich; he himself is now in Venice working. It is a
> positive pleasure to watch the faces of the doubting
> Thomases—the painters and art critics especially—
> as they listen interestedly about what the process
> can do. You feel their cynical smile. Then, showing
> them the transparencies, one and all faces look posi-
> tively paralysed [*sic*], stunned. A color kinemato-
> graphic record of them would be priceless in many
> respects. Then enthusiasm, delighted, unbounded,
> breaks loose, like yours and mine and everyone's
> who sees decent results. All are amazed at the
> remarkably truthful color rendering; the wonder-
> ful luminosity of the shadows, that bugbear of the
> photographer in monochrome; the endless range of
> grays; the richness of the deep colors. In short, soon
> the world will be color-mad, and Lumière will be
> responsible.[60]

On his return to New York that autumn, Stieglitz
called the press into his Little Galleries of the Photo-
Secession, at 291 Fifth Avenue, to show off his color
plates, along with those of Steichen and Eugene,
and to expansively announce: "Color photography is
an accomplished fact."[61] In the next issue of *Camera
Work*, which coincidentally reached its readers just
as the first Autochrome plates were arriving in the
United States for commercial sale, he strategically

preceded his celebration of the new process with a text by J. M. Bowles praising the photographs of Stieglitz's favorite artists as true art works in all but one aspect—they were monochrome. By being "shut out from the whole wonderful world of color," Bowles asserted, these photographs, despite their fine-art pretentions, would never be able to truly stand on a footing with the other arts.[62] Bowles's exhortation to photographers to vigorously attack the problem of color created the perfect foil for Stieglitz's ensuing article. There he declared, "What the Daguerreotype has been to modern monochrome photography, the Autochromotype [sic] will be to the future color photography." He cautioned that correct exposure of Autochrome plates was essential, that it was impossible to get pure whites, and that the required protective varnishing of the finished plates had a tendency to change the image colors. But he excitedly predicted that it would be just a matter of time before the Lumières would figure out how to produce color photographic prints, and that "the effect of these pictorial color photographs when up to the Secession standards will be revolutionary." He then announced that a special color supplement to *Camera Work* was in the works, and two pages later he reprinted the invitation to his mid-September press gathering at the 291 gallery appended with an exuberant report of the event that concludes: "Thus color photography and its wonders were set loose upon America. . . . Here then is another dream come true."[63]

WITH FRENCH ART CIRCLES in an uproar over Paul Gauguin's bold, false-color paintings and Paul Cézanne's dissolution of form into facets of color, it now seemed that photography would carry the torch of color realism. The Lumière brothers sold out of plates almost immediately, and for many months thereafter demand far exceeded supply.[64] Boston photographer Alvin Langdon Coburn, now living in London, wrote Stieglitz in early October: "I [too] have the color fever badly and have a number of things that I am simply in raptures over," adding in a subsequent note: "I can understand Steichen's not wanting to do any more black and white work. I am getting

that way myself."[65] Coburn's friend Dixon Scott called Autochromes "more beautiful than many famous pictures," adding, "as I looked at them I thought rather sadly of certain earnest friends of mine toiling in dull studios . . . studying perspective in chilly schools, going out . . . with unresponsive pigments and stubborn, primitive tools, gallantly, unsuccessfully striving to make their stiff hands transcribe the lush splendors their eyes so longingly discerned."[66]

Yet for all of Scott's enthusiasm, his response alludes to two issues that would eventually come to dominate the conversation: photography's relationship to painting and its character of recording the world with relative verisimilitude. The London periodical *The Amateur Photographer* had already presented color halftone reproductions of Autochromes of a mother and daughter next to actual swatches of their dress fabrics to trumpet the process's color accuracy.[67] With Autochrome use spreading fast across the broader community of amateur and commercial photographers, Stieglitz and his colleagues began to grow concerned about the place for art in this rapid transition. In his letter to *Photography*, Stieglitz had warned: "The difference between the results that will be obtained between the artistic fine feeling and the everyday blind will even be greater in color than in monochrome."[68] Coburn now elaborated further in a *Liverpool Courier* interview:

> These people with their silly little enthusiasm and their entire inability to appreciate the niceties of color will produce the most appalling fried-egg results. They'll plant their cameras anywhere and everywhere; they'll photograph pink flowers against a purple sky; they'll get their color all out of tone— blues and yellows and scarlets jumping about and hitting one another in the teeth—the whole thing screaming like Sousa's band gone mad . . . Much more than the old monochromist, the new color photographer will have to select his picture, rearrange his omelettes and flowers and sunlight, pick out the single perfect picture from among the dozens of discordant pictures which nature offers him at every turn.[69]

Even as he devoted the April 1908 issue of *Camera Work* to celebrating the beauty of Steichen's Autochromes, Stieglitz was starting to question the artistic viability of the process. He had gone out of his way to get Steichen's four Autochromes printed by a top-quality German printer only to receive reproductions that projected none of the vitality of the original plates.[70] Steichen was far more sanguine. Taking advantage of the opportunity to extol the Autochrome process even above painting, he wrote in that same issue: "I have no medium that can give me color of such wonderful luminosity as the Autochrome plate. One must go to stained glass for such color resonance, as the palette and canvas are a dull and lifeless medium in comparison."[71] He called on his readers to pay attention to the mutable character of color, including how colors change over the course of a day or in different weather conditions. The Autochrome process exaggerated these changes, he warned. He advocated looking to painters for guidance on color and atmosphere, and even recommended getting a camera lens that had been corrected for chromatic aberration to get the best color.[72] In the next issue of *Camera Work* he continued his instruction. Complaining about oversaturated color, he suggested attending to Whistler's tone-degraded gamut of hues.[73] The British photographer Frederick Evans agreed. In *Camera Work*'s January 1909 issue he exclaimed:

> . . . the fact that photographers have been, necessarily, training themselves in black-and-white and all its subtleties, and therefore neglecting the study of color, may compel most of them to very dreadful failures; and failure in this color direction will be more painful than failure in black-and-white. The sense of values in color is a rare one, even among painters, with whom it is a daily professional study; it is but rarely we can say, so-and-so is a great colorist.[74]

He saw "endless difficulties and failures," and recognized that the novelty of color made critical judgment difficult, but he too was optimistic, declaring that for those passionate about color, the difficulties will be incitements toward greater achievements: "And if we can hope to go as far with it as photography already has gone in black-and-white, what a 'feast of fat thing[s]' may be looked for!"[75]

The challenge of color photography, Evans and Steichen both astutely realized, was more than simply teaching oneself, like a painter, how to achieve technical proficiency. One had to think differently. To date, photography had relied on a vocabulary of light, close description, and the modeling of form. Color delivered a new, far more active language. Hues could more clearly describe form, but they also could act independently, projecting forward or receding in ways entirely separate from the form. Photographers' limited ability to control their palette presented further problems. Where painters could select and blend specific hues to create color harmonies, photographers had to work with what was in front of their lens. A single bit of bright color off in a corner of a scene could throw a composition into disarray. Finally, there was the quandary that believable color was required to keep an image from seeming wrong. Where was the new place for expression in this scenario? For all of these reasons, Dixon Scott had already changed his mind about Autochromes. He now called them crass novelties: "exquisite automatic delicac[ies] resulting in an image of unyielding exactness" whose insistence on "fanatical truthfulness" leaves no room for artistic interpretation. "The operator has to stand helplessly aside whilst these lilliputian Frankensteins of his creation automatically conduct their own unswerving campaign," he complained, describing Autochrome plates as "metallic," "discomforting," and "far removed from either that sensuous illusion called nature, or that voluptuous reality called art."[76]

American photographer John Nilsen Laurvik, on the other hand, celebrated this new realism. He extolled Autochromes for their ability to assist the study of diseases, allow art lectures to be illustrated with "facsimiles of paintings," and provide more "authentic" family portraits. He also pointed out, as Stieglitz had done, the luminosity of Autochrome shadows compared to the "dead-flat" shadows of black-and-white photographs, suggesting that this depth was proof of Monet's assertion that shadows

are filled with color. Autochromes' recognition of the changing nature of color, he argued, meant that color photography "will surely exert a most important influence on the art of painting, establishing as it does the soundness of the much-abused theories of the Impressionists."[77]

Steichen was the artist among Stieglitz's colleagues who sought most concertedly to explore the artistic potential of the Autochrome. The breadth of his work will never be known because hundreds of his plates were severely damaged or destroyed when he was forced to abandon his French home during World War I.[78] Still, extant plates reveal him to have treated color from the start in line with his painterly roots, allowing it to shape the emotional character of his images, as in his lovely October 1907 portrait of Jean Simpson (Figure 1.7). Making full use of the soft-focus romanticism so central to pictorialism, he posed the young girl in front of shaded window capturing her demurely looking down to the viewer's left. Light crosses not her face but the white ribbon gracing her head and white scarf draped over her shoulders, drawing attention down to the pink-ribboned straw hat in her hands. Although what dominates the image first and last is the glow of the girl's blue dress.

Not being a painter, Stieglitz took a more technical approach to the Autochrome, often counterpointing his female models' white dresses with brightly colored flowers, and drawing special attention to details like the chips of light cascading around two friends playing chess (Figure 1.8). He publicly supported others' explorations of the process, hosting eight exhibitions presenting plates by Coburn, Eugene, Steichen, Paul Haviland, Baron de Meyer, George H. Seeley, Karl Struss, and Clarence White at his gallery between September 1907 and February 1910, but he rejected the process's viability as an artistic advance. After 1908, he made Autochromes only intermittently, and then mainly as private snapshots of family and friends. He also chose not to include any Autochromes in the major summary exhibition of the best pictorialist photography that he assembled in 1911 for the Albright Gallery in Buffalo, New York.

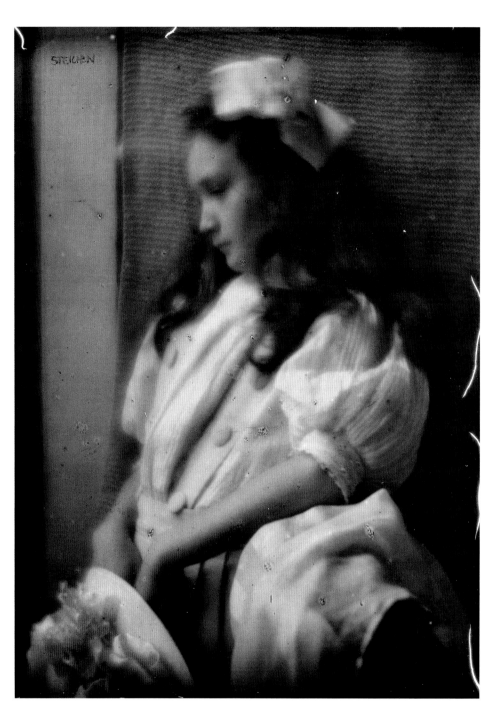

FIGURE 1.7
Edward Steichen (1879–1973), *Jean Simpson*, 1907. Lumière Autochrome. The Nelson-Atkins Museum of Art, Kansas City, MO. Gift of Hallmark Cards, Inc. Permission of the Estate of Edward Steichen. Photograph by Joshua Ferdinand.

FIGURE 1.8
Alfred Stieglitz (1864–1946), *Chess Game, Tutzing,* 1907. Lumière Autochrome. The Nelson-Atkins Museum of Art, Kansas City, MO. Gift of Hallmark Cards, Inc. Photograph by Joshua Ferdinand. © 2012 Georgia O'Keeffe Museum/ Artists Rights Society (ARS), New York.

Four major problems induced Stieglitz to turn his back on Autochromes. First, they were difficult to publicly display. Their colors faded on extended exposure to light, and they required back lighting to be seen. Second, they were difficult to reproduce, as his attempts to print Stiechen's work had shown.[79] Third, to be attractive, the colors in Autochromes needed to provide a believable approximation of what one saw in the world. This attribute drew attention to the very quandary that Stieglitz had been trying to overcome—photographs' penchant to be read as objects of purely descriptive verisimilitude. Finally, contrary to painting, photographers had limited control over exactly how Autochromes rendered each color of the scenes before their cameras. For these reasons, Stieglitz concluded that color would remain the domain of painters. Reinforcing his views were reports that Steichen was sending back to him from Paris about the rise of a strange new kind of art founded on a combination of quickly drawn gesture and abstracted form. Stieglitz did not understand the new work being created by Henri Matisse, Pablo Picasso, and Auguste Rodin, but it seemed vibrant, a clearer reflection of

the power and constant change of contemporary life than the imagery of pictorialism, and he took to showing their drawings, watercolors, and etchings in his gallery and publishing them in *Camera Work*. When he eventually found a photographic response to that art, it would come not through color but in the form of Paul Strand's sharply angled black-and-white views of New York City's street life and close-up portraits of people who spent their days on those streets (Figure 1.9).

Most of Stieglitz's immediate circle followed his lead and largely gave up making Autochromes as works of fine art by the early 1910s, but Steichen was not one of them. Perhaps influenced by meeting Matisse and Picasso, Steichen mixed the geometric vocabulary of modern art into his color-driven Autochrome portrait of Stieglitz's wife, Emily, which he created around 1911 (Plate 1.6). Here, tight framing causes the upturned copper bowl with its cascade of blue flowers to counterpoint Emily's black-and-white outfit and broad-brimmed hat. Her sunhat dominates the upper quadrant of the image, spilling out over the edges of the scene, mirroring the bowl, and drawing attention to the sitter's face, where her dreamy eyes look straight back into the camera lens. Every inch of the composition is alive, a meticulous balance of intersecting facets. The photograph would attract the eye if it were in black and white, but the burnt orange of the copper bowl and the deep vibrant blue of the flowers energize the image, offsetting Emily's severe black dress, hat, and white gloves.

Photographers around the periphery of Stieglitz's circle also continued exploring the process in creative ways. Karl Struss made Autochromes in and around New York and Long Island, including a striking diptych of the boardwalk lining a central Long Island beach (Plate 1.7 A&B). A technical tour-de-force, the object projects the relaxed character of a snapshot in its informal depiction of sunbathers, swimmers, and people strolling the wooden footpath. The scene's broad wash of pale blue, counterpointed by a shadow and accented by splashes of moving color, brings to mind paintings of Claude Monet and Georges Seurat.

Colorado photographer Laura Gilpin, who would
soon take up study under Stieglitz's competitor
Clarence White, made a mix of Autochrome land-
scapes, portraits, and still lifes, including a lumines-
cent still life of peaches (Plate 1.8).

Autochromes were so popular by this date that
they were providing the foundation for a multitude
of public lectures on gardens and scenic sites. The
French banker Albert Kahn was even financing a
dozen photographers' travels across the world to
construct an "Archives of the Planet" in color.[80] In
March 1912, the Professional Photographers' Society
of New York presented more than two hundred color
images at its seventh annual convention, and by the
following year the Lumière factory was producing six
thousand plates a day.

Photographer Arnold Genthe made a practice of
contributing his Autochrome plates to these kinds
of exhibitions, where they were selected out for ac-
claim.[81] He was so successful with such a wide range
of subjects, from portraits of public figures like Julia
Marlowe as Lady Macbeth to sunsets and rainbows
(Plate 1.9), that J. Pierpont Morgan hired him to
document the interiors of his grand New York City
residence by Autochrome.

George Eastman, the founder of Eastman Kodak
Company in Rochester, New York, who already had
become quite wealthy on the sales of roll film and
inexpensive snapshot cameras, even looked into buy-
ing out the Lumières. Instead he hired C. E. Kenneth
Mees away from Wratten and Wainwright to run a
newly established Kodak research laboratory, and

gave him the charge of developing a color film for still photography and cinematic uses, along with a commercially viable color print process. In 1914, just two years after opening the lab, Eastman's employee John George Capstaff came up with a process that involved the superimposition of two glass-plate transparencies that had been dyed green and red. The company called it Kodachrome.[82] While the lack of blue made Kodachrome inappropriate for landscape work, it provided quite credible portraits (Plate 1.10).[83] The following year, Frederic Ives started marketing a color print process he called Hicrome. The format required the meticulous layering of two colored films in exact registration on a cyanotype print, and produced photographs that have a slight underwater feel to them, but with proper exposure and processing it delivered an expansive array of hues (Plate 1.11).[84]

In the face of all this activity, Paul Strand, who by the mid-1910s had become Stieglitz's new closest colleague, acidly asserted that "color and photography have nothing in common."[85] His colleague, photographer Paul Anderson, agreed, suggesting that artist-photographers should not work in color because color is purely sensual, whereas artistic photographs were by definition about line, mass, and gradation.[86]

Yet Steichen refused to be pulled in. Continuing his color explorations on a variety of fronts, he employed Ives's Hicrome process to create a portrait of his daughter Mary in a blue dress, and as part of what he called his "second apprenticeship" in photography, he experimented with printing an orange-red-filtered negative in brown palladium layered over a blue-green one printed as a cyanotype (Figures 1.10 and 1.11). Although the hues of the palladium print are not entirely true, the process so sensitively conveys the pale red color of the clay pots and brown wood of the wheelbarrow that the prints seem, at a glance, to be in color.

Besides disagreeing about the artistic potential of color, Steichen had fallen out with Stieglitz over the older man's dictate that photographs made for commercial purposes were compromised. In 1923,

FIGURE 1.11
Edward Steichen (1879–1973),
Untitled, ca. 1920. Palladium
and ferroprussiate. George
Eastman House, International
Museum of Photography and
Film, Rochester, NY. Permis-
sion of the Estate of Edward
Steichen.

Steichen would accept the job of chief photographer for Condé Nast's high-end magazines *Vanity Fair* and *Vogue*. Although his initial work for the company was entirely in black and white, it would not remain so for long. Aided by Albert H. Munsell's development of a system for rationally describing color, and abetted by books like Louis Weinberg's *Color in Everyday Life*, the design aesthetic of the day was incorporating brighter colors into consumer products and fashions.[87] This commercial embrace of color got a lift with the development of better three-color cameras able to shoot each primary color negative at once, along with a substantially improved color photographic printing process called tricolor carbro (Figures 1.12 and 1.13). This process still required the meticulous separation and recombination of

a scene's primary colors through the use of color tissues. It was complicated, expensive, and time-consuming, and worked best at 60°F conditions, making it difficult to use in many American cities in the days before air conditioning. But in the hands of a master, it produced prints of wide-ranging clean color. When, in June 1931, *Ladies' Home Journal* published a two-page spread of swimsuit models relaxing around a pool based on Nickolas Muray's tricolor carbro print diptych (Plate 1.12), the magazine set a vivid new standard for reproduction.[88] Steichen celebrated and summarized the challenge that September in a speech before the New York's Art Director's Club. With 50 to 90 percent of advertisements now illustrated by photographs, he declared, companies had already substantively upgraded their

packaging. Soon, he asserted, these same companies would have to meet the pent-up demand for color by adjusting their products, packaging, and advertisements accordingly.[89] Successful advertising meant not merely drawing attention to a product, he explained, but communicating its emotional allure, and that meant color photography. Even Steichen found it difficult to get the colors just right. In his work for Condé Nast, he had a reputation for often forcing his printers to labor for days on a single guide print for the magazine's printers until it met his exacting criteria.[90] With their more than forty steps to achieve a final print, and a mistake in any step meaning failure, tricolor carbro printing was only for the strong of both heart and pocketbook.

Shortly after Steichen's speech, deciding that color was the future, M. F. Agha, the art director at Condé Nast, hired one of the premier product photographers of the day, Anton Bruehl, and teamed him up with the master technician Fernand Bourges to bring perfect color to his company's magazines.[91] Bruehl had already won two Harvard Awards and eight Gold Medals from the Art Directors Club for

his innovative integrations of abstraction and light into advertising. Like Steichen, he crossed easily back and forth between the worlds of fine art and commerce. His photographs had appeared in the influential 1929 *Film und Foto* exhibition in Stuttgart, the first major presentation of European and American modernist photography and film, and in an exhibition at New York's Delphic Studios in 1931. Although he had no experience with color, he and Bourges quickly perfected their production of color photographs. Bruehl would use a one-shot camera to make the three single-color negatives. Bourges would then combine the three negatives into a single color transparency and oversee its reproduction as a four-color halftone in the magazine. In May 1932, Bruehl-Bourges's still life of fruit and silver became the first color photograph to run in *Vogue* (Figure 1.14). The photograph delivered subtle, three-dimensional presence that far transcended even the best of the magazine's black-and-white photographic reproductions. Two months later, the magazine ran Steichen's graphically simpler color photograph of a woman in a red swimsuit holding up a beach ball as its first

FIGURE 1.12
National Single Shot Camera, ca. 1925. National Photocolor Corporation, New York. George Eastman House, International Museum of Photography and Film, Rochester, NY.

FIGURE 1.13
Pigment tissues for tricolor carbro process.

color cover (Figure 1.15). Both images were technical achievements of meticulous lighting. Where the Bruehl-Bourges team trumpeted its ability to arrange and depict highly reflective objects, Steichen showed off his control over shadows, delivering just enough light to the model's face to allow readers to see her smile yet retaining the focus on her pose and swimsuit. Recognizing that even in the face of the Great Depression color could build circulation, Condé Nast publications presented almost two hundred such editorial pages of color photographs in its magazines over the next thirty months. In addition, the Bruehl-Bourges team turned out close to five hundred color images for various advertisers. The need to take three exposures through color filters so slowed the process that the company's photographers were generally confined to studios with massive banks of lights. At the end of his life, Bruehl described the contortions he had to go through: "I made my own flash equipment; the reflectors were three or four feet in diameter with one big flashbulb in the middle . . . The camera alone weighed 75 pounds and everything was on a tripod."[92]

In 1935, Condé Nast proclaimed its leadership in producing top-quality color photographs by publishing the book *Color Sells* (Figure 1.16), opening the text with the self-justifying assertion: "Every photographer has many times said to himself, as he focused his subject on the ground glass, 'What wouldn't I give if I could only reproduce these colors!'"[93] Referencing the May 1, 1932, issue of *Vogue*, the unidentified author declared that with Anton Bruehl's still life, "the new art of color photography was launched."[94] The heart of the publication showed off the Bruehl-Bourges team's expertise in capturing cleanly lit, nuanced color and the ability of Condé Nast's in-house engravers to print the results as vivid four-color reproductions. The book's sixty-four Bruehl-Bourges color photographs run the gamut from shots of jewelry to portraits of movie stars like Marlene Dietrich. One of the most technically spectacular images is a two-page spread of forty performers from Billy Rose's Music Hall that includes acrobats, dancers, musicians, singers, and even a seal juggling a red

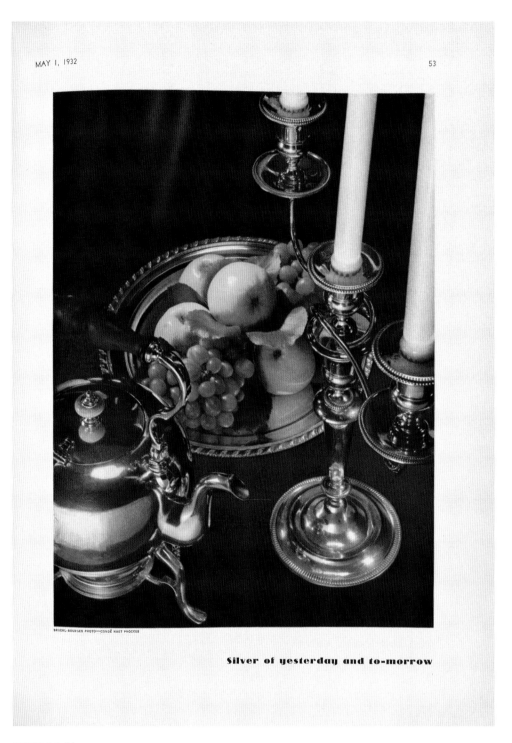

FIGURE 1.14
Anton Bruehl (1900–1982) and Fernand Bourges (1886–1963), [Silver and fruit], 1932. *Vogue*, May 1, 1932. © Condé Nast Publications, Inc.

ball (Figure 1.17). Its accompanying text explains that Bruehl had to use five hundred flash bulbs to get the shot.

But stopping action and getting correct color was only the start. *Color Sells* openly recognizes that "color is like dynamite—dangerous, unless you know how to use it. The high attention-value of color lays a mediocre color page open to keener criticism than a poor black-and-white reproduction. If the final result is harsh, garish, or flat, it repels—and repels sharply."[95] Questionable color grouping and badly chosen inks are just as problematic, the book suggests. To overcome these difficulties, Bruehl often made a practice of employing one or two solid background colors. Recognizing the tendencies of red and blue to dominate in photographic emulsions, he used red clothing and red and blue accents to pull viewers into and across his compositions. Today the results look saccharine, simplistic, and at times garish, but by the standards of the day they were impressive in their

realism and balance. To induce more business, the book closes with a list of sixty-six companies that had already used its services, including B. F. Goodrich, Coca-Cola, Eastman Kodak, Heinz, Kellogg, Procter & Gamble, and R. J. Reynolds.

Most tricolor carbro prints and large transparencies of the day were made as guides for reproductions in magazines, posters, and billboards. Few top-quality prints seem to have survived. But two of these prints symbolize the challenges and the potential that would shape artists' conversations about color photography over coming decades. James N. Doolittle's transformation of the actress Ann Harding into a glowing palette of gold, beige, and brown reveals how color could be orchestrated to evoke luxury and wealth (Plate 1.13). The royal-blue backdrop is a necessary foil included to bring attention to Harding's blue eyes and offset her bright red lipstick. In black and white, the portrait would convey elegance; but in color it glows, blending vivid realism with a dramatic otherworldliness.

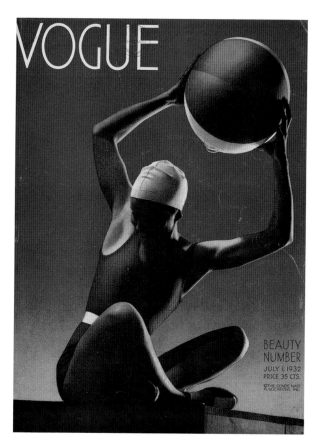

FIGURE 1.15
Edward Steichen (1879–1973), [Cover], 1932. *Vogue,* June 1, 1932. © Condé Nast Publications, Inc.

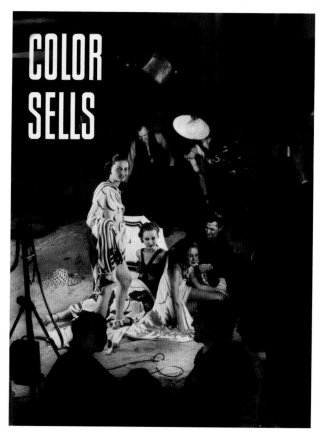

FIGURE 1.16
The cover of *Color Sells: Showing Examples of Color Photography by Bruehl-Bourges.* © Condé Nast Publications, Inc.

If Doolittle could fashion color into theater, Paul Outerbridge was a master at conveying in his best prints engaging dimension and solidity. Like most photographers working in color at this time, Outerbridge gained his initial acclaim in black and white. His smart, graphic photographs integrating cubist compositional structures into product displays were already finding their way into museums when he took up color around 1930.[96] Between 1933 and 1935, he mastered the tricolor carbro process and used magazine jobs to support his personal production of surreal-tinged still lifes and alluring if strange photographs of young, scantily clad or nude women that tended toward the bizarre and fetishistic.[97] One of the most spectacular of his still lifes is *Party Mask with Shells* (1936)—a symphony of delicate reflections that takes one into a dreamland blend of shapes and spaces (Figure 1.18). But it is one of the artist's simpler, more commercial concoctions made that same very productive year that reveals how far color had come. *Avocado Pears* (1936) presents nothing more than a whole and half avocado sitting on a wood table next to a knife and lemon, but the print's color is so clean and the textures so sharp that it delivers the feeling of standing in front of the fruits (Plate 1.14). In 1942, the Museum of Modern Art would acquire *Avocado Pears* as its first color photograph.

THEN THE WORLD CHANGED. Just as Outerbridge was reaching the height of his fame, Eastman Kodak Company introduced a new film that would once again revolutionize photography.[98] Developed by Kodak scientists Leopold Godowsky Jr. and Leopold Mannes, or God and Man as their colleagues called

FIGURE 1.17
Anton Bruehl (1900–1982) and Fernand Bourges (1886–1963), [Music hall], ca. 1932. In *Color Sells: Showing Examples of Color Photography by Bruehl-Bourges*. © Condé Nast Publications, Inc.

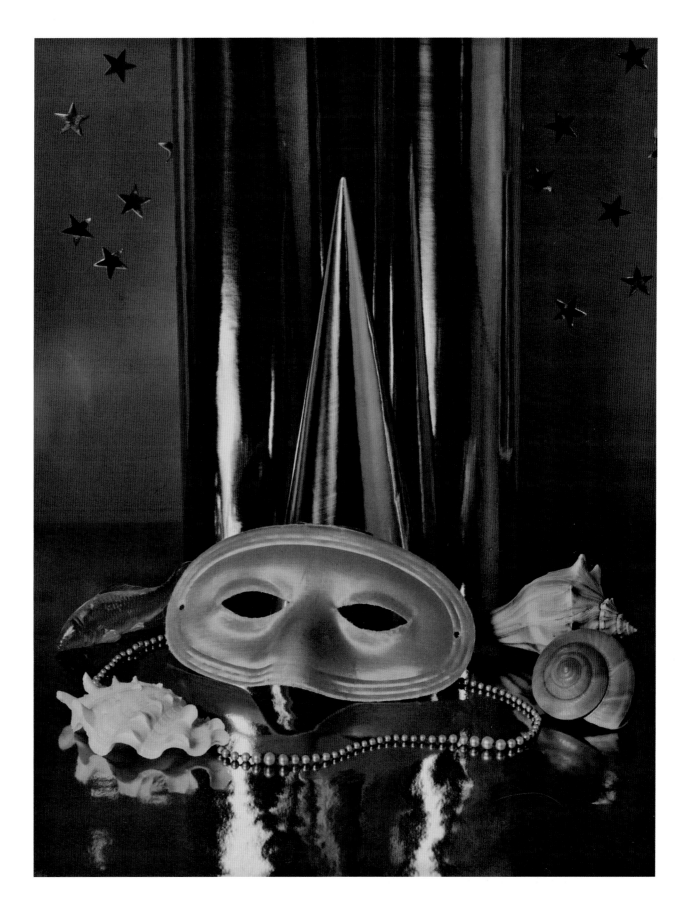

FIGURE 1.18
Paul Outerbridge (1896–1958), *Party Mask with Shells*, 1936.
Tricolor carbro print. Amon Carter Museum of American Art,
Fort Worth, TX. © 1996 Estate of Paul Outerbridge Jr. Cour-
tesy of G. Ray Hawkins.

them, this innovative film was comprised of three very thin emulsion layers on a single plastic backing, each sensitized to the primary colors red, green, and blue.[99] Kodak called it Kodachrome, though it was totally unlike their previous material carrying that name. One simply ran the film through any camera like black-and-white film, sent it back to Kodak for processing, then waited impatiently at the mailbox to get a batch of bright full-color transparencies. Although the film was slow, requiring a shutter speed of $\frac{1}{30}$ of a second in bright light, it produced a grainless image in sparkling, saturated hues. In tandem, the company introduced a slightly simpler process for making color prints called Wash-Off Relief, a new printing process that was easier than tricolor carbro in that it relied on the transfer of dyes to a receiving paper rather than the layering of color emulsions on top of each other, but which still required the cumbersome separation and recombination of colors to achieve a final print.[100] The true breakthrough was the film.

Even Kodak's own employees were ecstatic about Kodachrome. To show off its brilliance and prove the precision with which it rendered color, Kodak's senior photographer in the advertising department, John F. Collins, went into his studio and photographed such subjects as a mannequin surrounded by gold lamé, beakers filled with colored waters, light shooting through a prism, and a tire set against a bright blue backdrop and bathed in brilliant red, yellow, and green light (Plate 1.15). His resulting photographs are a revelation of theatrical clarity. Suddenly color was not merely descriptive, it was exciting—and it was available to everyone. ◆

1. Durand quoted by Levi L. Hill, *A Treatise on Heliochromy; or, the Production of Pictures, by Means of Light, in Natural Colors* (New York: Robinson and Caswell, 1856), 14.

2. Levi L. Hill, *A Treatise on Daguerreotype; the Whole Art Made Easy, and All the Recent Improvements Revealed* (Lexington, NY: Holman and Gray, 1850), quoted in *Humphrey's Journal*. Helios, "The Hillotype," *Humphrey's Journal: Devoted to the Daguerreian and Photogenic Arts* 6, no. 20 (February 1, 1855): 313–314. A number of historians have written about Hill's photographic claims. See particularly, Beaumont Newhall, "The Misadventures of L. L. Hill," *Image: Journal of Photography and Motion Pictures of the International Museum of Photography at George Eastman House* 1, no. 5 (May 1952): 2; Marion Rinhart, "Levi L. Hill," *The Magazine Antiques* 152, no. 4 (April 2003): 122–125; and William B. Becker, "Inventive Genius or Ingenious Fraud? The Enduring Mystery of Levi L. Hill," *Camera Arts* 1, no. 1, (January/February 1981): 28–31, 125–127.

3. Beaumont Newhall discusses the efforts of French inventors Nicéphore Niépce and Louis-Jacques-Mandé Daguerre to achieve color in their experiments that led to the invention of the daguerreotype and the general disappointment of the lack of color in daguerreotypes. The Museum of Modern Art, *Photography, 1839–1937* (New York: The Museum of Modern Art, 1937), 81. Heinz and Bridget Henisch note Frenchman François Arago's comment on the lack of color in photographs in his January 7, 1839, introduction of the daguerreotype to the French Académie des Sciences. Heinz K. Henisch and Bridget A. Henisch, *The Painted Photograph, 1839–1914: Origins, Techniques, Aspirations* (University Park, PA: The Penn State University Press, 1996), 2.

4. Louis-Jacques-Mandé Daguerre had been able to record four of the spectral colors by 1827. Beaumont Newhall, *The History of Photography: From 1839 to the Present* (New York: The Museum of Modern Art, 1982), 269. The German physicist Thomas Johann Seebeck recorded a full spectrum on wet paper saturated with silver chloride in 1811, though the colors disappeared when the paper dried. Johann Wolfgang von Goethe reported on Seebeck's experiments. Johann Wolfgang von Goethe, *Anzeige und Uebersicht des Goethischen Werkes zur Farbenlehre* (Tübingen [Stuttgart], Germany: J. G. Cotta, 1810). In 1840, Sir John Frederick Herschel succeeded in registering colors on paper coated with silver chloride exposed to sunlight through a prism, but he too was unable to fix and retain them. William I. Alschuler, "The Source and Nature of Inherent Colour in Early Photographic Processes: Niépce's Heliochrome to Burder's Colour Daguerreotypes, and Their Relation to Lippmann Process Images. A Comparative Analysis of the Optical Phenomena That Might Explain the Colour," *Photo-Historian: The Quarterly of the Historical Group of the Royal Photographic Society* 152 (August 2007): 10. The Henisches call Herschel's assertion "wishful thinking," explaining that the colors he created derived from silver deposits rather than light. Henisch, *The Painted Photograph*, 3. The French physicist Antoine Henri Becquerel was able to record a spectrum on a daguerreotype plate coated with silver chloride in 1848. Herschel's son William noted that the Becquerel image had bright colors as of October 18, 1884, and again in January 1914, though with white spots on its surface; but when William Alschuler viewed the plate in 2002 it had lost its color. Alschuler, "Source and Nature," 14. Users of the calotype, meanwhile, were finding that certain combinations of chemicals and development could deliver bright single colors.

5. Stanley B. Burns. *Forgotten Marriage: The Painted Tintype and the Decorative Frame, 1860–1910: A Lost Chapter in American Portraiture* (New York: Burns Collection, Ltd., 1995), 49–55. On daguerreotypes the work often involved using a fine camel's hair brush to apply a mix of pigment powder and gum arabic and then gently breathing on the plate to dissolve the gum arabic. Erotic daguerreotypes were among the most extensively colored plates.

6. T. Antisell published a series of articles titled "Light" in *The Daguerreian Journal* over the months of November 1850 to January 1851, and the *Journal*'s editor Samuel D. Humphrey took public note of the color experiments by Becquerel and others. Hill clearly knew of this color research and even discussed Becquerel and the properties of light in his book *A Treatise on Daguerreotype*. Even aesthetic considerations were in the air thanks to Goethe's book *Zur Farbenlehre* and Michel Eugène Chevreul's presentation of a color wheel and findings on optical mixing in his text. Michel Eugène Chevreul, *De la Loi de Contraste Simultané des Couleurs, et de l'Assortiment des Objets Colorés* (Paris: Pitois-Levrault et Cie., 1839). Chevreul developed a color wheel and concept of color opposites to help him in his job as director of dyes at a textile manufactory.

7. Samuel D. Humphrey, "A New and Valuable Discovery," *The Daguerreian Journal* 1, no. 7 (February 15, 1851): 209.

8. Ibid., 209–210.

9. Levi L. Hill, "Mr. Editor," *The Daguerreian Journal* 1, no. 7 (February 15, 1851): 210–211.

10. Samuel D. Humphrey, "Hillotype," *The Daguerreian Journal* 1, no. 8 (March 1, 1851): 241.

11. Levi L. Hill, "S. D. Humphrey, Esq.," *The Daguerreian Journal* 1, no. 9 (March 12, 1851): 241.

12. *The Daguerreian Journal* 2, no. 1 (May 15, 1851): 17–18.

13. Hill articulates the problem of people questioning his integrity and motives in a letter published in June 1851. Levi L. Hill, *The Daguerreian Journal* 2, no. 2 (June 1, 1851): 50–51.

14. The report detailed Niépce's March 1851 presentation of his color discoveries at the Academy of Sciences in Paris. Niépce explained that he had achieved color by exposing his plates to chlorine before placing them in his camera. Interestingly, where Hill had difficulty in achieving yellow, this tint was the most brilliant achieved by Niépce. *The Daguerreian Journal* 2, no. 6 (August 1, 1851): 177–178. Niépce de Saint-Victor was the cousin of Nicéphore Niépce, whose early work in light-sensitive materials had created the basis for Daguerre's development of photography.

15. *The Daguerreian Journal* 2, no. 11 (October 15, 1851): 337–338.

16. Ibid., 339.

17. Becker, "Inventive Genius," 28.

18. Samuel F. B. Morse, "Photographic Colors," *Daily National Intelligencer* (Washington DC) 40, no. 12,360 (October 8, 1852): 2, col. 2; Samuel F. B. Morse, *Scientific American* (October 23, 1852); Samuel F. B. Morse, "Testimonials," in "To the Daguerreotypists of the United States, and the Public at Large. A Statement Respecting the Natural Colors," Levi L. Hill, *New-York Daily Times* 2, no. 345 (October 26, 1852) 6, col. 3. All reprinted in *Humphrey's Journal: Devoted to the Daguerreian and Photogenic Arts* 4, no. 14 (November 1, 1852): 217–224; and *Humphrey's Journal: Devoted to the Daguerreian and Photogenic Arts* 4, no. 15 (November 15, 1852): 239. Despite publishing these letters, Humphrey complained of Hill's continuing unwillingness to openly share and explain the details of his Hillotype process. One curious detail about the Hillotypes mentioned by Morse was that strong buffing of the plates enhanced their colors, making them stronger and brighter.

19. The committee was led by Edward Anthony, head of the largest photographic stock house in New York City. Word arrived at about this same time that Niépce had demonstrated to the Parisian Academy of Sciences how he could retain bright colors in his daguerreotypes, which he called Héliochromes, by fixing them with ammonia, though his exposures remained far too long for practical use and getting dark colors was still problematic. "Natural Colors Produced by the Daguerreotype," *Humphrey's Journal: Devoted to the Daguerreian and Photogenic Arts* 4, no. 17 (December 15, 1852): 264; and "Hillotype," *Humphrey's Journal: Devoted to the Daguerreian and Photogenic Arts* 4, no. 19 (January 15, 1853): 298–299.

20. *Humphrey's Journal: Devoted to the Daguerreian and Photogenic Arts* 4, no. 23 (March 15, 1853): 361–362. The committee rejected Hill's application because his achievement was a chemical recipe rather than a newly fabricated object; still, it voted to insert his report into the records of the Senate to help Hill establish American primacy.

21. "Hillotype," *Humphrey's Journal* 6, no. 20 (February 1, 1855): 321.

22. Helios, "The Hillotype," 313–319.

23. Ibid., 318–319.

24. Hill was successful, but found that it cost more to make than it was worth. *Humphrey's Journal: Devoted to the Daguerreian and Photogenic Arts* 16, no. 20 (February 15, 1865): 315.

25. Becker, "Inventive Genius," 29. Hill immediately threatened to sue the *Journal*, forcing Humphrey to publish an apology in the next issue.

26. John Towler, "Obituary. Rev. Levi L. Hill," *Humphrey's Journal* 16, no. 20 (February 15, 1865): 315–316.

27. Mid-twentieth-century photography historians Robert Taft and Josef Maria Eder labeled Hill's work a hoax that was based on hand-colored daguerreotypes. The historian of color photography Louis Walton Sipley ignored Hill.

28. Conservator Corinne Dunne surveyed the collection in 2005. Corinne Dunne, "The Hillotypes" (Advanced Residency Program in Photographic Conservation, August 10, 2005), 5–6. Curatorial Research Files, Amon Carter Museum of American Art, Fort Worth, TX.

29. Although Morse and others suggested that the plates regained brilliant color by being strongly buffed, no one today is willing to attempt that buffing for fear of ruining a plate.

30. The Getty Trust, "The Smithsonian's National Museum of American History, the Getty Conservation Institute, and the Getty Foundation Collaborate to Unravel Photography's Most Controversial Mystery," http://www.getty.edu/news/press/center/hillotypes _release_102307.html (accessed August 4, 2008). In 1987, Joseph Boudreau of the Paier College of Art in Hamden, Connecticut, announced that he had made color daguerreotypes by following the recipe laid out in *A Treatise on Heliochromy*, but this assertion seems suspect. See Herbert Keppler, "The Horrible Fate of Levi Hill: Inventor of Color Photography," *Popular Photography* 58, no. 7 (July 1994): 42–43, 140.

31. In 1855, the year before Hill published his convoluted "recipe" for making Hillotypes, Maxwell had published a paper proposing his solution. Kodak scientist W. T. Hanson Jr. suggests that Maxwell and his assistant Thomas Sutton used four filters, but the report of the meeting explains that Maxwell achieved his results using three exposures of red, green, and blue. W. T. Hanson Jr., "Color Photography: From Dream, to Reality, to Commonplace," in *Pioneers of Photography: Their Achievements in Science and Technology*, ed. Eugene Ostroff, 200–207 (Springfield, VA: Society of Photographic Scientists and Engineers, 1987).

32. Maxwell's procedure required twenty-two minutes of exposure time to make the initial plates. Ibid. Ralph Evans, a research scientist at Kodak, later revealed that Maxwell was able to record the color red even though collodion emulsion is not sensitive to that hue, because the red dyes used to make the ribbon he photographed fluoresced, meaning that he actually recorded the fluorescing. Newhall, *History of Photography*, 272.

33. Ducos du Hauron enunciated the principle of making color photographs by superimposing images of red, yellow, and blue in 1862. Several of these prints, including one of a stuffed parrot and another of a view of Agen, France, exist today, but they reveal only modestly accurate color. See Louis Ducos du Hauron, *Les Couleurs en Photographie: Solution du Probléme* (Paris: A. Marion, 1869). In 1878, he and his brother published a second manual for making color prints following their method. Louis Ducos du Hauron and Alcide Ducos du Hauron, *Traité Pratique de Photographie: Système d'Héliochromie Louis Ducos du Hauron: Description Détaillée des Moyens Perfectionnés d'Exécution Récemment Découverts* (Paris: Librairie Gauthier-Villars, 1878). See also, Beaumont Newhall, "An 1877 Color Photograph," *Image: Journal of Photography of the George Eastman House* 3, no. 5 (May 1954): 33–34.

34. The editor of *Wilson's Photographic Magazine* noted in 1907 that "'Color photography' has been 'discovered' at more or less regular intervals ever since photography was invented, until latterly it has been used by the Sunday papers to alternate with the sea-serpent as a space filler in the dull season." "The Lumiere Autochrome Process," *Wilson's Photographic Magazine* 44 (October 1907): 433, in Keith F. Davis, *An American Century of Photography, From Dry-plate to Digital: The Hallmark Photographic Collection* (Kansas City, MO: Hallmark Cards, Inc. in association with Harry N. Abrams, Inc., 1999), 527, note 403. Edward Steichen also remarked on the flow of false announcements in his article. Edward Steichen, "Color Photography," *Camera Work* 22 (April 1908): 13.

35. The article, drawn from the British magazine *Manufacturer and Builder*, stated that the process was apparently discovered by a Frenchman and improved by the proprietor in England, and that the colors of the photographs were said to be "protected from the action of light by being passed through a boiling solution, of which gelatine forms the principal ingredient" to prevent fading. "Photographs in Natural Colors," *Nebraska Herald* (August 18, 1881): 1, col. 6.

36. Frederic E. Ives, "Photographs in Natural Colors," *American Journal of Photography* 9, no. 3 (March 1888): 56–58. Ives claimed he had taken up the problem of color almost twenty years earlier while assisting in a photography laboratory at Cornell University. By 1888 (the year George Eastman introduced roll film), he was perfecting a mechanism that might attach to any camera and capture three shots through red, green, and blue-violet filters.

37. Tony Banks, "The Life and Work of Frederick [*sic*] Eugene Ives" (August 10, 2008), 2, 3, 5, 20, Curatorial Research Files, Amon Carter Museum of American Art, Fort Worth, TX.

38. Efforts to achieve color directly were not quite dead. In 1891, French physicist Gabriel Lippmann reported that he had come up with a way of making color photographs based on light interference that he called "photochromie." His innovative idea was that light rays striking the film could be reflected back on themselves, creating a wide range of hues much like the colors on an oil slick. The finding would gain Lippmann the Nobel Prize in Physics in 1908. Unfortunately, the process required use of a special plateholder filled with mercury and a special camera that

could accommodate it between the lens and the film and then a similar plate for viewing. Additionally, the range and nuance of hues became apparent only when the images were seen by projection in a special viewer. Lippmann plates induced American artist and photographer Edward Steichen to extol them as offering a "startling realism" that equaled a Renoir painting, at least when projected. Steichen, "Color Photography," 14. Viewed directly, the color in the plates is greatly circumscribed. Finally, the process required exposures of at least two minutes in full summer sun. In 1895, the Societé Française de Photographie organized a competition to make color photographs using the Lippmann process. Keith Davis suggests that Carl Zeiss Company sold outfits for its use through 1910. Though used for scientific research, the process was more a curiosity than a viable commercial endeavor. Davis, *American Century*, 66.

39. Robert Redfield, "The Photographic Society of Philadelphia," *American Journal of Photography* 9, no. 4 (April 1888): 81–82. The slides unleashed a furious nationalist-tinged debate over whether Ives had produced a major advance or merely absorbed work that was being done in Europe. The German chemist Hermann W. Vogel, who had taken a special interest in photography, strongly disputed Ives's claims that he had made a major advance, and the French artist Léon Vidal called his process a hoax. Philadelphia's scientific and photographic organizations, including the Photographic Society of Philadelphia and the nationally renowned *American Journal of Photography*, on the other hand, remained vocal supporters of Ives. "Photography in Natural Colors," *American Journal of Photography* 9, no. 12 (December 1888): 321–322.

40. After exposing three black-and-white negatives through blue-violet, green, and red filters, one made a positive version of each and set these black-and-white transparencies into special mounts that were connected by ribbons into a ladder-like form. The ladder was then fitted into the viewer so that each positive sat behind its corresponding color filter, and the whole was carefully aligned to achieve registration. Ives admitted that his heliochromoscope required someone with scientific expertise to properly adjust the color screens.

41. Frederic E. Ives, *The Autobiography of an Amateur Inventor* (Philadelphia: Press of Innes & Sons, 1928), 39. Despite this achievement, debates over Ives's claims continued. Only in October 1898 did Ives get the opportunity to impress the distinguished Hermann W.

Vogel with a demonstration of what by this date he called a Krōmskōp. Prior to that demonstration, Vogel had been so vociferously disputing Ives's theories and claims that the photographic scientist Josef Eder had taken to calling the exchange "the twelve years war." In response to seeing Ives's invention, though, Vogel quit all subsequent criticism. Ibid., 20. Ives also impressed Léon Vidal, who up to that point had been suggesting that the inventor had been promulgating a hoax. Ibid., 63.

42. Frederic E. Ives, "The Heliochromoscope," *American Journal of Photography* 13, no. 155 (November 1892): 515.

43. The best image was a shot of a black-and-white photograph pinned against a background made up of strips of blue, yellow, and green paper. Here, the unidentified reporter recalled, "the photograph appeared in its proper neutral gray, while the strips of paper came out in telling colors." "Ives's Heliochromoscope," *The New York Times*, November 22, 1892.

44. Single-plate mechanisms cost twenty-five dollars in 1907 and stereo versions cost twice that. Ives gained substantive sales of his Krōmskōp in Great Britain but had less success in the United States. Jane Baum McCarthy, "The Two-color Kodachrome Collection at the George Eastman House," *Image: Journal of Photography and Motion Pictures of the International Museum of Photography at George Eastman House* 30, no. 1 (September 1987): 1. See also, "The Heliochromoscope," *American Amateur Photographer* 4, no. 10 (October 1892): 447–448; and W. I. Lincoln Adams, "The Heliochromoscope," *The American Annual of Photography and Photographic Times Almanac for 1893* 7 (1892): 165–166. Albert B. Porter was still heralding Ives's Kromograms in the May 1907 issue of his Chicago periodical *The Scientific Shop* as "permanent color records" that could be made "by anyone having a moderate amount of photographic skill": "The [Krōmskōp] image is so true to nature in every quality of color, texture, sheen, translucency, atmosphere, and solidity, that it is hard at first to believe that one is not looking directly at the scene itself. The brilliant hues of sunset clouds, the soft coloring of old tapestries, the delicate iridescence of Tiffany glass, the cool greens and hazy distances of landscapes, the warm colors of hothouse flowers, and even the rainbow tints in the Niagara mist, are all reproduced in a manner so perfect as to be beyond the conception of one who has not seen the pictures themselves." But by this date the introduction of panchromatic film had transformed

Ives's mechanism into an antique. Albert B. Porter, "Krōmskōp Color-Photography, F. E. Ives Patents," *The Scientific Shop* 348 (May 1907): 1.

45. The Photocrom process had been developed in 1890 by the Swiss graphic arts firm Art Institute Orell Fussli.

46. See Jim Hughes, *The Birth of a Century: Early Color Photographs of America* (London: Tauris Parke Books, 1994).

47. In 1888, Thomas Edison's associate Charles L. Brasseur of Orange, New Jersey, produced a carbon print that reflected browns and yellows in a heavy metallic sheen that he called a "metallograph." Unfortunately, the prints had a disconcerting physicality to their renderings of metal and little subtlety in their colors. One of these images is in the collection of the National Museum of American History, Smithsonian Institution. In 1902, the Virginia photographer Michael Milley would gain a patent for a means of making color prints by superimposing red, yellow, and blue carbon tissue images. Marshall W. Fishwick, "Michael Miley: Southern Artist in the Brown Decades," *American Quarterly* 3, no. 3 (Fall 1951): 221–231.

48. In 1894, Irishman John Joly unveiled a color system that fronted black-and-white photographs with screens of tiny ruled lines (two hundred per inch) to approximate color. James William McDonough of Chicago dusted photographic plates with a random array of powdered glass that had been stained with blue, green, and red dyes and in 1896 patented a lined screen process of his own. That same year, Brasseur introduced his Brasseur process, a marginally successful carbon color print build up from a screen plate image.

49. Sadakichi Hartmann, "Color and Texture in Photography," *Camera Notes* 4, no. 1 (July 1900): 11.

50. Joel Smith provides a solid overview of Steichen's pictorialist roots. Joel Smith, *Edward Steichen: The Early Years* (Princeton, NJ: Princeton University Press in association with the Metropolitan Museum of Art, 1999). Debates over whether photography could be an expressive art on par with painting had flowed and ebbed since the medium's earliest days, and by this date a small but solid corps of practitioners, led by Stieglitz, were pressing their argument that photographs could be artful by eschewing sharp focus and printing their works on matte-surface papers rather than the glossy commercial papers of the day to better evoke atmosphere and mood in line with tonalist paintings. Some of them even advocated drawing on or scratching into their prints to counter the machine character of their chosen medium. They called themselves pictorialists. Stieglitz would spearhead exhibitions of the best pictorialist photographs with the help of painters like William Merritt Chase, establish a group he called the Photo-Secession of the best American pictorialist artists in homage to the avant-garde Secessionist artist groups in Munich and Vienna, start his own independent arts journal called *Camera Work* to proselytize his views, and even open his own art gallery.

51. Demachy and Austrian Heinrich Kühn extended the pictorialist vocabulary to encompass color in the mid-1890s, when each took up the newly perfected process of gum bichromate. The gum process allowed multiple printings on a wide range of papers and easy reworking of each printing to mimic the feel of brushwork, pencil, and erasure. While Demachy often added bits of bright color to his images, Kühn created works that approximated small Tonalist paintings in their blend of color and form.

52. That same August, Steichen asked Stieglitz, who was traveling in Germany and Austria, to purchase Adolf Miethe's new and improved model of the camera.

53. In April 1903, Stieglitz published his British colleague R. Child Bayley's declaration that "photography in natural colors . . . is simply impossible in the present state of our knowledge" because such photographs lack nuance. R. Child Bayley, "The Pictorial Aspect of Photography in Colors," *Camera Work* 2 (April 1903): 42. Bayley was the editor of the British journal *Photography*. Stieglitz displayed Steichen's gum prints, and two- and three-color photographs at the Little Galleries of the Photo-Secession in March 1906 and published them in the April and July 1906 issues of *Camera Work*.

54. Brandow, *Steichen*, 146–147. Founded in 1843, *L'Illustration* was France's first illustrated magazine. It housed the offices of the Photo-Club de Paris. Stieglitz scheduled a European family vacation to coincide with the event. Sue Davidson Lowe, *Stieglitz: A Memoir/Biography* (New York: Farrar, Straus and Giroux, 1983), 384.

55. Steichen, "Color Photography," *Camera Work* 22 (April 1908): 13. Tania Passafiume, "Photography in Natural Colors: Steichen and the Autochrome Process," in *Coatings on Photographs: Materials, Techniques, and Conservation*, ed. Constance McCabe, 316 (Washington DC: American Institute for Conservation of Historic and Artistic Works, 2005).

56. R. Child Bayley, "An Interview with Mr. Edouard J. Steichen," *Photography* 24, no. 975 (July 16, 1907): 45–47. See also, Catherine T. Tuggle, "Edouard Steichen and the Autochrome, 1907–1909," *History of Photography* 18, no. 2 (Summer 1994): 145–147.

57. According to Lowe, Stieglitz made his first Autochromes between June 20 and July 17 in Baden-Baden. Lowe, *Stieglitz*, 134, 384. He then moved on to Tutzing, a resort near Munich where he was joined by and got further advice from the photographers Frank Eugene, Heinrich Kühn, and Steichen. John Wood, *The Art of the Autochrome: The Birth of Color Photography* (Iowa City: University of Iowa Press, 1993), 10.

58. Alfred Stieglitz, "The Colour Problem for Practical Work Solved," *Photography* (August 13, 1907): 136. Stieglitz reprinted this letter in the October issue of *Camera Work*; and Alfred Stieglitz, "The New Color Photography—A Bit of History," *Camera Work* 20 (October 1907): 20–25.

59. Stieglitz was so pleased with the composition that he retained at least three plates of the sitting. The plates are in the collections of the Metropolitan Museum of Art, the National Gallery of Art, and the International Museum of Photography and Film in Rochester, New York.

60. Stieglitz, "New Color Photography," 21–22.

61. Stieglitz presented the Autochromes surrounded by thick paper mats with gold bevels. He gave his interview on September 27. Douglas R. Nickel, "Autochromes by Clarence H. White," *Record of the Art Museum, Princeton University* 51, no. 2 (1992): 31; and Wood, *Autochrome*, 11.

62. J. M. Bowles, "In Praise of Photography," *Camera Work* 20 (October 1907): 17–19. An advertisement run by the Lumières on the last page of the issue lists the subsidiary Lumière N. A. Co. Ltd. at 11 West 27th Street, New York, and mentions factories in Burlington, Vermont, and Lyons, France. Plates came in four sizes ranging from 3¼ × 4 inches to 6½ × 8½ inches with a box of a dozen large plates selling for twelve dollars. Pamela Roberts, *A Century of Colour Photography: From the Autochrome to the Digital Age* (London: André Deutsch, 2007), 33.

63. Stieglitz, "New Color Photography," 20, 25.

64. McCabe, *Coatings on Photographs*, 316; and Davis, *American Century*, 67. One Autochrome plate cost the equivalent of twelve black-and-white glass plates of same size, expensive but within the reach of most photographers. Roberts, *Century of Colour*, 26.

65. Alvin Langdon Coburn to Alfred Stieglitz, October 5, 1907. Wood, *Autochrome*, 9; and Coburn to Stieglitz, October 20, 1907. Nickel, "Autochromes," 32. Steichen had taught Coburn the process in Paris that September.

66. John Wood, *The Photographic Arts* (Iowa City: University of Iowa Press, 1997), 24. These are just a few of the more than two hundred articles that Wood found to be published about the Autochrome in the eighteen months after its introduction. Wood, *Autochrome*, 9.

67. Anne Hammond, "Impressionist Theory and the Autochrome," *History of Photography* 15, no. 2 (Summer 1991): 99.

68. Stieglitz, "New Color Photography," 22.

69. "The Painters' New Rival: Color Photography as an Expert Sees It," *Liverpool Courier* (October 31, 1907). The article was reprinted in the January 1908 issue of *American Photography*. "The Painters' New Rival: An Interview with Alvin Langdon Coburn," *American Photography* 2, no. 1 (January 1908): 14, 16.

70. Never again would he include color photographs in *Camera Work*. Sarah Greenough, *Alfred Stieglitz: The Key Set* (Washington DC: National Gallery of Art and Harry N. Abrams, Inc., 2002), 939.

71. Steichen, "Color Photography," 24. Steichen extolled in this same article a direct color process invented in 1891 by the Frenchman Gabriel Lippmann wherein color is achieved through the refraction of light, though he recognized that the process was cumbersome and impractical. Ibid., 14. He also gave instruction over how to expose and develop the plates, warning like Stieglitz that exacting control over exposure and development were essential.

72. Ibid., 18–24.

73. Edward Steichen, "Painting and Photography," *Camera Work* 23 (July 1908): 4. That same year, in a special color issue of the British art journal *The Studio*, British critic Charles Holme argued that photographers new to color tend to fill their images with a panoply of bright hues, often led by brilliant red. "Just as a drop of actual pigment will instantly transform a glass of clear water, so the introduction of this element of colour immediately and profoundly changes the character," he wrote. Get over the novelty of color and use it sparingly, he argued. He complained that Autochromes deliver a sensation of "a nature curiously tense and glittering, almost metallic," what he called a "rather tart echo of Nature." But rather than totally reject the process, he declared: "the fact should not be lost sight of that . . . colour-photography is still in its infancy." Charles Holme, ed., *Colour Photography and*

Other Recent Developments of the Art of the Camera (London: The Studio, 1908), A2, 1–2.

74. Frederick H. Evans, "Personality in Photography—With a Word on Colour," *Camera Work* 25 (January 1909): 38.

75. Ibid.

76. Holme, *Colour Photography*, 1–10.

77. J. Nilsen Laurvik, "The New Color-Photography," *The Century Magazine* 75, no. 3 (January 1908): 322–330. Donato Pietrodangelo discusses these debates. Donato Pietrodangelo, "Stieglitz and Autochrome: Beginnings of a Color Aesthetic," *exposure* 19, no. 4 (1981): 16–19.

78. Roberts, *Century of Colour*, 27.

79. People had tried to make prints from Autochromes on Uto paper, without success. "Colour Photography," *Photography* 24, no. 976 (July 23, 1907): 65.

80. Kahn's project, which ran from 1909 to 1931, led to the creation of some 72,000 Autochromes and 183,000 meters of cinema film. It is the subject of a BBC series and book. David Okuefuna and Albert Kahn, *The Wonderful World of Albert Kahn: Colour Photographs from a Lost Age* (London: BBC Books, 2008). During these same years, with the support of Tsar Nicholas II, Sergei Mikhailovich Prokudin-Gorskii was building an extensive survey of the Russian Empire in color by creating negatives representing each of the primary colors that he then translated into positives to project through colored filters in illustrated lectures. Robert H. Allshouse, ed., *Photographs for the Tsar: The Pioneering Color Photography of Sergei Mikhailovich Prokudin-Gorskii, Commissioned by Tsar Nicholas II* (New York: The Dial Press, 1980).

81. The Success of Color Photography," *The Craftsman* 21, no. 6 (March 1912): 687.

82. Ostroff, *Pioneers of Photography*, 203; McCarthy, "Kodachrome Collection," 1–12; and C. E. Kenneth Mees, "The Kodachrome Process of Color Portraiture," *American Annual of Photography 1916* 30 (1915): 9–21. To make a two-color Kodachrome, one exposed a scene with a camera that produced two negatives, one reversed from the other. The two negatives were then differentially bleached, dyed (red/green) and superimposed. The resulting transparency was best viewed through transmitted artificial light, using the yellow color of the light to fill the gap of missing color. Kodak created special viewing apparatus to illuminate plates evenly. McCarthy, "Kodachrome Collection," 3. Kodak's main use for Kodachrome was as a cinema film. *The Light in the Dark* (Clarence Brown, director. New York: Vitagraph Co. of America, 1922) was

the first commercial feature to use the two-color film. Coincidentally, 1914 was the same year that *National Geographic* magazine published the first of what would become more than 2,300 color photographs drawn from Autochromes.

83. Through the spring of 1915, Eastman Kodak Company trumpeted Kodachromes at the annual meeting of the Professional Photographers' Society of New York, the Panama-Pacific International Exposition in San Francisco, and the Royal Photographic Society in London to generally positive reviews. Critics appreciated their lack of screen and the realism of their flesh tints, though they agreed that the process was less effective beyond portraiture and medical uses. The start of World War I held up further marketing of the film since the only workable dyes were manufactured in Germany, and it was subsequently abandoned. McCarthy, "Kodachrome Collection," 4. The George Eastman House, International Museum of Photography and Film in Rochester, New York, owns a selection of images using this process.

84. To make Hicrome prints one printed the first negative on cyanotype paper. The second would be printed on red-dyed gelatin, and the third would be printed on yellow-dyed gelatin. The three positives would then be superimposed in registration and cemented together to give a full-color print. By 1917, Ives was marketing a film pack that could make single shot color images in any standard plate camera. Although the process was too complicated and its results too chancy to gain substantive commercial appeal, it was tried by a number of artist-photographers including Karl Struss and Paul Anderson. Historian Pamela Roberts (*Century of Colour*, 71) has suggested that inventors patented more than three hundred different additive color processes by the early 1930s. Many of these processes used thinly ruled parallel or crosshatched lines, but none, she says, provided full competition for Autochromes. John Lewisohn muses about a variety of potential solutions to creating color phtographs in "A Phantasy About Color-Photography and Colors," *The American Annual of Photography 1917* 31 (1916): 182–187. Frederic Ives kept up with the changing field by introducing an improved version of his single-shot three color camera that he called a Hicro Universal camera.

85. Paul Strand, "Photography," *Camera Work* 49/50 (June 1917): 3.

86. Paul L. Anderson, "The Hess-Ives Process of Color Photography," *The American Annual of Photography*

1918 32 (1917): 60, 62. David J. Sheahan and Wayne Morris addressed the topic of the artful use of color in this same issue of the magazine. Sheahan called on Autochrome photographers to use soft focus to blend colors in order to better reflect the paintings of Jean-Baptiste Camille Corot and Joseph Mallord William Turner. See "A Few Words About Autochroms" [*sic*], 104–105; Morris argued that photographers should not worry about limiting the color palette in their images because, he said, colors have a way of balancing a picture on their own. See Wayne Morris, "Color-Photography," 55–57.

87. Albert H. Munsell, *A Color Notation: A Measured Color System Based on the Three Qualities, Hue, Values, and Chroma, with Illustrative Models, Charts, and a Course of Study Arranged for Teachers* (Boston: George H. Ellis, 1905); Albert H. Munsell, *Munsell Book of Color: Defining, Explaining, and Illustrating the Fundamental Characteristics of Color* (Baltimore: Munsell Color Co., 1929); and Louis Weinberg, *Color in Everyday Life: A Manual for Lay Students, Artisans and Artists; On Their Principles of Color Agreement, and Their Applications in Dress, Home, Business, the Theatre and Community Play* (New York: Moffat, Yard and Co., 1918). Along these same lines, in 1912, Smithsonian Institution ornithologist Robert Ridgeway published *Color Standards and Nomenclature* to help scientists at a distance from each other assure themselves that they were talking about the same colors. The book covers 1,150 colors, including the technology for making them and printing with them. Robert Ridgway, *Color Standards and Color Nomenclature* (Washington DC: Robert Ridgway, 1912). See also, Traude Gomez-Rhine, "In Living Color: A Conversation with the Dibner Senior Curator of the History of Science & Technology," *Huntington Frontiers* 4, no. 2 (Fall/Winter 2008): 7.

88. Color was not entirely new to magazines. Color reproductions had been made from transparencies or separations since as early as 1900, and Nickolas Muray had seen his Autochromes used on the covers of *Photoplay* in the mid-1920s. Color was also moving more aggressively into cinema. In 1932, Walt Disney completed his first color film with Mickey Mouse, a two-minute short not designed for commercial release titled *Parade of the Award Nominees*.

89. Edward Steichen, "Artist or Photographer?" *Printer's Ink* 157 (November 26, 1931): 64. By 1930, $84 million was already being spent on color by advertisers, and 50 percent of the advertisements in the *Saturday Evening Post* included color elements. Patricia Johnston, *Real Fantasies: Edward Steichen's Advertising Photography* (Berkeley: University of California Press, 1997), 239–240. A 1932 Gallop Poll reported that most American consumers found photographic illustrations more persuasive and compelling than other forms of representation. If photographs were more persuasive than drawings, color photographs were even more compelling. Carol Payne, "Negotiating Photographic Modernism in *USA: A Quarterly Magazine of the American Scene* (1930)," *Visual Resources: An International Journal of Documentation* 23, no. 4 (December 2007): 341.

90. Brandow, *Steichen*, 151. The artist took a particular affinity to getting just the right blues, like the blues he was breeding into his delphiniums. In the last week of June 1936, "Edward Steichen's Delphiniums" opened at the Museum of Modern Art in New York. The show presented not photographs of flowers but actual delphiniums. The display was the culmination of years of research involving five full-time gardeners who Steichen had hired to help him sustain one hundred thousand specimens. The two-week show drew large crowds. Christian Mosar, *Bloom! Experiments in Color Photography by Edward Steichen* (Luxembourg: Musée d'Art Moderne Grand-Duc Jean, 2007), 100.

91. See Gael Newton, ed., *In the Spotlight: Anton Bruehl Photographs, 1920–1950s* (Canberra, Australia: National Gallery of Australia, 2010).

92. Casey Allen, "Bruehl," *Camera 35* 23, no. 9 (October 1978): 75.

93. Anton Bruehl and Fernand Bourges, *Color Sells: Showing Examples of Color Photography by Bruehl-Borges* (New York: Condé Nast Publications, Inc., 1935).

94. Ibid.

95. Ibid.

96. The Metropolitan Museum of Art purchased ten of Outerbridge's platinum prints in 1929. Ibid., 8. Even before *Ladies' Home Journal* had published Muray's swimsuit advertisement, Outerbridge had started teaching himself how to make color prints. He began showing his tricolor carbro photographs in 1936, and by that fall his color images were being published in *House Beautiful*. Over the next three years the magazine published fifty-four more of his color photographs, using nearly half for covers. Paul Martineau, *Paul Outerbridge: Command Performance* (Los Angeles: J. Paul Getty Museum, 2009), 10.

97. Where Bruehl was committed by contract to Condé Nast, Outerbridge developed a highly successful career as a freelancer, providing color photographs for up to four-figure fees to *Mademoiselle, McCall's, Woman's Home Companion*, and *Town & Country*, and to such corporate clients as the Great Atlantic and Pacific Tea Company (A&P), Scott Paper Company, Frankfort Distilling Company, J. Walter Thompson Advertising Agency, and Leo Burnett and Company. Ibid., 11.

98. Practical color photography had been George Eastman's dream since before the invention of the Autochrome. On April 18, 1926, while on his way to Africa for one of his many safaris, Eastman wrote to his Kodak associate Frank W. Lovejoy: "Last night, as I lay in my berth, I dreamed a dream," that Mees had found practical color process for amateur use in making movies and described in detail how it would be made, marketed, and advertised and forecast huge sales. Eastman would not live to see that day, but he must have surmised that his researchers would solve the problem of color. In 1932, perhaps in response to the sharp pain of spinal stenosis, Eastman committed suicide at age seventy-seven, just four years before Kodak introduced the new three-color version of Kodachrome. He left a short note stating: "To my friends: my work is done. Why wait?" Elizabeth Brayer, *George Eastman: A Biography* (Baltimore: The Johns Hopkins University Press, 1996), 217–220, 225.

99. Godowsky and Mannes had become interested in the problem of color in 1916 after seeing a two-color movie in high school. Hanson, "Color Photography," 224. Following their fathers' footsteps and expectations, they applied themselves in school to become accomplished musicians; Mannes played the piano while Godowsky focused on the violin. But advancing color photography was just as much their passion. After seeking unsuccessfully to produce a practical film version of color screen processes like Autochromes, they switched tracks to focus on developing research in dye couplers. Drawing on the ideas of James Clerk Maxwell, they developed this first tripack film to accept couplers and then dyes in the appropriate layer during the development process. The film came in sizes ranging from 35mm to 8 × 10 inches. Processing involved a twenty-eight-step method that took 3½ hours. See also, McCarthy, "Kodachrome Collection," 10; Horst W. Staubach, "Kodachrome," in *50 Jahre Moderne Farbfotografie 1936–1986 (50 Years Modern Color Photography 1936–1986)*, trans. Manfred Heiting, 17–25 (Cologne, Germany: Messe- und Ausstellungs- Ges.m.b.H., 1986); Horst W. Staubach, "Kodak: The History of Kodachrome Film," *Camera* 7 (July 1977): 39–40; and Ostroff, *Pioneers of Photography*, 203–204.

100. The Wash-Off Relief process was based on research by Louis Condax.

PLATE 1.1

Charles H. Williamson (1826–1874)

[Mother with cameo and daughter in a pink dress], ca. 1850s. Daguerreotypes with applied color, sixth plates, each 2¾ × 2¼ inches.

PLATE 1.2

Levi L. Hill (1816–1865)

Untitled, ca. 1851. Hillotype, 8½ × 6½ inches.

Unknown photographer

[Woman with two daughters], ca. 1850s.
Salted paper print with applied color,
6³⁄₁₆ × 8⅜ inches.

PLATE 1.4

Unknown photographer

[Girl in a fancy dress in a garden], 1887.
Tintype, hand-colored by George M. McConnell,
14 × 11 inches.

PLATE 1.5

Alfred Stieglitz (1864–1946)

Frank Eugene, 1907. Lumière Autochrome,
7¹⁄₁₆ × 5⅛ inches.

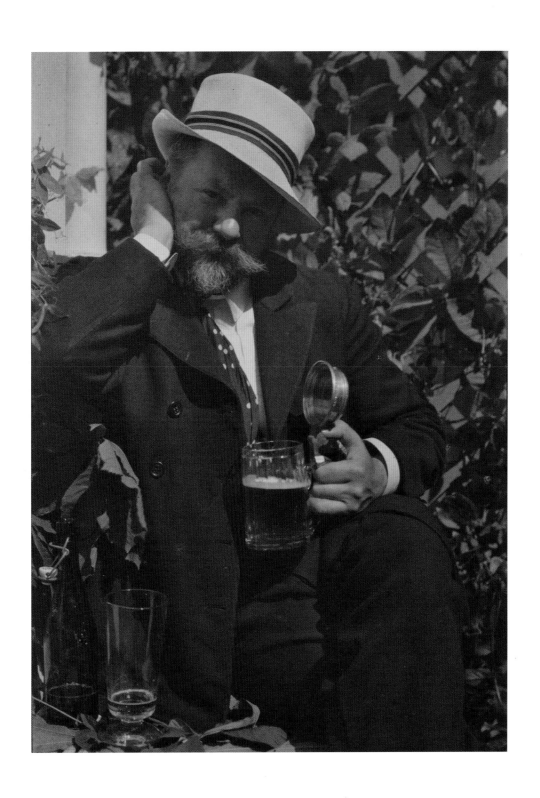

PLATE 1.6

Edward Steichen (1879–1973)

Emily Stieglitz with Copper Bowl, ca. 1911.
Lumière Autochrome, 7 × 5 inches.

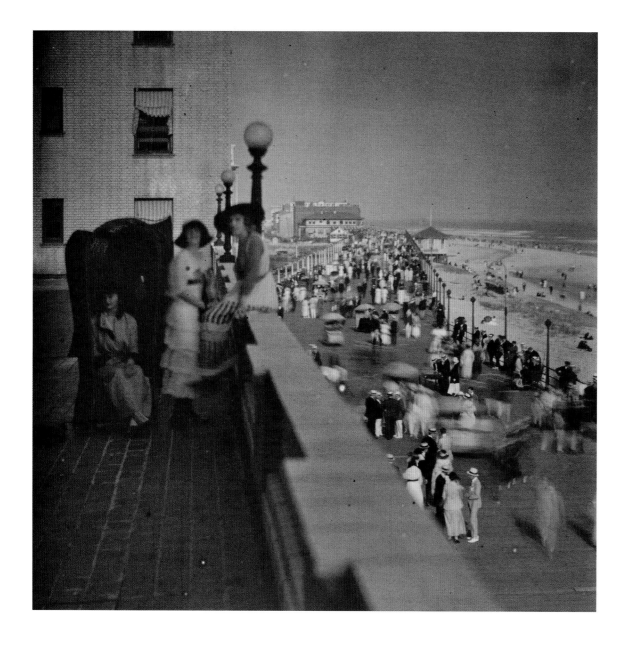

PLATE 1.7 A & B

Karl Struss (1886–1981)

Boardwalk, Long Island, ca. 1910. Lumière
Autochromes (diptych), each 6 × 6¹⁄₁₆ inches.

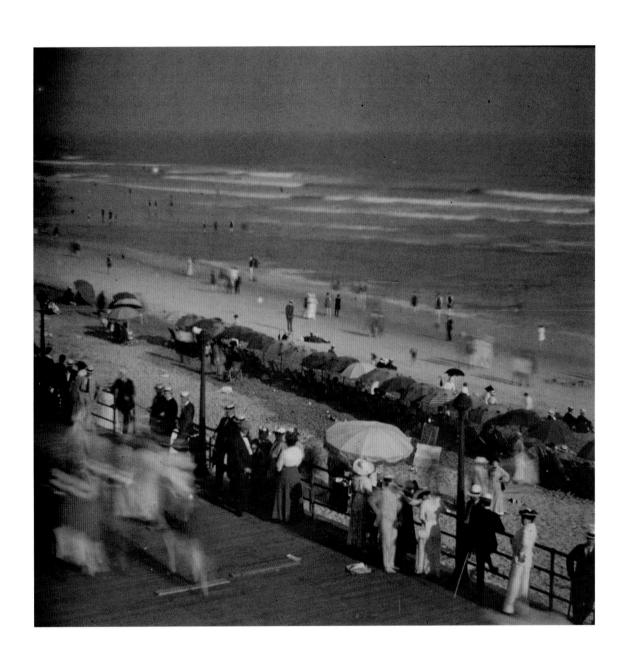

PLATE 1.8

Laura Gilpin (1891–1979)

[Basket of peaches], 1912. Lumière Autochrome,
$3 \times 5\frac{1}{8}$ inches.

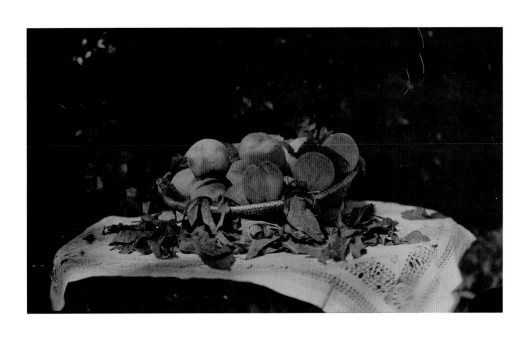

PLATE 1.9

Arnold Genthe (1869–1942)

Rainbow, Grand Canyon, Arizona, ca. 1914.
Lumière Autochrome, 5 × 7 inches.

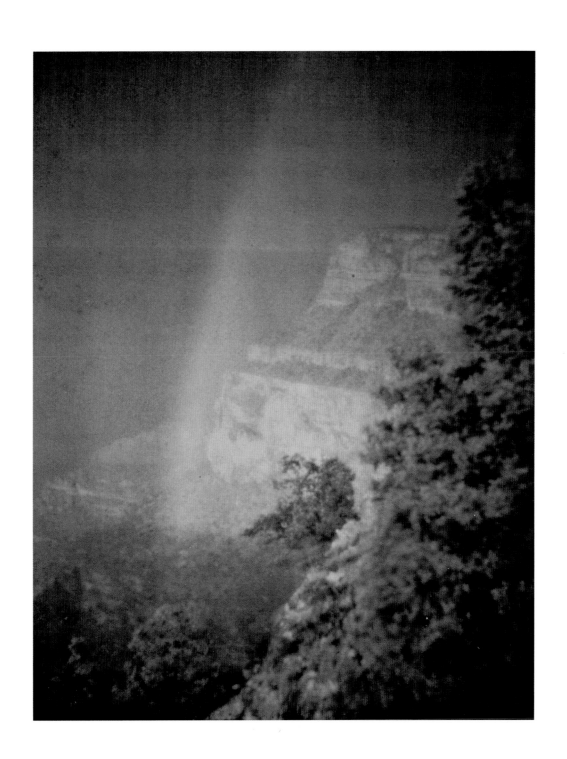

PLATE 1.10

John G. Capstaff (active 1910s)

Untitled, ca. 1915. Two-color Kodachrome, 8 × 5 inches.

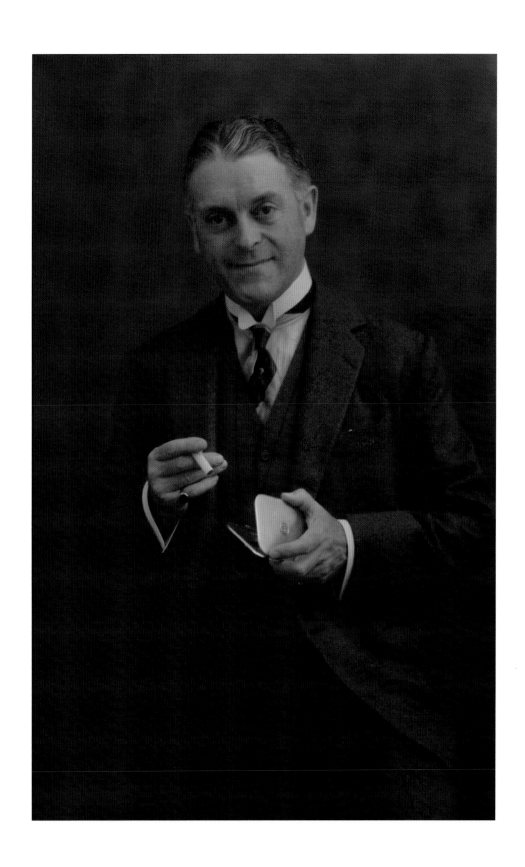

PLATE 1.11

Frederic E. Ives (1856–1937)

Untitled, ca. 1915–1920. Hicrome print, 4 × 6 inches.

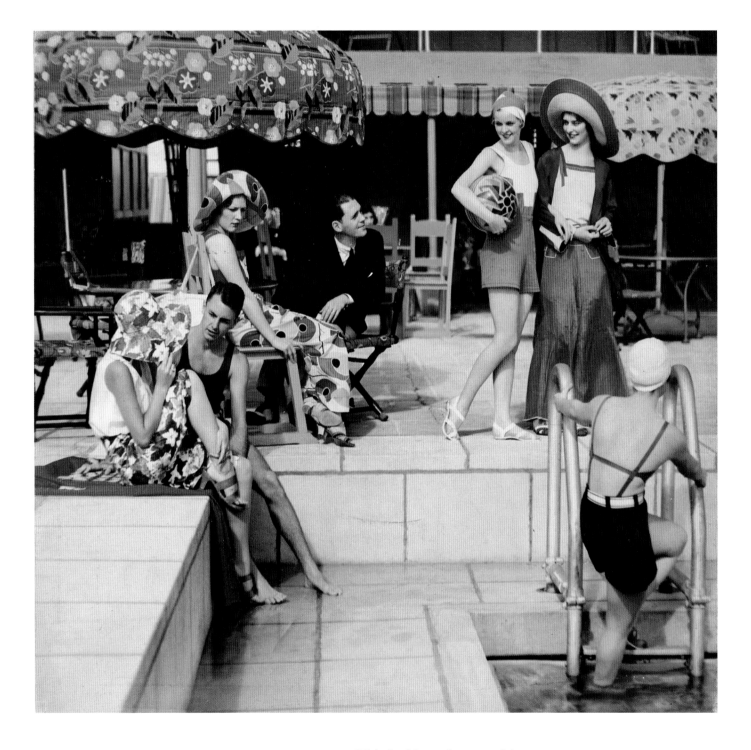

Nickolas Muray (1892–1965)

Bathing Pool Scene, Ladies' Home Journal, Swimsuit Layout, 1931. Tricolor carbro print (diptych), 9½ × 22½ inches.

PLATE 1.13

James N. Doolittle (1889–1954)

Ann Harding, ca. 1932. Tricolor carbro print, 13 × 10½ inches.

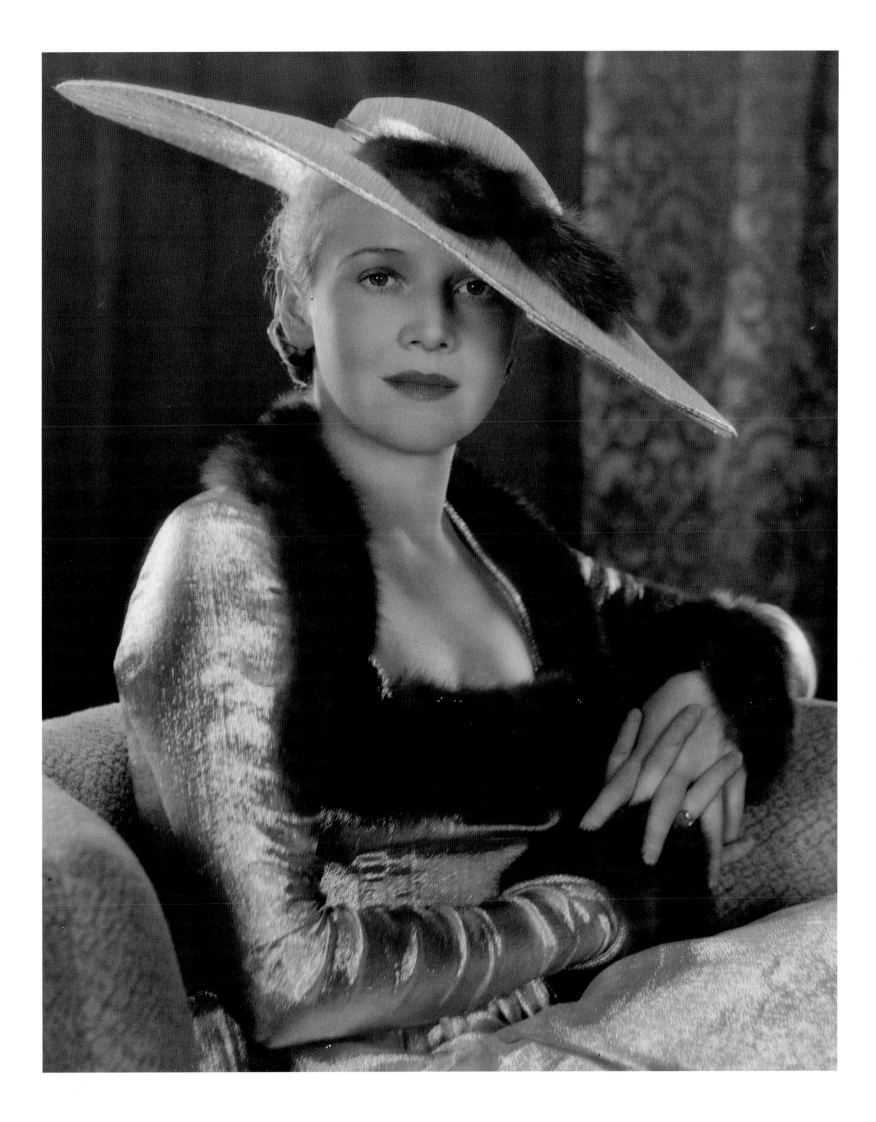

PLATE 1.14

Paul Outerbridge (1896–1958)

Avocado Pears, 1936. Tricolor carbro print, 10 × 15⅝ inches.

PLATE 1.15

John F. Collins (1888–1991)

Tire, 1938. Silver dye-bleach print, 1988,
11 × 14 inches.

CHAPTER

Defining Color, 1936–1970

Is color a new medium for the artist or is it a means for supplementing or elaborating the recognized attainments of black and white photography?

EDWARD STEICHEN, 1950[1]

JUST MONTHS AFTER Eastman Kodak Company introduced Kodachrome roll film in 1936, the young librarian at New York's Museum of Modern Art, Beaumont Newhall, mounted at that institution the first major museum survey of photography's historical development. That groundbreaking eight-hundred-print show symbolized photography's acceptance as a medium of aesthetic importance, if not on par with painting, at least as a significant contemporary visual force. In the book that accompanied the project, Newhall cheered Kodachrome's introduction, but he suggested that it was too early to form an opinion about what that achievement would bring.[2] The continuing need to separate and recombine primary colors when making color photographic prints set both a barrier and new possibilities, he surmised. The printing process remained so delicate and cumbersome that few photographers had the capability to take it on. Black-and-white photography had revealed that "the best work has been done by those photographers who are able to work out every detail of the process themselves."[3] On the other hand,

the complexity of color printmaking opened opportunities to adjust each color to both enhance straightforward reflection of the world and move beyond photography's descriptive core. When photographers started using color more widely, Newhall suggested, comparisons with painting would inevitably shape the discussion; but he wondered whether the distortions of hue in most color photographs he was seeing were signals of new artistic pathways or problems to be overcome.

Newhall's uncertainty over color photography's future direction marks the beginning of a debate that would consume artist-photographers and their critics for decades to come. Should color push photography to become more like painting and printmaking? Or was it enough that color enhanced photographers' commitment to describing the world with ever more verisimilitude? Most artist-photographers across the United States had embraced an aesthetic of sharp focus by this date. The argument now ran that one should accept the machine character of cameras and embrace the ability of lenses to render the world in all

its fine detail in full acknowledgement that black-and-white photography, by its lack of color, was an interpretation. The injection of color into photography complicated that stance. The self-appointed leader of the blossoming community of fine art photographers, Alfred Stieglitz, and many of his closest followers had decided shortly after the introduction of the Autochrome in 1907 that color photographs looked wrong unless their hues reflected the world in realistic ways. That stance had caused them to quickly dismiss color photography because mirroring sight ran counter to art's reliance on interpretation. Yet the color photographs in the Condé Nast magazines, on advertising posters, and in the form of tricolor carbro prints through the early and mid-1930s had shown how straightforward color photographs attracted the eye in their very directness; color was more informative, and it made photographs more entertaining.

When, just a year after his original show, Newhall published a revised edition of his history of photography, he made one significant change, dedicating the new text to Stieglitz. In so doing, he signaled his embrace of the older man's longstanding commitment to promoting the medium's artistic possibilities, to sharp focus, and to black-and-white.[4]

But another line of thinking was rising to challenge that direction. The Hungarian painter, photographer, and educator László Moholy-Nagy had garnered international stature as an imaginative theorist-practitioner through five years of teaching photography and design at the Bauhaus, the distinguished German arts and design academy. Newhall had made him an honorary advisor to his survey exhibition and had included sixteen of Moholy-Nagy's works, including three color works, in that show. At the Bauhaus, Moholy-Nagy had learned to celebrate photography not for its ability to record the look of the world but as a means for extending and expanding human sight.

Just as Newhall's historical survey of photography was getting underway at MoMA, Moholy-Nagy had published an essay titled "Paths to the Unleashed Colour Camera" wherein he had argued that Kodachrome and a similar new integral-color film being marketed by the German company Agfa offered important opportunities to lead photography in exciting new directions.[5] Color photography would never exactly mirror human sight, he explained, because its only practical means was built of three primaries rather than the full spectral array.[6] But far from being a detriment, this limitation opened opportunities for photographers to choose the way and degree that they might transmute nature, he argued. Color photography's artistic model is not a lens-structured mirroring of the world, he suggested, but rather the work of French painter Paul Cézanne, and in particular his presentation of form as abstract patches of color.[7] Shortly after seeing publication of this article, Moholy-Nagy had arrived in the United States to set up the New Bauhaus in Chicago. He made photography and color central features of the new school's curriculum and key segments of the foundation course required of all incoming students.[8] To break himself and his students from their subscription to photography's descriptive roots, he built a moving sculpture that he called a light-space modulator and lit it with light bulbs, at times using colored bulbs, to study and record its shifting shadows. He also had his students project light through colored gels, and built simple constructions of paper and boxes with holes cut into them, through which he then pointed lights (Figure 2.1). Even black-and-white photographs stemming from these contraptions so divorced light from form that he characterized the results as "painting with light."[9]

Eastman Kodak Company focused its initial promotion of Kodachrome on hobbyists and amateurs, but many professionals and young artist-photographers were also immediately drawn to the new film.[10] Months after receiving a career-establishing exhibition at Alfred Stieglitz's New York gallery in 1936 and oblivious to Stieglitz's distaste for color, the young San Francisco photographer Ansel Adams innocently wrote back to the older man exclaiming excitedly over his experiments with Kodachrome: "I have some color pictures of the Autumn

Coloring in Colorado that make me feel that Color photography has possibilities for me. I want you to see these, too."[11] Eliot Elisofon, who after World War II would become a staff photographer at *LIFE* magazine, tried out the film, and Luke Swank started pairing black-and-white and color shots of the same subject in his ongoing documentation of Pittsburgh's steel mills.[12] Even Stieglitz's old partner, Edward Steichen, was intrigued enough by Kodachrome that in January 1938, when he retired from Condé Nast and shut down his New York studio, he took the film with him on a two month vacation to Mexico. He also made sure that the darkroom at his new Connecticut home had the facility to allow production of color prints.[13] If each of these photographers followed the path of straightforward naturalism, Indiana photographer Henry Holmes Smith moved in the opposite direction. Even as he mastered an updated form of Frederic Ives's Hicrome process called Chromatone, he was sensing a broader possibility for color beyond pure description (Figure 2.2). Moholy-Nagy's article, "Paths to the Unleashed Colour Camera," confirmed his inklings and induced him to make a special point of meeting the Hungarian when he arrived in Chicago. By that date, Smith had already recognized that one could make color photograms by shining colored lights across semi-opaque and transparent objects on color photographic papers and by superimposing color-dyed films.[14] Moholy-Nagy was so impressed with Smith's command of color and commitment to its broad language that he invited Smith to join the inaugural faculty of the New Bauhaus.[15]

Color photography clearly offered great potential, but implementing its creative promise was not easy. Compositions that worked in black-and-white photographs often looked banal or inappropriately skewed in color. Color could certainly describe the world with great efficiency, but when lighting was not carefully arranged, hues from one object could reflect color onto adjacent objects making them look off-key. Additionally, the bright, clean lighting required by the slow speed of color film meant that the subtleties of light, shadow, and emotion so central to black-and-white

FIGURE 2.1 *top*
O. Millie Goldsholl (1920–2012), *Light Modulator*, 1945. In László Moholy-Nagy, *Vision in Motion* (Chicago: Paul Theobold, 1947), 199.

FIGURE 2.2 *bottom*
Henry Holmes Smith (1909–1986), *Untitled*, 1936. Chromatone print. Henry Holmes Smith Archive, Indiana University Art Museum, Bloomington. Permission granted by the Smith Family Trust. Photograph by Kevin Montague.

were often lost. This problem was particularly apparent in portraiture, where sitters often appeared as stolid casts devoid of personality.[16] Making matters worse, unless publications printed color photographs with great care, they looked garish, uncrafted, and ugly. Finally, photographers working in black-and-white realized that color delivered emotional cues not suggested by tones of gray. Quite simply, color added a new syntax that many of them felt they did not need.

One of the most vituperative attacks on color photography in these early years of Kodachrome came from the California commercial photographer–teacher William Mortensen in an extended four-part series on the subject in the West Coast journal *Camera Craft*.[17] After acknowledging the tremendous allure and popularity of the new color films, he warned: "Our present liking for color has something violent and hysterical about it. It is symptomatic of the nervous excitement and restless uncertainty of the times. Something calamitous seems to be pending, we know not what. So, while the world slips irrevocably toward the abyss, we paint the town red." He counterpointed the quality of the color reproductions in the Condé Nast family of periodicals against the color photographs appearing in most other magazines, which he called botched translations that delivered "vicious blue skies" and "livid pink complexions."[18] In his third installment, published in July 1938, he pointed to a key problem that would bedevil photographers for some time to come—the difficulty and expense of making quality color prints. The tricolor carbro process was, he said, so difficult that getting a good print was "barely short of the miraculous," and Kodak's new Wash-Off Relief imbibition process was just as "heart-breaking and nerve-wracking," often delivering not a success "but an abortion."[19]

Still, this was the hour of color. In 1939, Hollywood released two momentous films, *Gone with the Wind* and *The Wizard of Oz*, that each highlighted the magical sense of reality provided by color. That same year, the New York World's Fair made an elaborate rainbow color scheme a central feature of its layout and architecture as a way-finding tool, and

In the great Cavalcade of Color in the Eastman Kodak building at the World's Fair—1940, ninety-three sequences of full color pictures are projected on the world's longest screen—187 feet in length and 22 feet high.
More than six hundred individual transparencies in brilliant, natural color are required for the com-

a fair highlight was Kodak's "Cavalcade of Color," a programmed projection of more than two thousand Kodachrome slides onto a curving screen 187 feet long and 22 feet high.[20] The display, which Kodak advertised as "the greatest photographic show on earth" (Figure 2.3), succeeded in attracting four million people over the course of the fair's two-year run.[21]

1939 was also the year that Roy Stryker, head of the federal government's Farm Security Administration photographic bureau, began handing out color film to his staff photographers for use in building their portrait of rural America in support of government remedial programs.[22] Stryker's interest in color

FIGURE 2.3
"Cavalcade of Color," Kodak advertisement in *U.S. Camera Magazine* 1, no. 10 (June–July 1940): 36–37.

was soon tempered by his realization that although *LIFE* was starting to put color photographs on its covers, newspapers and most magazines were not willing to take on the added expense of color printing.[23] Before he shut the experiment down in 1943 though, his staff, including the distinguished photographers Jack Delano, Russell Lee, Arthur Rothstein, and Marion Post Wolcott, had exposed more than 1,600

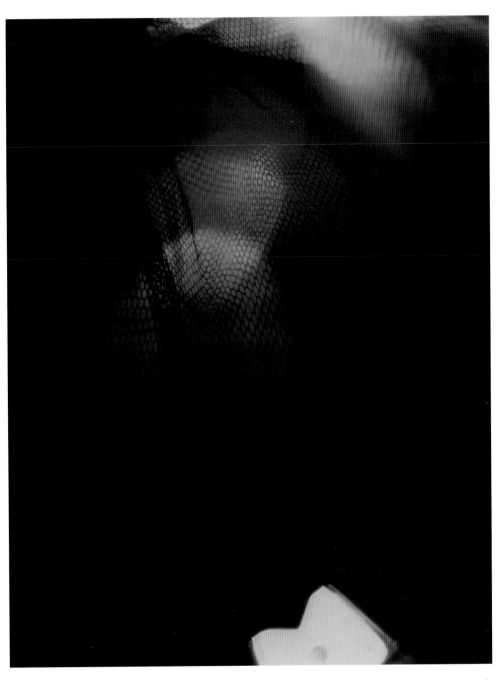

FIGURE 2.4
Nicholas Ház (1883–1953), *Untitled*, ca. 1940. Dye imbibition print (Kodak Wash-Off Relief). The Museum of Modern Art, New York. Gift of the photographer. Digital image © The Museum of Modern Art/Licensed by SCALA/Art Resource, NY.

Kodachrome slides and transparencies documenting diverse regions of the country. Today, viewers of these government images often react with surprise, relating that they do not tend to think of the 1930s and early 1940s in terms of color. But they are delighted to see them.[24] Jack Delano had a particularly good eye for acknowledging color without letting it dominate his subjects. His June 1941 photograph of cotton hoeing in Greene County, Georgia, delivers a snapshot-like immediacy that we tend not to ascribe to the era of the Great Depression (Plate 2.1). It also relays attributes of that region and time not conveyable in black-and-white, like the area's distinctive red soil and the colorful patterns of the women's clothing.

In spring 1940, the Newark Museum summarized the achievements of contemporary color photography. Reviewing the show in his monthly "Color" column for the new magazine *U.S. Camera*, Paul Outerbridge heralded the organizers for including work by "most of the well-known names in color photography."[25] But though he extolled the display's range and variety of work, he suggested that contemporary color photographers were doing nothing more than mimicking what had been done earlier by others in black-and-white and other media.[26] Fashion photographer Caroline Whiting-Fellows, for example, was adapting the techniques of painters like Salvador Dalí to photography and the color photograms of Hungarian emigrant Nicholas Ház (Figure 2.4) mirrored what the artists Man Ray and Moholy-Nagy had invented in black-and-white fifteen years earlier.[27] Outerbridge's criticisms did not stop Ansel Adams from using the Newark show later that year as the color section of his exhibition summary of contemporary photographic trends assembled for the Golden Gate International Exposition. It also did not stop Adams from engaging Outerbridge to write that second show's catalogue entry about color. There, Outerbridge acknowledged that color would soon take over all of photography.[28] He asserted that, unlike black-and-white processing, most color processing would likely remain in the hands of "large scientific laboratories"; but he put a positive slant on

that scenario, suggesting that it freed photographers to focus on their artistic messages.

Adams also asked Moholy-Nagy to contribute an essay discussing types of photographic seeing to the San Francisco show's catalogue, but he and Newhall, who had just been named founding director of MoMA's newly established photography department, made clear in their own catalogue entries that the Hungarian's broad-based photographic methodology was a minority position. Straight recording of the world was the approach of the day.[29] To this end, in his introduction to the exhibition's catalogue, Adams complained that color was too complex and rigid.[30]

Actually, rigidity was not the problem, Nancy Newhall countered in an article the following spring.[31] Nancy was Beaumont Newhall's wife and a burgeoning critic in her own right. Photographers themselves were to blame for color's slow artistic advance, she argued. Just like painters who insist on being contemptuous of photography because they think it is effortless, she asserted, Adams and other top photographers who had established their credentials in black-and-white were now shying away from color because they had not taken the time to understand it. One could hardly blame them, she admitted, when so much published color photography was garish, simplistic, saccharine, and formulaic.[32] But that was no excuse. To find the way to great color photographs, she prescribed a framework that had long guided artist-photographers working in black-and-white: don't try to imitate other art media; think in color, and previsualize what the final photograph will look like before snapping the shutter; do not retouch; keep experimenting; train the eye by constant looking; and do not imitate others but find your own vision. This track, she wrote, would in the near future lead someone to create "not photographs with color—but *color photographs*."[33] She would soon find her answer in the work of Eliot Porter.

Porter had been a committed black-and-white photographer when, in late 1938, Stieglitz had awarded him a coveted solo exhibition at his New York City gallery.[34] To build on his new artistic standing, after

the show he had taken some of his black-and-white photographs of birds, including several that he had included in the display, to Paul Brooks, editor-in-chief at Houghton Mifflin, because the house had recently met with success publishing Roger Tory Peterson's *A Field Guide to Birds of Eastern and Central North America*. Brooks had voiced deep appreciation for Porter's work, but he had demurred on constructing a book of the photographs because their absence of color made the creatures hard to identify. In response, Porter had picked some up some Kodachrome sheet film and taught himself how to make his own Wash-Off Relief prints. If color photography could not capture every nuance of hue visible to the human eye, thanks to the Wash-Off Relief process it could get pretty close (Figure 2.5).

Impressed with Porter's black-and-white photographs, shortly after the 1938 exhibition Stieglitz had praised the young photographer with the remarkable declaration, "Some of your photographs are the first I have ever seen which made me feel: 'There is my own spirit.'" He had even initiated conversation with Porter about presenting a second solo show.[35] But when he heard that the photographer had taken up color, he summarily quit all discussions. Nancy Newhall, on the other hand, now found herself captivated by Porter's expertly conceived and printed color depictions of birds. In October 1942, she convinced MoMA to accept Porter's gift of thirty-seven of the photographs, and the following March, the museum presented an exhibition of the works where they drew words of appreciation from Georgia O'Keeffe and Walker Evans and raves from Evans's friend Lincoln Kirstein, who called them the finest color photographs he had ever seen.[36]

If the leaders of the New York and California photographic communities were coalescing around verisimilitude as the model for color, Moholy-Nagy's celebration of abstraction was attracting its own group of adherents in the Midwest. The young Detroit photographer Arthur Siegel had become enamored of color in 1937 while enrolled for a year at the New Bauhaus. Siegel's fellow Detroiter Harry

Callahan was also finding his way to color. Callahan was an industrial photographer for Chrysler Motors and a camera-club enthusiast when Siegel invited Ansel Adams to that city to give a photographic workshop in late summer 1941. The presentation changed Callahan's life. Inspired by Adams's declaration that photographs are inherently inventions, he started making semi-abstract studies of grasses and clouds.[37] With color so much in the air, he then tried his hand in that direction. Even before hearing about Moholy-Nagy or knowing of Siegel's color experiments, he began using the film to make multiple exposures, at times deliberately moving his camera as he pointed it at street lights and neon signs. Most of the resulting images reflect the look and feel of scrawled graffiti; but one of the strongest works, *Detroit* (ca. 1941), is

more articulate, transforming neon light into a suggestion of ethereal blue candles emitting red flames (Plate 2.2). Here, color and form blend fluidly, offering a vision that is purely photographic, both of this world and not. Such use of color melded perfectly with Moholy-Nagy's interest in transforming colored light into new forms and spaces. In 1945, Moholy-Nagy would invite Siegel back to run the photography program at what was now called the Institute of Design, and a year later Siegel would invite Callahan to join him. In his own work, Siegel focused on photographing Chicago's shop windows, often making reflections a key part of the image (Plate 2.3). But he also showed Callahan's color light studies to Moholy-Nagy, who was so impressed that he made a point of projecting them in lectures.[38]

Unfortunately, Callahan did not have the funds or facility to make his own color prints. Kodak had introduced Kodacolor positive-negative film in 1942, but processing of that film and printmaking had to be done by the company. Four years later Kodak would introduce an improved version of Eastman Wash-Off Relief printing called Kodak Dye Transfer, but that process still necessitated the cumbersome separation and recombination of colors.[39] In trained hands, the results could be extraordinarily delicate and true to life, but to reach that stage took tremendous patience and practice. Few artists beyond Eliot Porter were willing to make the leap. While Callahan had small commercial prints made of some of his images, and he never gave up color, he decided to focus his main energy on exploring the easier-to-print format of black-and-white.

None of these efforts, however, could match the sophisticated blend of realism and abstraction coming out of Condé Nast. Thanks to the extensive support of that company and the vision of art director Alexander Liberman, leading photographers of the fashion world had already moved well beyond the debates stalling artists about verisimilitude, formalism, abstraction, and whether color was an advance for black-and-white or an entirely different sensibility. Fashion is founded on color, how it attracts the eye and creates a psychological or emotional moment. The Condé Nast photographers most attuned to color, including Cecil Beaton, Erwin Blumenfeld, Horst P. Horst, and John Rawlings, realized that control over the way color is photographically rendered is key, but verisimilitude is less important than believability and entertainment. The goal, after all, is to attract, reward, and sustain the attentions of busy eyes. Rather than push color behind subject, these photographers were fast learning to bring it forward to engage readers equally with the hues of their images and the objects those photographs described. A perfect example of this entertaining balance of color, design, and subject is company photographer Anton Bruehl's *Harlem Number at the Versailles Café* (1943) (Plate 2.4). Bruehl had been producing color

photographs for Condé Nast for fifteen years by this date, working in close tandem with his technical partner, Fernand Bourges, to produce transparencies of clear description and rich, clean color, and Newhall had included two of the team's color photographs in his monumental 1937 MoMA survey of photography's history. *Harlem Number* comes from one of the Bruehl-Bourges team's outside-wartime commissions, a request from *Esquire* magazine to produce a series of nightclub tableaus to entertain American soldiers. While the tangoing dancers Eleanor Fairchild and Hugh Ellsworth are the image's ostensible subject, one is drawn to the photograph by its saturated choreography of purple, pink, and mustard yellow. Counterpointing these colors is a deep nighttime blue in the upper right, which brings notice to the young boy eavesdropping with rapt attention in the window.

By the war's last year, Erwin Blumenfeld, a recent German immigrant to New York, was producing some of the most imaginative of Condé Nast's color fashion photographs, like his graphic *Red Cross*, which graced the March 15, 1945, issue of *Vogue* (Plate 2.5).[40] Overtly rejecting staged sentimentalism, that cover transforms the potent symbol of disaster-time medical assistance into a platform for drawing attention to the white-gloved model's green hat. By greatly subduing the colors of the model, Blumenfeld even added an extra bonus to viewers willing to take a closer look, delivering to the model an elegant red dress without offending wartime exigencies. By also softening her focus, he expertly keeps attention on the main task at hand: the war.

American entry into World War II slowed the general market expansion of color photography almost to a standstill as the military co-opted photographic materials and processing facilities for the war effort.[41] But after the war, business, fashion, and picture magazines recommenced, as finances permitted, their fragmented embrace of the medium.[42] To convince artists and committed amateurs to take up color, the Eastman Kodak Company cajoled Ansel Adams, Charles Sheeler, Paul Strand, and Edward

Weston to try their hands at it. The company arranged to give each photographer free film and processing in exchange for the right to use in its advertising campaigns whatever images they released, and on top of that to pay them $250 for each image they used.[43] The project induced Weston to expose more than sixty sheets before Parkinson's disease forced him to stop photographing entirely. He gave at least seven of those color transparencies to Kodak and exuberantly suggested that he saw real potential in the medium, exclaiming that color opened new worlds that would look meaningless in black-and-white.[44] By May 1947, the company was running Weston's images in leading photography magazines, trumpeting the artist's declaration that several of his Kodachrome 8 × 10–inch transparencies "seem to

equal my best in black-and-white," and his assertion: "I feel color will be part of my future."[45] The artist's enthusiasm provided the perfect foil for Kodak to suggest: "If you have been working only in black-and-white, isn't it high time you joined Edward Weston in exploring the boundless possibilities which Kodak color holds?"[46] Kodak used Weston's more traditional landscape views for its ad copy (Figure 2.6), but his close-ups, like *Nautilus Shells*, were fully in line with the refined depictions of singular objects that had established his artistic standing. Graphic and centered, this color image might easily stand on its own in black-and-white, but in color it shifts from a study of light and texture to a celebration of the varied hues of brown, tan, gray, and white (Figure 2.7).

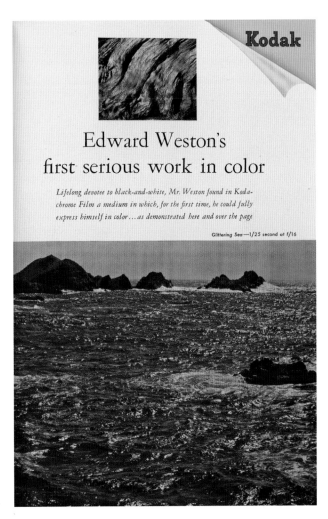

FIGURE 2.6
"Edward Weston's First Serious Work in Color," Kodak advertisement in *Minicam* 10, no. 8 (May 1947): 51–53.
© 1981 Arizona Board of Regents.

FIGURE 2.7
Edward Weston (1886–1958), *Nautilus Shells*, ca. 1947. Silver dye-bleach print from original transparency, 1985. Center for Creative Photography, University of Arizona Libraries, Tucson. © 1981 Arizona Board of Regents.

Adams's results were more modest. The photographer allowed Kodak to use at least five of his color transparencies, including ones presenting rainbow-emblazoned waterfalls and Sequoia trunks. He even wrote the Newhalls that one of his Zion National Park Ektachromes (Figure 2.8) was "gorgeous," labeling it "the G-DambnestSOBchen wonderful thing I ever did."[47] Time, though, would show that the main lure of the arrangement for Adams was that it provided him the funds to buy extra black-and-white film for his concurrent Guggenheim-funded project photographing the National Parks.[48] Although he would continue to make color photographs for commercial jobs for the rest of his career, and willingly try out new printing technologies, he remained committed to black-and-white. The situation was much the same with Strand who created a few images that seem simply to have been color versions of his black-and-white exposures. Although he too allowed Kodak to use at least one of his color images, he seems not to have voiced any enthusiasm about the medium.[49] Sheeler would exhibit a color transparency in a 1950 MoMA exhibition, but he too stuck with black-and-white.[50] The Kodak campaign did not last long.

As Weston and Porter were embracing color as an enhanced way to reflect the world, even as leukemia was taking over his body, Moholy-Nagy was institutionalizing his philosophy of color as a means for creating new worlds. In his book *Vision in Motion*, published less than a year after his 1946 death, he called color "the new frontier of photography." Color photographic emulsions produce "a boringly unified 'complexion'" because they provide a carefully calibrated synthesis of the three primaries that can only approximate the world's infinite array of hues, he asserted.[51] To transcend this limitation, he wrote, photographers needed, like painters, to study the physical and psychological effects of color. Don't try to mimic the solidity of pigment though, or present the illusion of the natural scene, he went on. Rather, attend to light.[52] He illustrated his argument with his own, and others', photographs of light reflecting off plaster casts, and through colored plastic and the

FIGURE 2.8

Ansel Adams (1902–1984), *Vertical Cliff, Zion National Park, Utah*, 1946. Kodachrome transparency. Center for Creative Photography, University of Arizona Libraries, Tucson. © 2012 The Ansel Adams Publishing Rights Trust.

FIGURE 2.9 *top*
László Moholy-Nagy (1894–1946), *Untitled (light box abstraction)*, 1937–1946. Dye coupler print, 2006. Amon Carter Museum of American Art, Fort Worth, TX. Purchase with funds provided by the Stieglitz Circle of the Amon Carter Museum. © 2012 Artists Rights Society (ARS), New York/VG Bild-Kunst, Bonn.

FIGURE 2.10 *bottom*
Nathan Lerner (1913–1997) and Henry Holmes Smith (1909–1986), *Untitled*, 1946. Dye imbibition print. Henry Holmes Smith Archive, Indiana University Art Museum, Bloomington. Permission granted by the Smith Family Trust. Photograph by Kevin Montague.

screens of his "light modulators" that were a central part of the core curriculum for the beginning student at the Institute of Design (Figure 2.9). He considered these photographs not ends in themselves so much as means for exploring how color described form while also acting independently of it, and for opening the imagination. Despite Moholy-Nagy's death, others were more than willing to carry forth his ideas. Harry Callahan, Nathan Lerner, and Arthur Siegel were now teaching these methods at the Institute (Figure 2.10). Henry Holmes Smith, who had left the school in early 1938, had stayed in touch with Lerner and Moholy-Nagy and would bring their ideas to Indiana University when he started teaching there in fall 1947.[53] (See Figure 2.11 and Plate 2.6.) Although he was not directly connected to Moholy-Nagy, New Orleans photographer Clarence John Laughlin was by 1944 also experimenting with an alternative way of breaking the stranglehold of photographic verisimilitude—by painting on matrices and then printing them photographically (Figure 2.12).[54]

Smith's work was the most revolutionary of these explorations. He not only mixed up his colors, but also reversed some of his negatives as he printed them one on top of the other to make dye imbibition photographic prints. The results are abstract and photographically dimensional at the same time, of this world and distinctly free from it.[55] Over coming years he would take on Moholy-Nagy's mantle and wage an ongoing rear-guard battle against the Stieglitz-Adams-Newhall aesthetic of photographic naturalism that would extend for decades.[56]

Yet the other end of the debate over color was not secure either. Ansel Adams was concluding that his own attempts at color were little better than amateur snapshots. Influencing him were critics' castigation of his oversized color transparency featured in a spring 1948 MoMA exhibition titled *In and Out of Focus*. Edward Steichen, who had taken over MoMA's photography program after the war, acknowledged the experimental side of color photography in this show through inclusion of James Fitzsimmons's color

explorations of solarization, surface reticulation, and extreme close-up, but he sided with using color for straight description, drawing special attention to Adams's and Edward Weston's naturalistic transparencies, and even opened the show with Adams's mural-sized color transparency of Wyoming's Teton Mountains, produced by Eastman Kodak specifically for the occasion. He called the Adams and Weston works "breathtaking" for their evocation of "holding a mirror up to nature."[57] In counterpoint, he disparagingly described Fitzsimmons's contributions as occupying "a no man's land" between photography and painting.[58] Unfortunately, critics were not as impressed with Adams's and Weston's works. The art historian Milton Brown, for example, labeled them garish.[59]

By the following spring, recognizing that his commercial color work was by now far more in evidence than his black-and-white photographs, Adams formally renounced color photography in the journal of New York's photography cooperative the Photo League. He was not a color photographer, he explained: "[T]he expressive capacities of black-and-white vastly exceed those of color photography as it stands today."[60] He decried transparencies for their excessive brilliance, and argued that color film's inability to capture both bright light and deep shadow at the same time was too limiting. Quite simply, color did not render natural light, and especially blue skies, very convincingly, he said. To make matters worse, the substantively reduced brilliancy of color prints created a situation where hues "never seem to have the vitality and validity they possess in nature."[61] In a follow-up text published a year later, he was even more direct, complaining that the reigning paradigm decreed: "If you can't make it good, make it red."[62]

Lurking behind Adams's clarifications, justifications, and complaints was his recognition that artist-photographers could not escape color.[63] Beaumont Newhall also acknowledged this inevitable rise of color by making Edward Weston's color photograph of the Monterey docks (Figure 2.13) the frontispiece

FIGURE 2.11 *top*
Henry Holmes Smith (1909–1986), *Untitled*, 1946. Dye imbibition print. Henry Holmes Smith Archive, Indiana University Art Museum, Bloomington. Permission granted by the Smith Family Trust. Photograph by Kevin Montague.

FIGURE 2.12 *bottom*
Clarence John Laughlin (1905–1985), *A Greedy Glance*, 1944. Dye imbibition print. © The Historic New Orleans Collection, Louisiana.

of his new 1949 edition of his historical text, now called *The History of Photography from 1839 to the Present Day*.[64] The following spring, Steichen did the same, summarizing "the status of color photography as a creative medium" through a 342-print MoMA exhibition he titled *All Color Photography*.[65] The show presented photographic prints, tear sheets, and transparencies by more than seventy-five practitioners, including Adams, Callahan, Outerbridge, Porter, Strand, and Weston, along with Richard Avedon, Robert Capa, Henri Cartier-Bresson, Elliott Erwitt, Walker Evans, Arnold Newman, Ralph Steiner, Roman Vishniac, Todd Webb, and Weegee.[66] Works ran the gamut from straightforward description to pure abstraction and even included a section on photographic color's technical development, but

documentary photography dominated, especially images from *LIFE*, *Fortune*, and the current Standard Oil project highlighting the contributions of oil to American society. Although Steichen suggested his intention to produce future displays analyzing color in advertising and fashion, he also included numerous photographs from *Vogue*. But save for the color work of Harry Callahan and some experimental photographs called "Derivations" by Adams and Eastman Kodak employees Jeannette Klute (Plate 2.7) and Dorothea Patterson (created by switching the colors of their Dye Transfer prints so that the final prints mimicked the flat patterns of lithographs), the show largely neglected non-descriptive photography.[67] No color works by Moholy-Nagy, Henry Holmes Smith, or their students were included.

The curator's choice to mix tear sheets with prints and transparencies created problems. In this context, the prints often looked murky and off-color.[68] Most of the photographic prints were produced by commercial labs. Porter was one of the few participants to present photographic prints of his own making. Additionally, visitors had to shift back and forth between brightly lit rooms filled with magazine pages and original photographs and darkened rooms presenting displays of transparencies. While some sections left space between the images, in other areas images were butted up against each other in long strips. Almost all the images were small; none seem to have been matted. Quite simply, the show did not look very good.

Steichen admitted his dissatisfaction with the results right up front. Ignoring Moholy-Nagy's assertion of color being a new abstract language, he suggested in the show's opening text panel that "neither the photographer nor the public has as yet overcome the unconscious conditioning firmly established by the black-and-white photograph."[69] He voiced concern that experimental practitioners tended to embrace the "coloriferous" over the colorful.[70] Despite his longstanding personal love of color, he admitted: "This exhibition asks more questions than it answers, for in spite of fine individual attainments and rich promise [a point that he did not clarify], color photography as a medium for the artist is still something of a riddle."[71] The press agreed. Jacob Deschin, writing in *The New York Times*, suggested that the show had an air of experimentation about it, "as if it were trying to say that since color photography itself is still rather exploratory, any exhibition of contemporary work in this field must also reflect this feeling of indecision as to just how to evaluate it."[72] Immediately, Steichen backed off his plans for his exhibitions on color in fashion and advertising.

If Steichen could not figure out color photography's artistic contribution, *LIFE* magazine could; it came through the medium's fluid blend with modern painting. That November they ran a seven-page spread celebrating Arthur Siegel's new color photographs under the title "Modern Art by a

FIGURE 2.14
Arthur Siegel (1913–1978), *Still Life with Lemon*, ca. 1949. *LIFE*, November 20, 1950. Time & Life Images/ Getty Images. The Estate of Arthur Siegel.

Photographer."[73] By this date, the artist had greatly simplified his compositions to focus on the austere beauty of form and color. The *LIFE* article trumpeted Siegel's water reflections, close-ups of building walls and cracked mud, and a picture of a lemon sitting precariously on the seat of a chair as rivaling the work of contemporary painters (Figure 2.14). The artist concurred, suggesting that "in some ways the photographer should displace the painter," and arguing that the camera "seems to be more suitable to this modern age than the tedious manual methods of the painter."[74] The article exuberantly asserted that the artist's lemon close-up "has reminded critics of Braque," that his view of water reflections suggest Claude Monet's haystacks, and his abstract view of rail signals shot from a moving train resembles "the works of America's young ultra-modern painter, Jackson Pollock."[75]

Commenting on the images in *The New York Times*, Jacob Deschin agreed, suggesting that they represented an "inspiring" use of real world subjects to convey "subtle color values [that] are hidden from the casual glance."[76] Siegel would not embrace this line of thinking for long. When displaying his semi-abstract close-ups of objects and scenes at the Art Institute of Chicago four years later, he would defensively declare in the exhibition brochure: "I am not a frustrated

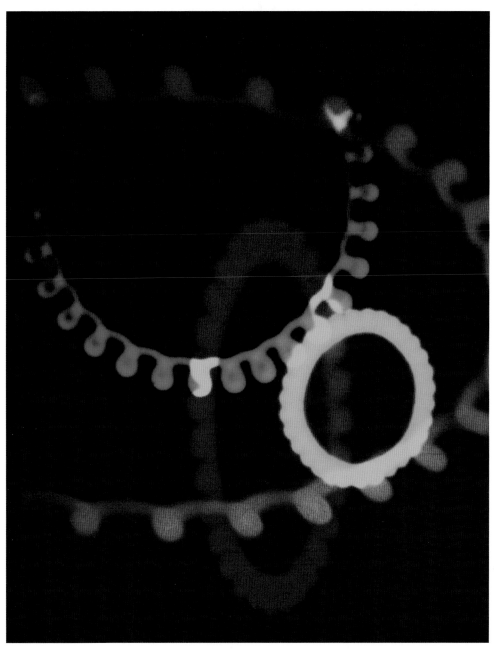

FIGURE 2.15
Hy Hirsh (1911–1961), *Untitled*, ca. 1950. Dye coupler print (Printon). Amon Carter Museum of American Art, Fort Worth, TX.

painter."[77] But the style struck a chord. Hungarian-born photographer Ferenc Berko was also building a following by moving in close to subjects like fences and water surfaces to create tightly framed blends of abstraction and reality (Plate 2.8). New York Fashion photographer Saul Leiter was using his roots as a painter to apply his love of color and overlapping form to slides he was making in his free time of New York's street life (Plate 2.9).[78] Photographer and experimental filmmaker Hy Hirsh was creating lively photogram abstractions in California that used overlapping spring and cord-like forms to build purely photographic dimensional space (Figure 2.15).

Steichen's decision to give up his plans to assemble exhibitions analyzing the applications of color in fashion and advertising was unfortunate because the top photographers in these fields were developing a sophisticated alternative to both straightforward naturalism and the kind of formalism promoted by *LIFE*. The year after MoMA presented *All Color Photography*, Condé Nast came out with a compendium that, much like its 1935 book *Color Sells*, proclaimed the company's preeminence in developing commercial uses of color.[79] Years of working with the tricolor carbro process had given fashion magazines and high-end commercial photographers a head start at exploring color's expressive potential, the company's art director, Alexander Liberman, wrote in the book's foreword. He freely admitted that magazines like his had the financial wherewithal to give photographers the freedom to experiment and the outlet for publishing their results. Magazine offices had become, he asserted, "the meeting place of all talents, a new salon where the whole world is on exhibition."[80] In the book's introduction, *The New York Times* associate art editor, Aline B. Louchheim, added that the best color photographers plied a mix of magic realism, surrealism, and stylized abstraction, not simply to mirror painting, which she called an inevitably banal route, but to say something new. Unlike amateurs, the Condé Nast photographers featured in the book used color strategically, she said, employing a circumscribed range of hues and often incorporating

an accent color to establish a mood.[81] Such work was changing design itself, she pointed out. The piercing purple-blue that Bruehl had used in *Harlem Number* was unique to photography, and color film's particular way of rendering pink, sage green, and blues had led to a new palette for fabrics, furniture, and even makeup.[82]

Despite the company's optimism, the seventeen Condé Nast photographers whose portfolios filled the book offered less than universal support for Liberman's and Louchheim's declarations. Those willing to let go of verisimilitude, like John Rawlings, reveled in color's freedom to escape reality. Those bound to naturalism, like André Kertész, expressed frustration over color's inability to exactly reflect human sight.[83] The book made clear that Condé Nast had committed its resources to celebrating a carefully shaped naturalism. Irving Penn, who had come to the company

in 1943, was a master of this technique. On his own he would at times play openly with color, distilling it down to pinpoints of hue in *Seine Rowboat, Paris, 1951*. But for the magazine he generally held to the clean, shadowless lighting and white backdrops found in *After Dinner Games* (1947). (Figure 2.16 and Plate 2.10.)

Advertising photography rarely raised itself to this same level, but by this date that field too had its masters who used color not merely to describe but to actively attract, please, and loosen pocketbooks.[84] Although not of the stature of Penn, Victor Keppler, in his Camel Cigarettes advertisement image of 1951, takes Bruehl's willingness to build images out of saturated color to astonishing conclusion (Figure 2.17). Here red so dominates the image that one strains to escape it, landing, just as Keppler intends, on the smiling face of the model and her uplifted cigarette.

FIGURE 2.16
Irving Penn (1917–2009), *Seine Rowboat, Paris, 1951*. Dye imbibition print, ca. 1959. © Condé Nast Publications, Inc.

FIGURE 2.17 *top*
Victor Keppler (1904–1987), *Camel Cigarettes* (*Woman in Red*), 1951. Tricolor carbro process. George Eastman House, International Museum of Photography and Film, Rochester, NY.

FIGURE 2.18 *bottom*
Henry Holmes Smith (1909–1986), *Angels* (*Red*), 1952/1974. Dye imbibition print. Henry Holmes Smith Archive, Indiana University Art Museum, Bloomington. Permission granted by the Smith Family Trust. Photograph by Kevin Montague.

Forecasting the self-consciously staged photographs that would come to popularity in the 1980s, the photographer shows his hand, making clearly apparent the spotlight that delivers the clean light from the upper left. In tune with the tale, even the outside housing of that lamp is red.

Still, most established artist-photographers now backed off or downplayed their use of color. Ansel Adams continued to take on color commercial jobs like providing transparencies for the 18×60 foot Colorama screen that Kodak installed in 1950 in Grand Central Station in New York City, but he actively eschewed color as merely a way to make ends meet.[85] To him, color was for popular appeal; black-and-white photography was for art. Harry Callahan did not give up color entirely, but he chose not to include any of that work in his spring 1951 retrospective at the Art Institute of Chicago. The following year, Edward Weston did not include any of his color photographs among the 830 images representing his life's achievement that he selected with his son, Brett, to print for distribution to museums.

Even so, Weston was not ready to give up entirely on color. In the December 1953 issue of *Popular Photography* he suggested that black-and-white photography might have a creative advantage by being from the start a step removed from factual rendering, but he called on his associates to get over their prejudices: "You can say things with color that can't be said in black and white."[86] Henry Holmes Smith agreed and was now making semi-abstract drawings of humanoid figures with syrup on glass and using these constructions as the basis for colorful photograms (Figure 2.18). In California, hobbyist Lynn G. Fayman was deliberately mixing up the hues of everyday subjects (Figure 2.19).

Steichen's support for color photography did not entirely disappear in the aftermath of his color show debacle. He included twenty of Porter's photographs in his 1952 presentation of his intermittent contemporary exhibition series *Diogenes with a Camera*. The following year he included several of Leiter's color street photographs in a show titled *Always the*

Young Stranger. But when it came to presenting his monumental 1955 exhibition, *The Family of Man*, he included only one color photograph. That choice presented a powerful statement—an 8 × 6–foot color transparency of a hydrogen bomb explosion mounted in a blackened room.[87] But he did not include the image in the show's world tour.

Color photography was a big artistic problem. The editors of *Popular Photography* estimated that about ten million still-camera users were shooting color film and three million were shooting exclusively in color by this date. The continuing absence of innovative fine art color photography so bothered them that they and the editors at *U.S. Camera* started convening panels to take up the issue.[88] The most insightful of these events took place in 1956 when they assembled thirteen photographers, editors, and critics and asked them, "How Creative Is Color Photography?"[89] Established fine art photographers on the panel, including Bill Brandt, Arnold Newman, Paul Strand, and Minor White, delivered their usual anti-color arguments. Though they acknowledged the recent introduction of a new color dye coupler photographic printing paper that alleviated the need to separate and recombine a photograph's primary colors, Brandt related his friend Pablo Picasso's stance that color photography was "still very ugly," and said: "Until color becomes less of a hit-and-miss affair, I shall stick to black-and-white."[90] Strand suggested that merely translating black-and-white photographs into color diminished their original vitality, leaving a "more or less corny verisimilitude."[91] André Kertész called color photography too dependent on painting. Yet, those panel members working in the editorial and commercial arenas retorted that that their colleagues needed to look beyond naturalism. Color, they said, delivered great opportunity to expand beyond straight description. Creativity is in the mind of the photographer, they argued. Implicitly asserting their agreement with this latter stance, *Popular Photography*'s editors juxtaposed the article with a feature celebrating

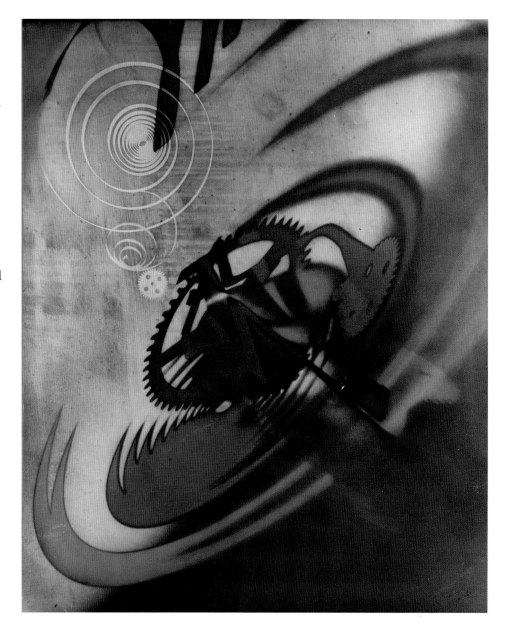

Ernst Haas as a "master of color" committed to using photography not as a medium of reproduction but of transformation.[92]

A photojournalist by trade, Haas's star had been rising since September 1953 when *LIFE* magazine had devoted an unparalleled two consecutive issues to the artist's lyrical views of New York City.[93] That series would become the first of many articles *LIFE* would publish celebrating his work. Haas freely described himself as "a painter in a hurry." In the midst of the

FIGURE 2.19
Lynn G. Fayman (1904–1969), *Machinery Movement*, 1954. Flexichrome. Private collection. Courtesy the Fayman Family.

photography journal debates over the creative place for color, he had discovered a new breakthrough. Needing to photograph a Spanish bullfight without a flash in fading evening light led him to realize the abstracting beauty of movement.[94] That success would induce him to photograph a wide range of subjects in motion (Plate 2.11) and to his creation of a purely photographic language of color photography that critics would call "painting with the camera." The artist justified his blend of abstraction and realism by suggesting:

> In the creation of the color image we discover the fleeting and transitory nature of color and light. Colors not only originate from the breaking down of light, but are also depend upon it. Too much light, as too little, can destroy color. It is a miraculous relationship based on give and take. There are colors which have their own illumination, and others which require illumination to be seen at all. As there exists no absolute light, there exists also no absolute color.[95]

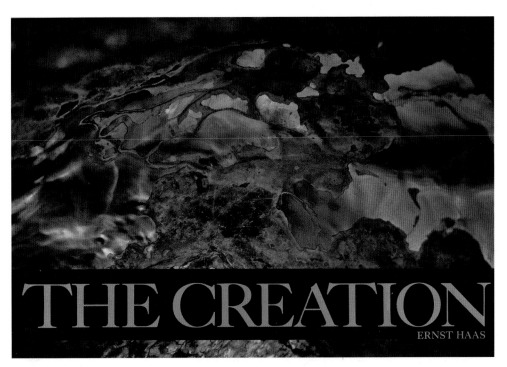

FIGURE 2.20
Ernst Haas (1921–1986), cover of *The Creation*
(New York: The Viking Company, 1971).
© Estate of Ernst Haas.

Haas's work struck a chord with Ansel Adams. Declaring that he had not yet seen any color photographs that fulfilled his concept of true art, Adams argued that Haas's color work at least approximated his expressive ideal, because it so dramatically and obviously left the "real" world behind to open "new vistas of perception and execution."[96] The following year the readers of *Popular Photography* agreed, selecting Haas as one of "the world's ten greatest photographers."

Haas recognized, as Bruehl, Blumenfeld, and Keppler had done, color's active qualities—that color could describe form and space and at the same time stand on its own. His achievement was to bring that recognition out of the studio. Although he was a photojournalist by profession and a member of the independent picture agency Magnum, he viewed himself more as a discoverer of the poetic in life. Color was the animating feature of his photographs. Often it rose out of darkness, delivering them life and depth. It was just starting to provide the foundation for a new as yet undefined project that would preoccupy him through the 1960s and eventually take shape as a photographic interpretation of the biblical creation of the world (Figure 2.20).[97]

Haas was by no means alone in this approach to color. Eliot Elisofon was doing the same thing at *LIFE*, using filters, films, and controlled light to enliven the colors of his otherwise descriptive photographs so that they reflected the emotive qualities of the scenes he was depicting (Figure 2.21).[98] Walker Evans was starting to do the same thing in a more documentary vein in his work for *Fortune* magazine. He had been assembling articles illustrated with his own color photographs for years at *Fortune*. Initially, he had photographed in color much as he had in black-and-white, understatedly. He had even complained in a July 1954 *Fortune* article about color photographers' penchant for "a bebop of electric blues, furious reds, and poison greens."[99] But by 1957 he was making full use of bright afternoon light to build up color saturation the *Fortune* magazine essay

"Before They Disappear" (Figure 2.22).[100] Later that same year, he would incorporate his love of painting into a series of abstract color close-ups of walls, doors, and pediments for *Architectural Forum* that he connected directly to Paul Klee and Jackson Pollock (Figure 2.23).[101] This same reliance on the activating qualities of color pervaded reportage in popular magazines by the late 1950s as photojournalists like Inge Morath and feature photographers like Garry Winogrand used color to draw the eye and organize space (Figure 2.24).[102]

Well-crafted straightforward descriptions of the world in color had not disappeared. Eliot Porter was quietly building a color photographic portrait of New England through its seasons. The Hungarian-American Nickolas Muray created the photograph *Santa's Coffee*, which draws expert, efficient attention through close framing and a carefully circumscribed palette across the green-edged chair and up Santa's arm to the meticulously lit coffee cup (Plate 2.12).

FIGURE 2.21
Eliot Elisofon (1911–1973), *Sailboats in the Bay of Biscay*, ca. 1949. *LIFE*, June 13, 1949. Time & Life Images/Getty Images.

FIGURE 2.22
Walker Evans (1903–1975), [Burlington route refrigerator car from studies of railroad car insignia, for *Fortune* article "Before They Disappear"], 1956. Color film transparency. The Metropolitan Museum of Art, Walker Evans Archive. © Walker Evans Archive, the Metropolitan Museum of Art. Image © The Metropolitan Museum of Art: Art Resource, NY.

FIGURE 2.23 *top*
Walker Evans (1903–1975), *Untitled*, ca. 1957. In "Color Accidents," *Architectural Forum: The Magazine of Building* (January 1958): 111. The Metropolitan Museum of Art, Walker Evans Archive. © Walker Evans Archive, the Metropolitan Museum of Art.

FIGURE 2.24 *bottom*
Garry Winogrand (1928–1984), *Untitled*, ca. 1950s. Center for Creative Photography, University of Arizona Libraries, Tucson. © The Estate of Garry Winogrand. Courtesy Fraenkel Gallery, San Francisco.

LIFE photographer Gordon Parks used color similarly, though without forward planning, in his provocative photographic essay on crime in urban neighborhoods. When Parks took up color deliberately, he tended to overplay it, making it the core subject rather than an attribute of the subject before his camera. But when he let color fall back, as he did in *Crime Suspect with Gun*, the result is powerful. This close view of a darkened hallway would be compelling in black-and-white, but in color it delivers a disturbing immediacy (Plate 2.13). The pale green and yellow light filling the hallway beyond the shadowy foreground figure pulls one incessantly beyond the gun and into the middle of the action.

The main trend though was to follow Haas's route of grabbing color aggressively, not for its own sake, as mere hue, but as a means for organizing and intensifying a message. New York photographer William Klein took this approach in making fashion photographs like *Antonia + Yellow Cab, Tuffeau & Bush, New York* (1962) (Plate 2.14). Photographers had been drawn since the early days of Kodachrome to New York City's distinctive yellow taxis, but here Klein does far more than reflect New York's crowded taxicab-filled streets. He innovatively transforms the bright yellow sides of overlapping Checker cabs into a framing device that compacts the scene, centering attention on the elegantly attired model as she steps regally out of the distant cab into the middle of the street. This same attention to hue would dominate selection of color photographs included in Ivan Dmitri's *Photography in the Fine Arts* exhibition summations of the best of contemporary photography (in both black-and-white and color) hosted by the Metropolitan Museum of Art between 1959 and 1967.[103] Top-end commercial photographer Pete Turner would take this idea to its extreme, making high-key saturated color his trademark. Turner had started out in the mid-1950s as a pictorialist, appreciating the soft glow of color-permeated scenes, like the blue atmosphere of New York's snow-covered streets at dusk. But by the early 1960s he had shifted dramatically to build his reputation on eye-catching

saturated bright color and was pulling the commercial world along with him. *Dyer's Hand* (1963), a work created in a moment of free time while he was in India for *Esquire* magazine, offers a perfect example of his approach (Plate 2.15). The image's brilliant red color overwhelms the subject, evoking blood and violence. But the crossed open palms also bring the image an unsettling calm. The hands seem to have opened gently to make space for the housefly at the image's center. One sees color first, the hands second, and finally the fly. Only then does one piece together that the fly just landed on hands coated in scarlet-red fabric dye. The record producer Creed Taylor would use *Dyer's Hand* for the jacket of Airto's album *Fingers* in 1973.[104]

In February 1962, shortly before he retired from MoMA, still unsettled about how to think about color, Steichen invited the California photographer Wynn Bullock to the museum to present a slide lecture of his color photographs. It was an interesting choice because Bullock approached color along the lines of László Moholy-Nagy and Henry Holmes Smith, thinking of it as a new tool for exploring the abstract currents of life. Initially drawn to music, he had gone to Paris in the 1920s to study voice, but his encounter there with the photographs of Man Ray and Moholy-Nagy had caused him to shift his attentions to photography. The transition was gradual, circumscribed by family responsibilities, but by the late 1950s, he had established a reputation for making beautifully printed, poetic black-and-white photographs of rural details and woodland settings that were often driven by light and tinged with a sense of the mystical. His extensive reading in art, psychology, physics, and religion shaped his interest in using photography like music, leading him to become fascinated by how people intuit and emotionally respond to the space-time continuum. That preoccupation in turn led him to take up color in 1959, not to describe the world in all its clarity but to explore the axis of abstraction and realism. He built himself a slotted plank that he stood on edge. Inserting pieces of glass

into various slots, he then placed objects like shells, colored glass, crystals, and colored gels on the different levels, and photographed straight down through the multiple levels with a narrow depth of field so that little was in focus. Over the next five years, he created hundreds of Kodachrome slides that evoke dreamscapes filled with luminescent caves, mountain ranges, rivers, and faraway galaxies (Plate 2.16).[105] Although he called his brightly hued photographs "abstractions," rather than follow painting's trend toward flattened and compacted space, he deepened space and often deliberately obscured orientation so that even he would change his mind about which direction was up.[106] The images are not about color, but about light and energy revealed through color. In these elemental forces, the deeply philosophical Bullock found what he called the "internal realism" hidden behind the visible and known reality.[107] The artist made dozens of dye coupler prints and even oversaw the production of a limited edition portfolio of the works. He exhibited the prints a few times over subsequent years, but the mainstream world of photographic art was moving in a different direction.

In 1962, Eliot Porter published a book of his straightforward depictions of woodland details. Titled *"In Wildness Is the Preservation of the World"* and published by the Sierra Club, the book matched Porter's color photographs like *Brook Pond, Whiteface Intervale, New Hampshire, October 5, 1956* (Plate 2.17) with excerpts from the writings of Henry David Thoreau that the photographer had selected and meticulously paired with his images. *Brook Pond* presents an exquisite summation of blue sky and golden autumnal leaves reflecting off the surface of a New England woodland stream. It may take up a commonplace calendar subject, but it is far from a saccharine cliché, instead offering a substantively more complex compositional structure and unparalleled breadth and delicacy of color. Where Haas's photographs draw attention to colors in the world, and Bullock's color images reflect the abstract nexus

of physics and psychology, as Nancy Newhall recognized two decades earlier, Porter's works reflect the world in color.

Even getting the book published had been a major achievement. Despite his exhibitions at Alfred Stieglitz's gallery, MoMA, and other places, Porter's work had long been dismissed by most of his colleagues. Adams's disdain was particularly galling. The two photographers were friends, and Adams would stay over at Porter's house on his visits to Santa Fe. But even in the face of Porter's repeated gentle cajoling, Adams always refused to take a more than cursory glance at Porter's prints. Porter had tried to justify his commitment to color in *U.S. Camera* in late 1956, arguing that, whether a photograph be in black-and-white or color, what distinguished it as art was the photographer's attunement to the world's subtle complexity and variety.[108] But few paid attention. On the other hand, artists working in other media had been giving him heart. Porter explained the discrepancy to his son Jonathan:

It is a curious phenomenon that photographers on the whole do not like to look at color prints, whereas painters are usually very much interested. This is borne out by the reaction of Elaine de Kooning who has spent the week-end with us, and who said, when I first met her, that she was not interested in photography but then spent several hours looking at my pictures without being asked to and finally simply took possession of several Mexican prints from my show and several other pictures from the pile of discard prints on my table.[109]

The painter Jorge Fick, who had studied at Black Mountain College and was friends with the Tenth Street Studio group of abstract expressionist painters, had a similar response. While many Santa Fe locals dismissed Porter's images as oversized postcards, Fick, who had developed a sophisticated color sense from his work for the designer Alexander Girard, found them to project a complex tapestry of tightly wound detail held together by a poetically nuanced sensitivity to color.[110] In late 1959, Eliot's brother, Fairfield, used the opportunity of a traveling exhibition of Eliot's woodland studies to celebrate what photography could deliver over painting: "What color photography has that painting does not, is that it seems to have no laws—no laws are followed, but still everything by itself is ever so much more orderly than lawful art can achieve."[111] Fairfield had gained wide respect among painters for his choice to hold out against Abstract Expressionism. He wrote about art for *The Nation* and was close friends with the painters Willem de Kooning, Alex Katz, and Larry Rivers. Eliot valued his brother's judgment. Fairfield subsequently observed in *The Nation* that where color usually looks added to photographs, color was fully integrated with its subject in Eliot's prints, offering a revelatory range of hues. Heralding Eliot's ability to reflect "the immediacy of experience," Fairfield asked rhetorically, "Can we as adults be sure that we see more deeply, through art, than the photographer who pretends to do nothing but pays the closest possible attention to everything?"[112]

Still, publishers turned Porter's New England project down as too parochial and expensive to produce. Only when the ambitious young executive director of the Sierra Club, David Brower, found himself so taken in by the beauty of the images did *"In Wildness"* reach publication.[113] As a Sierra Club Board member, Adams graciously hosted a party to celebrate the club's publication plans, but when Porter was coaxed into bringing out some of his prints to share with the assembled, Adams left the room so that he did not have to look at and comment on them.[114] At publication, the first printing of thirteen thousand copies of the book had already sold out. Despite its high price, twenty-five dollars, it went on to sell twenty thousand copies over its first two years in print. The success not only showed the marketability of finely printed, expensive photography books, but ones filled with naturalistic color photographs.[115]

When Steichen retired from MoMA, he handed the reins and a planned Haas retrospective exhibition to John Szarkowski, but the young curator was not enthusiastic. Szarkowski presented the 1962 show in corridors rather than the main galleries, and disdainfully suggested that the work made color sensation its subject matter of the world. Despite having created color photographs himself in the mid-1950s, he was not sympathetic to the medium.[116] He resuscitated Walker Evans's career but focused wholly on the photographer's black-and-white work, added the social eyes of Robert Frank and Diane Arbus to the high-art pantheon, and started heralding the new quasi-formalist black-and-white documentary-style photographs of Bruce Davidson, Garry Winogrand, and Lee Friedlander. If MoMA had long set the terms by which fine art photography would be considered, Szarkowski's strong opinions, supported by his exquisite writing, would make that influence even stronger. His approach emphasized photography's mechanical underpinnings of focus, framing, point-of-view, time, and, most of all, hard direct looking at the world before the lens. It was a vision that left little room for color.

In autumn 1963, Szarkowski acknowledged Porter's work in a modest exhibition and book, *The Photographer and the American Landscape*, but he connected Porter to Adams's romantic celebration of nature, leaving no doubt that he considered Porter part of an older more romantic tradition of artistic photography. But whether Szarkowski liked it or not, color was coming on fast. Kodak had just introduced its Instamatic cameras, which incorporated preset cartridges of color film that merely had to be dropped into the back of the camera. By 1964, amateurs were using more color film than black-and-white.[117] Even Harry Callahan broke down that year and exhibited sixty color slides in an exhibition of his work hosted by Hallmark Corporation (Figure 2.25).[118]

As Porter was preparing for *"In Wildness"* to be published, Boston photographer Marie Cosindas was finding her way to this same photographic embrace of naturalism. Where Porter was a medical-researcher-turned-photographer, Cosindas was a designer by training with aspirations to be a painter. She had made color her specialty, priding herself on her ability to mix 150 hues from ten colors of paint.[119] Taking up black-and-white photography to help her develop new designs, she enrolled in Adams's 1961 Yosemite workshop to improve her skills, but over the course of the workshop, Adams realized that the images she was framing on the ground glass of her 4 × 5–inch view camera were so subtle that they would not register well in black-and-white. To overcome Cosindas's sensitivity to color, he gave her a special filter that reduced what she saw through her viewfinder to monotones.[120] Adams was also a consultant to Polaroid Corporation, and the following year recommended Cosindas in response to the company's request for recommendations of photographers to test a new color version of their popular instant-development black-and-white film. Cosindas quickly realized that through careful filtration and extended exposure and development she could stretch the palette of the film beyond its obvious limits. When she showed her still-lifes and portraits of friends to others, they stood amazed at the jewel-like immediacy of the photographs and word spread quickly that she had achieved something remarkable. Soon, Edwin Land, the inventor-president of Polaroid Corporation, asked to see her prints and refused to let them go until he could share them with his color technicians. In 1965, at the urging of MoMA curator Grace Mayer, Cosindas showed a selection of her Polacolor prints to John Szarkowski. Szarkowski initially told her that her photographs looked like paintings. Six months later, after further reflection, he told her that he was giving her a show.[121]

Szarkowski had good reason to take notice of Cosindas's work. Not only was Edwin Land's new instant color film a technical marvel that delivered far more subtle hues than any other process, Cosindas was a master of the process, sometimes working for hours adjusting filters and exposure to achieve just the right quality of light and color. If photographers were seeking verisimilitude, this was about as close

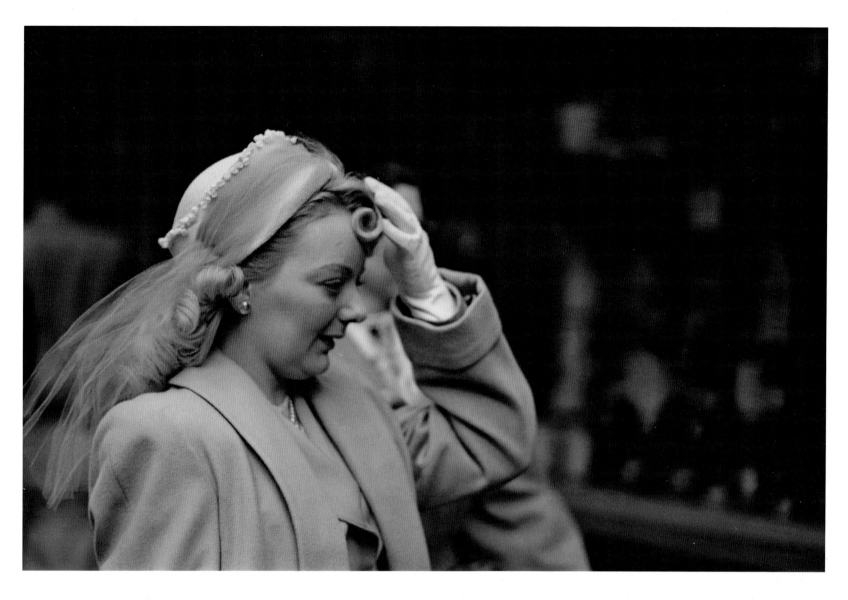

as one could get. But her images were more than that too. Although tiny by today's standards, measuring only 4 × 5 inches, her prints radiate detail and atmosphere. Her 1965 image *Floral with Painting*, with its array of vases filled with delicate yellow and white flowers set against the base of one of her colorful abstract paintings, blends all facets of her persona (Plate 2.18). It is as much a stage setting as one of Severin Roesen's grand flower paintings. Baroque in its luxury, it conveys a softly lit, delicate balance between color, form, and texture that drives one to peruse every minuscule detail for its realism and clarity.[122]

Cosindas and Porter understood the immediacy that finely tuned naturalistic color brought to photography. They also both recognized naturalistic color as a shaped vision; that slight changes in hue made the difference between success and failure, and they understood how atmosphere is filled with color, often almost imperceptible, but filled with hue nonetheless.

Moholy-Nagy's vision for color was far from dead. By 1967, the year that all the major television networks shifted entirely to color broadcasting, Henry Holmes Smith, who was still teaching at Indiana University, was finding new acceptance for his

experiments in color among a new generation of students less tied to the sharp-focus strictures of photographic modernism. Pop Art, with its aggressive embrace and manipulation of the photographic image, was certainly an influence. So was conceptual art, with its intent to tease out and critique the underpinnings of artistic illusion. Process was preeminent and the folding of one medium into another accepted, especially, the blend of photography with printmaking. Richard Avedon's psychedelic portrait of John Lennon on the January 1968 cover of *Look* magazine, and his similar portraits of the other three Beatles inside was only one manifestation of the energy pervading this trend (Figure 2.26). While Porter's photographs helped ignite the environmental movement, Avedon's portraits symbolized the rise of a younger generation that felt free to question established mores and establish its own freewheeling terms. To reflect this topsy-turvy atmosphere, the artist and his assistants had solarized each head shot and freely printed them in the false colors of mixed matrices, much like Jeannette Klute's and Dorothea Patterson's derivations of fifteen years earlier. What was decorative in those earlier works had now become a political statement.

Szarkowski was not yet ready to accept color photography. He could not find work that embraced the same urban and vernacular subjects and intellectualized self-consciousness about photographic sight that provided the foundations for his favorite photographers working in black-and-white. Conceptual artist Dan Graham challenged that view with his *Homes for America* project.[123] First presented in

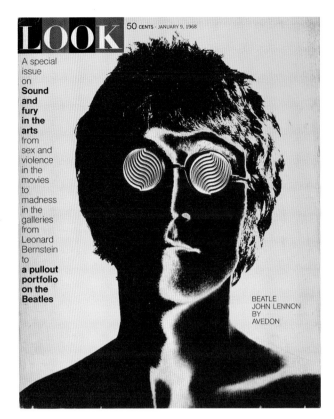

1966 as a slide show, and as what the artist called a "fake think piece" on the prefabricated mundanity of postwar suburban developments, it pointed out how slight changes in design and color allow one to distinguish between mass-produced objects that are essentially the same (Plate 2.19).[124] If photographers were going to truly critique contemporary life, they needed to address these kinds of subtleties, and do so in color. ◆

1. Edward Steichen, "Museum's First Exhibition of All Color Photography to Be on View May 10 Through June 25," 1950, typescript of press release, Exhibition Files, Department of Photographs, the Museum of Modern Art, New York.

2. Beaumont Newhall, *Photography, 1839–1937* (New York: The Museum of Modern Art, 1937), 84. The book would become the standard outline for photography's history well into the 1970s.

3. Ibid., 85.

4. The book opened with a new preface wherein Newhall announced his explicit intention: "The purpose of this book is to construct a foundation by which the significance of photography as an esthetic medium can be more fully grasped." Beaumont Newhall, *Photography: A Short Critical History* (New York: The Museum of Modern Art, 1938), 9. Newhall trumpeted Stieglitz even though the master photographer and influential promoter of American art had refused to cooperate with his original project, probably because he did not control it himself.

5. Lázló Moholy-Nagy, "Paths to the Unleashed Colour Camera," *The Penrose Annual* 39 (1937): 25–28. The article was reprinted the following year in *Printing Art Quarterly* 67, no. 3 (1938).

6. The film companies recognized this limitation and ran advertisements heralding their films' particular color qualities. Complicating the advocacy of verisimilitude was everyone's recognition that each brand of color film had its own syntax, recording some colors with great acuity while being off on others. Kodak openly celebrated Kodachrome's overtly saturated hues, but after World War II the company's main competitors, Dufaycolor and Ansco, tried to obscure the fact, suggesting that their films offered "natural color" or "high-fidelity." See advertisements: "Color Goes Candid with Dufaycolor," *Minicam: The Miniature Camera Monthly* 1, no. 1 (September 1937); and "It's High-fidelity Color—It's Ansco!," *Minicam Photography* 10, no. 9 (June 1947): 103. Ansco also ran advertisements trumpeting that its Ansco Color film delivered "living color." See Ansco Color advertisement in Tom Maloney, ed., *U.S. Camera 1946: Victory Volume* (New York: U.S. Camera Publishers, 1945), 387.

7. Moholy-Nagy's words would be mirrored by art critic Frank Crowninshield's review of the 1939 First International Photographic Exposition at Grand Central Palace in New York. Crowninshield complained that Paul Outerbridge's color photographs of fruits and vegetables were too realistic, lacking the aura of Cézanne's paintings of fruit.

8. See László Moholy-Nagy, *The New Vision: From Material to Architecture* (New York: Brewer, Warren & Putnam, Inc., 1932); and László Moholy-Nagy, *Vision in Motion* (Chicago: Paul Theobald, 1947). He brought with him to Chicago fellow Hungarian Gyorgy Kepes, and charged Kepes with heading the school's curricular area called Light and Color. The New Bauhaus closed after one year when it lost financial backing, reopened in 1939 as the School of Design, and today is the Institute of Design, Illinois Institute of Technology.

9. László Moholy-Nagy, "Make a Light Modulator," in *Moholy-Nagy: An Anthology*, ed. Richard Kostelanetz, 103 (New York: Da Capo Press, Inc., 1991).

10. Film manifacturers' focus on amateurs was matched by *Popular Photography* and *Minicam*, which had started up in response to the introduction of consumer-level 35mm cameras. In these titles, hobbyists and low-end professionals were encouraged to take up color and were given instruction on how to compose their photographs and make prints, though magazines quickly learned to warn photographers not to use red or blue backgrounds because of the way they reflected color into other areas of the picture. Unidentified author, "Lighting for Color Shots," *Popular Photography* 1, no. 1 (1937): 32. Further assistance came in the form of instruction books like Victor Keppler's *The Eighth Art: A Life in Color Photography* (New York: William Morrow & Company, 1938); and Ivan Dmitri's *Color in Photography* (Chicago: Ziff-Davis Publishing Company, 1939). To better meet the needs of professional photographers, in September 1938 Kodak introduced a variety of new roll-film sizes and color sheet film up to 11 × 14 inches.

11. Ansel Adams to Alfred Stieglitz, November 12, 1937. Harry M. Callahan, ed., *Ansel Adams in Color* (New York: Little, Brown and Company, 1993), 117. Adams was the first new photographer that Stieglitz had publicly recognized since Paul Strand in 1915. Adams had tried making Autochromes in September 1921, documenting his parents' dahlia garden in San Francisco, but had not continued with the process.

12. Swank had exhibited at various galleries and museums in New York City by this date.

13. Steichen used the Kodachrome in a new Contax camera given to him as a retirement gift from the lensmaker Zeiss.

14. Henry Holmes Smith, "On Color Photography," typescript dated September 26, 1937, Henry Holmes Smith Papers, Center for Creative Photography, University of Arizona, Tucson, AG32:2/60.

15. Smith discusses his recognition that he and Moholy-Nagy were independently on the same track of color, and details the history of his initial contacts with the Hungarian. Henry Holmes Smith, "On Color Photography—A Brief Memoir," *exposure* 12, no. 3 (September 1974): 4–5.

16. A perfect example of the stilted realism presented by color photographic portraiture of the period is Harry Warnecke's celebrity portraits owned by the National Portrait Gallery in Washington DC. See Neil Genzlinger, "Adding a Colorful Gloss To a Black-and-White World," *The New York Times* 161, no. 55,710 (March 14, 2012): section C, 1, col. 5.

17. William Mortensen, "Color in Photography," *Camera Craft* 45, no. 5 (May 1938): 200–207; William Mortensen, "Color in Photography, Part II," *Camera Craft* 45, no. 6 (June 1938): 250–257; William Mortensen, "Color in Photography, Part III," *Camera Craft* 45, no. 7 (July 1938): 300–307; and William Mortensen, "Color in Photography, Part IV, Some Ideas on Composition in Color," *Camera Craft* 45, no. 9 (September 1938): 398–406. The series may have been a response to the burgeoning of shows like the Art Institute of Chicago's April 1938 exhibition of color photographic prints created by staff of the *Chicago Tribune*. See James O'Donnell Bennett, "Art Institute Shows Tribune Color Photos," *Chicago Daily Tribune* (April 21, 1938): 1–2.

18. Mortensen, "Color in Photography, Part II," 252, 254.

19. Mortensen, "Color in Photography, Part III," 302–304.

20. Helen A. Harrison, *Dawn of a New Day: The New York World's Fair, 1939/40* (Flushing, NY: Queens Museum, 1980).

21. Kodak asked John Collins to design the Cavalcade of Color. "Cavalcade of Color, 1940," *U.S. Camera Magazine* 1, no. 10 (June–July 1940): 36–37.

22. The Kodachromes are split between the collections of the Farm Security Administration and Office of War Information. Not being prints, these color images became a forgotten part of the archive until Sally Stein rediscovered them in 1978. Sally Stein, "FSA Color: The Forgotten Document," *Modern Photography* 43, no. 1 (January 1979); and Paul Hendrickson, *Bound for Glory: America in Color, 1939–1943* (New York: Harry N. Abrams, Inc. in association with the Library of Congress, 2004).

23. *LIFE* magazine published its first color cover, a portrait of Major General George S. Patton Jr. by Eliot Elisofon, on July 7, 1941.

24. The author encountered this reaction repeatedly when the Amon Carter Museum presented an exhibition of these photographs in Fall 2008.

25. Paul Outerbridge, "Color," *U.S. Camera* 1, no. 10 (June–July 1940): 76.

26. Kodachrome's attendant Eastman Wash-Off Relief printing process had by this date cut seriously into Outerbridge's commercial business by making his trademark tricolor carbro prints obsolete even as he was publishing an expensive manual celebrating color and that process as the culmination of color technology, *Photographing in Color* (New York: Random House, 1940). By 1942, even as MoMA accepted a donation of two of Outerbridge's color photographs and the Cleveland Museum of Art accepted six more, demand for his services was drying up. Paul Martineau, *Paul Outerbridge: Command Performance* (Los Angeles: J. Paul Getty Museum, 2009): 17.

27. Like Newhall's historical survey three years earlier, the Newark show took an all-inclusive approach. Sections describing the principles of color and a historical summary of the medium's technical development led to a mixture of fashion, advertising, corporate work, and overtly artistic work. Outerbridge called the show thorough. He celebrated the ideal of meticulously staged verisimilitude: "In black and white you suggest; in color you state. . . . Happy accidents do not occur in color." Outerbridge, *Photographing in Color*, xi.

28. T. J. Maloney, ed., *A Pageant of Photography* (San Francisco: San Francisco Bay Exposition Co., 1940). Adams wrote the introduction, while Newhall provided a text titled "Photography as an Art."

29. Adams celebrated Clarence Kennedy's mechanism for showing enlarged stereo transparencies, remarking on the impressive realism of these images.

30. Ibid.

31. Nancy Newhall, "Painter or Color Photographer?," *U.S. Camera* 1, no. 14 (Spring 1941): 42. Newhall may also have been prompted to write her article in response to commercial photographer Ivan Dmitri's new book celebrating saccharine commercial imagery, *Kodachrome and How to Use It* (New York: Simon and Schuster, 1940).

32. Newhall singled out the work of Ivan Dmitri, Paul Outerbridge, the fashion pages of *Vogue*, and most advertising photographs for castigation.

33. Newhall, "Painter or Color Photographer?," 42.

34. Alfred Stieglitz, *Eliot Porter—Exhibition of Photographs, An American Place, December 19, 1938–January 18, 1939* (New York: Alfred Stieglitz, 1938).

35. Alfred Stieglitz to Eliot Porter, January 21, 1939, Eliot Porter Papers, Box 17, Scrapbook XIV-18, Amon Carter Museum of American Art, Fort Worth, TX. The show had induced Porter to quit a promising career as a biomedical researcher at Harvard to devote himself full-time to his photography.

36. With her husband off to war, Nancy had taken over as acting curator at MoMA. When the artist could not make it to the opening, Newhall wrote him of his colleagues' acclaim for the works. Nancy Newhall to Eliot Porter, March 11, 1943; and Nancy Newhall to Eliot Porter, April 9, 1943, Eliot Porter Papers, Box 64, Museum of Modern Art File, 1942–1950, Amon Carter Museum of American Art, Fort Worth, TX.

37. Sally Stein details Callahan's color photography. Sally Stein and Terence R. Pitts, *Harry Callahan: Photographs in Color / The Years 1946–1978* (Tucson: Center for Creative Photography, University of Arizona, 1980), 7.

38. Ibid., 35, n. 36.

39. To invent Dye Transfer, Kodak hired Louis M. Condax, who had been making successful dye imbibition prints since 1938. Condax introduced a tanning developer system and developed a new set of faster transferring dyes. Phillip Condax, interview with author, Rochester, NY, July 2010, Curatorial Research Files, Amon Carter Museum of American Art, Fort Worth, TX. In 1947, Kodak introduced Ektachrome color transparency film, which could be processed by photographers at home.

40. Blumenfeld had encountered a Kodak publication with Kodak employee John F. Collins's color images in 1939 and credited it with "making a devastating impression on him." Marty Carey, *John F. Collins: Master Photographer* (New York: Photofind Gallery, 1987), 5.

41. The war cut short domestic uses of color photography, including Eliot Porter's Guggenheim project to photograph birds in black-and-white and color. Historian Pamela Roberts remarks that much of the war was photographed in color by all of the combatant countries, delivering a disturbing sense of immediacy. Robert Capa was one of those photographers. He carried two cameras, one with black-and-white film and the other with color film. Pamela Roberts, *A Century of Colour Photography: From the Autochrome to the Digital Age* (London: André Deutsch, 2007), 123. *U.S. Camera 1949* presented a section of color photographs showing the aftermath of the atomic bombings of Hiroshima and Nagasaki. Tom Maloney, ed., *U.S. Camera 1949* (New York: U.S. Camera Publishing Corp., 1948), 207–208.

42. The January 1946 issue of *Fortune* magazine presented the first of what would become many articles illustrated with color photographs by Walker Evans. Milanowski reports that between 1946 and 1950 almost one-third of Walker Evans's *Fortune* magazine articles were in color, and over the next fifteen years, half of Evans's *Fortune* articles were in color. Stephen R. Milanowski, "The Biases Against Color in Photography," *exposure* 23, no. 2 (Summer 1985), 13.

43. George L. Waters, head of Kodak's advertising department, made the arrangements. Carol McCusker, "An Eruption of Color: The History of Color Photography from WWII to the Dawn of Digital," *Color Magazine* no. 2 (July 2009): 30.

44. Kodak paid him $1,750 in return. For Weston's response to the film see McCusker, "Eruption of Color," 31.

45. "Edward Weston's First Serious Work in Color," *Minicam Photography* 10, no. 8 (May 1947): 51–53.

46. Ibid., 53.

47. Callahan, *Ansel Adams*, 141. He also was providing color images to *Arizona Highways* magazine. For a reproduction of Adams's color photograph *Monument Valley*, see Raymond Carlson, "Photography Sells Arizona," *Minicam Photography* (June 1947): 17.

48. Callahan, *Ansel Adams*, 140. Kodak was not the only company to ask Adams to use color film. Already, he was taking on what would be a steady stream of projects in color for Standard Oil, *Fortune* magazine, and other companies. Adams lists some of this commercial work in a September 22, 1946, letter to Beaumont and Nancy Newhall. Ibid., 141.

49. Dye imbibition prints of color photographs by Strand can be found at MoMA and the Philadelphia Museum of Art. See also Manfred Heiting, *50 Jahre Moderne Farbfotografie 1936–1986 (50 Years Modern Color Photography 1936–1986)* (Cologne, Germany: Messe- und Ausstellungs- Ges.m.b.H., 1986).

50. The checklist for the MoMA exhibition, *All Color Photography*, lists a transparency by Sheeler. Exhibition Files, Department of Photographs, the Museum of Modern Art, New York.

51. Moholy-Nagy, *Vision in Motion*, 170.

52. Ibid., 172–174.

53. Henry Holmes Smith, "Light Study: Notes on a Method Related to the Study, January 2, 1947," typescript of an illustrated lecture at Illinois Wesleyan University on January 7, 1947, Henry Holmes Smith Papers, Center for Creative Photography, University of Arizona, Tucson, AG32:11/26. See also letter from Henry Holmes Smith to Nathan Lerner, May 26, 1947,

Henry Holmes Smith Papers, Center for Creative Photography, University of Arizona, Tucson, AG32:7/21.

54. Laughlin's color photographic drawings are housed at the Historic New Orleans Collection. My thanks to John Lawrence for pointing them out.

55. A number of Smith's late 1940s students, including Joe Blakeslee and Jack Welpott, became captivated by these color experiments and continued them on their own.

56. In 1961, Smith wrote a critique of Newhall's *History of Photography*, which had become the standard outline for the history of the medium, ridiculing Newhall's assertion that Moholy-Nagy had been motivated by a desire to imitate painting, and suggesting that Newhall understood photography only in its most conventional terms. Henry Holmes Smith, "Some Thoughts on Newhall's *History of Photography*," typescript, February 12, 1961, Henry Holmes Smith Papers, Center for Creative Photography, University of Arizona, Tucson, AG32:11/51.

57. Edward Steichen, *In and Out of Focus*, press release and typescript of wall label, Exhibition Files, Department of Photographs, the Museum of Modern Art, New York. Steichen's conception of Weston's and Adams's work meshed perfectly with Kodak's goal to produce colors that reflected the world as closely as possible. Ralph M. Evans, *An Introduction to Color* (New York: John Wiley and Sons, Inc., 1948), v. Adams's transparencies included views of Yosemite and Ranchos de Taos church. Weston's work included images from Point Lobos. In 1948, the National Geographic Society, with permission from Eastman Kodak Company, chose an area near Bryce Canyon National Park in Utah and named it Kodachrome Basin State Park.

58. *The New York Times* photography critic Jacob Deschin agreed, wondering aloud whether Fitzsimmons's ideas might not have been better accomplished on a painter's easel. Jacob Deschin, "'In and Out of Focus': Show at Modern Museum Covers Wide Field," *The New York Times* 97, no. 32,950 (April 11, 1948): section X, 13, col. 1–3; and Stein and Pitts, *Harry Callahan*, 14. Steichen was not immune to experimentation himself. In January 1940, he had printed a series of deliberately false color images of a vase of flowers, but he seems to have kept these experiments to himself. The prints are in the collection of the George Eastman House, International Museum of Photography and Film.

59. Milton W. Brown, "Badly Out of Focus," *Photo Notes* (June 1948): 5–6. Unperturbed, Weston proudly showed off his color photographs to visitors and allowed his color photographs to grace the covers of *American Photography*. See *American Photography* 44, no. 2 (February 1950): cover; and *American Photography* 44, no. 3 (March 1950): cover.

60. Ansel Adams, "Some Thoughts on Color Photography," *Photo Notes* (Spring 1949): 10.

61. Ibid., 11.

62. Ansel Adams, "Some Thoughts on Color Photography," *Photo Notes* (Spring 1950): 14. Eastman Kodak Company initially promoted Kodachrome with advertisements that pointed out the film's high-key reds.

63. Rather than locate the solution in better prints or magazine reproductions, Adams now decided that the future of color photography lay in carefully planned slide-show sequences accompanied by music or commentary. Adams, "Some Thoughts," *Photo Notes* (Spring 1950): 15. Still, on January 18, 1950, Adams asked Paul Brooks, editor at Houghton Mifflin Company, about the commercial viability of a book made up primarily of his color photographs of the National Parks with a text by Bernard De Voto, though he made a point in his letter to Brooks of stating: "It will be a *popular* book and in no way conflict with the MY CAMERA series." Callahan, *Ansel Adams*, 142. That September, he provided color photographs to illustrate the LIFE magazine article "Mockingbird Flower: U.S. Breeders Glamorize Once Homely Begonia," LIFE 29, no. 12 (September 18, 1950): 97–103.

64. Newhall had become curator at the newly established photography museum George Eastman House in Rochester, New York. Beaumont Newhall, *The History of Photography: From 1839 to the Present Day* (New York: The Museum of Modern Art, 1949).

65. Steichen, "Museum's First Exhibition," 2.

66. *All Color Photography* ran from May 10–June 25, 1950. See Eugene Ostroff, ed., *Pioneers of Photography: Their Achievements in Science and Technology* (Springfield, VA: The Society for Imaging Science and Technology, 1987), 205. For technology buffs, the display included a historical section and examples of key transparency and print processes.

67. Kodak started promoting the idea of deliberately crossing up the colors when printing in Dye Transfer (using the magenta matrix to print the yellow information, for example) in spring 1950, calling the results "derivations" to distinguish them from straightforward photographs. The idea was not exactly new (Steichen had experimented with the idea years earlier), but it so intrigued Beaumont Newhall that he immediately assembled and traveled a forty-two print "derivations" exhibition around the country. "EK

Creates Art with Color," *Kodakery* 8, no. 18 (May 4, 1950): 1, 4; "New Technique for Color Photos Shown in Exhibit," *Rochester Democrat and Chronicle* (May 10, 1950); Exhibition Files, George Eastman House International Museum of Photography and Film, Rochester, NY. In 1950 and 1956, Adams would ask Kodak to reinterpret a number of his color photographs as "derivations." One of these prints, a close-up of leaves, is in the collection of the Center for Creative Photography.

68. See installation photographs for *All Color Photography*. Exhibition Files, the Museum of Modern Art, New York.

69. *All Color Photography*, typescript of introductory label, Exhibition Files, the Museum of Modern Art, New York.

70. Steichen, "Museum's First Exhibition," 2.

71. *All Color Photography*, typescript.

72. Deschin singled out the "derivations" as a key feature. Jacob Deschin, "Pictures in Color: Modern Museum Shows Contemporary Work," *The New York Times* 99, no. 33,317 (May 14, 1950): section X, 13, col. 2–4.

73. Arthur Siegel, "Modern Art by a Photographer: With a Camera for a Palette, Arthur Siegel Rivals the Work of Contemporary Painters," *LIFE* 29, no. 21 (November 20, 1950): 78–84.

74. Ibid., 79. Siegel created the water studies by photographing the surface of a swimming pool while on assignment for International Harvester.

75. Ibid., 79–84.

76. Jacob Deschin, "New World of Color: Experiments Show Subtle Values Seldom Seen," *The New York Times* 99, no. 33, 825 (September 3, 1950): section X, 9, col. 2–4.

77. Brochure for the exhibition, *Arthur Siegel*, September 15–November 1, 1954, Typescript, Artist Files, Photography Study Center, Art Institute of Chicago. The exhibition was not a good experience for the artist. He had arranged for a local lab to make the Dye Transfer prints for the show, but the costs were so high that it took him years to finish paying the bill. From then on, he generally presented his work in the format of slide lectures. John Grimes, *Arthur Siegel: Retrospective* (Chicago: Edwynn Houk Gallery, 1982). It did not help matters that Art Institute of Chicago photography curator Peter Pollock did little to promote the show.

78. Leiter had started out as a painter who had embraced Abstract Expressionism, Japanese prints, and the styles of Pierre Bonnard and Edouard Vuillard. Unable to make his own prints, and too poor to afford commercial lab printing, he showed his slides to friends but otherwise did not promote them until recently.

79. Alexander Liberman, ed., *The Art and Technique of Color Photography* (New York: Simon and Schuster, 1951).

80. Ibid., x–xi.

81. Ibid., xiv.

82. Ibid., xv.

83. In December 1949, Bruce Downes heralded the Condé Nast photographers' penchant for "deliberately exploiting the defects of the color process." Bruce Downes, "Let's Talk Photography," *Popular Photography* 25, no. 6 (December 1949): 46. Equally problematic to Kertész was the issue of photography's relationship to painting. At least black-and-white photography stood separate from painting, driven by its own terms. With color, he declared, one cannot help but think in terms of thousands of years of great painting, a comparison that did not work to photography's benefit. Liberman, *Art and Technique*, 44.

84. This was the period that color became an integral factor in automobile design. Roberts mentions the contrast between the glowing saturated colors of American consumerism and the restrained color infusing postwar Britain. Roberts, *Century of Colour*, 116–117.

85. Kodak presented 256 Coloramas at Grand Central Station from May 1950 until they permanently closed the display in 1990. Alison Nordström and Peggy Roalf, *Colorama: The World's Largest Photographs, from Kodak and the George Eastman House Collection* (New York: Aperture Foundation, 2004), 5.

86. Edward Weston, "Color as Form," *Popular Photography* 33, no. 6 (December 1953).

87. The bomb image came close to the end of the show, bringing cautionary reminder of humanity's destructive capacity. Always the optimist, though, Steichen ended the show with upbeat images of children. Around this same time, Steichen took up a four-year project photographing a shadblow tree on his Connecticut farm in color.

88. "Color," *Popular Photography* 36, no. 5 (May 1955): 71; "Color Photography Today: A Symposium," *Popular Photography Annual 1955* (1954): 144–170, 235–236; "Symposium on Color," *U.S. Camera* 18, no. 5 (May 1955): 58–63, 98–99; and "Symposium on Color," *U.S. Camera* 18, no. 6 (June 1955): 85–91, 108–109.

89. "How Creative Is Color Photography?" *Popular Photography Color Annual 1957* (1956): 12–25, 169–170.

90. Ibid., 14.

91. Ibid., 169.

92. Byron Dobell, "Ernst Haas: Master of Color," *Popular Photography Color Annual* 1957 (1956): 27–29.

93. Ernst Haas, "Images of a Magic City: Austrian Photographer Finds Fresh Wonder in New York's Familiar Sights," LIFE 35, no. 11 (September 14, 1953): 108–120; and Ernst Haas, "Images of a Magic City: Part II," LIFE 35, no. 12 (September 21, 1953): 116–126. Haas had started photographing in color just the year before. Philip Prodger discusses the two articles in William A. Ewing, *Ernst Haas: Color Correction* (Göttingen, Germany: Steidl, 2011).

94. Haas used Kodachrome with a speed of ASA25 to make his bullfight photographs. Ernst Haas, "Beauty in a Brutal Art: Great Cameraman Shows Bullfight's 'Perfect Flow of Motion,'" LIFE 43, no. 5 (July 29, 1957): 56–65.

95. Ernst Haas, "Haas on Color Photography," *Popular Photography Color Annual 1957*, quoted in Davis, *American Century*, 304. Haas was also making color photographs beyond his magazine commissions through this period. William Ewing has reviewed this unprinted work and offers a selection. See Ewing, *Ernst Haas: Color Correction*.

96. Ansel Adams, "Color Photography as a Creative Medium," *Image: Journal of Photography and Motion Pictures of the International Museum of Photography at George Eastman House* 6, no. 9 (November 1957): 212, 217. Ironically, Adams illustrated this article with his own realistic color photographs. He excepted Clarence Kennedy's color stereographs of Renaissance sculpture and painting from this decree, but based this exception on the beauty of Kennedy's subjects. He suggested that if one departed from reality in color, one needed to do it so dramatically that stylization dominates, and concluded that those color photographs that worked best were those with subjects offering muted color.

97. Ernst Haas, *The Creation* (New York: The Viking Press, Inc., 1971).

98. See Eliot Elisofon, *Color Photography* (New York: The Viking Press, 1961); and Roy Flukinger, *"To Help the World to See": An Eliot Elisofon Retrospective* (Austin: Harry Ranson Humanities Research Center, 2000).

99. Walker Evans, "Test Exposures," *Fortune*, July 1954, 80.

100. See Walker Evans "Before They Disappear," *Fortune*, March 1957, 141–146; Lesley K. Baier, *Walker Evans at Fortune 1945-1965* (Wellesley, MA: Wellesley College Museum, 1977); William Earle Williams, *Walker Evans in Color: Railroad Photographs* (Haverford, PA: Haverford College, 2011).

101. Walker Evans, "Color Accidents," *Architectural Forum: The Magazine of Building* (January 1958), 110–115.

102. See John P. Jacob, ed., *Inge Morath: First Color* (Göttingen, Germany: Steidl, 2009).

103. See Miles Barth, *Master Photographs from 'Photography in the Fine Arts' Exhibitions, 1959-1967* (New York: International Center of Photography, 1988).

104. Peter Turner generously shared this information with the author along with his story about how he came to make *Dyer's Hand*. Email, September 4, 2012. Curatorial Research Files, Amon Carter Museum of American Art, Fort Worth, TX.

105. See Barbara Bullock-Wilson, ed., *Wynn Bullock: Color Light Abstractions* (Carmel, CA: Bullock Family Photography LLC, 2010).

106. Bullock marked one print at the de Saisset Museum at Santa Clara University with an arrow to guide orientation and later crossed the arrow out and turned the image upside-down to meet his new preferred preference.

107. Wynn Bullock to John Gutmann, April 31, 1960, typescript photocopy of letter in Wynn Bullock Archive, Barbara and Gene Bullock-Wilson Collection.

108. Porter took full advantage of the allowance that the dye imbibition process provided to make fine adjustments not only to print contrast, but to the exact renditions of specific colors across the image. He differentiated his work from the billions of snapshots made each year across the United States by Eliot Porter, "The Rare Photograph," *U.S. Camera* 19, no. 11 (November 1956): 69.

109. Eliot Porter to Jonathan Porter, October 12, 1958, Eliot Porter Archives, Amon Carter Museum of American Art, Fort Worth, TX.

110. Jorge Fick, interview with the author, February 22–23, 1994, Curatorial Research Files, Amon Carter Museum of American Art, Fort Worth, TX.

111. Fairfield Porter to Eliot Porter, December 10, 1959, typescript, Stephen Porter Papers, Private Collection. My thanks to Stephen Porter for sharing this letter.

112. Fairfield Porter, "The Immediacy of Experience," in *Art in Its Own Terms: Selected Criticism, 1935-1975*, 79–81 (Cambridge, MA: Zoland Books, 1993).

113. Despite having no money and only a California base, Brower committed to taking the book on even if it meant, he later explained, "tak[ing] up a life of crime

to get the funds for it." David Brower, foreword to *"In Wildness Is the Preservation of the World"* (San Francisco: The Sierra Club, 1962), 10.

114. Adams also declined to review *"In Wildness Is the Preservation of the World"* for *Artforum*, admitting: "I have never been able to adjust myself to color photography. I do not understand it. It would be false for me to attempt a review, because I simply would exhibit the fact I did not know what I was talking about." He then continued: "I basically, fundamentally don't like the lily-painting which IS color photography." Ansel Adams to John Irwin, December 13, 1962, Ansel Adams Archive, Center for Creative Photography, University of Arizona, Tucson.

115. The runaway success of *"In Wildness"* set Porter on a path of photographing and book making that would lead to five more Sierra Club publications and more than twenty volumes over the next twenty-five years with other publishers.

116. John Szarkowski, *The Face of Minnesota* (Minneapolis: University of Minnesota Press, 1958).

117. It also happened to be the year that Yale University Press published Josef Albers's *Interaction of Color* and Pantone developed its color-matching system for the graphic design industry. While the Pantone system systematized color, Albers's project offered a hands-on means for exploring how colors changed their character when set in proximity to each other, proving once and for all that reading color is not subjective, but rather relative and interactive. Josef Albers, *Interaction of Color* (New Haven, CT: Yale University Press, 1963).

118. Milanowski, "Biases Against Color," 5.

119. Cosindas traces her fascination and aptitude for color to growing up looking at the mosaics in her family's Greek Orthodox Church. Marie Cosindas, interview with the author, November 6, 2009, Curatorial Research Files, Amon Carter Museum of American Art, Fort Worth, TX.

120. Ibid.

121. The exhibition subsequently traveled to the Museum of Fine Arts, Boston, and the Art Institute of Chicago, helping Cosindas gain a Guggenheim Artist Fellowship in 1967.

122. If Szarkowski was of mixed mind about Cosindas's work, Walker Evans extolled her as "an artist of perfect taste . . . and of immense technical mastery." Walker Evans, "Photography," in *Quality: Its Image in the Arts*, ed. Louis Kronenberger (New York: Athenaeum, 1969).

123. See John Szarkowski, *The Photographer's Eye* (New York: The Museum of Modern Art, 1966).

124. The project reflected the blossoming of architectural attention to vernacular spaces, signaled by Robert Venturi's influential book. Robert Venturi, *Complexity and Contradiction in Architecture* (New York: The Museum of Modern Art in Association with the Graham Foundation for Advanced Studies in the Fine Arts, Chicago, 1966). It was first presented at Finch College Museum of Art in New York, but it gained a far wider audience when it appeared as a two-page spread in *Arts Magazine*. Dan Graham, "Homes for America," *Arts Magazine* 41, no. 3 (December 1966–January 1967): 21–22; see also Kirsten Swenson, "Be My Mirror: Dan Graham," *Art in America* 97, no. 5 (May 2009): 104–110.

PLATE 2.1

Jack Delano (1914–1997)

Chopping cotton on rented land near White Plains, Greene County, GA, June 1941. Kodachrome transparency, 35mm.

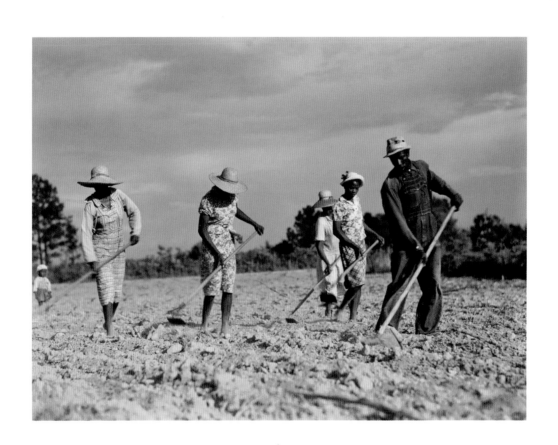

PLATE 2.2

Harry Callahan (1912–1999)

Detroit, ca. 1941. Dye imbibition print, 1980,
11 × 14 inches.

Arthur Siegel (1913–1978)

[Untitled, window reflection, Chicago], ca. 1950.
Dye imbibition print, 7⅛ × 10⁵⁄₁₆ inches.

PLATE 2.4

Anton Bruehl (1900–1982)

Harlem Number, at the Versailles Café, 1943.
Dye imbibition print, 13⅞ × 11 inches.

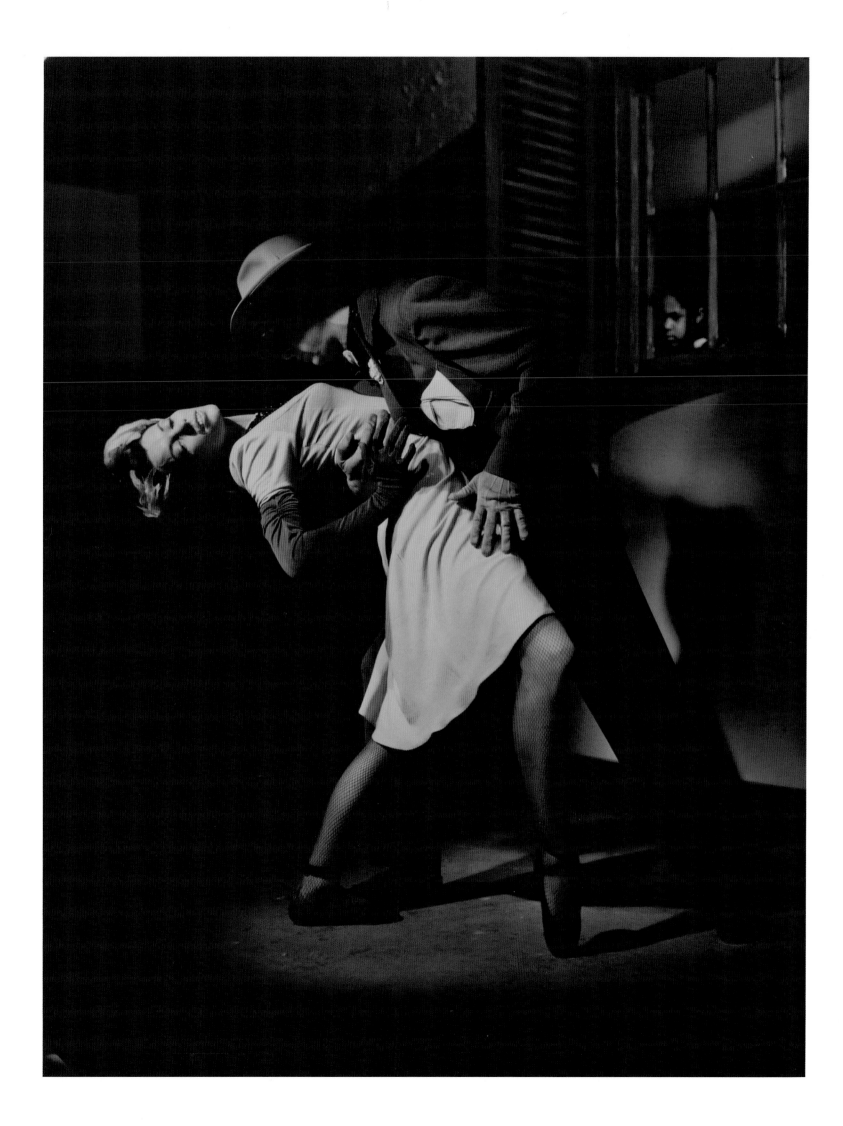

PLATE 2.5

Erwin Blumenfeld (1897–1969)

Red Cross, 1945. Inkjet print, 2009, 12 × 10 inches.

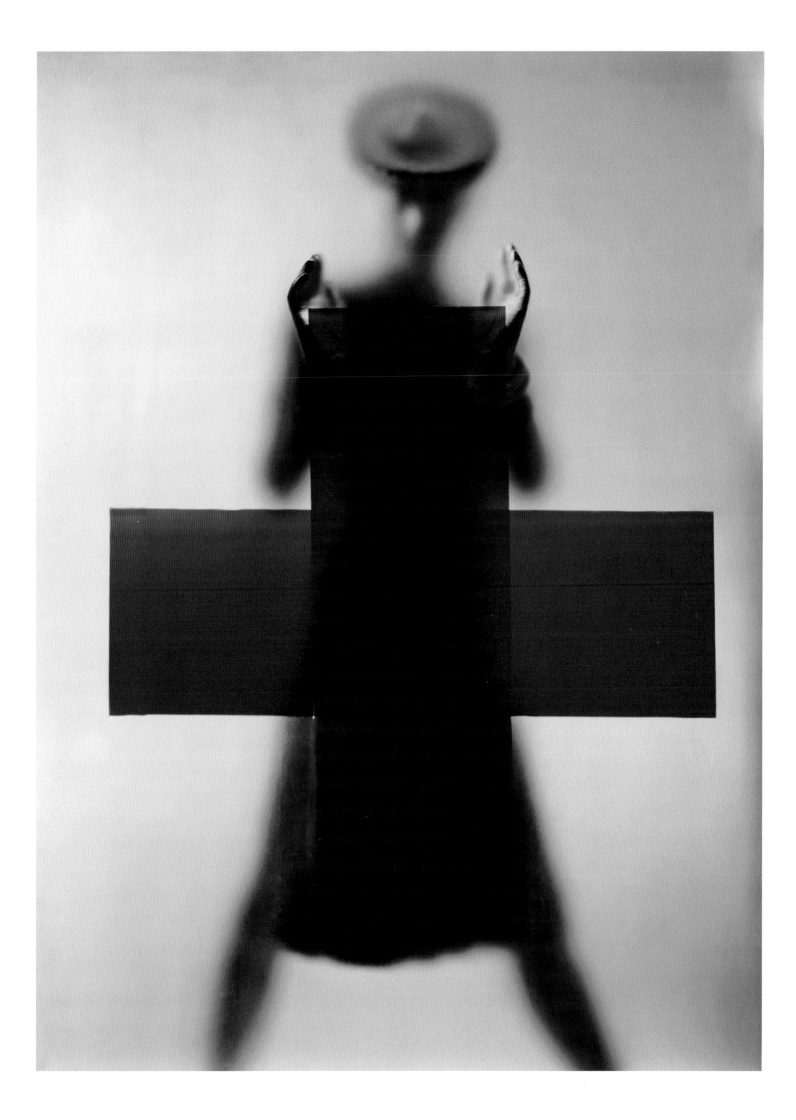

PLATE 2.6

Henry Holmes Smith (1909–1986)

Tricolor Collage on Black, 1946. Dye imbibition print over gelatin silver print, 9⁵⁄₁₆ × 7⁷⁄₁₆ inches.

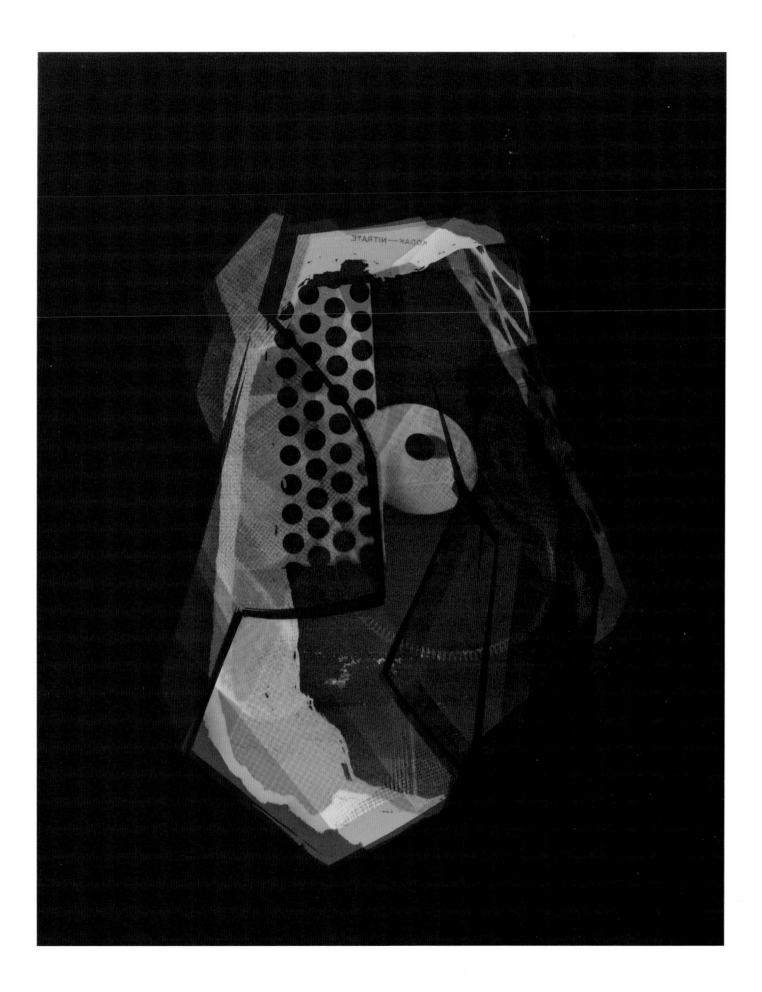

PLATE 2.7

Jeanette Klute (1918–2009)

Derivation—Plantain Lily, ca. 1950. Dye imbibition print, 12⅞ × 10⅛ inches.

PLATE 2.8

Ferenc Berko (1916–2000)

Monterey, California, 1954. Dye imbibition print,
9⅞ × 13⅞ inches.

PLATE 2.9

Saul Leiter (b. 1923)

Rain, ca. 1953. Silver dye-bleach print, ca. 1995,
13½ × 9 inches.

PLATE 2.10

Irving Penn (1917–2009)

After Dinner Games, New York, 1947. Dye imbibition print, 1985, 22 × 18 inches.

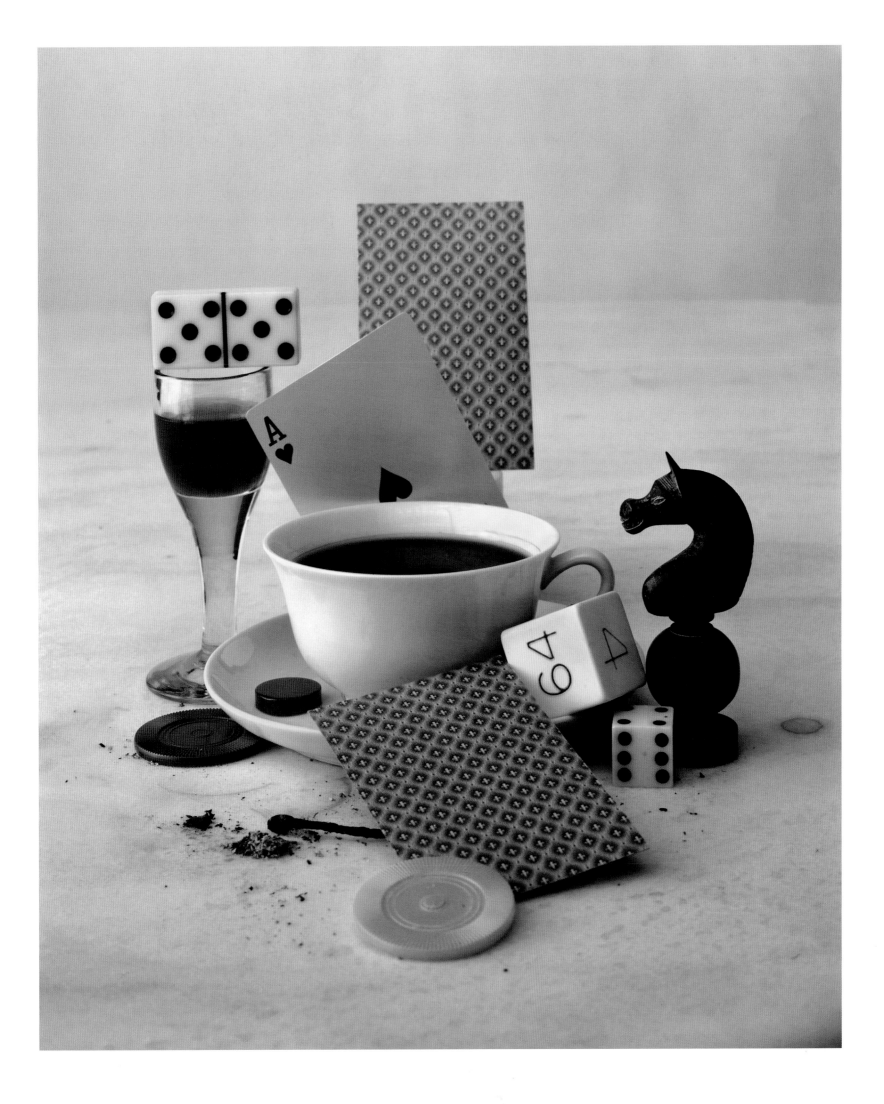

Ernst Haas (1921–1986)

Cowboy and Bronco, New York, 1958. Dye imbibition print, ca. 1962, 14^{11}⁄$_{16}$ × 22⅛ inches.

PLATE 2.12

Nickolas Muray (1892–1965)

Santa's Coffee, 1958. Dye imbibition print,
11 × 9 inches.

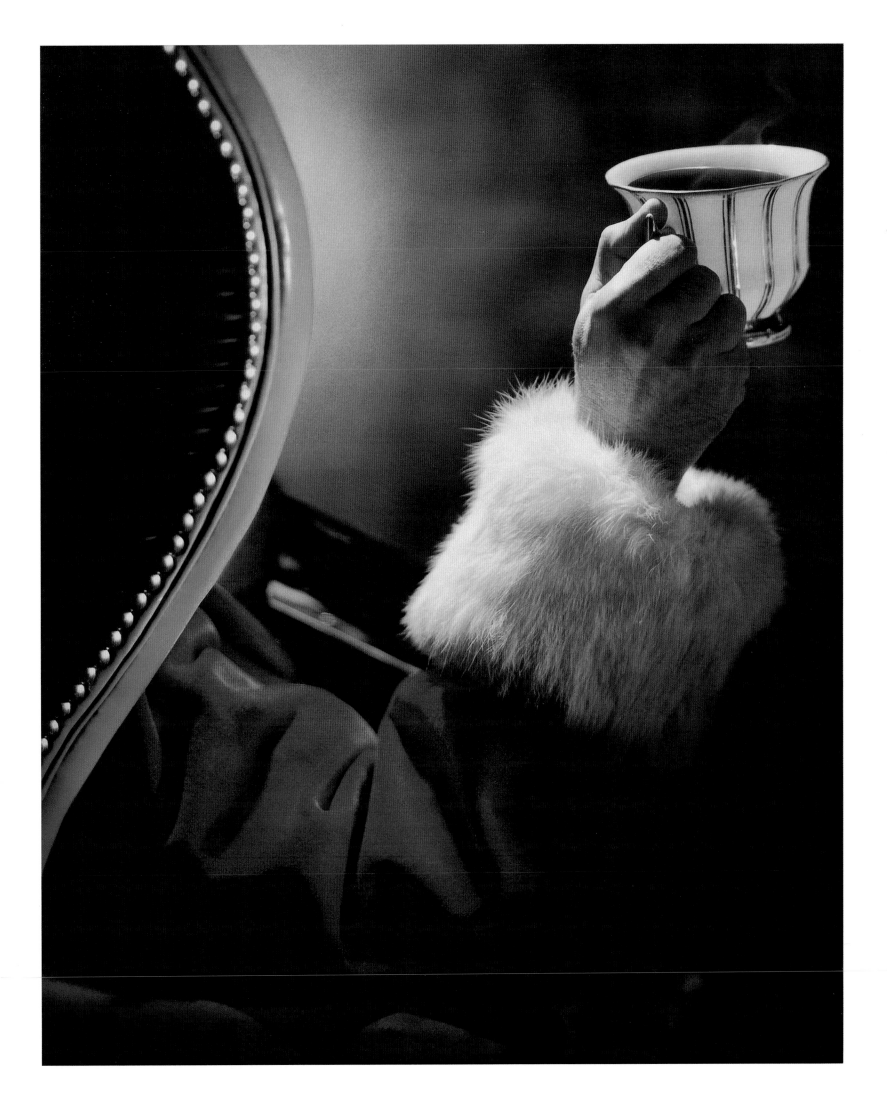

PLATE 2.13

Gordon Parks (1912–2006)

Crime Suspect with Gun, 1957. Dye coupler print, 2006, 19⅜ × 13⅜ inches.

PLATE 2.14

William Klein (b. 1928)

Antonia + Yellow Cab, Tuffeau & Bush, New York, 1962. Dye coupler print, 2012, 20 × 16 inches.

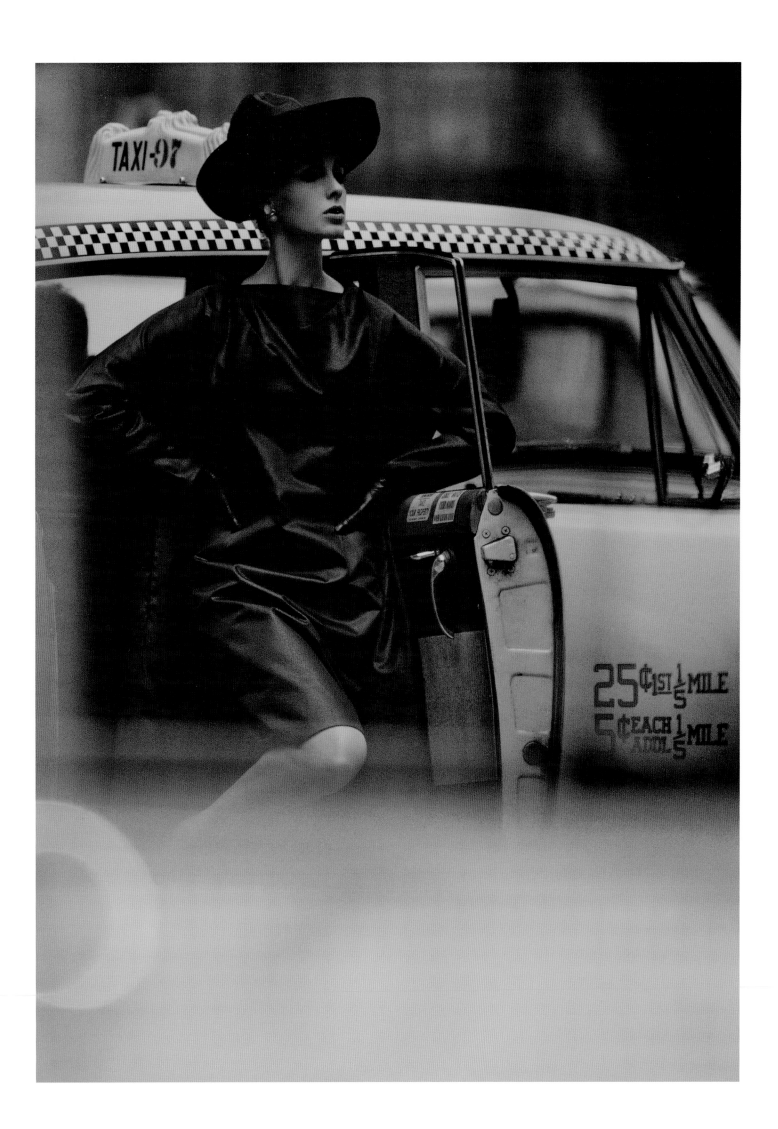

PLATE 2.15

Pete Turner (b. 1934)

Dyer's Hand, 1963. Dye imbibition print,
40 × 30 inches.

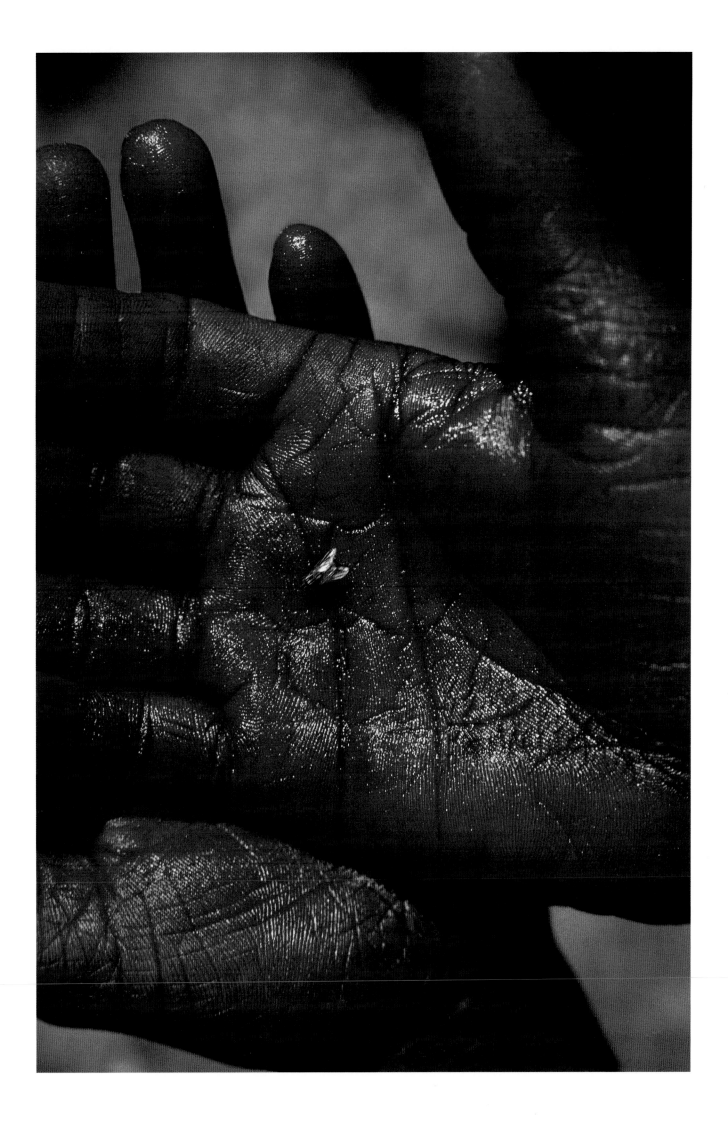

Wynn Bullock (1902–1975)

Color Light Abstraction 1185, 1964. Dye coupler print, 9¾ × 6¾ inches.

Eliot Porter (1901–1990)

Pond Brook, Whiteface Intervale, New Hampshire, October 5, 1956. Dye imbibition print, 8¼ × 10¾ inches.

Marie Cosindas (b. 1925)

Floral with Painting, 1965. Dye diffusion print (Polaroid), 4 × 5 inches.

Dan Graham (b. 1942)

Homes for America [Top: Family group in New Highway Restaurant, Jersey City, NJ; bottom: Trucks, New York City], 1966–1967. Two chromogenic prints mounted on board, top: 9$\frac{1}{16}$ × 13$\frac{3}{8}$ inches, bottom: 10$\frac{15}{16}$ × 13$\frac{3}{8}$ inches.

CHAPTER

Using Color, 1970–1990

Color is now one of the "hot" problems in this medium long dominated by black and white.

HILTON KRAMER, 1976[1]

BY 1970, TELEVISION, magazines, and movies had turned definitively to color, almost eighty percent of the photographs taken across the world each year were in color, and improved color photographic papers were allowing photographers to produce their own prints with almost the ease of black-and-white printing.[2] Within three short years, color would overtake black-and-white among people printing their own work.[3] Color photographs were also providing the foundation for a new style of painting called photo-realism. Yet while an increasing number of museums were buying and displaying photographs, color photography was not yet a substantive part of their programs. That fall, the New York Cultural Center presented an exhibition showcasing fifty-two photographers working in color. But the few critics who noted the show disparaged its contents as lacking artistic and intellectual heft.[4]

The New York Times photography critic A. D. Coleman summed up the situation in a column the following summer titled "I Have a Blind Spot About Color Photographs."[5] Ostensibly reviewing a photography exhibition made up largely of color works

at Lever House, he asserted: "Of all the color photographs I see—and that's a lot, if you include reproductions as well as original prints—very few achieve anything for me beyond a momentary gratification of the retinal synapses."[6] While not included in that show, Mitchell Funk's false-hued, multiple-exposure abstraction of New York skyscrapers, *New York City* (1971), represented the kind of image that Coleman abhorred (Figure 3.1). Strikingly graphic and colorful, Funk's work mirrored the mechanical manipulation being promoted by hobby magazines like *Popular Photography*. Until he found more provocative work, Coleman declared, he would refrain from reviewing exhibitions of color photographs.

Coleman asked his readers to write in with their thoughts about color, and three months later he published a column sharing some of that mail. In introducing this second article, he clarified that he was not opposed to color photography per se. He explained that he loved Eliot Porter's work, along with that of photographers like Wynn Bullock, but he reproduced reader Marvin W. Schwartz's complaint about the prevalence of oversaturated color in advertising:

FIGURE 3.1
Mitchell Funk (b. 1950), *New York City*, 1971. Inkjet print, 2008. Courtesy the artist.

"Color has brainwashed us—color, color, color—we're living in such an unnatural lifestyle, is it any wonder that nobody wants to see things as they are?" Color reportage is just as problematic, Schwartz went on. A black-and-white photograph of a Buddhist monk self-immolating is horrific, but in color the event becomes "almost a pretty picture."[7] Schwartz's assertion highlighted an important debate going on at that very moment among photojournalists. Although

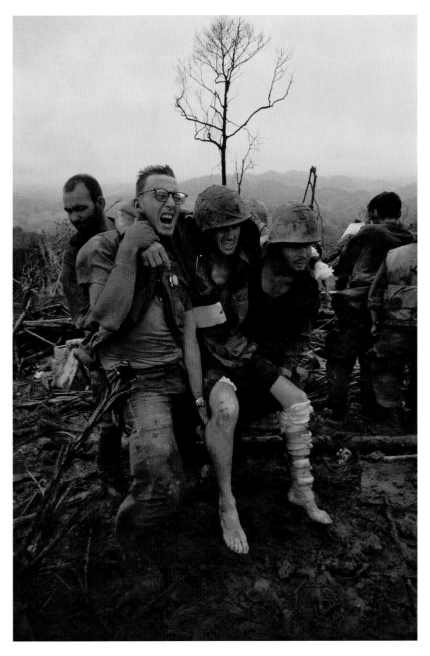

FIGURE 3.2
Larry Burrows (1926–1971), *First-aid Station, Mutter Ridge, Nui Cay Tri, October 1966.*
© Estate of Larry Burrows.

color had by now become a central feature of television news reporting on the Vietnam War, and some photojournalists like Larry Burrows (Figure 3.2) and Tim Page were capturing startling action shots of the war in color, traditionalists like the respected *LIFE* photojournalist David Douglas Duncan were defiant: "To this day I've never made a combat picture in color—ever. And I never will. It violates too many of the human decencies and the great privacy of the battlefield."[8] Proving his willingness to take criticism, Coleman shared reader Peter Clagdon's call not to ignore snapshots and Susan Trentahoste's rhetorical question: "Could it be that the more rational, cerebral male becomes bewildered when confronted with emotional color?"[9] He agreed with reader Lee DeJasu's suggestion that artists' shift to color photography was inevitable. But he declined to suggest what would make that shift successful. He also chose not to mention the expansive explorations of color that were infusing university fine art departments, investigations that the young Eastman House assistant curator William Jenkins heralded the following year as the "final breakdown of the anti-pictorial movement" and re-exploration of "the meaning of pictures through pictures."[10]

Influenced by Andy Warhol, Robert Rauschenberg, and the rise of psychedelic art, university art programs were aligning traditional fine art photography with printmaking and making color a key part of their vocabulary.[11] In this world, naturalistic color—depicting the world's hues as the eye sees them—was only one option, as were sharp focus and Renaissance perspective. Henry Holmes Smith had found renewed interest among his Indiana University students for exploring the anti-descriptive qualities of color, and his recent students Robert Fichter, Betty Hahn (Figure 3.3), and Bea Nettles were introducing his ideas in their teaching in Rochester and Los Angeles and in their own gum bichromate, offset, and fabric photographs.[12] In Brooklyn, New York, Scott Hyde was drawing on his study with Josef Albers and John Cage to make color Kwik Prints that presented images layered on top of each other in ways

suggestive of magazine bleed-throughs (Figure 3.4). At UCLA, Robert Heinecken was subverting the allure of female pinups by reconstructing them as mosaics built out of bits of black-and-white and color magazine photographs (Figure 3.5).[13] On the other side of the country, Todd Walker, who had just moved to Florida State University from UCLA, was working closely with the printmaker Ken Kerslake to produce color photo-etchings and silk screens.[14] While making photographs for print advertisements in the 1950s, Walker had often deliberately shifted the colors of his photographs away from naturalistic renderings, only to see pressmen insist on ignoring his deliberate color shifts.[15] Those frustrations had led him by the mid-1960s to switch careers to teaching art, and by the late 1960s he was making collotypes, gum prints, and Sabattier prints that while mostly in black-and-white attended closely to the color of each print's tones. When it came to photo-printmaking though he incorporated color more aggressively, mixing his own process colors and at times incorporating up to thirty-six different pigments into a single photography-rooted silkscreen (Plate 3.1).[16]

Against this backdrop, most museums focused their collecting and exhibiting activity on black-and-white photographs that either reflected straightforward documentation of the social world or self-consciously celebrated the visual peculiarities of photographic mechanics, for example the interruption and reorganization of space, time, and focus.[17] Color had no place in these arenas. Yet a small number of artists were embracing a snapshot-inflected way of looking at the world that took color for granted, and curators were starting to take notice. In 1971, the Corcoran Gallery of Art included a few snapshot-sized color photographs of rural scenes created by William Christenberry, a professor in the institution's art school, in a group show, and two years later the museum presented more of those images in a monographic exhibition of that artist's work.[18] Christenberry had begun making color photographs in the late 1950s using a Brownie camera to document well-worn buildings, signs, and related details around

FIGURE 3.3
Betty Hahn (b. 1940), *Ultra Red and Infra Violet*, 1967–1968. Gum bichromate on paper. Courtesy the artist.

FIGURE 3.4
Scott Hyde (b. 1926), *Astor Lunch II*, ca. 1970. Kwik Print. Courtesy the artist.

his home state as memory aids for his paintings and sculptures. Over time, he decided that these purely descriptive photographs, like *Abandoned House in Field, near Montgomery, Alabama* (1971), had the power to stand on their own, even as 3 × 5–inch prints (Plate 3.2). Christenberry's interest was not to insert a snapshot aesthetic into high art, but rather to reveal what color brings to photographic depictions of the world. *Abandoned House in Field* is simple and

FIGURE 3.5
Robert Heinecken (1931–2006), *Pin-up*, ca. 1971.
Dye coupler print. Courtesy Rhona Hoffman Gallery.

straightforward in subject and composition. It is not about color, but, as with the photographs of Marie Cosindas, Dan Graham, and Eliot Porter, it freely accepts how color shapes a scene, driving the eye from the pale blue sky across the empty shell of the dilapidated, windowless brown house and then across the overgrown yard filled with tan grasses to the white seed pods in the lower foreground. Without color the scene would be elegiac and timeless. In color it carries a poignant immediacy that is central to the artist's message of celebrating the rural Alabama landscape.

In 1971, another New Yorker, Stephen Shore, also took up this lowbrow approach in the form of a set of ten deliberately mundane color postcards of Amarillo, Texas (Figure 3.6). Clearly influenced by Ed Ruscha's conceptual art books like *Twentysix Gasoline Stations* (1962), the postcards poke fun at that city in their straightforwardness.[19] The series, Amarillo—"Tall in Texas," sets the town's architecture in playful competition with Shore's home city, deliberately leaving their compositions so empty of personality that they could easily have been made by any number of small-town commercial photographers doing a job for the local chamber of commerce. Shore had gained his conceptual art predilections while hanging around Andy Warhol's Factory as a teenager.[20] He now solidified them by surreptitiously inserting the cards into postcard racks at drug stores and hotels on a second trip across the country in 1972. On that same trip, taken as much under the influence of the legendary 1950s road trips of Robert Frank and Jack Kerouac as simply to see the world beyond New York, he built a color photographic diary portraying everyone he met, every meal he ate, and every town he visited. On his return to New York, he filled three walls of the back room at Light Gallery with a sampling of the project, hanging more than three hundred 3 × 5–inch prints in a grid three images high.[21] The installation delivered a repetitious matter-of-factness that undercut any notion of singular preciousness. By drawing such incessant attention to the look of everyday life, the photographs subverted any tendency to attend specifically to color.

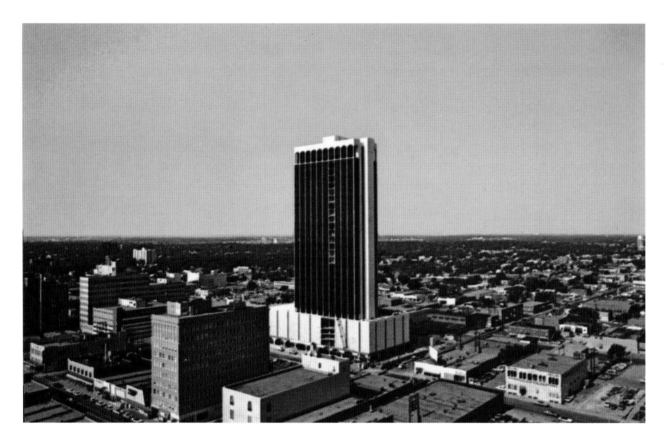

FIGURE 3.6
Stephen Shore (b. 1947),
*American National Bank
Building*, postcard from the
Amarillo—"Tall in Texas" series,
1971. Courtesy the artist and
303 Gallery, New York.

Christenberry and Shore were not the only ones exploring the aesthetic of the color snapshot. The young Memphis photographer William Eggleston was photographing hometown life with this same informality. Joel Meyerowitz had committed to investigating New York's street life in color, and Mitch Epstein and Joel Sternfeld were starting to explore how color shaped their quickly grabbed renderings of urban and suburban life.[22]

In the midst of the slowly gathering momentum for this kind of informal documentation of life, the Polaroid Corporation introduced the perfect tool for snapshot nonchalance, the SX-70.[23] Although this new camera and film lacked the subtlety of its predecessor Polacolor film, it still delivered a rich density of varied hues. One had to do nothing more than frame a view and push the shutter button. In return, the camera spit out 3⅛-inch square images that within just a few minutes developed up into a finished color print.[24] In an astute marketing ploy, just as Kodak had done in the aftermath of World War II, Polaroid decided to market the camera through accomplished artists, though this time the program was broader. Polaroid gave a wide range of young and established artists free film, and in some cases cameras, in exchange for examples of their work.[25] Their expansive offer attracted a multitude of photographers, including the old-school master Walker Evans. Despite creating and illustrating more than a dozen articles for *Fortune* and other magazines with his color photographs, Evans had downplayed and even tried to hide his use of color over recent years, not including any of that work in his 1971 retrospective at MoMA.[26] Having largely given up photographing because he was feeling too tired at age sixty-nine to lug around his 8× 10–inch view camera, he became the perfect exemplar for Polaroid of what instant photography could deliver. The much more manageable SX-70 camera rejuvenated Evans's passion for picture making, and over the fall and winter of 1973–1974, he made hundreds of SX-70 images of friends, road signs (Figure 3.7), rusted cars, and street corners, and

FIGURE 3.7
Walker Evans (1903–1975),
[Roadside ice cream cone
sign], 1973–1974. Instant
color print. The Metropolitan
Museum of Art, New York,
purchase, Samuel J. Wagstaff
Jr. Bequest and Lila Acheson
Wallace Gift, 1994. © Walker
Evans Archive, the Metropoli-
tan Museum of Art. Image ©
The Metropolitan Museum
of Art. Image source: Art
Resource, NY.

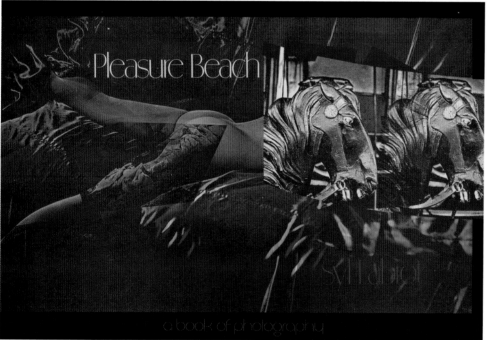

FIGURE 3.8
Syl Labrot (1929–1977), cover of *Pleasure Beach* (New York:
Eclipse, 1976). Courtesy Visual Studies Workshop, Inc.,
Rochester, NY.

even contracted with Polaroid to have enlargements made of dozens of these shots.[27]

The sculptor, painter, and performance artist Lucas Samaras, on the other hand, took a more painterly approach to the SX-70.[28] Obsessed with self-portraiture and unsatisfied with simple documentation, Samaras realized he could manipulate the SX-70 emulsion by pushing the dyes of the cards around with hard styluses to create ghoulish visions of himself flamboyantly acting out fantasies and nightmares. He called the results "Photo-Transformations" (Plate 3.3). In 1973—the same year that songwriter Paul Simon's pop hit "Kodachrome" celebrated the ubiquity of color photography and Susan Sontag published the first in her series of landmark essays dissecting the central place of photography in modern culture—Light Gallery presented Samaras's SX-70 prints as high art.

That same year, Indiana University opened a fifty-year retrospective of Henry Holmes Smith's explorations of color, and Southern Illinois University published a call for submissions to its planned exhibition of "synthetic color" photography.[29] Even the solidly black-and-white tabloid *Afterimage*, published by the Visual Studies Workshop in Rochester, New York, got into the act, printing in early 1974 a tipped-in color plate of one of Todd Walker's nude studies.[30] That fall, the magazine followed up on that foray with its first color cover, which celebrated the upcoming publication of Syl Labrot's *Pleasure Beach*, his elaborately printed autobiographical meditation on color photography (Figure 3.8). In the accompanying cover story, an excerpt from the book, Labrot explained that he had begun his career trying to photograph the world very straightforwardly, making calendar images and magazine covers. But he kept finding that "the photograph would always slip off and begin to generate a world of its own," where "[a]ppearances became separated from meaning."[31] That recognition led him to think of color as painters and color theorists had long thought of it—as separate from the things it describes—and to start deliberately switching up colors, treating them as free-floating passages that

sometimes describe form and just as often separate from the objects they describe. To further divorce his work from naturalism, he started combining and overlapping images and mimicking the alluring tactility of black-and-white by increasing color intensity in the foreground and overtly diminishing it in the background.

New York photographer Jan Groover blended these tracks of naturalism and abstraction in multipanel investigations of color juxtaposition created by vehicles in motion, which Light Gallery presented in 1974 (Figure 3.9). However, the main thrust of gallery and museum interest, at least in the Northeast, was moving quickly toward embrace of straightforward depiction. That same year, photography dealer Harry Lunn published a fourteen-print portfolio of William Eggleston's color images and John Szarkowski installed a slide show of New York photographer Helen Levitt's new color street photographs in MoMA's small Projects gallery.[32] Levitt was an easy choice for Szarkowski. She was widely respected for the poetic black-and-white photographs of the East Harlem street life that she had begun making since the late 1930s, and she plied the waters of naturalism. Levitt had actually started experimenting with color photography in 1959, but, unhappy with how printers had interpreted her transparencies, she had not stuck with the medium for very long. In 1971, shortly after a burglar stole that earlier work, she had taken up color again, focusing her attentions on the neighborhoods of New York's East Village, Lower East Side, and Garment District. As with her black-and-white photography,

these new photographs reflected her masterful ability to be a disarming bystander recording the dynamics of neighborhood interactions.[33] *New York* (1972), for example, focuses on a group of children who even in their chores fall victim to distractions (Plate 3.4). A girl copes with a huge basket of laundry while two siblings or friends focus intently on something going on down the street, and two more children playfully interact with each other behind her. All are oblivious to the camera.[34] Without color, the scene would focus wholly on the children and brilliant sunshine. The surroundings, including the graffiti-covered wall beyond them and red building façade along the frame's edge, would fall away. In color, the space opens up to create a stage where setting and action reinforce each other. In the museum's press release, Szarkowski heralded this descriptive core, but he also recognized how color could skew Levitt's photographs, warning that: "A lavender necktie may demand our attention more forcefully than the expression on a face above it, and the photographer must accept the new realities and work within them."[35]

While MoMA was presenting Levitt's color photographs, the George Eastman House in Rochester, New York, was celebrating its acceptance of the estate collection of the great commercial photographer Nickolas Muray with a grand retrospective exhibition.[36] The difference between Levitt's and Muray's approaches to color is enlightening. Muray, following the dictates of mid-century advertising, generally makes color shape and define his subjects; one notices color first and subject second. Levitt, on the

FIGURE 3.9
Jan Groover (1943–2012), *Untitled*, 1975. Dye coupler prints (triptych). © Jan Groover, courtesy Janet Borden, Inc.

FIGURE 3.10
Neal Slavin (b. 1941), *Capitol Wrestling Corporation, Washington, D.C.*, ca. 1975. Dye coupler print. Courtesy the artist.

of Kodachrome, who had taken it into his head that color photography should be about, not the sensations, but the sensationalizing of color."[39] Museums' slow acceptance of color was due to a general negligence in embracing careful looking, he complained. Eliot Porter's color woodland scenes, for example, "set forth their brilliance with a sensory realism almost combustible in impact," and despite their "devastating costs," this same power had caused the Gemini photographs of earth to capture the country's imagination.[40] Kozloff then introduced three young artists whose photographs he found similarly provocative. He suggested that Neal Slavin's group portraits of the members of various offbeat clubs and organizations (Figure 3.10) might be read as mildly amusing anthropological studies, but he explained that they are actually the artist's vehicles for drawing attention to the way that color organizes and informs the world.[41] He extolled Stephen Shore's new 8 × 10–inch view camera photographs for their ability to deliver "commanding visibility" to "grossly undistinguished vistas," like open fields, hotel bedrooms, parks, parking lots, and sidewalks.[42] Here too something more was going on. Rather than merely documenting the world, he suggested, Shore's images exude "the theme of being alone in color" (Figure 3.11).[43] Finally, he argued that Joel Meyerowitz was using 35mm Kodachrome to creatively and engagingly record the visual surprises brought by New York's street life (Figure 3.12).[44]

Kozloff's clear point was that it was time for major museums to give full recognition to color photography. The inclusion that coming summer of Shore's color photographs in an Eastman House exhibition, "New Topographics: Photographs of a Man-altered Landscape," would help address the situation, but Shore was the only color photographer out of the ten artists included in that show, and that project's curator, William Jenkins, never addressed what color delivered to Shore's images.[45] It would take another seventeen months for Kozloff to get his wish fulfilled. The response would not be founded on the work of any of the three photographers he heralded, and it would not make him happy.

other hand, lets color more passively inhabit her subjects; her color images are not about hue, but hue makes them viable.

Despite these presentations, color photography largely remained a stepchild in the museum world in 1974—something that was starting to show creative potential but, it was argued, could not compete with the technical and emotional luster of black-and-white.[37] Critic Max Kozloff summed up the predicament in a January 1975 *Artforum* article titled "Photography: The Coming of Age of Color."[38] He opened his discussion by rhetorically asking why we expect cinematic films to be in color, yet we don't expect photography shows to be in color. Color for color's sake was not the answer, he said, calling Ernst Haas nothing more than "a *LIFE* magazine Paganini

FIGURE 3.11
Stephen Shore (b. 1947), *Sault Ste. Marie, Ontario, August 13, 1974*, in *Uncommon Places: 50 Unpublished Photographs* (Düsseldorf: Verlag der Galerie Conrads, 2002). Courtesy the artist and 303 Gallery, New York.

JOHN SZARKOWSKI had presented three exhibitions of color photographs since taking over the MoMA photography program from Edward Steichen in 1962 (by photographers Ernst Haas in 1962, Marie Cosindas in 1966, and Helen Levitt in 1974). He had included color photographs among black-and-white works in several more shows, but he had largely ignored the medium in his two major explications of the art of photography, *The Photographer's Eye* (1966) and *Looking at Photographs* (1973).[46] To him, black-and-white photography was clearly superior. Yet seven years prior to Kozloff's article, he had bought one of William Eggleston's photographs after reviewing the Memphis photographer's suitcase full of drugstore color prints.[47] He had then stayed in

contact with the little-known artist, and over subsequent years he had started quietly building support at MoMA for a major exhibition and catalogue celebrating Eggleston's work.[48] For the first time, Szarkowski was asking the museum to give over its prime first-floor galleries to a color photographer. He also was pushing MoMA to publish a book—and it would be no simple production. He made sure that this hardcover, *William Eggleston's Guide*, was elaborately designed to draw attention to itself, with a textured, black exterior suggestive of an old snapshot camera; bright green text pages; forty-eight finely printed color plates; and a graphically strong cover graced by a photograph of a tricycle standing in the driveway of a suburban home (Figure 3.13).[49]

Eggleston had found his photographic calling around 1959, like many young photographers in those days, after encountering two masterful books of street photography: Henri Cartier-Bresson's *The Decisive Moment* (1952) and Robert Frank's *The Americans* (1959). He had been introduced to color around 1965 by William Christenberry at Memphis College of Art, and he had committed to the medium around 1966 after seeing Joel Meyerowitz's color street work.[50]

Two attributes induced Szarkowski's strong support for Eggleston's work. First was the photographer's snapshot-inflected engagement with contemporary life. Eggleston's subjects were his friends, relatives, and innocuous roadside details around Memphis and across his familiar stomping grounds in rural Mississippi, Alabama, and Louisiana. The works suggested the blank, yet intrusive, intimacy of a stranger's family photographs picked up at a flea market. Sometimes the portraits are unsettlingly personal, as in one showing a middle-aged nude man standing in a graffiti-tagged bedroom that is bathed in red light. At other times the photographs are so banal, like one depicting white plastic bottles strewn

along the edge of a dirt road pullout, that one wonders what so attracted the artist's eye.[51] Yet they are all too organized to be snapshots. Every detail is key to each image, just like a photograph by Alfred Stieglitz.

The second attribute to gain Szarkowski's notice was Eggleston's sophisticated use of color. The curator had struck up his ongoing conversation with the artist in 1967, but only in 1972, when the artist discovered the dye imbibition process at a Chicago photography lab, did Eggleston feel that he had found his true artistic voice. Fascinated by the mix of saturation and subtlety delivered by this printing process, he had reveled in how these attributes intensified the viewing experience, relating: "I couldn't wait to see what a plain Eggleston picture would look like with the same process. Every photograph I subsequently printed with the process seemed fantastic and each one seemed better than the previous one."[52] Just as Porter had recognized years earlier, the dye imbibition process allowed Eggleston to draw attention to color without making it the subject of the photograph. It enabled his colors to simultaneously describe and hover, actively shaping the emotional tenor of his images without getting in the way of

FIGURE 3.12
Joel Meyerowitz (b. 1938), *New York City*, 1975.
Dye coupler print. Courtesy the artist.

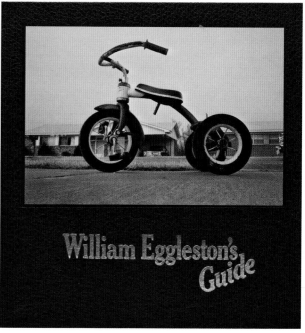

FIGURE 3.13
The cover of *William Eggleston's Guide* (New York: Museum of Modern Art, 1976). © 1976 The Museum of Modern Art, New York. Photo credit © Eggleston Artistic Trust. Courtesy Cheim & Read, New York.

subject. Occasionally color almost takes over, as in the unsettling shot *Greenwood, Mississippi* (1973), which focuses on black light Kama Sutra poster hung near the ceiling of a room where the walls and ceiling are crimson red. Most often, though, subject and color work in meticulous balance, as in the artist's photograph simply titled *Memphis* (Plate 3.5). Here, Eggleston employs careful framing and clean lighting to bestow a mundane green-tiled shower stall with balanced elegance. The lighting makes the back wall seem to lift forward as if it were the doorway to a secret passage. What makes the image most beguiling though is the liquidity of its dye imbibition hues. The expansive spectrum of greens delivered by the process creates a dynamic energy that offsets the stripe of pale red marking the top of the tile work and the room's steel fixtures. The colors describe the tub and tiles and at the same time separate from their surfaces in a quivering dynamism.

When MoMA opened the seventy-five print exhibition titled *Photographs by William Eggleston* on May 25, 1976, the museum set off a firestorm. The placement of the show in one of the museum's prime spaces and the publication of the book were surprises, but Szarkowski's unrestrained celebration of the photographs was a revolution. Mirroring Alfred Stieglitz's ebullient celebration of Paul Strand sixty years before, the curator called Eggleston's work "perfect" and a clear answer to the complicated problem of color.[53] Within two days *The New York Times* art critic Hilton Kramer publicly retorted: "Perfect? Perfectly banal, perhaps. Perfectly boring, certainly."[54] Kramer suggested that the images were so inane that the display had to be seen to be believed. To him, Eggleston's subjects were trite, his use of color either boorish or gruelingly ponderous, and his compositions little more than "snapshot chic": "[the] bathroom shower is an index to the kind of subject Mr. Eggleston favors. He likes trucks, cars, tricycles, unremarkable suburban houses and dreary landscapes, too, and he especially likes his family and friends, who may, for all I know, be wonderful people, but who appear in these pictures as dismal figures, inhabiting a commonplace

world of little visual interest." Kramer linked the photographs to photo-realist paintings, calling them a case of "the banal leading the banal."[55] At the end of his exhibition review, he heralded Louisiana photographer Clarence John Laughlin's display of black-and-white photographs, *The Transforming Eye*, at the International Center of Photography as achieving, in contrast, an extraordinary visual poetry.

Kramer was an acerbic critic by nature, but he was by no means alone in his distaste for Eggleston's photographs. In summarizing the 1976 photography season for *The New York Times*, critic Gene Thornton called Eggleston's exhibition "the most hated show of the year."[56] Chiming in a few months later, *The New Yorker* critic Janet Malcolm labeled Eggleston's work a ludicrous appropriation of photo-realist art that looked "insignificant, dull, even tacky, on the wall."[57] She suggested that Eggleston could get away with his vision in MoMA's book because in that format "color photography is always interesting to look at," but "the Eggleston photographs made particularly poor showing in exhibition. They looked inartistic, unmodern, out of place . . . [exuding] an atmosphere of slouching dejection and tentativeness."[58]

Kramer, Malcolm, and Thornton had been fighting a rearguard action against Szarkowski and his appreciation for a snapshot-inflected way of looking at the world since he had published *The Photographer's Eye*. Where Szarkowski chose to locate the main issues for fine art photography in the medium's mechanics—he divided the book into sections on "the thing itself," "the detail," "the frame," "time," and "vantage point"—they placed photography's artistic core within a framework of uplift.[59] What Kramer, Malcolm, Thornton, and others missed—and what Szarkowski recognized—was that Eggleston's work was only nominally about describing the world. Rather, the artist's intent was, as it continues to be today, to explore and trumpet color photography's peculiar way of reflecting the world—a point analogous to what Szarkowski found so appealing in the work of the black-and-white photographers he was championing, like Lee Friedlander and Garry Winogrand. In short,

Eggleston had solved for Szarkowski the longstanding conundrum of how to integrate color into the ongoing conversations of black-and-white. Prior to Eggleston, Szarkowski explained in *William Eggleston's Guide*, he found most color photographs "puerile," falling into one of two camps: "black-and-white photographs made with color film, in which the problem of color is solved by inattention" and "photographs of beautiful colors in pleasing relationships."[60] While the first approach at least reflected the world, he said, the latter works did little more than offer suggestions of cubist or abstract expressionist paintings. Irving Penn's still lifes and Marie Cosindas's Polaroids warranted praise, he said, but they were merely studio constructions designed to suit the camera. He voiced appreciation for Helen Levitt, Joel Meyerowitz, Eliot Porter, and Stephen Shore because they worked "as though the world itself existed in color, as though the blue and the sky were one thing."[61] Eggleston worked the same way, he declared, but he took one further step, not merely recognizing the world's colors but actively composing around them, not to create formal studies but to instigate fresh looking. Noting how the camera translated the world in its own peculiar fashion, Szarkowski returned to the warning he had issued about Helen Levitt's color work, explaining that Eggleston had allowed "the wedge of [a] purple necktie, or the red disk of the stoplight against the sky" to torque composition and meaning. This act allowed color to subvert the mundane and force the photographer's scenes into a precarious balance between form, color, and content.[62]

While mainstream photography critics could not cope with the Eggleston show, Szarkowski did get positive feedback from several key sources. After stopping by to see the display in early June, the director of the International Museum of Photography, Cornell Capa, sent Szarkowski a note calling the presentation "a strong, unflattering, unromantic statement on American life," and heralding the curator's presentation of the work as "a significant and courageous act."[63] In a postcard acknowledging receipt of Eggleston's book, the influential art critic Clement Greenberg called the artist's photographs and Szarkowski's essay "eye-opening," and suggested: "I had begun to think that good color photography was improbable save by accident; I would not call E's work accidental."[64]

However much Szarkowski loved Eggleston's photographs though, he was the first to admit that he did not fully understand them. He said they were more like "patterns of random facts" than clear statements. Yet the photographs seemed to reinvigorate and update what Robert Frank had started. Like Frank's black-and-white portrait of America from almost two decades earlier, Eggleston's depictions of Southern cultures cut through the bland stereotype of comfortable American life. But where Frank's photographs built an indictment of 1950s American culture, Eggleston's message was far more oblique. Szarkowski puzzled hard over the matter, at one point writing the photographer about his frustrations.[65] Ultimately, he was left with the poetic, if unsatisfactory, conclusion that the artist's photographs were "irreducible surrogates for the experience they pretend to record, visual analogues for the quality of one life, collectively a paradigm of a private view, a view one would have thought ineffable, described here with clarity, fullness, and elegance."[66] In one of the opening labels to the exhibition he celebrated this opacity, suggesting: "Preoccupation with private experience is a hallmark of the romantic artist. . . ."[67]

Despite the contentious debate surrounding Eggleston's work, the MoMA show left no doubt that color had finally entered the pantheon. This was Max Kozloff's uncomfortable point in his November 1976 *Artforum* review of the show and its accompanying book. If Eggleston's work had been shown in a college photography class, a camera club, or even a commercial gallery, Kozloff suggested, it would have fit in comfortably in a modish sort of way. But by being in MoMA's prime galleries, it raised special problems. Szarkowski had a responsibility, the critic argued, to analyze and contextualize Eggleston's work both historically and in relation to other contemporary Southern photographers. By shirking that

responsibility, Kozloff declared, Szarkowski had left his audience to take his word on faith that this "not conspicuously talented photographer" is important and that the problem of color photography had been solved.[68] Sean Callahan saw it the same way in his *New York* magazine review of the presentation: "The very fact that John Szarkowski is exhibiting color photographs by William Eggleston will spur dealers, collectors, curators, and photographers to reconsider color photography as a medium of saleable and collectable merit."[69] No longer was color photography a stepchild of black-and-white. No longer did it have to carry the burden of being viewed as better suited to commercial uses. But what that meant for the future of fine art photography was anyone's guess.

Szarkowski responded to the uproar the following year when he gave a slide lecture in association with the presentation of a reduced version of the Eggleston show at Reed College. Belatedly situating the photographer within an art historical continuum, he suggested that Eggleston was accomplishing what French photographer Eugène Atget had achieved in his images of Paris seventy-five years earlier— describing the familiar with such clarity that it seemed shocking. In reporting on that lecture and reviewing the show for the local newspaper, *Willamette Week*, Warren Nistad went further, calling Walker Evans the axis between Atget and Eggleston. Szarkowski could not have said it better. These were three of the curator's favorite photographers. Szarkowski had set his initial mark at MoMA by resuscitating Evans's artistic reputation.[70] A major Atget project would come to public fruition in 1981.[71] All three photographers reveled in the vernacular. Sympathetic to Szarkowski's position, Nistad quoted the curator's explanation of Eggleston's photographs as making vivid "the basic sensory and psychological textures that we do not understand, but that we recognize as important," and the curator's suggestion that Eggleston's photographs described the world "in such a way that our lives seem more adventurous, more threatening, more filled with promise and terror than we might in our daily rounds have guessed."[72]

Szarkowski's celebration of Eggleston and assertion that color photography had come of age received further corroboration from Allan Porter (no relation to Eliot Porter), publisher and editor of the Swiss periodical *Camera*, which had a wide readership among committed artist-photographers on both sides of the Atlantic. Most likely responding to the uproar over Eggleston's work in the United States, Porter devoted the July 1977 issue of that magazine to laying out the history of color photography. He argued that the period up to the introduction of Kodachrome in 1936 represented color photography's "pre-history," and that the period between the mid-1930s and the late 1960s represented the first generation of color. During this second period, he explained, "experimentation was at its peak," but photographers working in color were hindered by technical limitations so that color photography was mainly a phenomenon of magazines.[73] By the 1960s, he suggested, the prevalence of high quality color in print, cinema, and television led artists to think more about color. These influences in turn led to a rejection of abstraction in favor of returning to photography's core achievement—documenting the world in all its "true fidelity," an act, he said, that initiated the arrival in the early 1970s of the "second generation" of color photographers.[74] Although he did not analyze the work of this second generation, Porter singled out those he thought were doing the most important work, presenting plates of their images along with short biographies. Almost all of these twenty photographers were Americans, and all of them treated color in naturalistic terms as a tool for describing the world. Although most of them used color in far more formal and obvious ways than Eggleston, the Memphis photographer was among them.

SZARKOWSKI FOLLOWED UP his Eggleston show with a December 1976 exhibition of Stephen Shore's color photographs of commonplace public settings that had been heralded by Max Kozloff in his *Artforum* celebration of color the year before. He was likely drawn to Shore's work by its close superficial

allegiance to the photography of Walker Evans and William Christenberry in its appreciation for the worn detritus of rural life.[75] Shore, by this date, had become less preoccupied with color than with how view cameras allowed him to break free of the constricting terms of Renaissance perspective, but he remained cognizant of the ways that color organized his view camera images like *West 9th Avenue, Amarillo, Texas, October 2, 1974* (Plate 3.6). In this image, the theater's name, "Sunset," poetically references both the decrepitude of the aging monument and the time of day when the drive-in will come alive with movie-goers. But, in love with the hard crisp light of midday, Shore made this exposure at a moment when the hot western light induces thoughts of taking refuge in the shadows of the juniper trees at the base of the oversized screen. He set his camera exactly opposite the back of the screen, centering the wall like a target and leaving just enough space around it to suggest its setting without diminishing attention to its geometry. But the photograph's clean colors deliver an incessant immediacy that runs counter to Evans, keeping it adamantly in the present; the colors also work far more aggressively than those in Christenberry's photographs. Only after coming to terms with this image's golden browns and pastel blues is one freed to peruse the peeling paint across the screen's façade and be swept up by the allure of its imbalanced architectural beauty.[76] Those two cleanly rendered hues show up repeatedly in Shore's photographs of western scenes, distinguishing the region from the softer, yellower light that the artists found defining the atmosphere of the East.

As more photographers picked up color in the shadow of the Eggleston show, a triumvirate dominated the critical discussion about the insertion of color into fine art photography. After Eggleston and Shore, the third player in that group is Joel Meyerowitz, Kozloff's second major figure. Meyerowitz had been drawn to color by its more thorough ability to describe the world. He had developed his initial photographic vocabulary largely with black-and-white film, plunging into crowds to explore in the Cartier-Bresson/Winogrand tradition the unexpected ways that the camera caught people's interactions. Color film's relatively slow speed forced him to step back from the action and think more about space.[77] It was this geometrically driven color work that had drawn Kozloff's attention. Despite that success, Meyerowitz remained at loose ends, and in early 1976, feeling that he was reaching a dead end with his 35mm street work, he purchased an 8 × 10–inch view camera and set about teaching himself how to use it while summering with his family on the outer reaches of Cape Cod. The experiment would transform his photographic vision and his career. The results of that first summer were picked up and shown by Witkin Gallery in New York in November 1977. The following year the Museum of Fine Arts in Boston presented more than one hundred contact-print photographs under the title Cape Light, accompanied by a book, and Meyerowitz's path was set.[78]

Working with a view camera changed the way Meyerowitz thought about color. He had seen Eggleston's exhibition at MoMA just before leaving for the Cape, but he was moving in a different direction. Where Eggleston reveled in the lushness of color and Shore attended to its descriptive solidity, Meyerowitz now took notice of color's more liquid attributes—how it surrounds forms and saturates the atmosphere. Rather than describe form, he started using color to communicate sensation along the lines of a romantic poem. The most celebrated of his Cape Light images depict porches, swimming pools, and beach views in the late afternoon or on the verge of summertime storms. The skies are laden with activity evoking Hudson River School landscape paintings in their dominating reds and grays (Figures 3.14 and 3.15). The photographer's early evening shots of cottages and small businesses bathed in colorful neon and fluorescent lights induce pleasurable surprise and easy reminiscence of summertime evenings.[79] *Hartwig House, Truro* (1976), the artist's first view camera image and the first plate in *Cape Light*,

escapes both the dramatic romanticism of his beach
views and the dominating lollipop hues inscribing
his evening building shots (Plate 3.7). One hardly
notices the colors at first, instead getting pulled into
the architectural detail of this New England cottage—
its central hall with its wide floorboards, its hooked
rugs, furnishings, and the faded Norman Rockwell
reproduction gracing the bedroom. Only after tak-
ing in these points does one realize that what ties the
image together is light. If Stieglitz was frustrated over
how the Autochrome process could not deliver clean
whites, Meyerowitz here exults in the subtle shifts
conveyed by the white doorframes and wainscoting of
the entry hall. The image is completely understand-
able without color, but as in an Edward Hopper paint-
ing, color adds an indispensible warmth, dimension,
and immediacy to the scene.

Faced with this framing of color photography as
rooted in naturalism, some critics and college and
university MFA programs across the country remained
insistently sympathetic to blending photography,
printmaking, and drawing. Shortly before MoMA
presented *Photographs by William Eggleston*, Florida
State University published a limited edition port-
folio of color photography–based offset lithographs
titled *Colors* and engaged Henry Holmes Smith, the
long-term advocate for photography's abstracting
language, to write the introduction. There, Smith
once again took up with gusto his battle against natu-
ralism, decrying the rejection of arbitrary color in
photographs (Figure 3.16) because "there is no *photo-
graphic* esthetic to guide them" as "the objection of a
nitwit."[80] He called on photographers to embrace their
medium's connection with the other arts, and asked
them to reconsider the neglected world of symbolic
color. At UCLA, professor Judith Golden was following
a similar track (Figure 3.17). The culmination of a se-
ries of self-portraits that she had been creating since
1974, she now was cutting out the faces of women on
People magazine covers, holding the magazines up to
her own face, and photographing herself in black and
white. She then hand-colored the resulting prints. In
these acts she simultaneously played the clown and

FIGURE 3.14 *above*
Joel Meyerowitz (b. 1938), *Bay/Sky, Province-
town*, 1977. Dye coupler print. Courtesy the
artist.

FIGURE 3.15 *bottom*
Martin Johnson Heade (1819–1904), *Thunder
Storm on Narragansett Bay*, 1868. Oil on can-
vas. Amon Carter Museum of American Art,
Fort Worth, TX.

drew attention to the tendency of magazine readers to project themselves onto their public heroes. Using obvious false color was central to the joke, a reference to the common commercial practice of heavily retouching photographs to make public figures look more glamorous than they really are. In a September 1976 *Artforum* column, arts critic A. D. Coleman likewise called on photographers to break from the "imperative of realism," labeling it photography's "second major struggle."[81] The following December, he organized a conference at Apeiron Workshops as a forum for delineating a variety of artistic approaches to color. Photography curator Van Deren Coke also continued to argue for the blend of fabrication and photography.[82]

Naturalism, though, was quickly gaining momentum as the predominant track even among photographers who, under the influence of conceptual and performance art, were dissecting photography's foundation on Renaissance perspective. John Pfahl had largely made screen prints since getting his MFA degree at Syracuse University in the mid-1960s. But around 1975, he began a more traditional color photographic series he called Altered Landscapes, in which he used aluminum foil, colored tape, and other simple materials to create optical illusions that playfully undermine the depth suggested by the camera lens (Figure 3.18).[83] He displayed the work at the Visual Studies Workshop in Rochester, New York, over the months of Eggleston's MoMA show, and by 1977

FIGURE 3.17
Judith Golden (b. 1934), *Rose Kennedy at 85 with Ted*, 1976. From the *People* Magazine series. Gelatin silver print with oil paint. Center for Creative Photography, University of Arizona Libraries, Tucson. © 1976 Judith Golden.

FIGURE 3.16
Robert Fichter (b. 1939), *Colors*, 1975. Published by Center for Creative Photography, University of Arizona Libraries, Tucson. Courtesy the artist.

FIGURE 3.18
John Pfahl (b. 1939), *Shed with Blue Dotted Lines, Penland, NC,* 1975. Dye imbibition print, 1990. George Eastman House, International Museum of Photography and Film, Rochester, NY. © John Pfahl, courtesy Janet Borden, Inc.

the work had been picked up by the newly inaugurated Robert Freidus Gallery in New York.

On the West Coast, John Divola was employing color to equally realistic yet dissecting ends. Taking advantage of an abandoned house at Zuma Beach in Malibu, he started integrating the energy of "happenings" into his photographs by spray painting the walls and ceilings of the buildings and then photographing his markings, creating compositions that, with the help of his camera flash, evenly blend the house interiors with the world beyond (Plate 3.8). The resulting images transform the room into a John Marin–like painted frame for clean glimpses of the Pacific Ocean and sky that jump optically forward to float in space like op art or a color-field painting.

Divola returned intermittently to this same house over several months in 1977 to add to his markings and make more exposures that drew on the increasing contrast between the visual clutter of the interior and the soothing clarity of the window views. Often he worked at sunrise or sunset to more evenly blend inside and out. When vandals set fire to the interior between visits, he absorbed that dramatic scarring into his evolving series, and ended the project only when the Los Angeles Fire Department burned the house down for safety reasons.

Back in New York, Jan Groover was now creating closely cropped still lifes of bowls, forks, and knives caught in tangles of translucence and reflection (Plate 3.9).[84] The topic paid tribute to Paul Strand's

and Margaret Watkins's early twentieth-century bowl and kitchen studies. It also contributed to a trend of making the domestic sphere once again a credible art subject, introducing color into that matrix. One recognizes the objects in Groover's photographs, but one is emotionally engaged by the tenuous balance between description, shape, and color. Distinctions between foreground, middle ground, and background dissolve, while the hues, reflections, and unexpected balance of competing forms point incessantly toward abstraction. Yet the project remains solidly rooted in photographic naturalism.[85]

Interest in color was also spreading among photographic artists who had established a reputation in black-and-white. After seeing the Eastman House color exhibition *Road Shots*, photographer Mark Cohen approached that project's curator, William Jenkins, voicing interest in trying his own hand at color. Cohen had built an artistic reputation for making aggressive, closely framed black-and-white photographs of people around his hometown. Nathan Lyons had exhibited some of these photographs at Eastman House in 1969. Szarkowski had subsequently purchased several of the prints for MoMA, and had given him a small solo exhibition in 1973.[86] Jenkins and Cohen worked out an arrangement with Kodak whereby the company provided the artist with free rolls of 35mm color film and ongoing processing up through production of 16 × 20–inch dye coupler prints for an Eastman House exhibition. Freed from the added expense of color, Cohen approached the medium with the same visual intensity as he had black-and-white, though rather than rely on the strange twists of highlight and shadow delivered by close-up flash, he let hue provide that energy.[87] One of the most color-laden results of the project, *Boy in Yellow Shirt Smoking* (1977), shows a group of neighborhood kids happily mugging for the camera (Plate 3.10). They clearly are relaxed around the photographer. Their bravado establishes the energy of the scene. But the true star is the bright colors of their shirts and jackets, the white cigarette, and the red lollipop hoisted by the boy on the right. These colors reinforce the excitement of the moment.

Photography's status as the dynamic art form of the day was rising fast by the late 1970s and color was a key reason.[88] If Cohen's work was considered a bit antic and Eggleston's outlook continued to puzzle many, Stephen Shore's and Joel Meyerowitz's view-camera models of quiet, direct looking were coming to the fore. Joel Sternfeld was one photographer following this route. Sensitized to color by his artist parents and an appreciation for Josef Albers's color studies, he had taken up Kodachrome in 1971. A visit with William Eggleston in fall 1974 had then solidified that commitment to color and inspired him to take up a similar color-cognizant, snapshot-inflected cataloguing of the details of public life, though he brought to his version a more gentle appreciation for the people before his lens.[89] For a time, in 1976, Sternfeld tested his hand and eye at street photography using a strobe, much as Joel Meyerowitz had done early in the decade, not to isolate convergences as much as disconnections between people and the disaffection he saw characterizing contemporary life. His reputation and commitment were well enough established by 1978 that he was awarded an artist's fellowship from the Guggenheim Foundation. He had worked to this point with a 35mm camera, but following artistic trends he now took up an 8 × 10–inch view camera. His new goal was ambitious—to build a color photographic portrait of the country. Like Robert Frank some twenty years earlier and Shore more recently, he would focus on the disjunctions between ideal and real. In line with rising interest in environmentalism and photographic landscape, Sternfeld now directed his camera on scenes defined by modest middle-class suburban comfort. He made color central to the vocabulary of one of the project's first photographs, *McLean, Virginia, December 1978* (Plate 3.11). Here the color orange awkwardly connects a foreground pumpkin stand to a fire consuming a house in the distance. It brings attention to a fireman who seems more preoccupied with making the perfect Halloween purchase than with the house burning out of control behind him. The image actually depicts a fire training exercise, but it playfully also reflects the late 1970s and that period's stereotype of

"me generation" hedonism in the face of economic disorder. Without color, it would be a paltry semblance of itself. One would get its joke, but without the bite. As the project progressed, Sternfeld let his palette become dominated by more washed-out hues, especially beiges and light blues. He almost drains the color from his portrait of a homeless woman sitting outside her plastic tent in a pose reminiscent of Dorothea Lange's famous *Migrant Mother* photograph, as if it came from the Depression era. Balanced on the axis of documentary, fine art, and reportage, each image of what became the American Prospects series describes finite, familiar worlds, tied together by their passive framing and especially their paleness, to communicate Sternfeld's vision of the malaise pervading contemporary life.[90]

Boston photographer Jim Dow was just as interested in summarizing the look of contemporary life over these same years, and his approach also drew on earlier black-and-white models, in this case Walker Evans's documentation of the well-worn material culture of American small-town commerce. Dow started in the early 1970s working in black-and-white, but followed trends and switched to color in 1977. By 1979, he had come to recognize not only how color attracted the eye, but also how it allowed photographs to describe complicated indoor spaces, how it reflected off painted walls to imbue surrounding objects with unexpected hue, and how incandescent, fluorescent, and neon lights each delivered their own particular atmospheres.[91] In his 1979 interior view of Argeson's Shoe and Hat Repair Shop, he turns the tables entirely, using a framed black-and-white studio portrait on the counter to set the palette for the image, and to tune the delicate array of white, beige, and brown tones (Plate 3.12). Gradually, the sunlight filling the shop creeps forward to surround the viewer as it would a customer adjusting their eyes to the darkened interior.

Color's new equal status with black-and-white became effectively institutionalized in fall 1979 when the Metropolitan Museum of Art in New York gave Eliot Porter a major retrospective exhibition and the Corcoran Gallery of Art in Washington DC presented

the exhibition *American Images: New Works by Twenty Contemporary Photographers*.[92] The latter project represented the culmination of a grand commission by American Telephone and Telegraph Company (AT&T) designed to summarize the state of contemporary photography.[93] Only seven of the twenty photographers worked in color, but their works, from Jan Groover's continuing kitchen still lifes to Richard Misrach's flash-lit views of Hawaiian foliage at night, gave the show important energy. Harry Callahan, one of the few members of the older generation to be included in the commission, had even returned to color, submitting photographs of overlapping buildings, urban pedestrians, and storefront windows in clean, blocky compositions (Figure 3.19).[94]

By 1980, despite concerns over the dye fading of photographic papers, color photography had gained such wide acceptance that the term "color" was now rarely being used in exhibition titles. Ansel Adams was assembling a book on color wherein he would call the medium "one of the major expressions of our time."[95] The field was ready for a synopsis of the rapid changes that had overwhelmed it. Critic/curator Sally Eauclaire filled that gap with her 1981 book *The New*

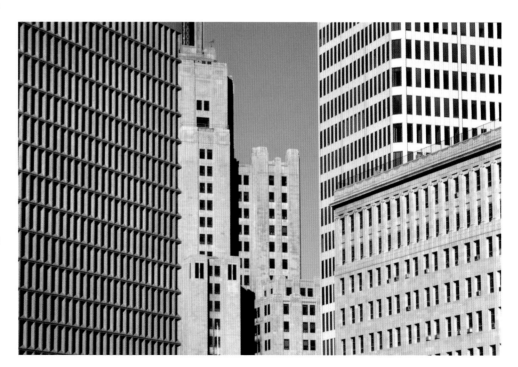

FIGURE 3.19
Harry Callahan (1912–1999), *New York*, 1978. Dye imbibition print. © The Estate of Harry Callahan, courtesy Pace/MacGill Gallery, New York.

Color Photography.[96] "Color is the issue in contemporary photography," she exclaimed right up front. Countering Allan Porter's Swiss *Camera* magazine assessment of 1977, she argued that so many young artist-photographers had recently taken up color not because of its pervasive use in television, advertising, and cinema, or because of improved films and easier-to-use printing papers, but because they had something to say in color.[97] Rather than offering a fresh critical analysis, however, Eauclaire mirrored Szarkowski and Porter right down to their wholesale dismissal of most color photographs made prior to the late 1960s.[98] Before the late 1960s, she asserted, the exaggerated hues of color films made the medium vulgar, preventing artists from being able to bring any subtlety to the process.[99] She dismissed the early color photographs by artists like Ansel Adams, Harry Callahan, and Edward Weston as "more curious than cogent" and lacking the authority of their black-and-white work. The commercial arena and popular photography publications were not any better for their enthusiastic subscription to slick sensationalism and technical play, she argued: "Rather than humbly seek out the 'spirit of fact,' they assume the role of God's art director making His immanence unequivocal and protrusive."[100] Even Eliot Porter's photographs she found compromised by their "jolting color effects" and their overly structured compositions.[101] The key to making successful color photographs, she explained, was to understand the descriptive tendencies of the medium and then to apply that knowledge, not as an end in itself, but to say something about the human condition.[102] Mirroring John Szarkowski, she called William Eggleston the first photographer to fully control these strategies. Color was absolutely necessary to the pictorial cohesion of his images, she argued, even as it was mainly a tool for describing the world.[103]

Almost everyone else was secondary. She called Shore's color too understated and Meyerowitz's Cape Cod work too preoccupied with the beauty of hue. She appreciated Mark Cohen's color photographs, but placed that work one step below that of Eggleston's

because, she felt, Cohen was too self-conscious about the act of photographing and the anomalies of photographic sight.[104] She dismissed John Pfahl's work as merely exploring perception.[105] Fabricated work, she complained, "inadvertently testif[ies] to the expansion of narcissistic trivialization in the 'Me Decade' rather than provide[s] poignant perceptions of it," though Lucas Samaras's Polaroids stood out to her as "genuinely provocative."[106] Even Joel Sternfeld's "American Prospects" project attracted her criticism. She called the work problematic for its passivity and moral framing, which she said favored elegy over clarity.[107] In contrast to that idealism, she suggested, Eggleston implicated himself directly in his images, taking "the romantic position that art can affirm life, unseat complacency, and indict mediocrity," not to explain but to reveal the "inexhaustible potential for speculation that the world itself invites."[108] Eggleston's work was so great, she explained, because his reliance on saturated color was central to communicating his engagement.[109]

The New Color Photography sold so well that it became the first of three analyses of contemporary color photography that Eauclaire assembled and published through the 1980s. Although her successor books introduced more young photographers, they essentially mirrored the first and did not sell nearly as many copies or have as much influence. By the time she published her second book in 1984, the field had already absorbed and moved beyond the Eggleston surprise.

One form that this shift took was Californian Richard Misrach's Desert Cantos. Influenced by the success of Eggleston, Meyerowitz, and Shore, Misrach had started using color film in 1978 to add dimension to an ongoing project depicting the natural world at night. But while he appreciated the intensely saturated blues and greens filling his flash-lit night shots of Hawaiian trees and shrubs and submitted them to the AT&T project, soon thereafter he shifted to more straightforward daytime depictions.[110] Attracted to the contradictions between the harsh aridity and the fast-blossoming economic

development across America's Southwest, he created a series of color photographic meditations on the variety of ways that people were using and misusing that desert landscape.[111] Photographs of highways, rail lines, fires, the landing of a space shuttle, and the aftermath of the flooded Salton Sea reflect the expansive scale of the region's landscape, but it is the pastel palette of the artist's dye coupler photographic prints that evokes the region's heat, harsh light, and unsettling magnitude. His photograph *Submerged Snack Bar, Salton Sea* (1984) is a perfect example, suggesting a mirage of indefinable color extending indefinitely in all directions, perforated by abandoned buildings and power lines (Figure 3.20).

Los Angeles photographer Robert Glenn Ketchum was moving at this same time to the other extreme, challenging notions of acceptable naturalism through landscapes of deeply saturated color. He created images like *Brewster Boogie Woogie, 27* (1979; Plate 3.13) at the height of the Hudson River Valley's autumnal season, then printed them in the bright, glossy palette of the silver dye-bleach process. In this woodland scene, a patchwork of brilliant orange, red, and yellow leaves delivers colors that lie right at the edge of believability.[112] Such color exaggeration is the artist's point, and the foundation for his Mondrian-rooted title. If the leaves seem structurally real, their almost unreal color signals the artist's hand (much

FIGURE 3.20
Richard Misrach (b. 1949), *Submerged Snack Bar, Salton Sea*, 1984. Dye coupler print, 1985. Amon Carter Museum of American Art, Fort Worth, TX. © Richard Misrach, courtesy Fraenkel Gallery, San Francisco, Pace/MacGill Gallery, New York, and Marc Selwyn Fine Art, Los Angeles.

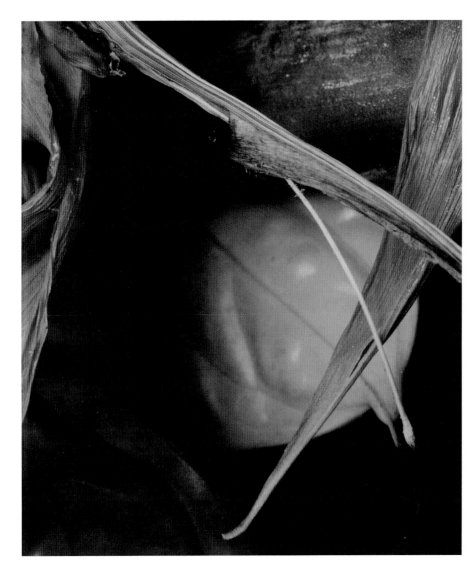

FIGURE 3.21
Chris Enos (b. 1944), *Untitled*, 1980. Dye diffusion print. Courtesy the artist.

the way soft-focus did for pictorialist photographers in the beginning years of the twentieth century) and color's flexibility. Printed at 30 × 40 inches, the photographs opened a new door to challenging painting, at least in wall presence.

Polaroid's introduction of a 20 × 24–inch version of its instant color technology in 1978 added further to the artists' embrace of color. Here too the company took up the practice of inviting artists to use the camera, and these artists quickly found that the oversized film delivered the subtlety of Polaroid's initial Polacolor films, at least in the camera's studio setting, where the film's colors could be best controlled. Lucas Samaras used it to make more self-portraits. Boston

photographer Chris Enos spent days in the studio exploring the subtlety with which the film could render the moist textures and hues of flowers that were well into decay (Figure 3.21).[113] Chicago artist Barbara Kasten used her training as a painter and commitment to the Bauhaus aesthetic to create interlocking assemblages of triangles, pyramids, and rhomboids that, through meticulous clean lighting and mirrors, inhabit a space that, like Jan Groover's Kitchen Still Life series forms, project solidity, dimension, and flatness simultaneously (Plate 3.14). Where Groover's assemblages retain solidity, Kasten's constructions hover between reality and hallucination, delivering a feeling more akin to the paintings of El Lissitzky than to photography.[114]

THE GROUNDS FOR FINE ART photography had changed dramatically. Young practitioners now graduating from university MFA programs understood the varied vocabularies of available color print processes—that dye coupler papers offered a muted pastel gamut while silver dye-bleach papers like Cibachrome exhibited a heavier, more saturated array of hues. They also accepted the wide latitude delivered by the notion of believable color. Grass and leaves could take on a wide variety of tones and still be considered reflections of the world. Equally influencing young photographers' thinking about color was a shift from outside the field. The solidification of a distinct art market for photographs had led some aspiring artists to adamantly declare that they were not photographers, but artists who used the camera.[115] While that shift was strategic—they could get higher prices for "art" than for "photographs"—it also reflected a rejection of the central tenets by which Szarkowski had come to define photography: as a craft with a distinct lens-based character and relationship to the world. Once photography lost this mechanical essentialism, picture taking became picture making, and reflecting the world became only one option, and a very flexible one at that. For some artists, this recognition opened the door to using color, not to simply record, surprise, or organize space, but as a means for clarifying and

intensifying their artistic and social messages. Such directed use of color gained additional grounding from the simultaneous wide intellectual embrace of semiotics as a meaningful way of understanding the world's layered meanings. In that embrace, truth became multifaceted and meaning became fluid, dependent on context, audience, and cultural expectation. In this new postmodernist world, while photographic color still often retained its connection to naturalism, it also comfortably absorbed the language of symbolism.

Inspired by a 1976 exhibition of Paul Outerbridge's early tricolor carbro photographs, Los Angeles photographer Jo Ann Callis keyed into these changes, creating staged marital and domestic dramas that deliberately mimic 1930s and 1940s fashion photography in their simplified palettes and sparsely furnished settings.[116] But where the earlier fashion photographers used color to clarify space and entertain, Callis applied it to shape her messages. In *Man and Tie*, for example, a model sulks uneasily against a wall of subtly patterned brown wallpaper, his disheveled white shirt open at the collar and his black tie pulled aggressively down as if the camera has found him at the end of a night at the disco (Figure 3.22). Only the lower section of his face is lit as if he were lounging at the edge of a stage. The bright light and deep shadow draw attention to his ruddy lips, his slightly open mouth, and his androgynous appearance. The lips and the wall behind him are the most colorful objects in the photograph. From there the image interrogates the language of black-and-white. Against the white shirt, the black tie reads as a blank open space, drawing attention down to the man's light gray pants and crotch. The photograph sits elegantly on the axis of color and black-and-white, male and female, description and narrative.

While Callis was creating her living tableaus of human isolation in Los Angeles, in New York Laurie Simmons was using color to draw attention to the fact that, despite the blossoming of feminism, women still were defined by traditional roles in the home. Her clearly fictional dollhouse constructions

FIGURE 3.22
Jo Ann Callis (b. 1940), *Man and Tie*, 1977. Dye imbibition print. George Eastman House, International Museum of Photography and Film, Rochester, NY. Courtesy the artist.

like *Woman/Red Couch/Newspaper* (1978; Plate 3.15) draw the viewer in with their saturated children's toy palette and their snapshot print size. The blonde female doll sits demurely at one end of the couch, her bright red, patterned dress blending into the seat and rug below. Her hands reach out as if to an unseen male whose miniature copy of *The New York Times* lies on the couch to her right. The scene is a bit too modern to fit the saccharine character of conventional dollhouses. It is framed from above, drawing attention to the fabrication. By employing the explicit artifice of bright colors and toys of young girls' games, Simmons injects humor into a topical issue, drawing effective attention to one root of continuing sexual stereotyping.

If Simmons was using dolls to question convention, others, including Tina Barney and Nan Goldin, were using their own lives. Goldin's snapshot-driven exploration of friendship, love, sex, violence, gender, and death as she transitioned in the late 1970s from her graduate-student days in Boston and Provincetown, Massachusetts, to the AIDS-afflicted and drug-inflected culture of New York's Bowery neighborhood, is particularly powerful, delivering the haunting intimacy of a private diary. The project, which she started showing publicly in 1978, took its cues from photographers Danny Lyon and Larry Clark, who had documented their own and others' lives at the edges of mainstream society in black-and-white over the preceding decade.[117] Offered initially as a presentation of up to eight hundred color slides, and published in book form by Aperture in 1986, "The Ballad of Sexual Dependency" complicates the stereotype of self-assured independent feminist, influencing a generation of women to photograph their own lives. Although one tends not to think of the series in terms of color, Goldin is too sophisticated a photographer not to make effective active use of it, at least in the project editing. In *The Hug, New York City* (1980; Plate 3.16), for example, the brilliant blue dress of Goldin's friend creates a foil around which everything else revolves. The only bright color in the image, the dress warmly counterpoints the woman's

jet-black hair, the deep black shadow created by the camera's flash, and the white-painted surroundings tinged with photographic cyan. So thoroughly does the blue dress dominate the scene that only gradually does one see the muscular arm wrapped tightly around her waist. The image is not singular. Goldin's photographic diary is not about color, but its images often use color to set atmosphere and draw attention to details like the bruises, tattoos, and makeup.

Where Goldin's photographs exude the heat and pain of young adults freed from the bounds of societal convention, Tina Barney extends this photographic conversation about class, status, stereotype, and convention to the cool constricting propriety of her upper-class family. Working with a view camera (as opposed to Goldin's 35mm camera), Barney has blended semi-candid shots with carefully posed tableaus. Her subjects may ignore her camera, but they cannot disregard the fact that they are being photographed. Where Goldin's images are often filled with flashes of bright color, Barney's decorator-refined settings offer more muted tones. The images exude privilege and stasis in their trappings and balance. This is not by mistake. Barney explained: "When people say that there is a distance, a stiffness in my photographs, that the people look like they do not connect, my answer is, that this is the best that we can do. This inability to show physical affection is in our heritage."[118] Her image *Beverly, Jill, and Polly* (1982; Plate 3.17) shows three women in a bedroom, each attending privately to their thoughts. The room's blend of pastel greens, pinks, and purples sets the controlled terms of the photograph. The three women are tied together by their white clothing, but they live in culturally and financially different worlds. While the two white women lounge in the back of the room, a black maid picks up their magazines strewn across the bed. The bright yellow blanket draws attention to her and marks her clear separation from the comfortable wealth that surrounds her. She also is the person who most connects with the world. At the second of the exposure, her attention is stopped short by a headshot of a white woman filling the front page of

the magazine she has just picked up. The magazine she quickly peruses presents all that she is not in race, wealth, and temporal freedom.

While Goldin and Barney were inviting viewers into their lives, Cindy Sherman was in the early stages of a prolific and still ongoing exploration of constructed persona that Golden and Barney take at face value. Her entertaining self-portraits, which presage the theatricality that would soon come to dominate photography, reflect her full absorption of the postmodern questioning of truth that had been blasting through photographic circles over the preceding ten years.[119] What one sees in them, or thinks one sees, may or may not be actually what is occurring. The artist's intent is less the point than what the viewer brings to each of her images. For Sherman, making such photographs does not identify her as a photographer of the world but as an artist constructing new worlds. Although she has built a sparkling career of photographing herself, the results deliver insight into her personality and thoughts in only the most circuitous way. Her subject is not herself, but a far more generic, constantly changing female character, an actress who has stepped out of narrative to offer momentary dramas that the viewer knows to be pure artifice, where truth is less important than the immediate emotional statement. As soon as Sherman took up color around 1980, she made it a central part of her vocabulary. Following the models of cinema and theater, in images like *Untitled #85* (1981; Plate 3.18) she uses color to paint atmosphere and reinforce emotion as much as to describe form. Here, the white midday light streaming in from just outside the image in the upper right delivers a reference point around which all the other colors resolve. Sherman created this performance for her Centerfolds series, but the image is far from a centerfold in the traditional sense. The red glow off to the left draws acute attention to her exhaustion. One is left free to stare, but the invitation to ogle is missing.

If naturalism was the dominant force in photography, the medium had not entirely let go of its printmaking proclivities in the early 1980s, and it is here that photography's redefinition as a flexible artistic tool solidified in the form of Sandy Skoglund's translations of Pop-Art kitsch into room-sized nightmares. The artist painted everything—from furniture to floors, walls, and ceilings—the same bright, synthetic color. She then blanketed these spaces with clearly fake accoutrements, like animals that she sculpted herself. Photographing these installations allowed her to break free from what she has called "the tragedy of ephemeralness" underlying installation art.[120] But these photographs are more than mere documentation. Skoglund actually designed each installation with constant reference to what it would look like through the camera lens, and even displayed that photograph next to the room to raise the question of which work, installation or photograph, was the art piece.[121] *Revenge of the Goldfish* (1981; Plate 3.19) is typical. Here she presents a woman sleeping and a young boy sitting drowsily on the edge of the same bed in a room painted entirely turquoise and filled with "floating" oversized, orange goldfish. In this fabricated world, the fish, not the humans, are in control, and life is a mix of reality and dream.

Nic Nicosia started interrogating photography's documentary aura with similar room fabrications in 1982, creating cartoon-like blendings of three-dimensional solidity and two-dimensional illusion that were constructed strictly to be photographed. His *Near (modern) Disaster #8* (1983; Figure 3.23), presenting a comic, obviously fictional vision of tourists straining against a ferocious wind, holds more in common with theater than reality. Its bright colors and clean lighting (suggestive of a television studio) shouts its joke, yet the cleverness of the activity induces one to accept the ruse and to smile along with the photographer.[122]

If colorful fabrication for Nicosia and Skoglund was a game to be played, a light fiction, in the hands of Patrick Nagatani and Andrée Tracey it becomes a tool for more serious political agitation.[123] In reaction to the Reagan administration's nuclear-tinged

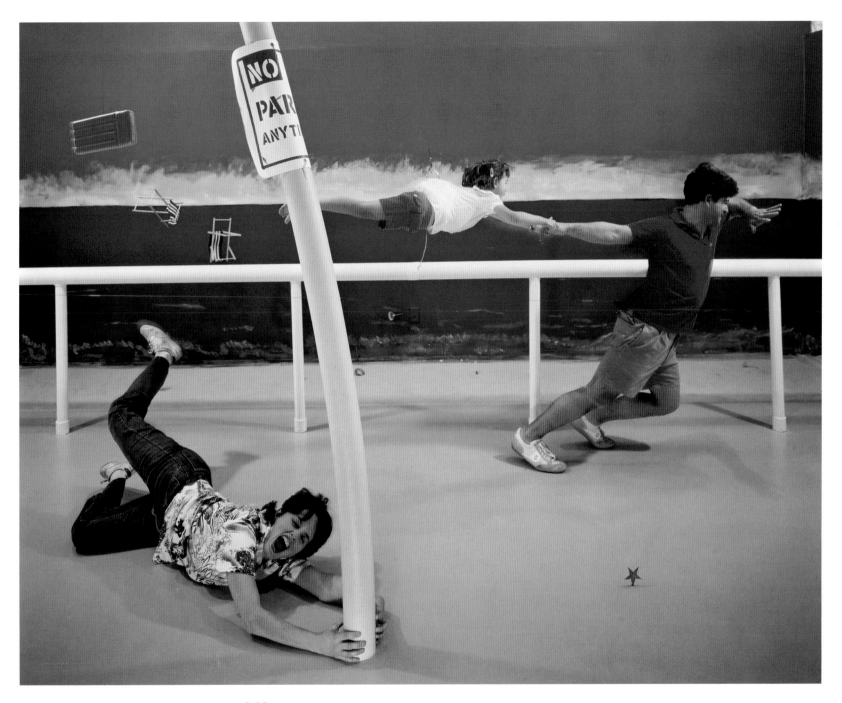

FIGURE 3.23
Nic Nicosia (b. 1951), *Near (modern) Disaster #8*, 1983. Silver
dye-bleach print. Courtesy the artist and Talley Dunn Gallery,
Dallas.

militaristic rhetoric, these artists developed vignettes portraying characters living consumerist "What, me worry?" lives perched on the edge of disaster. Their *Alamogordo Blues* (1986; Plate 3.20), a spectacularly saturated diptych of realistic and patently false color made with Polaroid's 20 × 24–inch camera, is based on a photograph of men watching a 1952 test of a nuclear bomb. It unnervingly presents a group of "Japanese tourists," including Nagatani and his cousins, stereotypically dressed in white shirts and ties and sitting in Adirondack chairs, excitedly photographing the explosion with their Polaroid SX-70 cameras. The blue light filling the foreground separates the men from the viewer in suggestion of a darkened theater, but this is not a game. Their flying snapshots might suggest humor, but the obviously painted backdrop projects the scarring of nuclear catastrophe. Its bright, clearly false hues deliver the diptych's power. This is not the world we see out our window. The colors' fake brilliance is absolutely necessary to communicate the passion and violence of the scene.

By the late 1980s, New York photographer Andres Serrano was making photographs that applied color to strike in equally visceral fashion at the heart of America's cultural vocabulary. Much like William Christenberry, who built some of his most compelling artworks out of his mutual attraction and revulsion to the Ku Klux Klan, Serrano had committed himself early in his career to challenging his viewers' deepest emotions, beginning with images of dead animals and hanging human bodies. Elegant in their clean lighting and balance, they could be product shots, but their subjects, rooted in the artist's Catholicism, deliver terror instead.[124] Serrano then chose to ramp up the challenge by incorporating bodily fluids, like blood, breast milk, and, most notoriously, urine, into his compositions. Printed up to 60 × 40 inches on glossy dye destruction paper, the photographs use color as their starting point. The paper's liquid hues attract the eye, leaving one then to hesitate and finally recoil at discovery of their subject. Serrano's most famous piece in this series presents a small crucifix

within a bubble-infused deep yellow liquid that one could easily believe to be amber or polyurethane. But the title, *Piss Christ*, instantly changes the dynamic; the artist's explanation that the yellow color in the photograph is his own urine raises the specter of sacrilege. Serrano tried to cut the uproar generated by this image by explaining that he made it to draw attention to the widespread commercialization of cheap Christian icons in contemporary culture rather than to demean religion, but he was clearly responding to the strident neoconservatism and religious fundamentalism that had arisen in backlash to a perceived dilution of moral and patriotic standards across the United States—joining what has become known as the "culture wars." When he exhibited this image in New York in 1989, conservatives were outraged to find that it had been produced with assistance from the federal government's National Endowment for the Arts. New York Senator Alfonse D'Amato ripped up a copy of *Piss Christ* on the Senate floor, and North Carolina Senator Jesse Helms declared: "I do not know Mr. Andres Serrano, and I hope I never meet him, because he is not an artist, he is a jerk."[125] One could just as easily argue, as the critic bell hooks has, that Serrano is bringing the sacrament down to its most personal and human level by tying it to the commonness of universal bodily functions.[126] *Piss Christ* was only the most openly provocative of Serrano's series of photographs of Christian icons dunked in bodily liquids. Other images present the Last Supper, the Madonna, angels, and the Pope. In the slightly more temperate *Madonna and Child II* (1989; Plate 3.21), the yellow liquid bathes the icon in a warm soft-focus glow. The orange shadowing on the figures further enhances that calming presence, until one notices the mucus-like case of bubbles connecting the Christ child's forehead to his mother's cheek. Even today these images incite great anger, leading some activists to try to destroy them when they encounter them.[127]

At the decade's end, Carrie Mae Weems similarly heralded color's cultural power in her project the

Colored People series, but to different ends. By over-laying graciously rendered black-and-white portraits of children and teenagers with blue, brown, green, or magenta hues, then labeling them with appellations like *Blue Black Boy* (1989–1990; Plate 3.22), she calls attention to photography's longstanding connection to cataloguing and to African Americans' proclivity for creating a hierarchy of skin color.[128] The project points out the range of skin colors covered by the term "black," reflecting on the identity politics that had risen from the civil rights movement, critiquing the extremes of such categorizing while accepting it as a fact of life. It also reflects color photography's willingness to challenge painting on its own terms. ◆

1. Hilton Kramer, "Art: Focus on Photo Shows," *The New York Times* 125, no. 43,224 (May 28, 1976): section C, 18, col. 5–8.

2. Eugene Ostroff, ed., *Pioneers of Photography: Their Achievements in Science and Technology* (Springfield, VA: The Society for Imaging Science and Technology, 1987), 206. *LIFE* magazine had already devoted its thirtieth anniversary issue to photography. "30th Anniversary Special Double Issue: Photography," *LIFE* 61, no. 26 (December 23, 1966). On October 21, 1974, *Newsweek* would do the same. In this cover story, Douglas Davis would suggest that Americans made an estimated six billion photographs that year. Douglas Davis, "Photography," *Newsweek*, October 21, 1974, 64.

3. Ostroff, *Pioneers of Photography*, 207. Kodak introduced RC (resin-coated) paper in 1968 and Ektaprint 3 color printing paper in 1970. By 1971, six major companies were marketing color papers. Paul Farber, "1-2-3-4-5-6: Color Printing Papers Compared," *Camera 35* 16, no. 1 (January–February 1972): 38–41, 75–77.

4. The exhibition highlighted a new silver dye-bleach color printing process called Cibachrome that offered high-saturated colors. Michael Bry, "Gallery Snooping," *Modern Photography* 34 (October 1970): 34.

5. A. D. Coleman, "I Have a Blind Spot About Color Photographs," *The New York Times* 120, no. 41490 (August 29, 1971): section D, 26, col. 2–6; also A. D. Coleman, *Light Readings: A Photography Critic's Writings, 1968–1978* (New York: Oxford University Press, 1979), 78–79.

6. Ibid. Coleman was reviewing the annual display of the CAMERA/Infinity photographers cooperative.

7. A. D. Coleman, "More on Color: Readers Speak Out," *The New York Times*, November 7, 1971; also Coleman, *Light Readings*, 85–88.

8. Duncan went on to suggest: "I can take the mood down to something so terrible that you don't realize the work isn't in color. It is color in your heart but not in your eye." Quoted in R. Smith Schuneman, *Photographic Communication: Principles, Problems, and Challenges of Photojournalism* (New York: Hastings House, 1972), 88; also Stephen R. Milanowski, "The Biases Against Color in Photography," *exposure* 23, no. 2 (Summer 1985): 14.

9. Coleman, *Light Readings*, 87.

10. William Jenkins, "Some Thoughts on 60's Continuum," *Image: Journal of Photography and Motion Pictures of the International Museum of Photography at the George Eastman House* 15, no. 1 (January 1972): 16.

11. Van Deren Coke offers one summary of these practices. Van Deren Coke, "60's Continuum," *Image: Journal of Photography and Motion Pictures of the International Museum of Photography at George Eastman House* 15, no. 1 (March 1972): 1–6. Jonathan Green also makes the subject of "photography as printmaking" a chapter of his book. Jonathan Green, *American Photography: A Critical History, 1945 to the Present* (New York: Harry N. Abrams, Inc., 1984), 143–162.

12. See Steve Yates, *Betty Hahn: Photography or Maybe Not* (Albuquerque: University of New Mexico Press, 1995); and Robert A. Sobieszek, *Robert Fichter: Photography and Other Questions* (Albuquerque: University of New Mexico Press, 1983). See Nettles's large piece *Sister in the Parrot Garden* now in the collection of the Philadelphia Museum of Art.

13. Heinecken was interested in using photography as a tool rather than an end product. In the late 1960s, he had learned from Edmund Teske that by placing magazine pages on a light table he could create subversive blends of news and advertising. He also was making hand-colored photograms of food. See Lynne Warren, et al., *Robert Heinecken: Photographist* (Chicago: Museum of Contemporary Art, 1999), 48–59. His student, Judith Golden, would be doing a similar thing by 1976, inserting her face into celebrity portraits gracing the covers of *People* magazine.

14. Todd Walker, . . . *One Thing Just Sort of Led to Another* . . . (Tucson: University of Arizona, 1979).

15. Author's conversation with Melanie Walker, August 16, 2012, Curatorial Research Files, Amon Carter Museum of American Art, Fort Worth, TX.

16. Walker became enamored of color in the early 1940s when, as a teenager, he had a job painting faux-finish backdrops for RKO Studios in Los Angeles. There he had learned on films like *Citizen Kane* how to translate colors so that they registered appropriately on black-and-white film. Charged with cleaning out paint buckets at the end of each day, he amused himself by seeing what new colors he could create by pouring the contents of one can into another.

17. Nathan Lyons, *Toward a Social Landscape* (New York: Horizon Press in association with George Eastman House, Rochester, New York, 1966).

18. The first exhibit, *Eleven Washington Photographers*, ran May 14–June 20, 1971, and the second, a mix of photographs and sculpture, *William Christenberry: Photographs*, ran April 13–May 27, 1973, at the Corcoran Gallery of Art, Washington DC.

19. Ed Ruscha, *Twentysix Gasoline Stations* (Alhambra, CA: Cunningham Press, 1962). The same year that Shore made the postcards, he assembled a show of black-and-white photographs comprised of newspaper images, photo booth portraits, police mug shots, and snapshots at 98 Greene Street Loft, an alternative gallery space run by Holly and Horace Solomon. He called the 1972 show *All the Meat You Can Eat.*

20. Shore spent extensive time at The Factory from 1965 to 1967. He was only seventeen years old when he first showed up there.

21. See Stephen Shore, *American Surfaces* (London: Phaidon Press Limited, 2005), 9. Shore describes the Light Gallery show in "Stephen Shore in a Conversation with Lynne Tillman," *Uncommon Places: The Complete Works* (New York: Aperture Foundation, Inc., 2004), 173–174.

22. See Kevin Moore's discussion of Mitch Epstein in *Starburst: Color Photography in America, 1970–1980* (Ostfildern, Germany: Hatje Cantz Verlag, 2010); Joel Sternfeld, *First Pictures* (Göttingen, Germany: Steidl, 2011); and Colin Westerbeck, *Joel Meyerowitz* (London: Phaidon Press Limited, 2001).

23. Polaroid introduced the SX-70 in 1972. In April 1976, Kodak introduced its own instant-color photographic process. Within a week of that announcement, Polaroid sued the company for patent infringement, a case that Polaroid would finally win in 1986.

24. One purchased a special Polaroid camera and ten-packs of film that had the developing agents built in. The careful coating of the finished prints required by earlier Polaroid products was no longer necessary.

25. Steve Crist, ed., *The Polaroid Book: Selections from the Polaroid Collections of Photography* (Köln, Germany: Taschen GmbH, 2005).

26. Three years earlier he had published a declaration wherein he had strongly castigated most color photography as banal, too focused on color for color's sake, and consistently undercut by bad printing. See Walker Evans, "Photography," in *Quality: Its Image in the Arts*, ed. Louis Kronenberger (New York: Atheneum, 1969).

27. Used to seeing his photographs larger, Evans took full advantage of Polaroid's offer to produce 5 × 5–inch and 8 × 8–inch enlargements of these images. A large selection of these copy prints are in the Walker Evans archive at the Metropolitan Museum of Art. Ironically, Polaroid printed the enlargements on Kodak dye coupler paper.

28. Samaras had taken up Polacolor film in 1971 to create self-portraits. See Lucas Samaras and Peter Schjeldahl, *Lucas Samaras* (New York: Pace/MacGill Gallery, 1991).

29. *Afterimage* (September 1973): 14.

30. The Visual Studies Workshop's students followed Walker's special instructions to make the reproductions in Rochester. The print illustrated an extended article detailing Walker's achievements.

31. Syl Labrot, "Syl Labrot: Work in Progress, The Invention of Color Photography," *Afterimage* 2, no. 3 (September 1974), 7.

32. William Eggleston, *14 Pictures* (Washington DC: Harry Lunn, 1974). The Levitt exhibition, *Projects: Helen Levitt in Color*, ran September 26–October 30, 1974.

33. Sandra S. Phillips and Maria Morris Hambourg, *Helen Levitt* (San Francisco: San Francisco Museum of Modern Art, 1991), 60–61. See also John Szarkowski, *Slide Show: The Color Photographs of Helen Levitt* (Brooklyn, NY: powerHouse Books, 2005).

34. *The New York Times* would use this image to represent color photography on the cover of its July 23, 1978, Sunday magazine issue devoted to celebrating photography.

35. "Helen Levitt in Color, September 26–October 20, 1974," press release, Folder: Exhibition 1074a, *Helen Levitt in Color*, the Museum of Modern Art Archives, New York.

36. Committed to supporting young photographers, Eastman House supplemented its Muray show with a display of large hand-colored photographs by Russell Drisch, and followed it up with a show of color photographs by Michael Becotte and Roger Mertin titled "Road Shots."

37. Complementing the debates over how to use color were rising concerns over the speedy deterioration of color photographic prints due to unstable dyes. In October 1975, Eastman House director Robert Doherty opened a colloquium on the preservation of color photographs with the declaration that museums do not collect color because "it doesn't last." "Color Photographs: Must They Always Fade?," *Afterimage* 3, no. 5 (November 1975): 16.

38. Max Kozloff, "Photography: The Coming of Age of Color," *Artforum* 13, no. 5 (January 1975): 30–35; also, Max Kozloff, *Photography & Fascination* (Danbury, NH: Addison House, 1979), 183–196.

39. *LIFE* magazine died as a weekly in 1972. Kozloff suggested of Haas: "His multiple styles were, indeed, at the mercy of these 'patterns,' this 'dynamism,' all a-flutter within the meringues and frappés of a hyped-up palette." Kozloff, *Photography and Fascination*, 188. Haas's 1971 book, *The Creation* (New York: The Viking Press, 1971), had found such sales success that, like Eliot Porter, he started making photographs for book projects.

40. Kozloff, *Photography and Fascination*, 188–190.

41. The photographs reflect a commercial sensibility of highly saturated color and contentment with the slight amusements of superficially conveyed oddity. See Neal Slavin, *When Two or More Are Gathered Together* (New York: Farrar, Straus and Giroux, 1976).

42. Kozloff, *Photography and Fascination*, 193.

43. Kozloff tied Shore's photographs to Eugene Atget's documentation of Paris in the early twentieth century, and suggested that amateurs might have similar photographs in their carrousels. Kozloff, *Photography and Fascination*, 193–195.

44. Meyerowitz has explained that he took up street photography under the influence of Henri Cartier-Bresson and Robert Frank. When he started photographing on his own in 1962, he shot color slide film. He then switched largely to black and white for the ease of making his own prints, returning more wholly to color in 1973 when color printing became easier. Kozloff could just as easily have mentioned Mitch Epstein or Joel Sternfeld, though neither photographer was yet showing their color work.

45. See William Jenkins, *New Topographics: Photographs of a Man-altered Landscape* (Rochester, NY: International Museum of Photography, George Eastman House, 1975).

46. Szarkowski presented Eliot Porter's dye imbibition nature studies in the 1963 exhibition *The Photographer and the American Landscape* (September 24–December 1) and Garry Winogrand's color slides in the 1967 exhibition *The New Documents* (February 28–May 7). But when the bulb burned out in the projector showing Winogrand's work after the first few days, the curator decided not to get it fixed, perhaps acceding to the photographer's mixed feelings about the work. He had mentioned Paul Outerbridge's color work in *Looking at Photographs*, but dismissed it as mere commercial illustration. John Szarkowski, *Looking at Photographs: 100 Pictures from the Collection of The Museum of Modern Art* (New York: The Museum of Modern Art, 1973). However, he did invite photographers who worked in color, including William Eggleston, into his Cooper Union photography classroom. Moore, *Starburst*, 20–21.

47. Eggleston had connected in New York with photographers Diane Arbus, Lee Friedlander, and Garry Winogrand, and it is likely that at their urging Szarkowski met with Eggleston and first saw his color photographs.

48. Despite Harry Lunn's portfolio of the artist's work of two years earlier, and Eggleston's already having been awarded a John Simon Guggenheim Artist's Fellowship and National Endowment for the Arts Photography Fellowship, the photographer was still little-known beyond the close-knit world of East Coast curators and dealers.

49. John Szarkowski, *William Eggleston's Guide* (New York: The Museum of Modern Art, 1976). Szarkowski had wanted to present this young Memphis photographer's work for several years and had held the show off until he could raise the funds to produce a book in conjunction with the show.

50. Henri Cartier-Bresson, *The Decisive Moment* (New York: Simon and Schuster, 1952); Robert Frank, *The Americans* (New York: Grove Press, 1959); and Joel Meyerowitz, conversation with John Rohrbach, March 25, 2012, Curatorial Research Files, Amon Carter Museum of American Art, Fort Worth, TX.

51. Moore, *Starburst*, 28. Historian Kevin Moore suggests that Eggleston's images convey a tone of "affectless loafing" reflecting an acceptance of defeat from idealism of the 1960s, and a "make-of-it-what-you-will attitude" in line with the apathy of the 1970s.

52. William Eggleston, *Ancient and Modern* (New York: Random House, 1992), 17–18.

53. Ironically, Strand would die in June 1976.

54. Kramer, "Art: Focus on Photo Shows."

55. Ibid.

56. Gene Thornton, "Photography Found a Home in Art Galleries," *The New York Times* (December 26, 1976): section D, 29, col. 2–3; section D, 39, col. 1–2.

57. Janet Malcolm, "Photography: Color," *The New Yorker*, October 10, 1977, 107–111; also Janet Malcolm, *Diana & Nikon: Essays on Photography* (New York: Aperture, 1997), 78–87.

58. Ibid., 80, 82. For confirmation, she shared her experience at a symposium at the new International Center of Photography, up the street from MoMA where Eggleston had been so inarticulate that the initially sympathetic crowd had turned against him, making the session strange and painful for everyone. That

event symbolized, she argued, how the artist's photography "doesn't quite add up." Ibid., 86–87.

59. Arnold Gasson, "Janet Malcom [*sic*] and the *New Yorker* criticism," *exposure* 14:4 (1976), 22–23.

60. Szarkowski, *William Eggleston's Guide*, 7–9.

61. Ibid., 9.

62. John Szarkowski, Introductory text panel for *Photographs by William Eggleston*, "Eggleston Publicity," Curatorial Exhibition Files, Exh. #1133, the Museum of Modern Art Archives, New York.

63. Cornell Capa to John Szarkowski, June 4, 1976, "Eggleston Party" folder, the Museum of Modern Art Archives, New York.

64. Clement Greenberg to John Szarkowski, July 6, 1976 "Eggleston Publicity" folder, the Museum of Modern Art Archives, New York.

65. John Szarkowski to William Eggleston, June 6, 1975, "Coresp with Eggleston & memos re: printing," Curatorial Exhibition Files, Exh. #1133, the Museum of Modern Art Archives, New York.

66. Szarkowski, *William Eggleston's Guide*, 12–14. In a September review in *Afterimage*, Dan Meinwald called the artist's photographs "emblematic of themselves." Dan Meinwald, "Reviews: Color Me MOMA," *Afterimage* 4, no. 3 (September 1976): 18.

67. John Szarkowski, "Wall Label for William Eggleston Show" folder, the Museum of Modern Art Archives, New York.

68. Max Kozloff, "How to Mystify Color Photography," *Artforum* 15, no. 3 (November 1976): 50.

69. Sean Callahan, "MOMA Lowers the Color Bar," *New York Magazine* 9, no. 26 (June 28, 1976): 74–75.

70. John Szarkowski, *Walker Evans* (New York: The Museum of Modern Art, 1971).

71. Between 1981 and 1985 MoMA produced four major books of Atget's work.

72. Warren Nistad, "Eggleston Photographs Color a Range of Experience," *Willamette Week* (May 2, 1977): 11.

73. Allan Porter, "The Second Generation of Colour Photographers," *Camera* 56, no. 7 (July 1977): 3–4.

74. Following Szarkowski, Porter called Marie Cosindas, Eliot Porter, and Edward Weston bridges between the first and second generations. Ibid.

75. Shore has suggested that he took up the 8 × 10 view camera at the urging of John Szarkowski.

76. Shore's appreciation for the vernacular induced Robert Venturi and Denise Scott Brown to include his work in their Renwick Gallery exhibition *Signs of Life: Symbols in the American City*, February 26–September 30, 1976. Robert Venturi, *Signs of Life:*

Symbols in the American City (New York: Aperture, Inc., 1976).

77. Meyerowitz explained his early color investigations to the author. Joel Meyerowitz, conversation with John Rohrbach, March 28, 2012, transcript, Curatorial Research Files, Amon Carter Museum of American Art, Fort Worth, TX.

78. Joel Meyerowitz, *Cape Light* (Boston: Museum of Fine Arts, 1978).

79. Reviewing the show in the *SoHo Weekly News*, Andy Grundberg suggested that in an age of gas lines, nuclear leakage, and the Ayatollah Khomeini, Meyerowitz's photographs offered relief in their updating of the picturesque. Andy Grundberg, "Joel Meyerowitz Gets His View," *SoHo Weekly News*, July 26, 1979; also Moore, *Starburst*, 261, note 154.

80. Henry Holmes Smith, "Color on the Cusp," in Robert Fichter, *Colors*, limited edition portfolio of original offset lithographs (Tallassee: Florida State University, 1975).

81. A. D. Coleman, "The Directorial Mode: Notes toward a Definition," *Artforum* 15, no. 1 (September 1976): 55–61; also, Coleman, Light Readings, 246–257.

82. Van Deren Coke, *Fabricated to Be Photographed* (San Francisco: San Francisco Museum of Modern Art, 1979).

83. See Cheryl Brutvan, *A Distanced Land: the Photographs of John Pfahl* (Albuquerque: University of New Mexico Press in association with Albright-Knox Art Gallery, 1990).

84. See *Jan Groover, Pure Invention: The Tabletop Still Life* (Washington DC: Smithsonian Institution Press, 1990).

85. To broaden her palette, Groover sometimes inserted peppers or houseplants into her compositions. In late 1976, when the Sonnabend Gallery presented Groover's "Kitchen Still Lifes," critic Ben Lifson related the photographs to the paintings of Cézanne and called the show the year's "most exciting event in photography." Ben Lifson, "Jan Groover's Abstractions Embrace the World," *The Village Voice*, November 6, 1976; also Moore, *Starburst*, 28.

86. In 1975, Cohen had exhibitions of his photographs at Light Gallery and the Art Institute of Chicago.

87. Cohen later claimed that he worked no differently in color than he did with black-and-white film, though his color images are defined far less by shadow and obvious flash illumination than his previous work. Mark Cohen, *True Color* (Brooklyn, NY: powerHouse Books, 2007), 14.

88. On July 23, 1978, *The New York Times Magazine* would run a cover story about photography's rising status. The following year, photography dealers found enough of a core to organize a business association, the Association of International Photography Art Dealers (AIPAD).

89. Jessica May, "Joel Sternfeld's Early Pictures," in *First Pictures*, ed. Joel Sternfeld (Göttingen: Steidl, 2011).

90. Sternfeld published the project in 1987. Joel Sternfeld, *American Prospects* (New York: Times Books in association with the Museum of Fine Arts, Houston, 1987). Although he chose a seemingly optimistic title for the book, his photographs suggest that the country's contemporary prospects are far more limited than the national ideals would suggest.

91. See *American Studies, Photographs by Jim Dow* (Brooklyn, NY: powerHouse Books, 2011).

92. *Eliot Porter, Intimate Landscapes* (New York: The Metropolitan Museum of Art, 1979). Renato Danese, ed., *American Images: New Work by Twenty Contemporary Photographers* (New York: McGraw-Hill Book Company, 1979). That same year, the Metropolitan Museum of Art presented an Eliot Porter retrospective, the first color show it would provide for a living photographer, and Sally Stein rediscovered that the Farm Security Administration photographers had used color film. See Sally Stein, "FSA Color: The Forgotten Document," *Modern Photography* 43, no. 1 (January 1979).

93. The photographers were chosen by project director Renato Danese with the assistance of Jane Livingstone, associate director of The Corcoran Gallery of Art; Ted Hartwell, curator of photography at The Minneapolis Institute of Arts; and Carole Kismaric, managing editor at Aperture. Danese was by the project's completion Assistant Director of the Visual Arts Program of the National Endowment for the Arts. The photographers were allowed to photograph whatever they wanted as long as they created their images in the United States.

94. In 1980, Callahan would see publication of two books of his color photographs. Sally Stein and Terrence R. Pitts, *Harry Callahan: Photographs in Color / The Years 1946–1978* (Tucson: Center for Creative Photography, University of Arizona, 1980); and Robert Tow and Ricker Winsor, ed., *Harry Callahan: Color, 1941–1980* (Providence, RI: Matrix Publications, 1980).

95. Quoted in Harry M. Callahan, ed., *Ansel Adams in Color* (New York: Little, Brown and Company, 2009), 12.

96. Sally Eauclaire, *The New Color Photography* (New York: Abbeville Press, 1981). With assistance from the National Endowment for the Arts, a two-hundred-print exhibition was organized by the Everson Museum of Art in Syracuse, New York, and shown at the International Center of Photography. Eauclaire was by no means alone in her effort to develop a critical structure for understanding the shift to color. See also A. D. Coleman, "Is Criticism of Color Photography Possible?" *Camera Lucida* 5 (1982): 24–29; and Andy Grundberg and Julia Scully, "Currents: American Photography Today," *Modern Photography* 44, no. 10 (October 1980): 94–97, 160–161, 166, 168, 170, 173. Coleman originally presented a version of his article as a talk at the Color Symposium hosted by the International Center of Photography on March 22, 1980.

97. Eauclaire, *New Color*, 7.

98. Eauclaire explained that she was merely detailing what John Szarkowski and Max Kozloff "instinctively understood" about the faults of early color photography. Ibid., 8.

99. Ibid., 9. Eauclaire recognized that this was the same excuse that Walker Evans had used in "Test Exposures" in *Fortune* magazine (July 1954), and why Edward Steichen had called the medium, "coloriferous," in his 1963 autobiography. Edward Steichen, *A Life in Photography* (Garden City, NY: Doubleday & Company, Inc. in collaboration with the Museum of Modern Art, 1963).

100. Ibid., 9–10. Eauclaire called color "the ideal purveyor of conspicuous consumption." Ibid., 11.

101. Ibid., 10–11.

102. Szarkowski's 1976 argument runs clearly through Eauclaire's analyses but she took a more formalist stance, dividing contemporary color photography into structural categories ranging from formalism, vernacular, and self-reflection to enchantments and fabricated fictions.

103. Ibid., 17–35.

104. Ibid., 69, 78, 79.

105. Ibid., 102.

106. Ibid., 227. Eauclaire rejected Polaroid film in general, and especially SX-70 film, as inadequate in its color renditions. Andy Grundberg and Julia Scully discuss this school of fabricated work, including the color photographs of Robert Heinecken and Leland Rice. Grundberg, "Currents," 94–97.

107. Ibid., 144, 164.

108. Ibid., 177.

109. Ibid., 184.

110. Arthur Ollman was another photographer exploring night in color. He began that course in 1976 drawn to how street lamps, car headlights, and neon all bounced around in the West Coast fog.

111. See Richard Misrach, *Desert Cantos* (Albuquerque: University of New Mexico Press, 1987); and Anne Wilkes Tucker, *Crimes and Splendors: The Desert Cantos of Richard Misrach* (Boston: Bulfinch Press in association with the Museum of Fine Arts, Houston, 1996).

112. Ketchum also stood outside the mainstream by his insistence on the continuing importance of Eliot Porter's love for natural beauty and his aggressive application of his photography to specific environmental causes. One of his first books relecting this vein is Robert Glenn Ketchum, *The Hudson River & the Highlands* (New York: Aperture, 1985).

113. Enos would put the flowers in the microwave oven to reach the stage of decay she desired for her still lifes. She then would attach a circular flash at the end of the camera lens to concentrate the light. Chris Enos, conversation with John Rohrbach, March 21, 2012, transcript, Curatorial Research Files, Amon Carter Museum of American Art, Fort Worth, TX.

114. Kasten has remarked that she was influenced by the abstractions of painters like Al Held and Dorothea Rockburne, and more broadly by László Moholy-Nagy's light box constructions of the 1930s and early 1940s.

115. This distinction between photographers who viewed themselves as such and photographers who demanded to be known as artists was a key quality of the "pictures generation" group of artists who rose to prominence in New York starting in the late 1970s. Douglas Eklund, *The Pictures Generation, 1974–1984* (New York: The Metropolitan Museum of Art, 2009).

116. Judith Keller, *Jo Ann Callis: Woman Twirling* (Los Angeles: J. Paul Getty Museum, 2009).

117. See Danny Lyon, *The Bikeriders* (New York: Macmillan Company, 1968); and Larry Clark, *Tulsa* (New York: Lustrum Press, 1971).

118. "Tina Barney," Museum of Contemporary Photography, http://www.mocp.org/collections/permanent/barney_tina.php.

119. A key early statement of this postmodern loosening of photographic truth is Mike Mandel and Larry Sultan's book *Evidence* (Greenbrae, CA: Clatworthy Colorvues, 1977). Martha Wilson, who came to New York in 1976 to help found the avant-garde arts organization Franklin Furnace, had made self-portraits in this vein between 1971 and 1974.

120. Robert Rosenblum, "An Interview with Sandy Skoglund," in *Sandy Skoglund: Reality Under Siege: A Retrospective*, 12 (Northampton, MA: Smith College Museum of Art in association with Harry N. Abrams, Inc., 1998).

121. Carol Squiers, "Entertainment and Distress," in *Sandy Skoglund: Reality Under Siege: A Retrospective*, 42 (Northampton, MA: Smith College Museum of Art in association with Harry N. Abrams, Inc., 1998).

122. In 1983, Nicosia's work was included in the Whitney Biennial and in the New Perspectives in American Art, 1983 Exxon National Exhibition at the Guggenheim Museum. He then was awarded a Louis Comfort Tiffany Foundation grant in 1984.

123. Nagatani learned filmmaking and model building on a large scale while working for Hollywood movie companies in the 1970s, including for the films *Blade Runner* and *Close Encounters of the Third Kind*. Tracey brought experience making storyboards for television and films. They often were the actors in their own dramas. Michelle M. Penhall, ed. *Desire for Magic: Patrick Nagatani, 1978–2008* (Albuquerque: University of New Mexico Art Museum, 2010), 16–17. Like Nicosia, they were more than willing to show the edges of their stage settings and even the monofilament lines that held up some of their props.

124. Serrano began his career as an assistant art director for an advertising firm.

125. Brian Wallis, ed., *Andres Serrano: Body and Soul* (New York: Takarajima Books, 1995), jacket flap.

126. bell hooks, "The Radiance of Red: Blood Work," in *Andres Serrano: Body and Soul*, Brian Wallis, ed. (New York: Takarajima Books, 1995).

127. At a 1997 showing at the National Gallery of Victoria, two teenagers attacked a print of the photograph with a hammer, and several Serrano photographs were vandalized at a 2011 presentation at the Collection Lambert in Avignon, France. Angelique Chrisafis, "Attack on 'Blasphemous' Art Work Fires Debate on Role of Religion in France," *The Guardian*, April 18, 2011, http://www.guardian.co.uk/world/2011/apr/18/andres-serrano-piss-christ-destroyed-christian-protesters.

128. See Andrea Kirsh, Susan Fisher Sterling, and Carrie Mae Weems, *Carrie Mae Weems* (Washington DC: National Museum of Women in the Arts, 1993), 16–17.

PLATE 3.1

Todd Walker (1917–1999)

Sheila, Four Times, 1971. Silkscreen, 15¾ × 19¾.

William Christenberry (b. 1936)

Abandoned House in Field, near Montgomery, Alabama, 1971. Dye coupler print, 1988, 3¼ × 4⅞ inches.

Lucas Samaras (b. 1936)

Photo-Transformation, November 22, 1973.
Dye diffusion print (Polaroid SX-70), 3 × 3 inches.

PLATE 3.4

Helen Levitt (1913–2009)

New York, 1972. Dye imbibition print,
9⅜ × 14⁵⁄₁₆ inches.

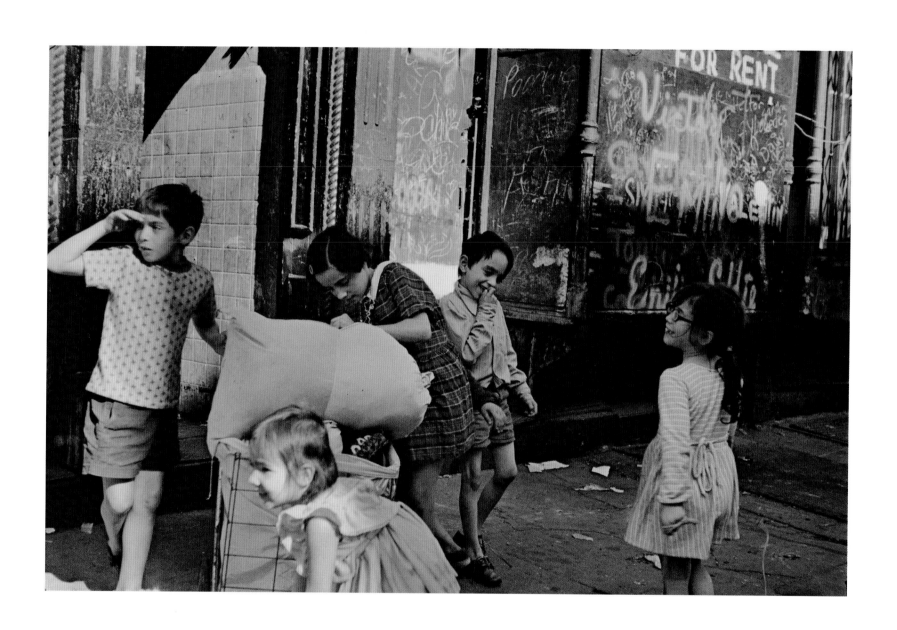

PLATE 3.5

William Eggleston (b. 1939)

Memphis, ca. 1971. Dye imbibition print, $18^1/_8 \times 12^3/_{16}$ inches.

PLATE 3.6

Stephen Shore (b. 1947)

West 9th Avenue, Amarillo, Texas, October 2, 1974.
Dye coupler print, 8 × 10 inches.

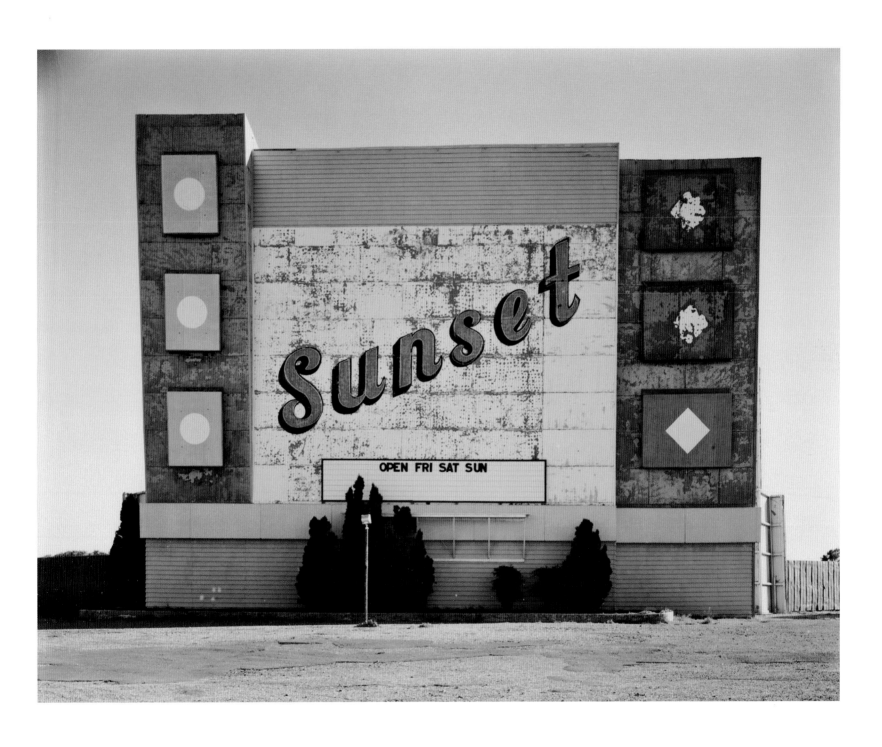

PLATE 3.7

Joel Meyerowitz (b. 1938)

Hartwig House, Truro, 1976. Dye imbibition print, 1980, 14½ × 18¾ inches.

PLATE 3.8

John Divola (b. 1949)

Zuma #25, 1977. Dye coupler print, $9^{11}\!/_{16} \times 12$ inches.

PLATE 3.9

Jan Groover (1943–2012)

Untitled, 1978. Dye coupler print, 14³/₄ × 19 inches.

PLATE 3.10

Mark Cohen (b. 1943)

Boy in Yellow Shirt Smoking, 1977. Dye coupler print, 16 × 20 inches.

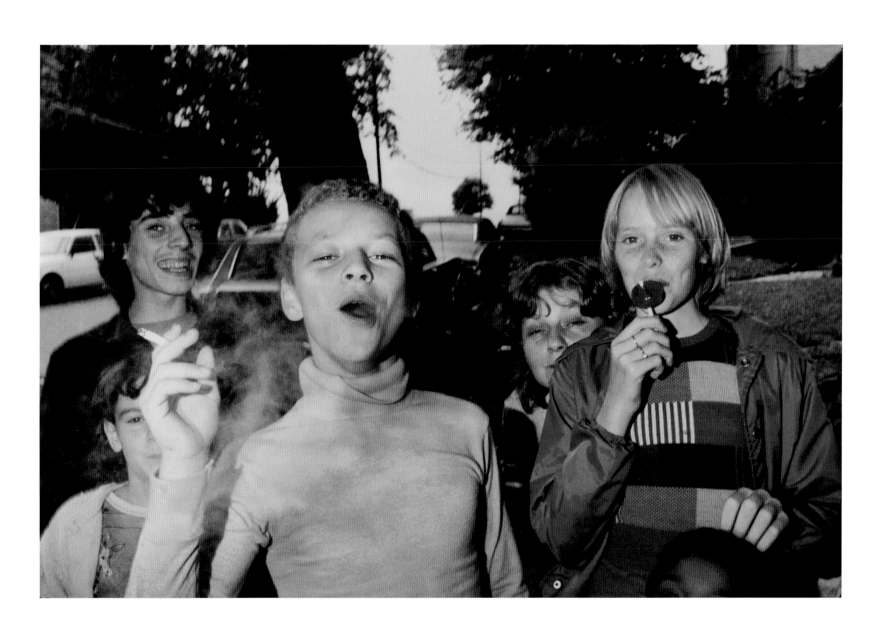

Joel Sternfeld (b. 1944)

McLean, Virginia, December 1978. Dye coupler print, 2003, 16 × 20 inches.

PLATE 3.12

Jim Dow (b. 1942)

Interior, Argeson's Shoe and Hat Repair Shop,
Allentown, Pennsylvania, September 1979.
Dye coupler print, 2013, 16 × 20 inches.

Robert Glenn Ketchum (b. 1947)

Brewster Boogie Woogie, 27, 1979. Silver dye-bleach print, 29⅝₁₆ × 37⅝₁₆ inches.

PLATE 3.14

Barbara Kasten (b. 1936)

Construct XXI, 1983. Dye diffusion print,
30¼ × 22 inches.

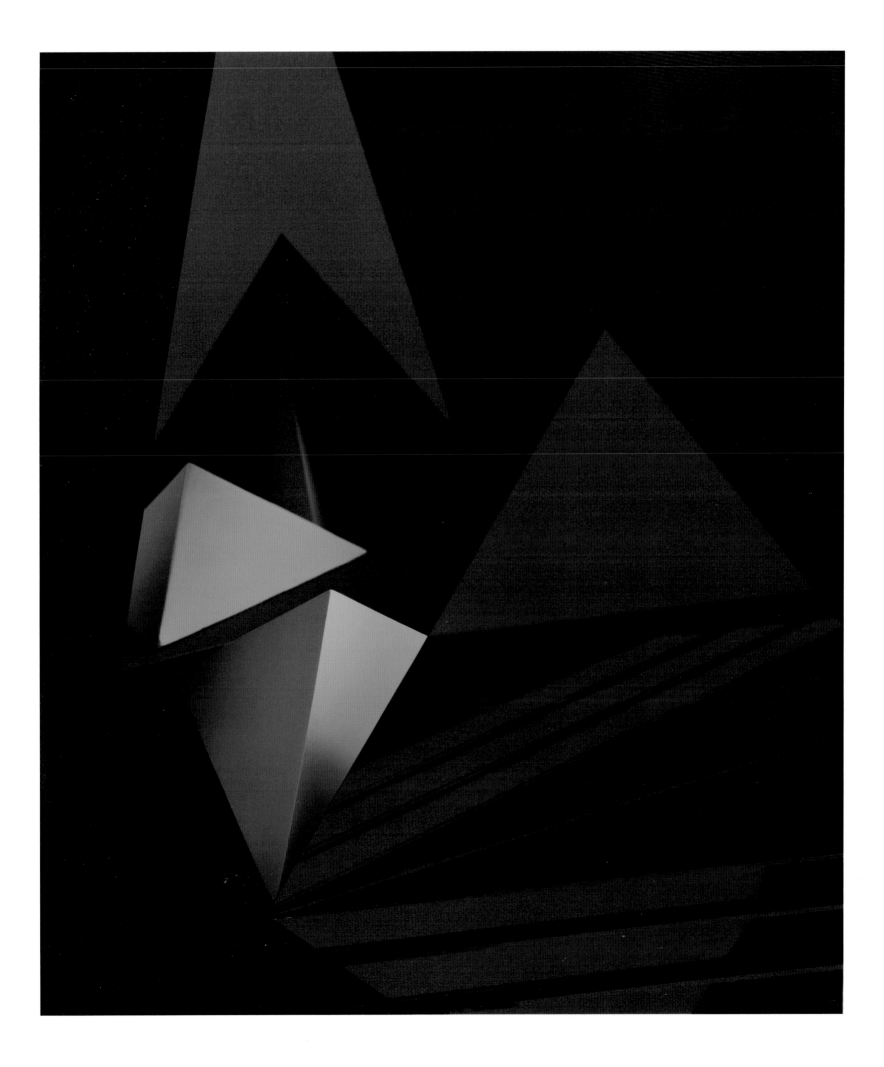

PLATE 3.15

Laurie Simmons (b. 1949)

Woman/Red Couch/Newspaper, 1978. Silver dye-bleach print, 3×5 inches.

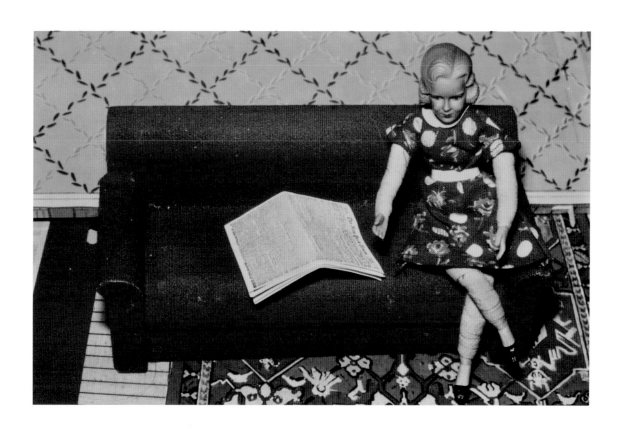

PLATE 3.16

Nan Goldin (b. 1953)

The Hug, New York City, 1980. Silver dye-bleach print, 24 × 20 inches.

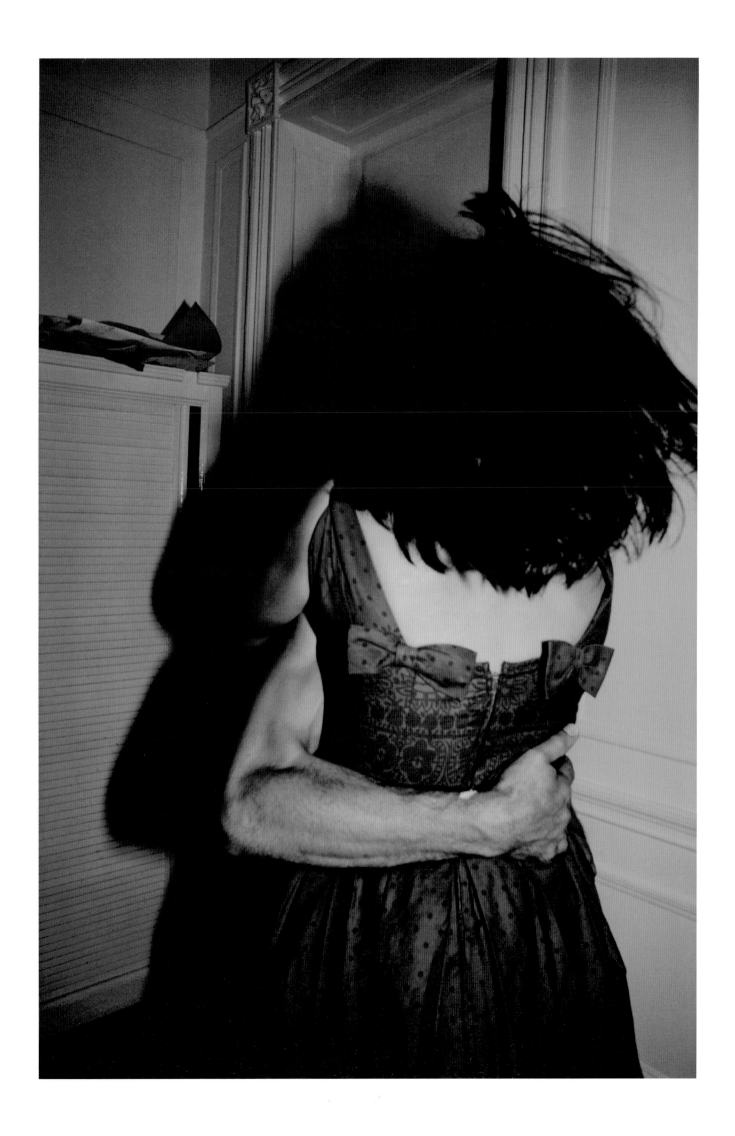

PLATE 3.17

Tina Barney (b. 1945)

Beverly, Jill, and Polly, New York City, 1982.
Dye imbibition print, 47½ × 60⅞ inches.

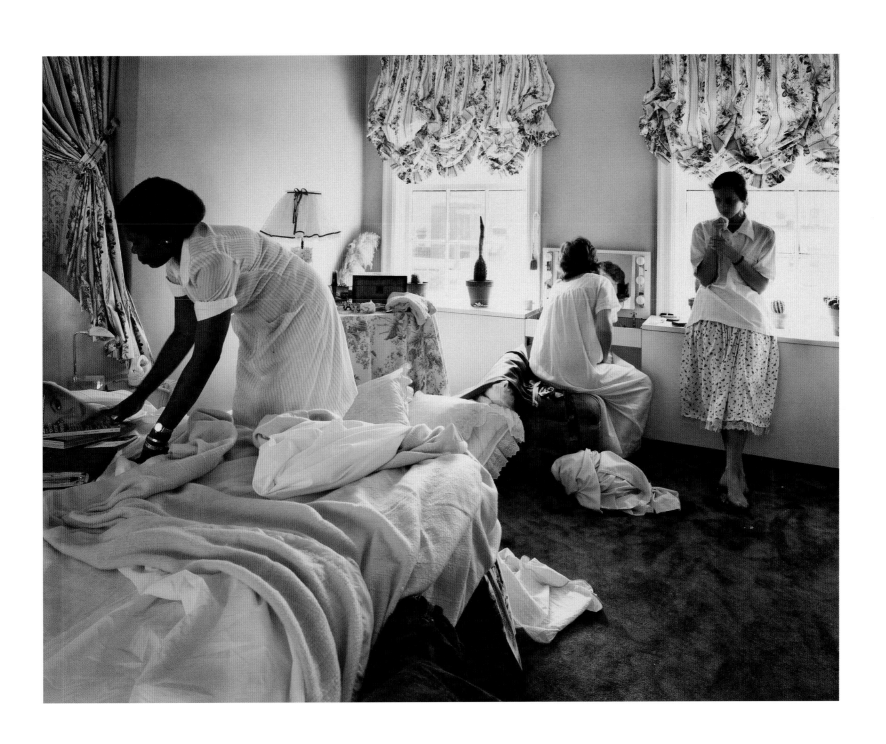

PLATE 3.18

Cindy Sherman (b. 1954)

Untitled #85, 1981. Dye coupler print, 30 × 54 inches.

PLATE 3.19

Sandy Skoglund (b. 1946)

Revenge of the Goldfish, 1981. Silver dye-bleach print,
27 × 35 inches.

PLATE 3.20

Patrick Nagatani (b. 1945)
Andrée Tracey (b. 1948)

Alamogordo Blues, 1986. Dye diffusion prints
(diptych), 24 × 40 inches.

PLATE 3.21

Andres Serrano (b. 1950)

Madonna and Child II, 1989. Silver dye-bleach print, 60 × 40 inches.

PLATE 3.22

Carrie Mae Weems (b. 1948)

Blue Black Boy, 1990. Gelatin silver prints toned blue (triptych), each 16⁷/₈ × 16⁷/₈ inches.

CHAPTER

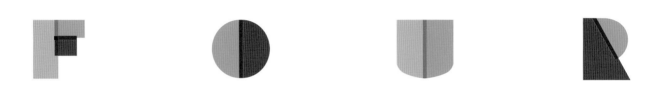

FOUR

Interrogating Color, 1990–2010

What is the difference between a photographer and an artist who works with photography?

NANCY SPECTOR, 2003[1]

THE EARLY 1990S were a heady time for fine art photography. The successful absorption of color had helped bring the medium to ascendency and fully integrated its contemporary wing into the spectrum of fine arts.[2] Although the photographic art marketplace continued to be driven by black-and-white, color was fast coming to dominate contemporary practice.[3] Even the Ansel Adams Trust was downplaying their namesake photographer's longstanding rejection of color to belatedly celebrate his personal explorations of the medium.[4]

The urge to simply describe the world in color remained strong in 1990, yet artists' absorption of semiotics over the previous decade had added to that proclivity a new understanding of hue as a quality to be controlled and shifted at will.[5] Aided by the emerging transition from analog to digital means of image making, some American artists were making such adjustments a central feature of their practices. The most significant technical advance since George Eastman's invention of roll film in 1888, digital photography was starting to take off in 1990 with the introduction of the first fully digital consumer-model camera and Eastman Kodak Company's marketing of a photo CD system for viewing photographic images on televisions.[6] While most forays into digital manipulation were still at this stage primitive, obvious, and centered on the act of creation, people in and around the photographic field were filled with excited expectancy when, in 1991, Kodak released the first commercial digital SLR camera and rock musician–photographer Graham Nash opened the world's first fine art digital-printing lab.[7] Journalist Peter Nulty even predicted in *Fortune* magazine that computers would "blow away much that is familiar" in photography.[8] That same year saw the death of Polaroid Corporation founder and inventor Edwin Land and the retirement of John Szarkowski from MoMA.[9]

If the mid-1970s saw color photography absorbed into ongoing artistic trends of black-and-white, the late 1980s and early 1990s saw it come into dialogue with painting. The connection to painting was not new in itself. Photographers had, from their medium's beginnings, looked to painting for guidance

about composition, lighting, and even subjects, and painters had used photographs as references and resources for shaping their work.[10] But now photographers were not mimicking painting as much as mining paintings for inspiration, including ways to use color. If the trend in contemporary painting was to divorce color from meaning, to make it merely hue, for artist-photographers it was to recognize color as a carrier of meaning, a drawing card to interrogate sight and expectation.[11]

Neil Winokur's *Glass of Water* (1990) aptly symbolizes this track. Over the previous decade, this New York City artist had become what he called "court photographer" to leading artists and cultural figures living in Lower Manhattan. His headshots of Philip Glass, Cindy Sherman, and other key players of the period are banal in their straightforwardness—the subject stands against a wall and blankly faces the camera—save in two attributes. Winokur's employment of bright, single-color backdrops and his choice to print the portraits in the high-key saturated colors of silver dye-bleach paper deliver to each photograph an upbeat Pop Art feel, where color and subject compete for attention.[12] By 1986, Winokur was also photographing personal objects selected by each of his sitters against the same bright backgrounds—"totems" he called them—and then arranging these object photographs around the portraits.[13] The work led him, in 1990, to create a forty-print self-portrait via this new blend of person-surrounded-by-accoutrement that MoMA curator Peter Galassi chose to excerpt in his 1991 exhibition summary of contemporary photographic trends titled *Pleasures and Terrors of Domestic Comfort*.[14] Galassi had room to show only half of Winokur's self-portrait and focused his selection on obviously personal mementos like a New York Mets cap, a menorah, and the artist's tattered copy of Jack Kerouac's book *On the Road*. One image, *Glass of Water*, was too generic to make the cut, but it was important in another key way (Plate 4.1). It signaled the artist's acknowledgment of the new linguistic framework for color photography. Technically, the photograph presents nothing more than a modest

material attribute of the artist. But it also plays on the malleability of visual semantics. We see and think of water as blue even though we know it is clear. *Glass of Water* conveys it as both at the same time. Instead of merely describing the world in color, or calling attention to how color frames meaning, the photograph launches headlong into the descriptive conflict pervading one of earth's most basic substances. Additionally, by printing the image at 40×30 inches, Winokur gave the glass a monumentality well beyond its mundane design, and a significance more in line with painting than photography.

Minneapolis photographer Robert Bergman was exploring this same semantic conundrum in the form of beguiling portraits of working-class people he encountered on urban streets across the Rust Belt. The artist had originally taken up street photography under the influence of Robert Frank's book *The Americans*, even shooting with a 35mm camera and black-and-white film. But finding that he could not let go of his appreciation for contemporary painting, he switched to color in 1985.[15] Attracted to strangers whose demeanors evidenced the wear of rough lives, he made full use of his uncanny ability to coax his sitters into openly presenting themselves to his camera. The terms of each encounter remain hidden, as are the goals of each sitter. Even in their willingness to be photographed, the sitters hold part of themselves back, just like the people Paul Strand depicted in his groundbreaking street portraits of 1915 (Figure 4.1). Mirroring Strand, Bergman framed his subjects so closely that the surrounding street is more hint than reality. By leaving each sitter unnamed and without locational reference, he transforms them into characters. (His mother was a Shakespearian actress.)[16] But where Strand surreptitiously grabbed his portraits with the aid of a false lens, Bergman constructed collaborations, albeit uneven ones; and where Strand's goal was social indictment, Bergman now offered invitations to bond. Color is absolutely key to establishing this connection. Strand's photographs may have been shocking in their day, but today their black-and-white tones deliver separation.

FIGURE 4.1
Paul Strand (1890–1976),
Man, Five Points Square, 1916.
Photogravure. In *Camera Work*,
no. 49/50, June 1917. Amon
Carter Museum of American
Art, Fort Worth, TX.

By using color, Bergman creates presence. But the artist goes beyond that characteristic too. The colorful, often pastel hues gracing his sitters' faces and clothing deliver the urban street that surrounds them, countering stereotypes of the gritty yellow-green street lamp darkness with reflections of active commercial settings. Each sitter's exhaustion is still evident, but Bergman's meticulously articulated hues deliver solidity, context, atmosphere, and most of all a gentleness that evokes not merely sympathy, but empathy.

Bergman has explained the centrality of color in his street portraits by relating that when he looked through his viewfinder shortly after taking up color film, he would see not the world so much as Rothko paintings.[17] This divergence became his artistic language. Color intensifies each image's intimacy, delivering to each sitter a contextual beauty found more often in painting than photography. At times the sitters are bathed in an array of saturated hues more suggestive of Disneyland than dingy urban streets. Even the more straightforward portrait of the unidentified man in [untitled] (1990; Plate 4.2) is infused with delicate light reminiscent of a painting. Following Eggleston's model, Bergman's color not only describes, it vibrates with energy. But where Eggleston remained content with that tension, Bergman applies it, as Eliot Porter did, to cajole us into reconsidering the fluidity of light and how one hue is often infused with another. Also, as with Porter, color itself is not the issue, though Bergman walks a fine line. His sitters would be overwhelmed by his masterful ability to tease out an expansive palette of subtle, overlapping hues if not for the emotional weight of their exhaustion, which pulls one insistently back to confront their humanity.

Few in the photographic art community were ready for Bergman's Technicolor world when Pantheon published a book of these portraits in 1998. Although the esteemed novelist Toni Morrison and respected art historian Meyer Schapiro both wrote for the publication, the book was largely ignored.[18] Only in 2009, fourteen years after the project ended, was the world ready. That year, Bergman secured solo exhibitions at the National Gallery of Art and MoMA's contemporary outpost in Queens, PS1, as well as representation by the Yossi Milo Gallery in New York City. Countering decades of critical complaint that saturated color was ugly and inappropriate—the purview of advertising—the National Gallery's curator of photographs, Sarah Greenough, remarked: "When I first saw his photos, I was actually kind of amazed by the strength of the images and the extraordinary use of color. It's beautiful and saturated."[19] Other critics agreed, comparing the artist's directness and eye for color to painters like Thomas Eakins, Hans Holbein, and John Singer Sargent.[20] The very quality of color that had been rejected in Porter's work in the 1950s was now acceptable.

Painting also influenced Chicago-based photographer Dawoud Bey's approach to color in the early

1990s. The artist had established a modest standing over the previous fifteen years with his poetic black-and-white photographs of street life in Mexico, New York, and Puerto Rico along with occasional portraits of his friends. But a 1991 opportunity to work with Polaroid's 20 × 24–inch camera dramatically changed his approach.[21] The studio environment required by the oversized camera induced him to think of his image backgrounds as blank canvases—a way to divorce his sitters from their settings and all of the attributes carried by those surroundings. By the following year, Bey was assembling color diptychs, triptychs, and polyptychs, sometimes including parts of his subjects in more than one shot, an approach that allowed the same sitter to engage with the camera in one shot and be distracted or withdrawn in the next. Bey then started creating group portraits, often cropping his edges so that a sitter might be shown in part in one frame and in full in the second. The variety of poses his sitters bring to the camera and the relaxed human connections they offer are impressive. But cropping, isolation, and the passage of time are only part of the story. The 20 × 24–inch Polaroid camera caused the artist to think about how painters use color. He once explained: "My use of color has to do with wanting to make an unabashedly lush and romantic rendering of people who seldom receive that kind of attention."[22] Where Bergman had discovered the expansive palette of color-field painting in his sitters, Bey chose to aggressively narrow his focus to the brown tones he so loved in Rembrandt's paintings.[23] The choice was brilliant. His tan and sienna backdrops meld beautifully with the rich skin tones of many of his sitters, uniting the scenes and giving them comfortable warmth. In the diptych *Nikki and Manting* (1992; Plate 4.3), this compacted array of hues encourages one to take note of subtle color shifts—his russet shirt and skin, her black-and-orange cap, striped shirt, and slightly lighter skin. The palette dominates the image, just as it does in Carrie Mae Weems's critiques of self-imposed racial distinctions discussed in the previous chapter. But by coming from within the scene rather than being an overlay, it invites more sustained

sympathetic contemplation. Its circumscribed range also lessens distraction, allowing one to focus on the embrace and tender expressions of these Chicago teenagers—his more open to the camera than hers.

While the early 1990s saw a plethora of artists exploring portraiture, Los Angeles photographer Catherine Opie turned the genre on its head. She made portraits of people facing away from the lens. To create metaphors for the challenge of not fitting in to mainstream culture, like Nan Goldin, she even imputed herself into her practice with *Self-Portrait* (1993; Figure 4.2).[24] Here, like Winokur and Bey, she frames herself in an image with a single color backdrop, in this case claiming Hans Holbein for inspiration. But rather than proffer comfort through closely matching hues, she employs counterpoint to build confrontation. The deep green velour wallpaper backdrop draws one in, offsetting Opie's pale skin, brown hair, silver earrings, and the blue tattoo circling her right arm. But the green backdrop's main purpose is to provide a foil for the bloody drawing etched into her back. The two smiling stick-figure women holding hands before a house and a sun half hidden by a moving cloud is exactly the kind of sketch that a kindergartener would make, save for where and how it is accomplished. The blood dripping from each section of the scene draws attention to her pain, an emotion that multiplies when one learns that the carving reflects her struggles with a recent breakup. Yet, her goal is not to induce personal sympathy about the difficulty of trying to live a loving life surrounded by a culture that often still rejects, ridicules, and sometimes even threatens lesbians.[25] By facing away from the camera, she offers not herself but an anti-portrait that references the generic terms of her condition. In black-and-white, the image would not work. It would remain readable, but it would lack the visceral power brought by the ruddy color of blood. In color, it effectively demands attention to its poignant blend of allure, revulsion, and sadness. Further, Opie transcends even this basic attribute; through her meticulous orchestration of hues, she melds photography into painting.

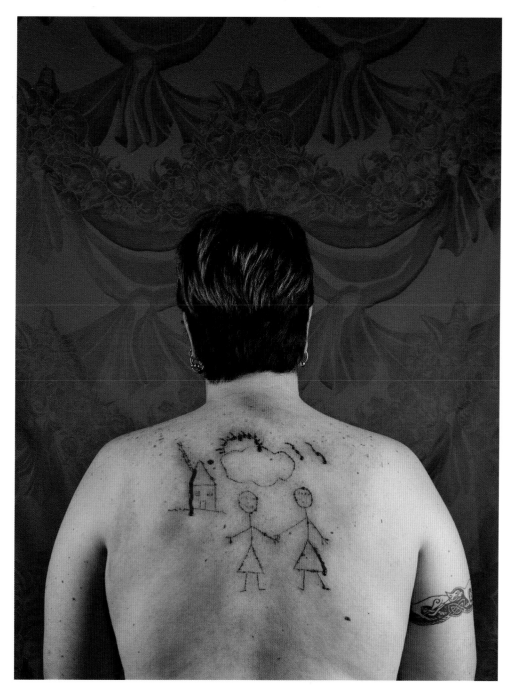

By the mid-1990s, Anthony Hernandez, another
Los Angeles artist, was achieving this same effect in
his poetic documentation of the physical abrasions
of that city. He had taken up this subject after first
working through the angled, people-oriented street
style laid out by photographers like Joel Meyerowitz
and Joel Sternfeld in the early 1970s. His own take on
this older style was a mid-1980s color series summa-
rizing the atmosphere on Rodeo Drive. Much like his
predecessors, he found the street's tempo in flashes
of color, in this case the clothing and accoutrements
worn by that neighborhood's wealthier inhabit-
ants to set themselves off from their generally pale
surroundings.[26] But now Hernandez had shifted to
reflecting on the cold world of Los Angeles's public
service network, a world dominated by the dull grays
of concrete, aluminum, and steel, and punctuated by
fluorescent lights, public telephones, cigarette butts,
and graffiti.

Where the Rodeo Drive images suggested snip-
pets of cinematic narrative in their elongated 35mm
rectangles, in this new project Hernandez worked
with a square negative to draw attention to the op-
pressive staccato patterns of the social agency archi-
tecture as well as the stoppage of time implied by
these places. To Hernandez's art-astute audiences,
Waiting in Line (#21) (1996; Plate 4.4) might sug-
gest, in its white rectangles, its bright red line, and its
overall pallid green hue, a cross between the works of
El Lissitzky and Mark Rothko. But this momentary
attraction quickly gives way to a depressing shud-
der as one realizes that the wide red stripe, the only
part of the image that is in focus, sets a barrier to the
empty waiting room beyond. The crimson ribbon acts
as both a warning and instruction of how to move
through the space. The green fluorescent light filling
the room counterpoints the bright red line even as
it calls to mind the ambiance of an unemployment
office or a health clinic. We are not told what kind
of office this photograph records, but the prospect
of succumbing to spending the next three hours,
senses dulled, waiting for your name or number to
be called, is palpable.[27] Here, people are not actors as

much as numbers—cogs in a machine. Such ubiquitous institutional spaces do not normally attract the attentions of artists, though we all are familiar with them as representative of our contemporary urban vernacular. *Waiting in Line (#21)* does not provoke a happy feeling, but then Hernandez is not concerned with making pictures to instill pleasure. His goal is to acknowledge the deadening bureaucratic spaces that exist as a function of living in large communities.

While Bergman, Hernandez, and Opie were blending photography and painting through interrogations of the semiotics of color and cultural expectation, by the mid-1990s, other artists were using the camera to deconstruct the romantic artistic underpinnings of atmospheric color. One of the most painterly manifestations of this second approach is Richard Misrach's sky project. What Neil Winokur drolly commented on with his glass of water photograph reaches expansive magnificence here. If water is both clear and blue, sky can be read in the same terms. If photography is light, sky is the purity of light. Through most of the nineteenth century, photographic emulsions had an exaggerated sensitivity to blue that made photographing ground and sky at the same time almost impossible. The invention of panchromatic films in the early twentieth century solved the problem and laid the foundation for color photography. But as soon as photographers started using color, they realized that rather than conveying airiness, clear blue skies read in color films and prints as solid patterns that tended to lift forward to distract the eye. Even Eliot Porter, who so marveled at the nuanced colors of nature, sought to avoid photographing clear skies, considering them wasted emptiness.[28]

After more than a decade of delineating the pale ochre palette of the desert Southwest, in the mid-1990s Misrach turned his camera upward, creating what he called Desert Canto XV in the form of records of early morning, evening, and nighttime skies.[29] Where his predecessors had found endless, monotonous blue, he now recognized, with the help of more sensitive film, a spectrum that started with yellow and stretched through an array of blues,

indigoes, and purples. In line with photography's new crossover artistic status, he printed the results large to tie into the color-field preoccupations of painter Mark Rothko and installation proclivities of artists Doug Wheeler, Dan Flavin, and James Turrell.[30] In Misrach's photograph *Paradise Valley, [Arizona], 3.22.95, 7:05 P.M.* (Plate 4.5), one gains orientation not by a horizon (which is missing), but by memory of the evening sky. Like one of Turrell's open ceilings, the photograph's swath of pure color lures one in with its simplicity. But where Turrell's openings to the sky demand time to take full effect, this print shifts over to mimic the experience of looking at a Rothko painting, inviting one to revel in a moment extended. The image even seems to mirror a Rothko painting in its projection of pure color. But Misrach's goal was not to lead one away into reveries, as Alfred Stieglitz had done early in the century with black-and-white sky studies that he called "equivalents" of his emotional states. Neither was his intent to exult in pure geometric abstraction, as the photographer Bill Armstrong does in his Mandalas series; nor was it to draw attention to the factual solidity of photographic dyes, the aesthetic underlying Ellen Carey's drip-pattern Polaroids (Figures 4.3 and 4.4).[31] By titling each sky image with its location, date, and even hour, Misrach pulls the viewer in to vicariously join him as he waits next to his camera for the world to record itself on his film. The result offers up a quintessentially American optimism, until one digs a little deeper. In her essay for the book in which Misrach published this and his other sky images, cultural geographer Rebecca Solnit contemplates the sky as "the consciousness of landscape."[32] Paradise Valley was named in 1889, Misrach makes a point of explaining in that same publication, by Frank Conkey, manager of the Rio Verde Canal Company, who first encountered this Maricopa County, Arizona, site covered with wildflowers and blooming palo verde trees while prospecting for a place to lace with irrigation canals.[33] Color and history collide. This could just as easily have been a sky that Conley saw during his visit to this spot. Without any view of the ground, one is left to imagine its current state.

At this same time, North Texas photographer Terry Falke was injecting an even more acute color sensitivity into his photographic records of the light of the American West. His *Mitchell Butte, Arizona/ Utah Border* (1995; Figure 4.5) is just as focused on a specific moment as Misrach's view, reflecting that instant when a peach dawn envelops the campground site before the frost has burned off. Falke's masterful ability to tease extreme nuances of color out of his photographic papers put him in line with Marie Cosindas, whose exquisite color Polaroids thirty years earlier flabbergasted even Edwin Land, and at the physical limits of photography. Unfortunately, it also took the spectral range of his prints beyond the capabilities of offset printing. Additionally, by attending purely to the air, light, and the moment rather than to color's cultural tangents, his approach reflected where photography had come from rather than where the field was heading.

By the late 1990s, improvements in programs for digital manipulation coupled with advances in digital inks would allow Chicago artist Terry Evans to take Falke's striving for exacting photographic naturalism to the level of trompe l'oeil in a series of inkjet photographs of natural history specimens at the Field Museum in Chicago.[34] In images like *Field Museum, Helianthus, 1905* (1999; Figure 4.6), which shows an herbarium sheet, the dimensionality of the pigments and the artist's choice to step back and show the entire specimen sheet raise hesitation about whether one is looking at the actual sheet or a photograph of that sheet, a point made even more difficult when the

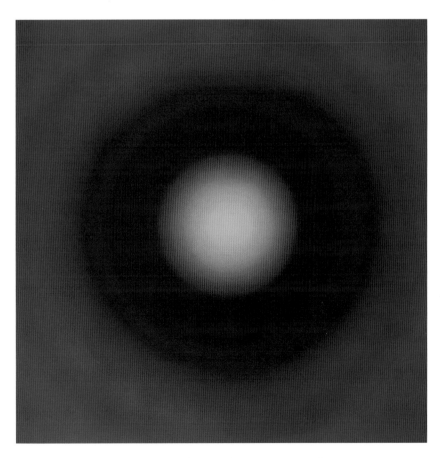

FIGURE 4.3
Bill Armstrong (b. 1952), *#450*, 2003, from the series Mandalas. Silver dye-bleach print. Courtesy the artist.

FIGURE 4.4
Ellen Carey (b. 1952), *Pulls with Flare and Filigree (Y, M, C)*, 1997. Polaroid 20 × 24 color positive prints (triptych). Collection of the artist. Courtesy of Jayn H. Baum Gallery, New York.

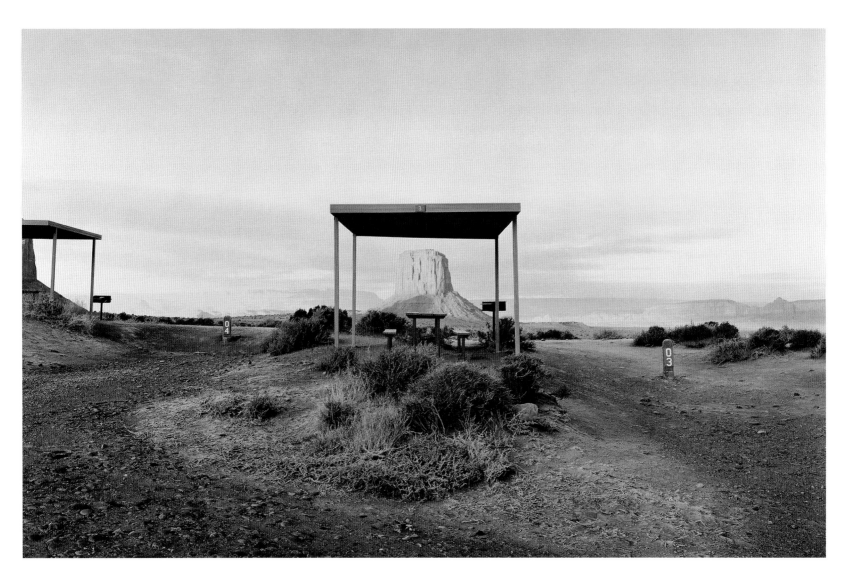

image is glazed, framed, and hung in gallery display. The result provokes visceral connection to botanical history and to the plants scattered across the Kansas prairie.

Yet exploring color's broader cultural interconnections had become the more dominant trend. San Francisco artist Todd Hido was following this very route in the mid-1990s, reflecting the isolation and loneliness of night in photographs of nondescript houses and apartment buildings. Rather than focus on the ways that night twists color, as artists in the 1970s had done, he left the colors of these images largely neutral, preferring to keep attention on the buildings and their inhabitants. But on a 1999 visit

to his childhood town of Kent, Ohio, his outlook took a dramatic turn: "It was raining . . . and I stopped at an intersection. All the water rushed off the roof of the car and poured down the windshield, making this wonderfully expressive scene in front of me."[35] In response, he created *Untitled #2431* (1999; Plate 4.6), an image that so pleased him that it started him on a whole new line of photographing through the water-streaked windows of his car. *Untitled #2431* looks out at a wet winter day after a major snowstorm has passed through. The air has warmed and rain is starting to melt the piles of plowed snow along the edges of the streets. One fights through the splotches of water splayed across the window to see

a new color-driven pictorialism that draws equally from photography's own historical roots and from painting.

Unlike Hido, who found his color language in atmosphere, Mitch Epstein located it in objects. Epstein had been photographing in color for decades by this date, shifting his sights from America to India, Vietnam, and back. Over much of this time, he had relied on flashes of color to attract the eye and organize his compositions, but in late 1999, when he took on the creation of a photograph and video elegy to his father, he let subject come definitively first.[36] Yet he also recognized a palette of pale and turquoise blues, brick-red browns, pink, and dirty white lurking actively in the background. A shot of an American flag still wrapped in its dry-cleaning bag and hanging against a pink wall symbolizes his acceptance of this color-driven order (Plate 4.7). The flag, which the artist's father had hung proudly, is left to compete for attention with the dingy wall behind it.

As Epstein was finding his way to the colors of Holyoke, Massachusetts, Alec Soth was locating color along the Mississippi River. Soth's approach fit snugly into the Eggleston model in subject, snapshot informality, and laconic attitude.[37] His photograph *Adelyn, Ash Wednesday, New Orleans, Louisiana* (2001; Plate 4.8) from that project is particularly indebted to Eggleston's vision in its orchestrated control of hues, but it steps beyond Eggleston in its closer attention to the cultural symbolism of color. The image centers on a slightly disheveled woman whose upturned face and raised eyes suggest religious ecstasy in all of her pain. Unlike Bergman, Soth even acknowledges the woman's name. Yet the image's power comes from her transformation into a symbol driven by color. Her flaming red hair and flowery blouse pull the viewer in. She is of this contemporary world in her tattoo and in the multicolored strands of hair framing her forehead, even as her pose recasts her as the timeless stereotype of a repentant lost soul. The charcoal cross marking her forehead mirrors the wrought-iron fence immediately behind her and the slightly out-of-focus wall beyond it. That wall, offering the color of

the intersection and neighborhood of modest middle-class houses. The interrupted focus transforms the scene into a dreamlike setting that induces memories of cancelled school, snowball fights, and early twentieth-century pictorialist photography.

The vibrant blue patch animating the center of the photograph (perhaps a swimming pool or a tarp covering a vehicle) lures attention down the street and offers a signal that the colors infusing the image are correct. It also reveals Hido's appreciation for how bits of color can organize and give vibrancy to otherwise nondescript encounters with the world. But the gray-green light permeating the image is what makes the photograph work. That color conveys the day's dampness with precision even as it suggests the cyan tone most photographers have long tried to avoid because it is the color of light-faded photographs. Its translucent veil, like a dilute wash of watercolor laid across the surface, delivers the photograph's nostalgic message. This recognition released Hido to embrace

a photographic gray card, might symbolize the dull spaces inhabited by cultural misfits along the Mississippi, but it also reflects the receding of black-and-white photography.

BY THE OPENING of the new century, color had become so widely accepted in photography that it was rarely even a point of discussion. Museums displayed and collected color photographs with regularity, commonly installing these shows in main feature galleries.[38] Photographers William Eggleston and Cindy Sherman had become cultural icons and guaranteed exhibition draws, and the mural-sized photographic prints of artists like Canadian Jeff Wall and German Andreas Gursky (Figures 4.7 and 4.8) were commanding attention. American artists had not fully embraced this mural sensibility, where prints measured in feet rather than inches, but they were deeply sympathetic to the notion of creating photographs large enough to compete with paintings for wall presence.[39]

When American feature photojournalist Alex Webb took up color in the late 1970s, he quickly built a reputation for creating acutely faceted compositions punctuated by bright hues.[40] His early-career depictions of street life across the Caribbean, Europe, Mexico, South America, and the United States often rely on bright color and deep shadow to organize space, sometimes to the point of overwhelming the image subjects. They bring to mind photographer Pete Turner's 1960s embrace of fully saturated color. But in accord with the changes of the 1990s, Webb started producing more open compositions still driven by color but built of subtler hues. Then, on a

FIGURE 4.7
Jeff Wall (b. 1946), *Dead Troops Talk (a vision after an ambush of a Red Army Patrol, near Moqor, Afghanistan, winter, 1986)*, 1992. Transparency in lightbox. Courtesy the artist.

FIGURE 4.8
Andreas Gursky (b. 1955),
Salerno, 1990. Dye coupler print.
© 2012 Andreas Gursky/Artists
Rights Society (ARS), New York/
VG Bild-Kunst, Bonn. Cour-
tesy Sprüth Magers, Berlin and
London.

black-and-white, this photograph would be a puzzle.
In color, it is a romance. The initial end for this image
may have been the printed page, but like his Magnum
colleagues, Webb freely crossed the line into art by
printing the image at 20 × 30 inches to take advan-
tage of the detail and added dimension brought by
this larger size.

Chicago photographer Laura Letinsky was using
color in a similar way over these same years, but to
more structural ends—showing how related hues
in meticulous balance can transform innocuous
tabletop settings into optical puzzles recognized and
unraveled at an absentminded glance.[42] Her pho-
tograph *Untitled #52* (2002) presents little more
than the residue of a child's snack on a hot summer
day (Plate 4.10). The image is deceivingly simple.
An orange plastic cup, the skin of a kiwi fruit, and a
half-eaten Popsicle sit on a woodgrain Formica table
that is pushed against a wall, nothing more than a
mess left to be cleaned up later. The scene is so seem-
ingly straightforward, delicate in color, and filled
with calming blank space that one could easily miss
its meticulously crafted conceptual play—that the
line set by the liquid in the orange cup blends exactly
with the shadow of the table along the wall beyond,
and that a piece of broken candy at the cup's base
mirrors in size and color the dent in the wall lying at
the center of the cup's shadow. These "coincidences"
draw attention to the pale blue and cyan blend that
mutually infuses the candy and wall; how the drops
of melted Popsicle on the table match the size and
form of the broken candy; and how the circular forms
and shadows of the kiwi mirror those of the orange
cup. The camera's angle, meanwhile, causes the table
to seem to be sliding toward the bottom of the image,
a feeling enhanced by the light glancing off its surface
undercutting its woodgrain and blending it into the
wall. What seemed like a quiet, mundane subject has
become a tense transit of interlocking facts held to-
gether by the bright orange cup. What photographer
John Pfahl started to dissect in the mid-1970s with
his Altered Landscapes series now had reached subtle
new heights. But where Pfahl grounded his work in

trip to Istanbul in 2001, he let faces, clothing, and
buildings become imbued with an extended array
of hues, and atmosphere start to regain a role.[41]
The fragmenting of form still existed. In the artist's
photograph *Istanbul* (2001; Plate 4.9), the facet-
ing of windows, mirrors, signs, and doorways is so
complex that one has to spend time to draw the scene
together. The scene's ostensible subject is street life.
A woman wearing hijab seems to look straight at the
photographer as she strides purposefully, full bag
in hand, across the center of the image and down
the middle of the street. A woman in jeans walks
past her going the other direction. A man sits on the
ground outside a shuttered storefront. Another man
enters a doorway in the distance. Only in noticing
a shadowed figure in the left foreground does one
realize that almost all of the street activity is actually
behind the photographer, reflected through a mirror
of the fluorescent-lit barbershop he stands in. Color
is key to this deciphering. It is what separates inte-
rior from exterior and gives order to the details. In

playfully questioning the phenomena of photographic optics, Letinsky, drawing on painting, is just as interested in abstraction.

When, in 2001, MoMA curator Peter Galassi presented a mid-career retrospective heralding Andreas Gursky's achievements, that artist's face-mounted, almost-billboard-sized works presented a frontal challenge to American artists.[43] But even more provoking was Gursky's digital manipulation of some of his photographs (Figure 4.9).[44] The adjustments were not always obvious, leaving viewers to figure out what seemed not quite right about the images. Most importantly, the practice signaled the arrival of a new photographic vocabulary that considered material

truth as just the starting point. In this new world, photographers were finally fully absolved of their subservience to whatever lay before their camera.[45] Reflection of the world did not disappear in Gursky's art. It was simply that, much like painting, the message took precedence over the document to satisfy his belief that a photographer's greatest achievement was to confront painting head on.[46] If Eggleston's triumph in the hands of John Szarkowski symbolized color photography's break from subservience to indexical record, Gursky's achievement solidified the full demise of that connection. Szarkowski's definition of photography as a language of selection was now largely irrelevant.

FIGURE 4.9
Andreas Gursky (b. 1955), *Atlanta*, 1996. Dye coupler print.
© Andreas Gursky/Artists Rights Society (ARS), New York/
VG Bild-Kunst, Bonn. Courtesy Sprüth Magers, Berlin and London.

Photography's release from reflecting the world led an expansive range of artists including Lori Nix to openly fold reality into fairy tale with images like *Wasps* (2002), in which she incorporates clearly dead insects into a falsely colored sky (Figure 4.10). However, the more provocative track to come out of this transition plied a more unnerving quasi-real side of the divide, finding its roots in theater and cinema.[47] This path reached its extreme in Yale professor Gregory Crewdson's Twilight series, images that, in their surreal nighttime darkness, reflect a maniacal blending of the fertile, off-kilter minds of Ray Bradbury, Rod Serling, and David Lynch. Their colorful lighting and overtly fictive narrative fragments all but shout theater. Typical of the series is the artist's untitled image of a man crawling in the darkness across the floor of his house (Plate 4.11). The work is a paean to his childhood memory of eavesdropping on sessions run by his psychoanalyst father downstairs in

the family's house.[48] The blue light streaming up from circular holes poked into the floorboards signal the strange blend of anxiety, longing, and neurosis coming up from below. The circles, the artist has admitted, could easily be metaphors for romantic obsession.[49] But the photographer leaves it to the agitated imaginations of the viewers to resolve the matter. Where Nix lets us in on her fiction, here we are left to interrogate on our own the boundaries between reality, memory, and story.

By this time, Adobe's increasingly sophisticated software program Photoshop allowed artists using the camera the ability not only to greatly enlarge prints while still holding image detail, but also to stitch together multiple images, synthesizing photographs like canvases, all with nuanced control.[50] Crewdson takes full advantage of these tools, making prints large enough to suggest a scene viewed on a Cineplex screen.

Los Angeles photographer Joaquin Trujillo frames a more real world in the same terms.[51] In *Jacky* (2003), from his Los Niños series, the artist updates his family's traditions of formal portraiture while at the same time openly acknowledging photography's constructed reality by posing his young niece on a chair that has been placed on a table in the middle of an empty room. Projecting self-assured composure, she sits elegantly upright showing off her fine dress and her specially curled hair (Plate 4.12). Her secure pose, meticulously set hands, and forthright gaze into the camera suggest Diego Velázquez's great painting *Las Meninas* (1656), even as the dirt-encrusted, pockmarked gray-brown walls behind her give away her poverty. However graceful her demeanor, she cannot be the daughter of royalty. The lively range of subtle brown, blue, and even pink tints that define the wall call one back to savor its animation. Yet, even more than the blue light streaming up through the floorboards in Crewdson's photograph, the bright cerulean hue of the girl's dress charges and anchors this scene. Its heavily saturated inkjet pigments sit on the surface of the smooth watercolor paper giving the portrait a tactility that is new to photography.

This intense hue drives one incessantly to the center of the print, almost overwhelming the seated girl in its ability to equally describe her dress and become a presence in its own right.[52]

This same forwarding of color was extending to American photojournalism by mid-decade as in images like Simon Norfolk's *Fantasma en la Ciudad, Nogales, Arizona/Nogales, Sonora, Mexico* (2006; Plate 4.13), which were showing up on the pages of *The New Yorker* and *The New York Times Magazine*.[53] Fulfilling the fluid blend of photojournalism and art long promulgated by Magnum and other upper-tier picture agencies, this photograph, a view of the heavily patrolled border in southern Arizona, is not a document in the traditional journalistic sense of capturing an event or offering a cleanly descriptive view.[54] Human interactions have been co-opted by a "New Topographics" remove, where contemporary life and issues are defined instead through a landscape emptied of people. The photograph derives from Norfolk's commission from *The New York Times Magazine* to illustrate a Joseph Lelyveld article on illegal immigration.[55] Lelyveld had taken up his story in response to the Republican Party's push to make this hot topic their key talking point for the fall 2006 congressional campaign. Recognizing the particular potency of the issue in Arizona, where arrests of illegal immigrants had been running at half a million a year (more than such arrests in California, New Mexico, and Texas combined), he chose to focus there. After several days of being shown around the area by a public affairs officer for the U.S. Border Patrol, Norfolk shot this view from the outskirts of Nogales, Arizona, looking into Nogales, Mexico, using the blatant hook of color to capture the reader's attention.[56] By photographing the scene at night, he envelopes the spot with superficial beauty and mystery, but also a sense of danger. Even though the border guards have night vision goggles, darkness enfolds the land in uncertainty and danger. What this photograph cannot show, but what Norfolk could hear, are the barking dogs, cars, and laughter from the Mexican side, and on the American side the controlled rumble of diesel generators and the Border Patrol SUVs. Yet the heart of this photograph lies in the lime-green glow of the industrial-sized mercury halide lights blanketing much of the American side and its contrast with the warm, orange streetlights in distant Mexican Nogales. Color has transformed this image into far more than a mere record. Green here becomes the color of emptiness while orange is the hue of activity. But this green is acrid rather than cool, more unnerving than soothing.

Fort Worth, Texas, artist Luther Smith brings color similarly to the fore in his 2006 documentation of the aftermath of a grass fire (Figure 4.11). The pale blue of the print's clear sky is so solid that it leaps forward to dominate the scene, animating the fire-decimated landscape and delivering an enticing beauty—at least until one explores the desecrated woodland more closely. Only extended careful looking reveals the gray carcasses that provide the image's title, *Dead Horses, grassfire near Carbon, Texas, 2006*, unleashing the photograph's powerful embrace of horror.

By the time Sharon Core created her trompe l'oiel photograph *Peaches and Blackberries* (2008; Plate 4.14), photography's blend of record and artifice had become its language. A trained painter, Core initially established her reputation with photographs that mirrored Wayne Thiebaud's well-known paintings of bakery desserts. She even went so far as to bake the foods she depicted and to compose them with such exactitude that the resulting photographs could be mistaken for reproductions of the paintings themselves. When she subsequently moved to the Hudson River Valley and discovered a catalogue devoted to the first museum exhibition of Raphaelle Peale's still-life paintings, she shifted direction to reflect the art of that early nineteenth-century realist painter. To prepare for her production, she closely analyzed the subject matter, composition, lighting, and scale of his still lifes to understand exactly how they were made, investigated his worldview, and even cultivated the fruits and vegetables that would have been available to the painter. Finally, she acquired period glassware,

porcelain, and cutlery. With these tools, she created her own Pealesque still lifes. Central to her process was mirroring the hues of Peale's paintings and his close description of light.[57] The miniscule highlights in *Peaches and Blackberries* mimic the white paint that the painter used to represent light glancing off a reflective surface. Art historian Alex Nemerov has argued that Peale's still lifes reflect the artist's preoccupation with his own mortality; Core's Peale-derived photographs play on photography's faded indexicality.[58]

Alex Prager took this mutating of photographic naturalism to its logical extreme in 2010, extending Cindy Sherman's cinematic constructions and Gregory Crewdson's theatrical stage settings into the realm of quasi-real anecdote. At a glance, her mural-sized photograph, *Crowd #1 (Stan Douglas)* (Plate 4.15), seems simply to document a crowd at a baseball game or racetrack. But closer inspection, guided by the title, bring recognition that much like advertisements and contemporary fashion photographs, the reality depicted does not quite hold up.

Prager fully embraces contemporary photography's rejection of any hard line dividing document and construction, and of the power of color to drive the conversation. Self-conscious about her place in photographic history, she suggests that her fascination with color comes from her appreciation of William Eggleston's photographs, but her application of color is far more directorial.[59] Like Crewdson, she looks to cinema, but *Crowd #1 (Stan Douglas)* replaces Crewdson's science-fiction-tinged horror with a work of pulp fiction drawn from the heyday of the studio era right down to the orchestrated palettes of her actors' clothing. Openly willing, like Simon Norfolk, to blur the line between art and commerce,

Prager created this image for the November 2010 issue of *W Magazine*.[60] But however much one wants to accept the scene as an extract from life, its elaborate arrangement of early 1960s fashions and the front-and-center placement of two women wearing brightly colored suits prevent it. These spots of intense color draw one in and release the image from its pastiche of reality. They induce closer interrogation of the rest of the image, and with that act the realization that no one is interacting with each other. Everyone in the crowd is striking a pose, showcasing the fact of the image's construction.[61]

PHOTOGRAPHY IS A VISUAL ART, but until recently it also has been a physical art, finding its release in prints. (Slides have always been a compromise.) As cell phones, computers, and tablets have cut into

the need to produce photographic prints, panels of distinguished experts have questioned whether photography is over, and a number of photographers have been drawing renewed attention to the medium's physicality.[62] Shortly after the invention of Kodachrome color film in 1936, Edward Steichen tried mixing up the colors in a series of photographs of a large flower-filled vase (Figure 4.12). When British artist Paul Graham was reviewing his thirty years of work for a 2009 retrospective, he was struck by the recent, often sudden disappearance of traditional color papers and film. As a result, he started making extreme close-ups of the patterns created by color dyes in the exposure and development of various films (Figure 4.13). The result became *Films*, a self-designed book tribute to these granular patterns. New York artist Cory Arcangel took this same track in

FIGURE 4.12
Edward Steichen (1879–1973), *Floral Arrangement*, ca. 1940. Dye imbibition prints. George Eastman House, International Museum of Photography and Film, Rochester, NY. Permission the Estate of Edward Steichen.

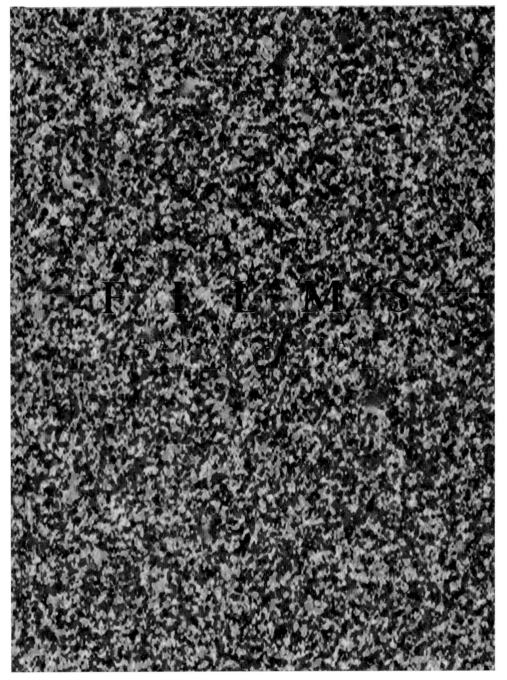

FIGURE 4.13
Paul Graham (b. 1956), cover of *Films* (London: Mack, 2011).
© Paul Graham, courtesy mack/www.macbooks.co.uk

his recent reflections on digital color, using the gradient tool of Photoshop CS to create spectral color arrays reflecting his play with the program's algorithms (Plate 4.16). The result is so simple, straightforward, and visually likeable that it opens the question of whether it makes any substantive contribution to art. But that is the point.[63] His titles delineating the recipe for making each of his Photoshop pieces embraces that predicament. Not only is it art access for all, it is photography without the world.

In her recent portraits of drug addicts, drag queens, and others along Hollywood Boulevard and in San Francisco's Tenderloin district, Katy Grannan takes up the color that so preoccupied Alfred Stieglitz in his short infatuation with the first successful commercial color process, the Autochrome: white.[64] Clean, bright whites have long defined color photography's technical success, providing the touchstone for determining the validity of every other hue. Grannan is not interested in white paint, fabric, snow, or clouds, the white that defines forms. Her infatuation is the white of bright midday light, photography's phenomenal foundation. Her "Boulevard" project photographs like *Anonymous, San Francisco* (2010) (Plate 4.17) symbolize not merely the physical challenges of aging but also—because they are physically driven in their intense whiteness—photography's corporeal dissolution. Trevor Paglen is equally preoccupied with photography's materiality. Mutually fascinated and disturbed by surveillance geographies that increasingly define the twenty-first century, he has created photographs of satellites traversing the nighttime skies above well-known western sites like Half Dome in Yosemite that are so light-filled due to hours-long exposures and surrounding ambient light that they look like colored-pencil drawings (Figure 4.14).[65] His nighttime views of security installations shot from miles away are filled with so much saturated color that the dyes start to read like thin layers of Jell-O (Figure 4.15). His blood-red image, *The Fence (Lake Kickapoo, Texas)* (2010), steps right to the edge of photographic possibility. The Lake Kickapoo installation just

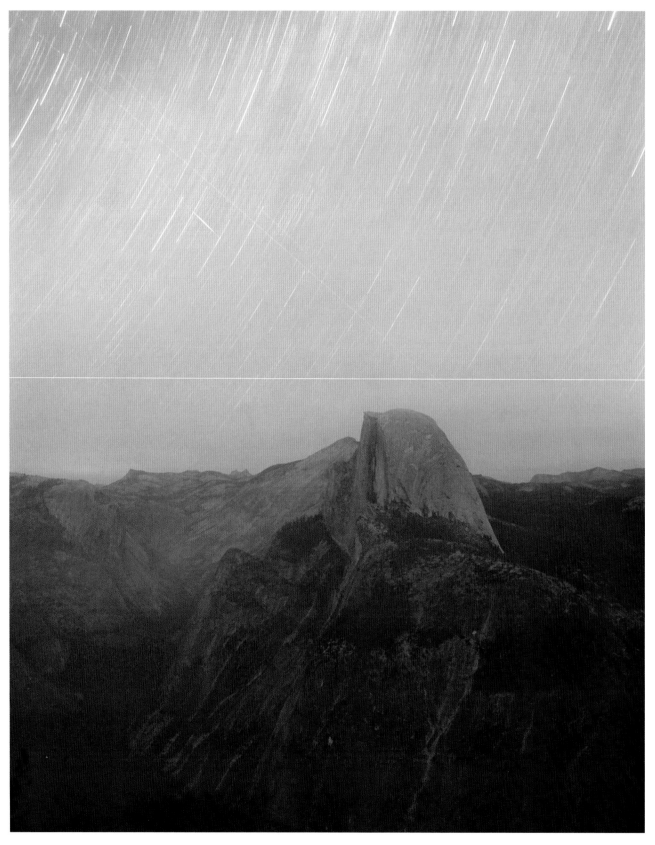

FIGURE 4.14
Trevor Paglen (b. 1974), *Keyhole Improved Crystal from Glacier Point (Optical Reconnaissance Satellite; USA 186)*, 2008. Dye coupler print. Courtesy the artist and Altman Siegel, San Francisco; Metro Pictures, New York; Thomas Zander, Cologne.

southwest of Wichita Falls, Texas, is the strongest of America's microwave transmitters for monitoring the country's borders and aerial space. Since we cannot see radio waves, the artist has to reimagine them with the help of an electronic reconstruction. He can record the electronic rendition of the radio waves that comprise this "fence," but not the "fence" itself. He then has to decide what color to give his reconstruction. As in NASA photographs of space, the image's color is a semi-arbitrary choice.[66] In the end, the image is a photograph of what we cannot see but know exists, a reimagining that uses color to draw us in (Plate 4.18).

Photography is light, but it also is a physical record of time. Rather than record the world with the aid of camera and lens, German-born New York artist Marco Breuer has been exploring the medium's fast-disappearing physicality by reminding us of the structure of the papers that for so many years have delivered us photographic color. Through the 1990s, Breuer explored the defamiliarization so inherent to photography by placing objects on the paper for short times during exposure to light, sometimes flashing them with a split-second of light to solarize them. He also abraded photographic papers, embossed them, applied a heat gun to them, lit sparklers over them, and even shot them with a shotgun. The resulting abstractions present a physicality that connects them back to abstract painting of the mid-twentieth century. But as photographic physicality has receded, Breuer has taken to creating images like *Spin (C-856)* (2009; Plate 4.19), where he exposes dye coupler

FIGURE 4.15
Trevor Paglen (b. 1974),
They Watch the Moon, 2010.
Dye coupler print. Courtesy the
artist and Altman Siegel, San
Francisco; Metro Pictures, New
York; Thomas Zander, Cologne.

paper to light, processes it, and then slices it very carefully with the help of a turntable and a razor blade to reveal its various dye layers. Out of the paper's black surface comes color, the depth of the cut determining the hue. The result is a circular pattern that suggests stars of different brightness and colors orbiting a planet in perfect alignment. Here, photography has blended into engraving, capturing and delivering light that is reshaped by the artist's hand to release texture and color not of the world but of the tools.

It took a while for artists and critics to see the possibilities afforded by color. But once they accepted how thoroughly it shifted the conversation, they found in it the means to speak to other art media in more universal terms. As exacting description fell away as photography's root language, record melded with creation, and photography became a dominant force in contemporary art.

One of photography's inventors, William Henry Fox Talbot, once called the medium "the art of fixing a shadow."[67] Thanks to color, it has also become an act of performance, framed by acknowledgement of its artifice. ◆

1. Nancy Spector, "Art Photography After Photography," in *Moving Pictures: Contemporary Photography and Video from the Guggenheim Museum Collection*, ed. Lisa Dennison, John G. Hanhardt, Nancy Spector, and Joan Young, 31 (New York: Solomon R. Guggenheim Museum and London: Thames & Hudson, 2003).

2. Besides success in the arenas of galleries and museums, the field saw an explosion of photographic book publishing and a broad expansion in collecting that caused prices for top quality works to jump. Charles Hagen, "The Triumph of Photography," *American Photo* 3, no. 1 (January–February 1992): 50–51. Issues of dye fading still hung over the field, causing some museums and collectors to hesitate over acquiring color photographs, though better materials promised increased longevity.

3. Even photojournalists were reconsidering their methods under the influence of newspapers' burgeoning absorption of color. Led by *USA Today*'s commitment to color photojournalism, other newspapers increasingly filled their front pages with color photographs. One of the last holdouts, *The New York Times* would start using color photographs on its front page in 1997.

4. Harry M. Callahan, ed., *Ansel Adams in Color* (New York: Little, Brown and Company, 1993).

5. See Douglas R. Nickel, "History of Photography: The State of Research," *The Art Bulletin* 83, no. 3 (September 2001): 548–558. It contains a good summary of the debate over photography's artistic and cultural underpinnings that blossomed in the 1980s and were still going strong at this time.

6. The Dycam Model 1 camera had a CCD image sensor and could plug directly into a computer for download.

7. Nash Editions, Ltd., quickly became a force in the production of digital prints. See Vincent Katz, "Wild Irises," *Aperture* 136 (Summer 1994): 38–45.

8. Peter Nulty and Thomas J. Martin, "The New Look of Photography: The Transition from Film to Electronic Imaging Seems Sure to Excite Consumers and Create Fast-growing Markets. Who Will Win Them? Kodak? Polaroid? Or the Japanese?," *Fortune*, July 1, 1991, http://money.cnn.com/magazines/fortune/fortune_archive/1991/07/01/75212/index.htm.

9. Szarkowski turned over the reins of the photography department to Peter Galassi and became photography director emeritus.

10. See Van Deren Coke, *The Painter and the Photograph: From Delacroix to Warhol* (Albuquerque: University of New Mexico Press, 1964), 1972, revised and enlarged edition.

11. See Anne Temkin, *Color Chart: Reinventing Color, 1950 to Today* (New York: The Museum of Modern Art, 2008).

12. This act mirrored color portraits that German Thomas Ruff had been making since 1984, though Ruff worked with the more muted hues of dye coupler photographic paper.

13. See Neil Winokur, *Everyday Things* (Washington DC: Smithsonian Institution Press in association with Constance Sullivan Editions, 1994).

14. Peter Galassi, *Pleasures and Terrors of Domestic Comfort* (New York: The Museum of Modern Art, 1991), 110–111.

15. Influenced by Robert Frank, Bergman traded using an 8 × 10–inch view camera for a 35mm camera. Jacqueline Trescott, "Photographer Robert Bergman's Show Opens at the National Gallery of Art," *Washington Post*, October 13, 2009, www.washingtonpost.com/wp-dyn/content/article/2009/10/12/AR2009101202981.html.

16. Ibid.

17. Judith H. Dobrzynski, "The Man Who Waited," *The Wall Street Journal*, October 6, 2009, online.wsj.com/article/SB10001424052748704471504574445390823842348.html.

18. Robert Bergman, *A Kind of Rapture* (New York: Pantheon Books, 1998).

19. Trescott, "Photographer Robert Bergman's Show."

20. Vicki Goldberg, et al., "The Photography of Robert Bergman," *The Brooklyn Rail*, May 2004, www.brooklynrail.org/2004/05/art/bergman. John Yau suggested that the photographer worked in the tradition of poets Walt Whitman and William Carlos Williams.

21. In 1988, Bey had started using Polaroid film almost exclusively in his 4 × 5 street photography. Kellie Jones, et al., *Dawoud Bey: Portraits, 1975–1995* (Minneapolis: Walker Art Center, 1995), 42.

22. Ibid., 64.

23. "Those brown background Polaroid works began with my interest in the paintings of Rembrandt—with their brown backgrounds and single dramatic light source—and wanting to use that influence and expand it, both to a wider range of contemporary subjects as well as formally, through the multiple photograph pieces." Dawoud Bey, e-mail to John Rohrbach, August 21, 2011, Curatorial Research Files, Amon Carter Museum of American Art, Fort Worth, TX.

24. *Catherine Opie: American Photographer* (New York: Solomon R. Guggenheim Foundation, 2008).

25. See Nat Trotman, et al., *Catherine Opie: American Photographer* (New York: Solomon R. Guggenheim Museum, 2008), 72–73.

26. Aperture Foundation published eleven images from the Rodeo Drive series. Anthony Hernandez, "Rodeo Drive," *Aperture* 101 (Winter 1985): 16–23.

27. Waiting, as Allan Sekula points out in his brief introduction to Hernandez's book *Waiting for Los Angeles* (Tucson, AZ: Nazraeli Press LLC, 2002), is what photographers do.

28. Eliot Porter, untitled lecture, Eyes West: Color; The Third West Coast Conference for Artists and Designers, Squaw Valley, CA, 1965, 18. Eliot Porter Archives, Amon Carter Museum of American Art.

29. Richard Misrach, *Desert Cantos* (Albuquerque: University of New Mexico Press, 1987); and Richard Misrach and Rebecca Solnit, *The Sky Book* (Santa Fe: Arena Editions, 2000).

30. The works also relate to the longstanding fascination with pure color found in the work of conceptual artists like Donald Judd, Ellsworth Kelly, Sol Lewitt, and Blinky Palermo. See Ann Temkin, *Color Chart*. Richard Avedon helped start this trend toward oversized photographs with the life-sized photographs of public figures he produced for a 1975 exhibition at Marlborough Gallery in New York.

31. See Bill Armstrong's "infinity series" of mandalas and seascapes. Carey calls her project "Photography Degree Zero" after Roland Barthes's 1953 book *Writing Degree Zero*, which is a meditation on the dispassionate, minimalist style of the new French novel. See Ellen Carey, "Artist's Statement: *Photography Degree Zero*," Ellen Carey Photography, http://www.ellencarey.com/history/As.html; and Roland Barthes, *Writing Degree Zero* (New York: Hill and Wang, 1953).

32. Misrach, *The Sky Book*, 9.

33. Despite Conkey's best efforts, the spot never got developed. Ibid., 118.

34. In May 1998, Adobe came out with Photoshop 5.0 with editable type and a full color management system.

35. Aaron Schuman, "Roaming: An Interview with Todd Hido," *Seesaw: an Online Photography Magazine: Observation Full and Felt* 1 (Winter 2004), http://www.seesawmagazine.com/roaming_pages/roaming_interview.html. See also Todd Hido, *Roaming: Landscape Photographs, 1994–2004* (Tucson, AZ: Nazraeli Press, 2004).

36. Mitch Epstein, *Family Business* (Göttingen, Germany: Steidl, 2003).

37. See Alec Soth, *Sleeping by the Mississippi* (Göttingen, Germany: Steidl, 2004).

38. Photographic dyes and pigments had gained substantively better stability by this date, but larger museums often installed elaborate cold storage systems to substantively slow down that fading, especially in older color prints and transparencies.

39. In 1981, Wall made a panoramic landscape photograph that he printed at more than seven feet on the long dimension. Michael Fried would dissect this compulsion for grand size in his book *Why Photography Matters as Art as Never Before* (New Haven, CT: Yale University Press, 2008).

40. See Alex Webb, *The Suffering of Light: Thirty Years of Photographs* (New York: Aperture Foundation, Inc., 2011).

41. See Alex Webb, *Istanbul: City of a Hundred Names* (New York: Aperture Foundation, Inc., 2007).

42. See Laura Letinsky, *Hardly More Than Ever: Photographs, 1997-2004* (Chicago: The Renaissance Society at the University of Chicago, 2004). Early images in this series point back to Baroque banquet table still lifes filled with the residue of half-eaten dinners.

43. See Peter Galassi, *Andreas Gursky* (New York: The Museum of Modern Art, 2001).

44. Lynda Hammes, "Reviews: Andreas Gursky," *Aperture* 165 (Winter 2001): 72–75.

45. In September 2003, Pedro Meyer would host a colloquium in Mexico City to mark the tenth anniversary of his online magazine *Zone Zero* and assess the state of digital imaging. There photography curator Rod Slemmons suggested that digital tools now allowed photographers to manipulate photographs the way poets play with words, and David Elliot Cohen, creator of the A Day in the Life series, declared analog photography to be dead, and handouts included a September 25, 2003, *Wall Street Journal* report announcing Eastman Kodak Company's decision to focus on digital imaging. Mark Haworth-Booth, "Meetings: 10 Years: From Analog to Digital: *Zone Zero*," *Aperture* 175 (Summer 2004): 76–79.

46. Galassi, *Andreas Gursky*, 31.

47. See Louise Neri and Vince Aletti, *Settings & Players: Theatrical Ambiguity in American Photography* (London: White Cube, 2001).

48. Rick Moody, "On Gregory Crewdson," *Twilight, Photographs by Gregory Crewdson* (New York: Harry N. Abrams, Inc., 2002), 6.

49. Stephan Berg, "The Dark Side of the American Dream," *Gregory Crewdson 1985-2005* (Ostfildern-Ruit, Germany: Hatje Cantz, 2005), 13.

50. Adobe introduced Photoshop in 1990. Derrick Story, "From Darkroom to Desktop: How Photoshop Came to Light," *Story Photography*, http://storyphoto.com /multimedia/multimedia_photoshop.html.

51. This characteristic of assemblage connects the photograph back to the nineteenth century practice of cutting and pasting people into barely coherent group portraits. See Mia Fineman, *Faking It: Manipulated Photography before Photoshop* (New York: Metropolitan Museum of Art, 2012).

52. This same period saw renewed interest in the psychological attributes of color. See David Batchelor's extended musing on the subjectivity of color, *Chromophobia* (London: Reaktion Books, Ltd., 2000).

53. Digital photography had become standard practice in photojournalism by this date, putting initial editing into the hands of photographers and allowing images to be sent around the world instantly.

54. Other leading practitioners of this hybrid form of photojournalism include Edward Burtynsky, Luc Delahaye, Sebastião Salgado, and David Taylor.

55. See Joseph Lelyveld, "The Border Dividing Arizona," *The New York Times Magazine*, October 15, 2006, http://www.nytimes.com/2006/10/15/magazine /15immigration.html?pagewanted=all.

56. Norfolk brought to the topic recent experience photographing in Afghanistan and Bosnia.

57. *Peaches and Blackberries* closely approximates Peale's painting *Fox Grapes and Peaches* (1815), owned by the Pennsylvania Academy of the Fine Arts down to the brown table and its cropping. The photograph's 12 × 14½ inch size even mirrors the 9½ × 11 ½ inch size of the painting. Core's replacement of grapes with blackberries reflects Peale's equal interest in blackberries, the subject of others of his still lifes. The photograph also matches late nineteenth-century trompe l'oeil paintings, like William J. McCloskey's *Wrapped Oranges* (1889).

58. By 2011, Core's blend of photography and painting had been taken up by painters Randy Hayes and Christopher Rush, not to add another chapter to photorealism, but to meld the physical qualities of painting and photography from the other side of the equation.

59. Alison Zavos, "Q&A: Alex Prager, Los Angeles," *Feature Shoot*, July 2008, http://www.featureshoot.com /2008/07/.

60. The Museum of Modern Art, *New Photography 2010: Alex Prager*, http://www.moma.org/interactives /exhibitions/2010/newphotography/alex-prager/. She also has contributed to *ID, Elle, Japan, Flaunt, MOJO*, and *Complex*.

61. Just as the main character in Douglas's *Subject to a Film: Marnie* is trapped within her office setting, these women in Prager's photograph are trapped in their seats. See also Douglas's installation video *Win, Place, or Show* (1998).

62. San Francisco Museum of Modern Art. "Is Photography Over?" *San Francisco Museum of Modern Art Research + Projects*. http://www.sfmoma.org/about /research_projects/research_projects_photography _over. In July 2010, freelance photojournalist and *National Geographic* photographer Steve McCurry shot the last roll of 36-exposure Kodachrome produced by Eastman Kodak. Dwayne's Photo Service of Parsons, Kansas, the last company processing Kodachrome, quit such work on December 10, 2010.

63. See Andrea K. Scott, "Futurism," *The New Yorker*, May 30, 2011, 33.

64. Grannan has known and photographed some of these subjects for years. Jerry Saltz, "Desolation Row," *New York Magazine*, April 17, 2011, http://nymag.com/arts /art/reviews/katy-grannan-saltz-review-2011-2014/.

65. Paglen has also added to photography's longstanding tradition of sky imagery with large pastel-hued prints that reflect color-field beauty save for their tiny, barely visible, spots of drones.

66. Trevor Paglen, email to John Rohrbach, October 2010, Curatorial Research Files, Amon Carter Museum of American Art, Fort Worth, TX.

67. In 1989, Sarah Greenough, Joel Snyder, David Travis, and Colin Westerbeck assembled an exhibition and book celebrating photography's first 150 years. They drew their project title, *On the Art of Fixing a Shadow* (Boston: Bulfinch Press, 1989), from a subheading in Talbot's first account of his photographic achievements.

PLATE 4.1

Neil Winokur (b. 1945)

Glass of Water, 1990. Silver dye-bleach print,
40 × 30 inches.

PLATE 4.2

Robert Bergman (b. 1944)

[untitled], 1990. Inkjet print, 2004,
$23^{11}/_{16} \times 15^{7}/_{8}$ inches.

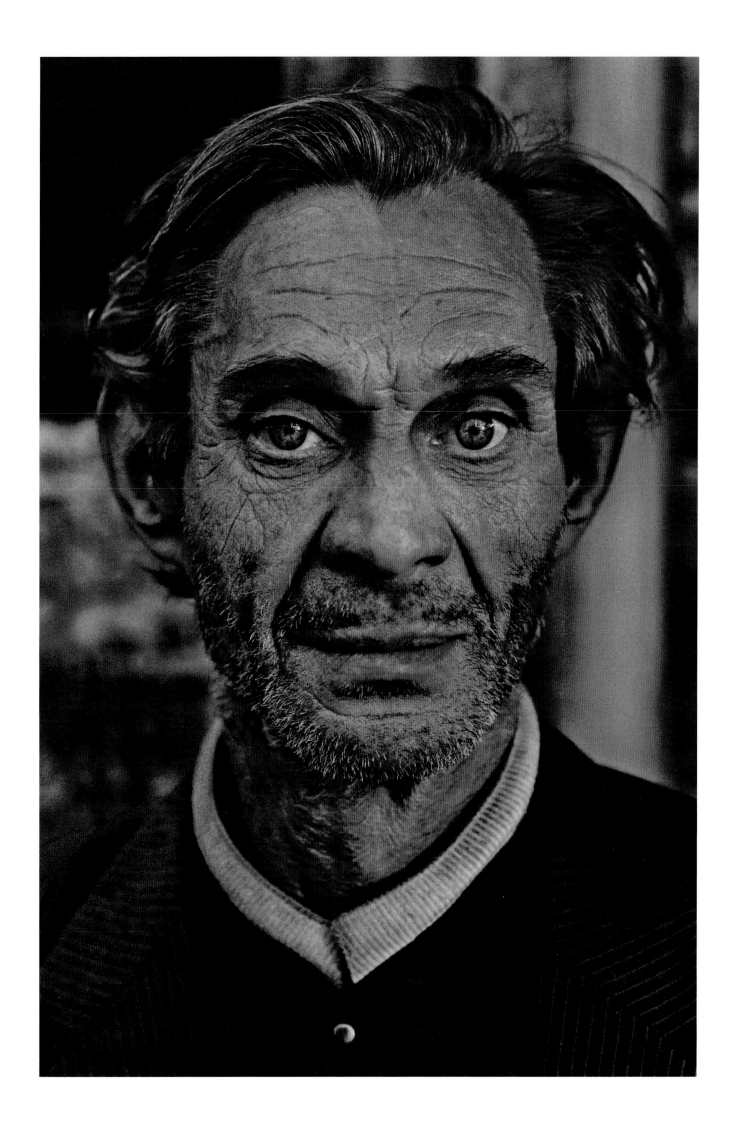

PLATE 4.3

Dawoud Bey (b. 1953)

Nikki and Manting, 1992. Dye diffusion print (Polacolor ER), 30 × 44 inches.

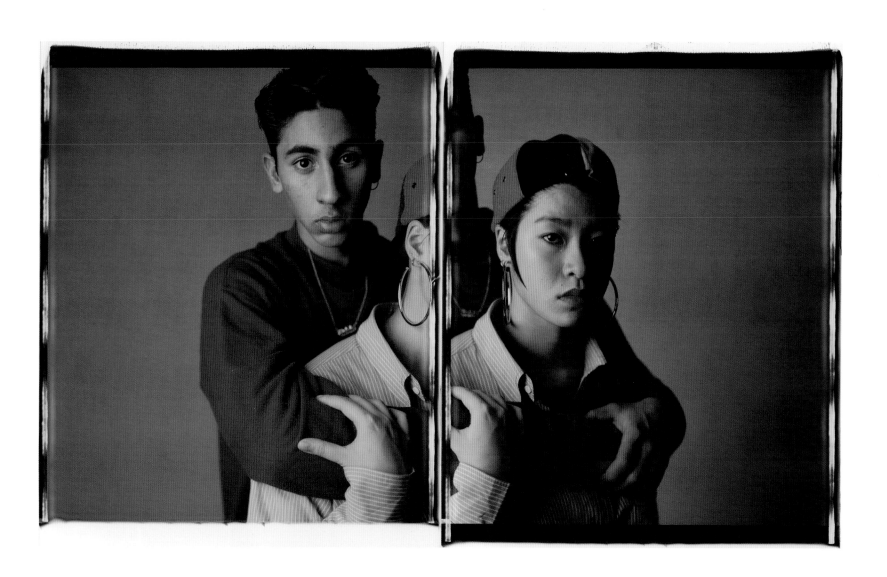

Anthony Hernandez (b. 1947)

Waiting in Line (#21), 1996. Dye coupler print,
40 × 40 inches.

PLATE 4.5

Richard Misrach (b. 1949)

Paradise Valley [Arizona], 3.22.95, 7:05 P.M.
Dye coupler print, 60 × 74 inches.

PLATE 4.6

Todd Hido (b. 1968)

Untitled #2431, 1999. Dye coupler print, 2006,
20 × 24 inches.

PLATE 4.7

Mitch Epstein (b. 1952)

Flag, 2000. Dye coupler print, 40 × 30 inches.

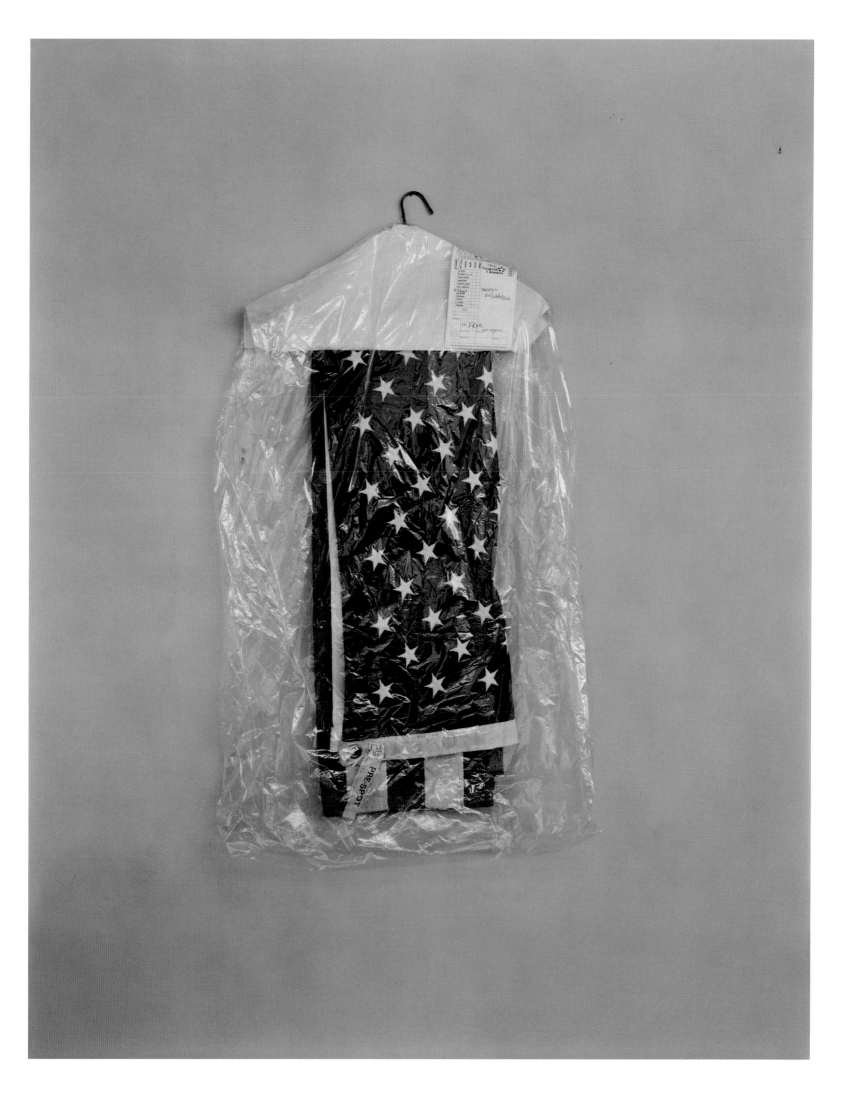

PLATE 4.8

Alec Soth (b. 1969)

Adelyn, Ash Wednesday, New Orleans, Louisiana, 2000. Dye coupler print, 16 × 20 inches.

PLATE 4.9

Alex Webb (b. 1952)

Istanbul [View from a barbershop near Taksim Square], 2001. Dye coupler print, 20 × 30 inches.

PLATE 4.10

Laura Letinsky (b. 1962)

Untitled, #52, 2002. Dye coupler print, 2007.
24 × 33 ½ inches.

PLATE 4.11

Gregory Crewdson (b. 1962)

Untitled (Dylan on the Floor), from the
Twilight series, 1998–2002. Dye coupler print,
48 × 60 inches.

PLATE 4.12

Joaquin Trujillo (b. 1976)

Jacky, 2003. Inkjet print, 2011, 40 × 32 inches.

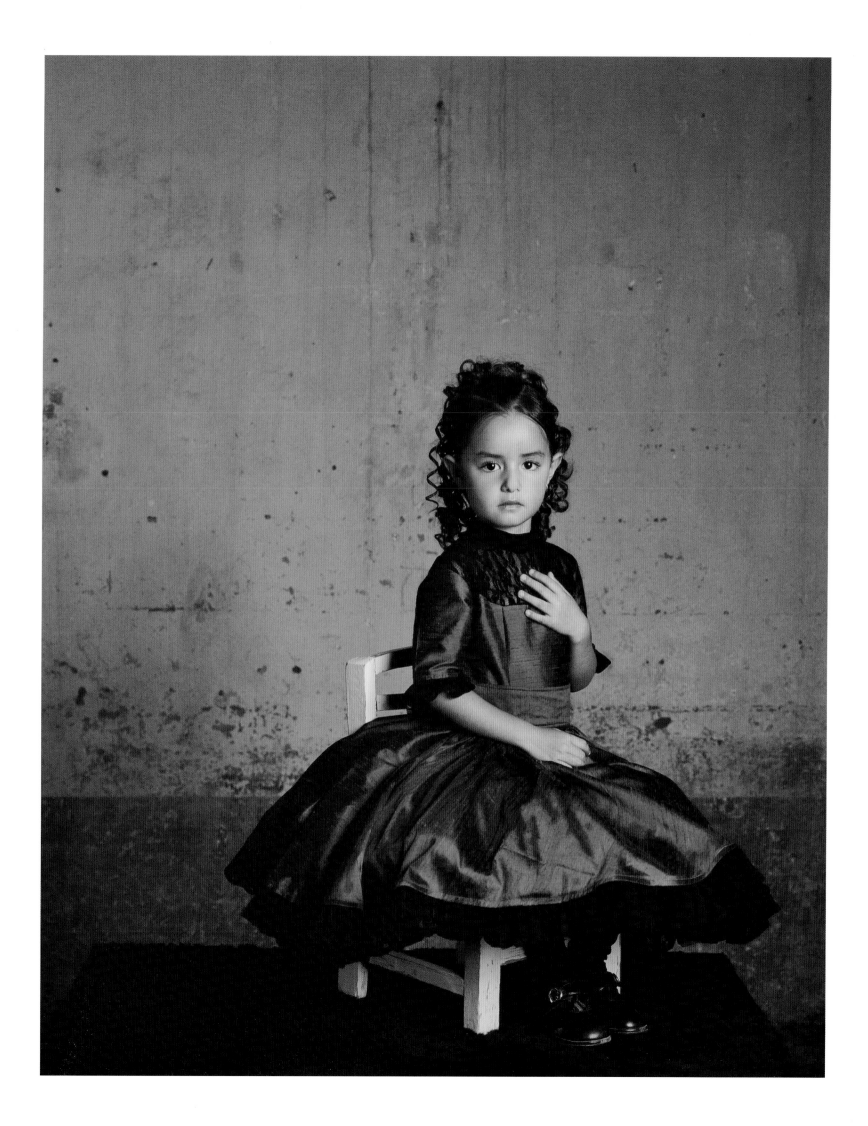

Simon Norfolk (b. 1963)

Fantasma en la Ciudad, Nogales, Arizona/Nogales, Sonora, Mexico, 2006. Dye coupler print, 40 × 50 inches.

PLATE 4.14

Sharon Core (b. 1965)

Peaches and Blackberries, 2008. Dye coupler print,
12½ × 16½ inches.

Alex Prager (b. 1979)

Crowd #1 (Stan Douglas), 2010. Dye coupler print, 36 × 60½ inches.

PLATE 4.16

Cory Arcangel (b. 1978)

Photoshop CS, 300 DPI, RGB, square pixels, default gradient "Spectrum," mousedown y=1416 x=1000, mouseup y=208 x=42, 2009, from the Photoshop Gradient Demonstrations series. Dye coupler print, 72 × 110 inches.

PLATE 4.17

Katy Grannan (b. 1969)

Anonymous, San Francisco, 2010. Inkjet print,
39 × 29 inches.

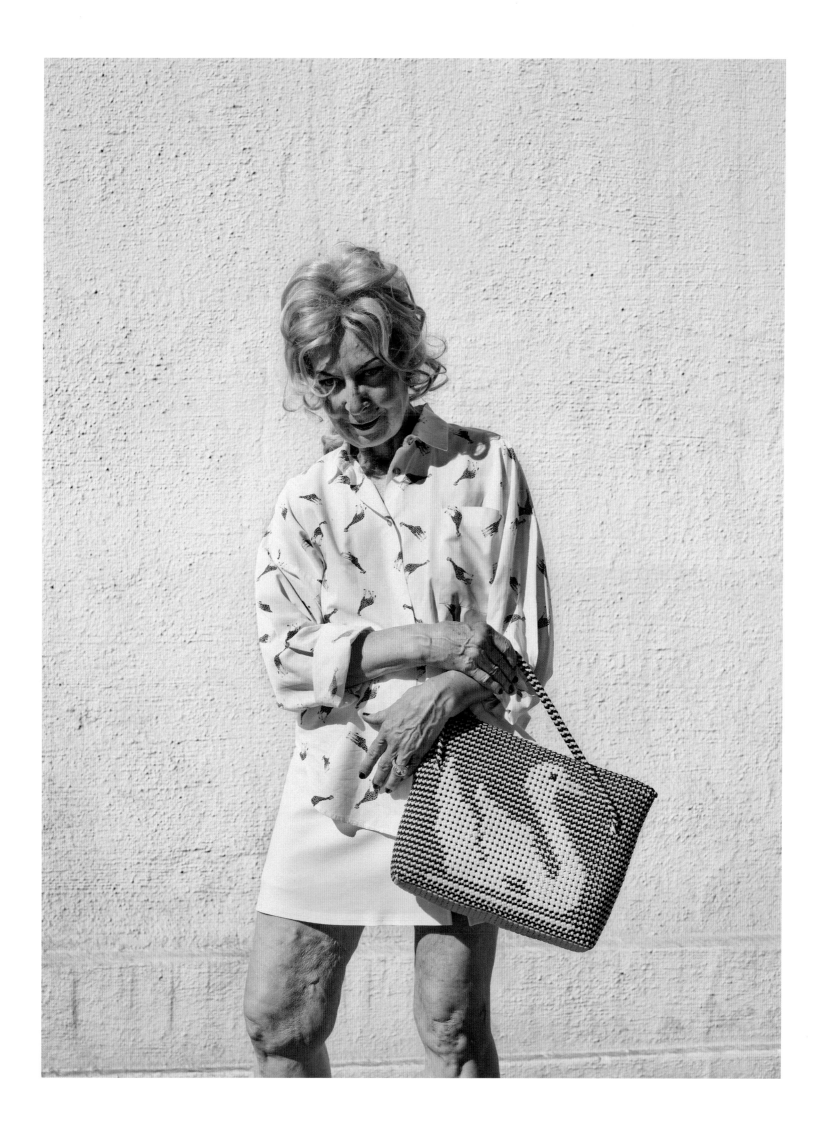

PLATE 4.18

Trevor Paglen (b. 1974)

The Fence (Lake Kickapoo, Texas), 2010. Dye coupler print, 2011, 50 × 40 inches.

PLATE 4.19

Marco Breuer (b. 1966)

Spin (C-856), 2008. Dye coupler paper, embossed/ scratched, 14⅛ × 10½ inches, unique.

FIGURE 0.1
Abel Niépce de Saint-Victor, *Doll on a stool*, ca.
1851–1859, Heliochrome. © Musée des Arts et
Métiers-CNAM, Paris/photo Studio CNAM

From Potatoes to Pixels

A Short Technical History of Color Photography

SYLVIE PÉNICHON

If we are going to have Colour Photography for heaven's sake let's have a riot of colour, and none of your wishy-washy hand-tinted effects.

MADAME YEVONDE, 1933[1]

WHEN FRANÇOIS ARAGO introduced the daguerreotype to his fellow members of the French Academy of Sciences in January 1839, he was prompt to note that Louis Daguerre had discovered a way to capture exact likenesses of nature, but without color.[2] As soon as details of the process became available, many scientists set out to correct this defect and find a solution to what would become known as the "problem of color" in photography. For the time being, color was manually added to portraits, enhancing rosy cheeks and jewelry and, in some rarer and more luxurious instances, exquisitely covering the entire plate (Plate 1.1).[3] Scientists first concentrated their efforts in searching for a substance that would be able to assume the color of any light that fell onto it, like a chameleon, and would bestow direct color onto photographs. In 1848, physicist Edmond Becquerel succeeded in capturing a full-color image of the solar spectrum on a daguerreotype plate.[4] Unfortunately, Becquerel was never able to fix his pictures permanently; they lasted indefinitely in the dark but faded rapidly in sunlight. Likewise, other researchers,

including Abel Niépce de Saint-Victor and Alphonse Poitevin, successfully obtained color images on silver plates and paper, but they failed in fixing them (Figure 0.1).[5] Even so, these first steps toward color photography were discussed extensively in scientific circles, and the objects themselves were exhibited at international fairs of the midcentury, where they drew immense curiosity and excitement. The heated controversy around Levi Hill's announcement in 1851 of daguerreotyping in the colors of nature, described in detail by John Rohrbach in this volume, shows how enthusiastically color was anticipated by the public. But color would remain elusive.

At the time, the understanding of the physical phenomenon of color, and how we perceive it, was in its infancy. In the seventeenth century, Sir Isaac Newton had demonstrated that sunlight (or white light) was in fact composed of many different colors when he placed a glass prism in a bright sunbeam and obtained a rainbow—what we call the color spectrum. To show that the light was not colored by the prism, he placed a second prism upside down in front of the

first one; as the band of colors passed through the second prism, it combined again into white sunlight.[6] Around 1800, Thomas Young asserted that humans perceived color thanks to three types of receptors in the eye, each sensitive to only one color: red, green, or blue.[7] Young's theory of color vision was highly disputed until physicists James Clerk Maxwell and Hermann von Helmholtz refined it.[8] In 1861, the former demonstrated it by taking three black-and-white transparencies of a tartan ribbon through red, green, and blue filters, the colors presumably seen by the human eye. He then put each transparency into one of three projectors, covering each lens with the same filters that had been used to take that specific picture. When he superimposed the images on a projection screen, a full-color image of the ribbon was formed (Figure 0.2). Even though the image, in Maxwell's own account of the experiment, exhibited deficiencies in the red and green, it was successful enough to demonstrate the validity of Young's theory.

Eight years later, Louis Ducos du Hauron and Charles Cros offered groundbreaking solutions to the problem of color in photography.[9] Working independently of each other, the two men had reached similar conclusions and described several methods of making full-color prints, foreseeing most of the color photographic processes that would be commercialized in the twentieth century. Instead of searching for an elusive substance that would capture all the colors of the spectrum, they proposed the trichrome separation of colors, like Maxwell had done.[10] After making three separation negatives of the same scene through three colored filters (red, green, and blue), they proposed to reconstruct the scene in full color through either the additive or subtractive synthesis of colors (Figure 0.3). With the additive method, the reproduction of color is done by combining or adding three beams of light, colored red, green, and blue, on the single image plane of a screen (Maxwell's experiment was the first photograph produced by this system). The additive synthesis can only be used with colored light, not with pigments or dyes. The subtractive method is based on the production of color by the absorption, or

subtraction, of the three primary colors (red, green, and blue) from incident white light. The three primary subtractive colors are yellow, magenta, and cyan; they absorb, or subtract, blue, green, and red light, respectively. However, there was a major obstacle to the application of the Ducos du Hauron and Cros inventions: photographic materials of the time were incapable of registering all the colors of the spectrum. Silver emulsions were inherently sensitive to blue but practically blind to the rest of the color spectrum. As would be demonstrated a hundred years later, Maxwell had been lucky in his endeavor. In 1961, scientists at Eastman Kodak Company showed that the green filter used in Maxwell's experiment transmitted some blue radiations, and that the red fabric of the tartan ribbon emitted infrared radiations.[11] Unbeknownst to Maxwell, these radiations had created the images on the green- and red-filtered plates where there should have been none. During the last decades

FIGURE 0.2
Digital reconstitution of Maxwell's experiment made from D. A. Spencer's duplicates of Maxwell and Sutton's original positives. Collection of Mark Jacobs.

FIGURE 0.3
Louis Ducos du Hauron (1837–1920), *View of Agen, France, showing the St. Caprais cathedral,* 1877. Heliochrome (multilayer dichromated pigmented gelatin process). George Eastman House, International Museum of Photography and Film Rochester, NY.

FIGURE 0.4
The screen of Autochrome plates is composed of minute grains of potato starch dyed blue-violet, orange-red, and green. Photograph by Sylvie Pénichon.

of the nineteenth century, progress in the chemistry of photographic emulsions and the discovery of spectral sensitization eventually led to the advent of panchromatic emulsions—photographic materials sensitive to all the colors of nature. With these, color photography became at last possible.[12]

At the dawn of the twentieth century, photographic journals were buzzing with frequent reports of new discoveries in color photography, but results were often irregular and disappointing. The breakthrough came from the Establishments Lumière of Lyon, a family enterprise that manufactured gelatin dry plates (glass-plate negatives) and was directed by two brothers, Auguste and Louis Lumière.[13] In his writings on color photography, Ducos du Hauron had described a colored screen of thinly ruled red, green, and blue lines that would act as individual filters and would separate the colors automatically without having to take three different shots of a scene.[14] The brothers followed this idea, but instead of ruled lines, they imagined a color screen made of minute colored particles of potato starch (Figure 0.4). They spread a mixture of starch grains dyed blue-violet, orange-red, and green onto a sticky glass plate before it was coated with a black-and-white panchromatic emulsion, like a regular negative. They named their invention Autochrome—automatic color. To take a picture, the Autochrome plate was placed in the camera with the glass side facing the lens so that light would go through the screen of colored starch before it reached the light-sensitive emulsion. Each grain acted as a minuscule filter imperceptibly separating colors; the emulsion behind the starch screen was exposed only by the light transmitted by the colored grain adjacent to it. After the picture was taken, the plate was developed in regular black-and-white reversal chemistry to obtain a positive transparency. Once dry, the color photograph was ready to be viewed through transmitted light, with no extra manipulation needed. The black-and-white transparency acted as a filter of the light, blocking it in the dark areas and transmitting it in the light ones. The light thus transmitted was seen through the screen of red-, green-, and blue-colored

starch grains, and the full color of the original scene was recreated by the additive synthesis of colors (Plate 1.7).

The commercial launch of the Autochrome in 1907 marked the beginning of color photography. While it was not the first color-screen product to be commercialized, the Autochrome was truly innovative. It presented the advantage of having the screen integrated with the photographic emulsion, thus eliminating the need of taping screen and image together in perfect register in order to see the image in full color. Unlike previously marketed color screens, whose pattern was easily discernable, individual starch grains were invisible to the naked eye. Autochrome plates were packaged and sold like regular glass-plate negatives. They could be used in any regular camera and required no overly complicated manipulation. They were immediately met with immense commercial success that lasted for decades.[15] Nonetheless, Autochromes presented inescapable drawbacks: they were approximately sixty times slower than black-and-white negatives and required long exposures because the colored screen absorbed most of the light (this is why most pictures were taken outdoors). Moreover, the plates were expensive, about four times more so than black-and-white glass plates, and images were one-of-a-kind transparencies that could not be manipulated or printed on paper.[16] It turned out color had been only partially tamed.

In the 1920s, magazines such as *National Geographic* and LIFE began to regularly feature color reproductions in their pages, and advertisers were starting to understand the selling potential of color (Figure 0.5). There was a growing demand for color photographs. The development of so-called color cameras (cameras that allowed the production of three individual separation negatives with only one click of the shutter), combined with the introduction of carbro printing, helped further advance color photography.[17] Carbro had its root in the tricolor carbon process used by Ducos du Hauron and was an improved version of a process called Ozobrome, which was commercialized at the turn of the century.

It was first marketed in 1921 by the Autotype Company of London under the name Trichrome Carbro and became the printing method of choice for advertising and fashion photographers of the 1920s and 1930s. Its name was a combination of the words "carbon" (carbon tissue) and "bromide" (photographic paper), both used in the process. However, carbro was not easy to master; it required extreme handiness, and the printing of one image could take as long as ten hours. Temperature and relative humidity of the room had to be controlled at all times during the process, and many things could go wrong and ruin the image. To make a carbro print, three black-and-white separation negatives were enlarged on sheets of regular black-and-white photographic paper called bromide. These three prints were then immersed in a bleaching bath and immediately placed in close contact with sheets of paper (or tissue) coated with a layer of pigmented gelatin colored cyan, magenta, or yellow—the complementary colors of red, green, and blue, respectively, as stated above. Under the chemical action of the bleach, the pigmented gelatin hardened in proportion to the amount of silver present in the bromide image. This created a mirror image of insoluble gelatin in the pigment tissue. After a few minutes, bromides and tissues were separated, and the tissues were squeegeed facedown onto a clean sheet of celluloid before they were immersed in warm water. The unhardened gelatin dissolved in the water and the tissue's paper support could be peeled off and discarded, leaving a color relief of the original image on the transparent plastic support. To finish the print, the three colored reliefs of gelatin were then transferred in perfect registration—one on top of the other—onto a sheet of white paper (Plate 1.14). The prints were often heavily retouched to correct defects and adjust color. In short, carbro was too complicated, too difficult, and too expensive for most photographers. For the time being, amateurs would continue to rely on additive color screen plates such as the Autochrome for their color photographs.

Like many in the photography business, Kodak founder George Eastman dreamed of the day when

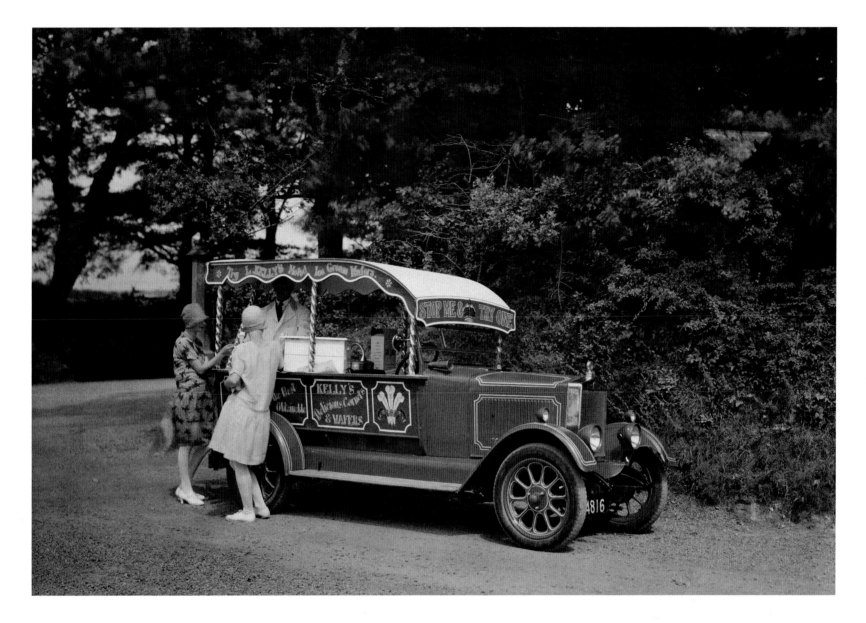

FIGURE 0.5
Clifton Adams, [Two women buying ice cream, Cornwall], 1928. National Geographic stock.

a practical process would make color photographs available to the masses.[18] His company had already revolutionized amateur photography with the introduction of the No. 1 Kodak camera in 1888 and the motto "You press the button, we do the rest." Convinced that the future of photography was in color, in 1912 Eastman hired C. E. K. Mees to set up and direct Kodak Research Laboratories and heavily invest in color photography.[19] These efforts eventually paid off. In 1935, Kodak launched the first integral color 16mm amateur motion-picture film called Kodachrome. Still films for miniature

and Bantam cameras were introduced the following year.[20] Kodachrome was revolutionary; not only did it provide vivid colors and sharp images that were not obscured by a color screen, it also was the first film that featured three layers of emulsion with different spectral sensitivity to red, green, or blue stacked on one side of a single piece of film. Before the advent of this so-called integral film, stacks of thin films called bi-packs and tri-packs were often used. In tri-packs, each film would be sensitive to red, green, or blue. With bi-packs, one of the pieces of film had emulsions coated on both sides. Invented by Leopold

Mannes and Leopold Godowsky Jr., Kodachrome
was based on earlier discoveries of the chromogenic
development mechanism and of dye couplers by Ger-
man chemists Benno Homolka and Rudolf Fischer.[21]
Couplers were colorless substances that could be
converted into dyes during the development of silver
images; they reacted with the developer and formed
small clouds of color around each developed silver
grain, hence the name chromogenic ("color forming")
development.

Fischer and other scientists had stumbled on their
inability to anchor these couplers around the silver
grains inside the different layers of films; during
development, dyes wandered within the different
layers of swollen gelatin, ruining the picture. Mannes
and Godowsky circumvented the problem by incor-
porating the couplers into the three different color
developers used to process the film (one for each of
the emulsion layers) and by relying on the controlled
penetration of bleaching solutions (Figure 0.6). After
a regular black-and-white development, each layer
of emulsion was individually bleached and redevel-
oped to form the appropriate color—cyan, magenta,
or yellow. Processing of Kodachrome was complex;
it involved twenty-eight steps, lasted three and a
half hours, and required three separate processing
machines. To ensure successful results, Kodak exclu-
sively handled all processing. Films were sold with
self-addressed, mail-in envelopes; once exposed, they
were returned to Kodak for development. Because
processing was extremely long and early materials
presented color stability issues, efforts were made
to improve and simplify Kodachrome (Figure 0.7).
In 1938, new dyes and a new processing technique
based on selective re-exposure and development
was adopted, and the number of processing steps
was reduced to eighteen. The new Kodachrome was
remarkably stable in the dark and many early ex-
amples still exhibit bright colors today. Kodachrome
would remain virtually the same for more than
seventy years until the product was discontinued
in 2009 and the last roll of film was processed in
December 2010.

FIGURE 0.6
Leopold Godowsky (left) looking at a new color plate while
Leopold Mannes holds a developing tray, November 13, 1930.
Image by © Bettmann/CORBIS.

FIGURE 0.7
Kodachrome transparencies processed with the controlled-diffusion bleach method had poor stability in the darks; most early Kodachromes have suffered complete loss of yellow dye. Russell Lee (1903–1986), *Orchestra during intermission at square dance; notice sweated shirt of host, McIntosh County, Oklahoma*, 1939 or 1940. Kodachrome transparency. Library of Congress, Farm Security Administration, Office of War Information Collection, Washington DC.

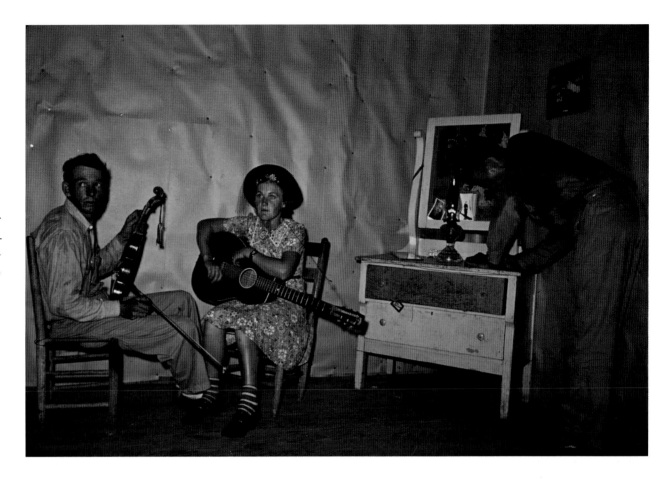

Also in 1936, the German company Agfa launched its own integral color transparency film called Agfacolor Neu. This multilayer slide film was different from Kodachrome in a very important way. Instead of adding color couplers in the developers, Agfa engineers had found a way to integrate and anchor the dye couplers during manufacture of the emulsions so that they would not wander within the film during development. This innovation offered the great advantage of much cheaper and less cumbersome processing, with just one color development step (Kodachrome needed three), during which all the dyes were formed simultaneously in their three respective layers. When the film was commercialized in the United States by the Agfa-Ansco Company under the name Ansco Color, processing chemicals were made available to photographers who, for the first time, could then develop their color films in their own darkrooms. Incorporated-coupler technology became the model adopted for most subsequent chromogenic materials manufactured all over the world to this day.

The introduction of Kodachrome and Agfacolor Neu films marked the beginning of the modern era of color photography. Still, both products remained burdened by some of the shortcomings their predecessor, Autochrome, had faced: sensitivity was low compared to that of black-and-white films (Kodachrome was launched with an exposure index of ISO 8), transparencies were unique and had to be projected, and it was not possible to obtain prints unless one resorted to complex assembly printing processes such as carbro. In 1941, Kodak introduced a printing service for wallet-size prints made from Kodachrome transparencies called Minicolor (Figure 0.8). However, making prints directly from color transparencies was still cumbersome—the processing steps were the same as for Kodachrome film, and the printing material

293

(pigmented white acetate coated with light-sensitive emulsion) was expensive to manufacture. Nonetheless, products like Minicolor and Printon (a printing material for transparencies introduced by Ansco in 1943) fulfilled the public's desire for color prints until a more convenient solution was found. That solution was finally reached in 1942, when Kodak released Kodacolor, its first negative-positive system with integrated dye couplers.[22] The new system allowed for paper prints at almost half the price of a Minicolor. Unfortunately, both Kodacolor films and prints were far less stable than Kodachrome and black-and-white materials. Prints faded and developed a dark yellow or orange stain overall after a short period of time (Figure 0.9). The discoloration was caused by

an unstable magenta dye coupler that remained in the print after processing. It was not until 1953 that Kodak managed to substantially reduce the staining problem by replacing the faulty couplers.

The intensification of World War II would bring color research to a halt as all existing technologies and resources were funneled to the war effort. After the war, however, the pace of innovation in color photography accelerated, largely because German patents and industrial know-how became freely available. Manufacturers of photographic goods around the world started to offer color materials based on Agfa's technology.[23] Worldwide, color photographic material that had been mostly restricted to use by the armed forces during the conflict suddenly became

FIGURE 0.8
Advertisement for Minicolor Prints.
Photo Technique, November 1941.

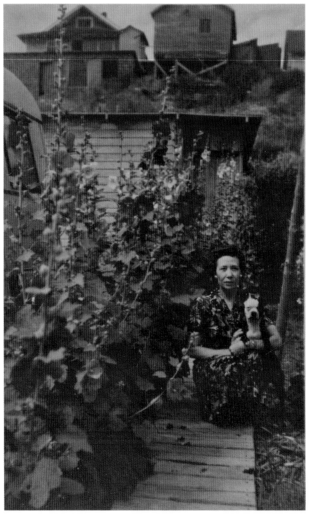

FIGURE 0.9
Unknown photographer, [Woman and dog in garden], 1942.
Yellowed Kodacolor print. Collection of the author.

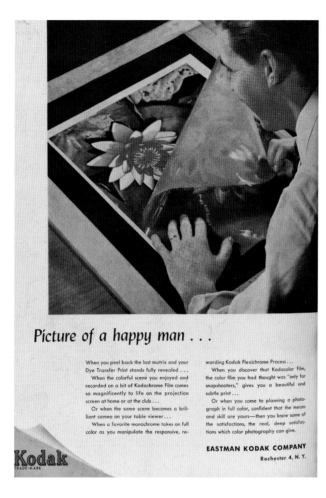

available to civilians. In 1946, Kodak introduced Kodak Ektachrome transparency sheet film, the company's first reversal color film with integrated couplers that could be processed by the user. Research and marketing efforts intensified; new discoveries and improved technologies led to a continuous offering of products feeding the appetite for color photographs. During the two decades that followed the war, the photographic industry, led by Kodak, introduced important modifications and improvements to chromogenic color films and papers, including more stable and better performing dyes and couplers; new coating technology resulting in thinner, sharper, and more sensitive films; and new printing and processing machines that allowed for a faster turnaround at processing plants.

Despite these great strides forward with new chromogenic materials and processes, much improvement was still needed to satisfy the needs of professional photographers, who sought tight control over the final color print and, above all, long-term stability of their production. The few chromogenic printing products then available to them offered little to no control on color and dismal stability; carbro remained the most permanent option. With this in mind, in 1945, Kodak launched Kodak Dye Transfer, an improved version of its prewar, dye imbibition assembly printing process Eastman Wash-Off Relief (Figure 0.10). Dye imbibition printing processes had been around since the end of the nineteenth century and had met with a variable level of commercial success.[24] Compared to the pigments used in carbro, dyes were more transparent and provided better color rendition. However, producing a print from scratch was still tedious and could take up to four hours. Dye imbibition was based on the successive transfer of dyes from relief matrices onto a final support. Matrices were somewhat similar to the bromides of carbro printing but were on transparent film instead of a paper support. Each color separation was printed on a sheet of matrix film, which was then developed. During development, the gelatin was hardened and became insoluble where there was a silver image. After development, the unhardened gelatin was eliminated in a bath of warm water. This produced an image with a relief proportional to its density: a thick layer of gelatin in the dark areas and a thin one in the highlights. To make a print, each matrix was soaked in a dye bath (cyan for the red separation, magenta for the green, and yellow for the blue), and the gelatin became saturated with color. The dyes were transferred by squeegeeing each matrix in turn against a wet receiving sheet of photographic paper. As the two layers of gelatin came in contact with each other, the dyes in the matrix penetrated the receiving paper's softer gelatin, and a color print was produced (Plate 3.7). The same matrices could be used again to generate multiple prints. If the dyes of Kodak Dye Transfer were not as stable as the pigments of carbro, they were much more stable than that of any color photographic paper, in the light or in the dark.

Although still quite laborious, Dye Transfer offered a series of improvements over carbro: printing took less time, there was more control over the final color print, and an unlimited number of prints could be produced from one single set of matrices. Dye Transfer became the printing process of choice for commercial and fine art photographers alike.

In 1963, almost thirty years after the introduction of Kodachrome, three defining moments would further shape the future of color photography: Kodak introduced the Instamatic camera, the Boston-based Polaroid Corporation launched Polacolor, and Swiss conglomerate CIBA announced Cibachrome. The introduction of the Kodak Instamatic camera and its film cartridge (format 126) was the most important development for amateur photography since the introduction of the Kodak camera in 1888. The cameras were cheap, and the film was easy to load with the new foolproof cartridge format. Millions were sold, and the number of color photographs taken in 1964 surpassed that of black-and-white in the United States. The trend would never reverse (Figure 0.11).

The founder of Polaroid, Edwin H. Land, had introduced instant photography back in 1947.[25] Land liked to say that the idea had come to him during a summer vacation when his young daughter had asked him why she could not immediately see the photographs he had just taken. With Polaroid cameras and films, photographs were produced instantly. Each film unit consisted of a negative, a positive sheet, and a pod containing a viscous fluid reagent to develop the photograph. After the picture was taken, negative, positive, and pod were pressed together between two rollers; the pod ruptured, and the reagent then spread evenly between the two sheets, initiating the development of the photograph. Through an intricate set of chemical reactions, the image was transferred from the negative to the positive. After one minute, the photograph could be peeled apart from its negative, ready for viewing. Early Polaroid images were

FIGURE 0.11
Kodak Instamatic camera and film cartridge 126.
Photograph by Steve Watson.

FIGURE 0.12
Edwin H. Land demonstrating
Polacolor, 1963. Photograph by
Fritz Goro. Time & Life Images.
Getty Images.

apart, the negative was discarded and the image was ready for viewing, without further manipulation. At the time of its launching in 1963, Polacolor was acclaimed as the "most outstanding single advance in photographic science made during this century."[27] Even though Polacolor prints were small and one-of-a-kind, the instant gratification they provided by generating a photograph only a few minutes after it was taken was irresistible; their success remains astonishing (Figure 0.12).

At the 1963 Cologne biennial photographic fair, Photokina, CIBA announced it was about to launch a new photographic system that was far superior to any other. The new product, called Cibachrome, could be used to print directly from color transparencies and was based on the silver dye-bleach process.[28] Contrary to chromogenic materials, where dyes were formed during development, silver dye-bleach printing materials were chromolytic, i.e. they already contained dyes in each of the emulsion layers at the time they were manufactured. To make a print, transparencies were projected onto a light-sensitive film with a white-pigmented opaque base. The print was first developed in a regular black-and-white developer that created a negative silver image in each emulsion layer. It was then immersed in a bleaching solution that destroyed the developed silver and the dye particles surrounding it, creating a positive color image. A final fixing bath eliminated all unexposed silver halide from the print (Plate 3.19). Cibachrome offered many advantages over other printing materials then available, including true blacks; bright flashy colors; extreme sharpness; dimensional stability; and, most important, long-term stability of the dyes, especially in the dark. Its detractors complained about its contrast, cost, and low sensitivity.

sepia in tone; improvements soon led to black-and-white photographs that looked very much like those obtained with regular negatives and photographic papers. The discovery of dye developers by Polaroid chemist Howard G. Rogers opened the door to an instant color system.[26] Dye developers were a revolutionary departure from dye-coupler systems, then dominant in color photography. They consisted of large molecules of preformed yellow, magenta, and cyan dyes attached to a silver halide developer. During development, which was activated by the rupture of the pod containing a chemical reagent, unreacted dye developers could diffuse from their original location in the negative onto an image-receiving layer to produce a unique, one-of-a-kind color image. After a minute, negative and positive could be peeled

As color films became more popular with consumers, delivering paper prints in a timely manner became a pressing problem for photofinishers. In spite of operating at maximum capacity, processing plants were unable to absorb the high volume of demand for color prints, and production bottlenecked. The problem was solved with the introduction of resin-coated

(RC) papers in 1968 (1970 in Europe). The new base consisted of a core of paper sandwiched in between two thin layers of extruded polyethylene (PE) resin. Resin-coated papers did not absorb as many chemicals as the traditional fiber-based papers did, and they could be rapidly air-dried. Complete processing was achieved in less than ten minutes (compared to twenty-five with the older paper), thus increasing the volume of processed materials.

At the onset of the 1970s, color was firmly established in all branches of photography except that of fine art. As Rohrbach explains elsewhere in this book, this last bastion of resistance would soon fall, too. Color photographs had become a commodity and were part of everyday life. As a result, the quest for color shifted from how to obtain affordable prints to how fast one could get them. In 1972, Polaroid introduced a new instant system called SX-70, where prints spilled magically out of the camera, requiring no timing or peeling apart. In 1974, an amateur version of Cibachrome products allowed photographers to print beautiful color prints from their kitchen sink in less than fifteen minutes; CIBA also developed a rapid system for color photo booths. By the end of the decade, one-hour minilabs would make their first appearance in department stores and rapidly become ubiquitous. In spite of these improvements, stability problems were still plaguing chromogenic papers and films. Prints and transparencies continued to exhibit poor to moderate resistance to light and poor stability in the dark. They rapidly acquired an unpleasing blue-green or reddish tone overall. The situation was so severe it led to several lawsuits filed against manufacturers of photographic materials by photofinishers and professional photographers. Petitions circulated among professionals, and numerous articles on the topic were published in journals and magazines.[29] It became impossible to ignore these shortcomings, and manufacturers began to make a serious effort to improve the stability of the dyes.

Still more technological breakthroughs were unveiled in the early 1980s: new tabular silver grains and L-couplers allowed for films with remarkable sharpness and fineness of grain at speeds never dreamed of before for color films, up to ISO 1600.[30] Color photography was in its heyday and the number of photographs taken and printed each year grew steadily. The advances in quality over the forty-year period since the introduction of the first chromogenic materials in 1935 had been remarkable: film speed and dye stability had improved by more than a hundredfold, and productivity in the photofinishing plants had jumped from twenty prints an hour to more than eight thousand. It was expected that technical progress would continue to advance and benefit photographers, consumers, photofinishers, and the photographic industry. But at the same time these major improvements were taking place, an important and irreversible turn in the history of the medium occurred: the arrival of electronic recording and printing devices. The Sony Mavica camera, commercialized in 1981, and the Hewlett Packard Deskjet printer, launched in 1984, would mark the beginning of the decline of silver-halide technology in favor of digital capture and printing.

During the 1990s, innovations in digital imaging escalated at a dizzying pace. Digital cameras could do things that film cameras could not: images were displayed immediately after they were taken, and storage discs and cards could be erased and reused. The development and constant improvement of tabletop printers and of image-editing software such as Adobe Photoshop, released in 1990, brought digital imaging within the reach of still more consumers. Among the different printing technologies that emerged at the time, inkjet proved the most promising. A typical image digital file consists of three color channels: red, green, and blue (or RGB), and each pixel that forms the image contains information for each of these channels. Inkjet printers were equipped with delicate printing heads that sprayed minute droplets of cyan, magenta, and yellow inks onto a sheet of paper according to the information contained in each pixel (Figure 0.13). The challenge was to create affordable prints that would rival traditional color photographs.[31] At Photokina 1994, Durst Phototechnik AG,

50.0 µm

FIGURE 0.13 *top*
Individual pixels on the LCD display
of an Apple iPhone 4S. Photograph by
Sylvie Pénichon.

FIGURE 0.14 *bottom*
Durst Lambda 130 digital imager, 1994.
Durst US.

a manufacturer of photographic and printing equipment, introduced the first digital enlarger, called Lambda. The new machine was a laser-supported, large-format-output device that printed digital files on conventional photographic paper (Figure 0.14). The novelty was welcomed by the growing number of photographers who used digital cameras but still wanted their images printed on traditional color paper. Concerns about the lack of permanence of digital prints were still very high, but Lambda offered a practical solution. With the Lambda printer, arrays of red, green, and blue lasers physically transferred the information contained in digital image files onto rolls of photographic paper, which were then processed in conventional wet chemistry.

Innovations in digital cameras, printers, inks, and papers have continued through the first decade of the new millennium, and digital prints have equaled or even surpassed the image quality and stability achievable with silver-halide materials. Although a portion of family photographs are still printed on silver-based photographic papers or digital media, the vast majority of captured images are never printed but rather consumed directly on computer or smartphone screens (Figure 0.15). Digital image capture and output have caused many manufacturers of traditional photographic materials to disappear. Agfa, Polaroid, and Kodak filed for bankruptcy in 2005, 2008, and 2011, respectively. Manufacture of Kodak Dye Transfer ceased in 1994, and the iconic Kodachrome was discontinued in 2009. Earlier last year (2012) Kodak announced the discontinuation of all color transparency films while Ilford produced its final batch of Ilfochrome silver dye-bleach materials. On the other hand, digital technology has liberated photographers from the darkroom and allowed many artists to revisit their work. Photographer Joel Meyerowitz, for example, thinks that contemporary digital printing has given him "the opportunity to recast certain pictures that were at best a compromise."[32] As digital photography continues to evolve, new methods of producing color images will continue to emerge as older technology slowly becomes obsolete.

FIGURE 0.15
Guests take pictures during a reception commemorating the enactment of the Matthew Shepard and James Byrd Jr. Hate Crimes Prevention Act, in the East Room of the White House, October 28, 2009. Official White House photo by Chuck Kennedy.

Color photography was imagined in the nineteenth century but truly developed in the twentieth. Important landmarks that influenced the development of traditional color photography during the twentieth century include the introduction of Autochrome color screen plates and that of Kodachrome film. Each revolutionized the field and commercially dominated it. Each democratized color photography and brought it to broader audiences. The advent of the digital era has made color photographs even more omnipresent than they were before.

Color photography has tremendously evolved during the last hundred and fifty years and will continue to do so. While the images that glow on our screens today look far removed from the tartan ribbon projected by Maxwell in 1861, they continue to share the same basic principle—the trichrome separation of colors. ◆

1. Madame Yevonde, "Why Colour?," address delivered to the Royal Photographic Society on December 6, 1932, *The Photographic Journal* 73 (March 1933): 116–120.

2. François Arago, "Communication sur la découverte de M. Daguerre concernant la fixation des images qui se forment au foyer de la chambre obscure" (Communication on Mr. Daguerre's discovery concerning the capture of images formed in the camera obscura), *Comptes Rendus Hebdomadaire des séances de l'Académie des sciences* 8 (1839): 4. Louis-Jacques-Mandé Daguerre (1787–1851) was a painter who co-invented and owned the Diorama, a popular Parisian theater. He invented the daguerreotype, the first commercially successful photographic process. François Arago (1786–1853) was an elected member of the chamber of deputies, the director of the Paris Observatory, and the secretary of the Academy of Sciences. He championed Daguerre and was pivotal in the inventor's success in securing a reward from the French government for the invention of the daguerreotype.

3. Finely hand-colored daguerreotypes resembled the familiar miniature portraits. The practice was mostly in vogue in London and Paris and never gained traction in the United States.

4. Alexandre-Edmond Becquerel (1820–1891) was an eminent French physicist. He conducted extensive research in the fields of magnetism, electricity, and optics.

5. Claude Félix Abel Niépce de Saint-Victor (1805–1870) was an army lieutenant who made important contributions to photography. He invented the first technique to produce negatives on glass and a photomechanical printing method called heliogravure. He was the cousin of Joseph-Nicéphore Niépce (1765–1833), one of the inventors of photography. Alphonse Poitevin (1819–1882) was a French chemist who discovered the light sensitivity of dichromated colloid and invented the carbon process, which would later be used to produce color photographs.

6. Sir Isaac Newton (1643–1727) published his experiments in *Opticks* in 1704. At the time, people thought that prisms colored light. Artists were fascinated by Newton's clear demonstration that all the colors in fact exist in white light. Isaac Newton, *Opticks, or A Treatise of the Reflections, Refractions, Inflexions and Colours of Light: Also Two Treatises of the Species and Magnitude of Curvilinear Figures* (London: Sam. Smith and Benj. Walford, 1704).

7. Thomas Young (1773–1829) was an English scientist who made many important contributions to the fields of optics, physiology, and Egyptology. The receptors he described are known today as cone cells. They are located in the image-receiving part of the eye, the retina.

8. James Clerk Maxwell (1831–1879) was a Scottish physicist and mathematician. His most prominent achievement was demonstrating that electric and magnetic fields travel through space in the form of waves, and at the constant speed of light. Hermann Ludwig Ferdinand von Helmholtz (1821–1894) was a German physicist who made many significant contributions in physiology and physics.

9. Louis Arthur Ducos du Hauron (1837–1920) was a French inventor who made key contributions to color photography. He invented the tricolor carbon process and foresaw many of the color processes that would later be developed, including the additive color screen plate. Charles Cros (1842–1888) was a Parisian poet and inventor. Besides his pioneering work in color photography, Cros also invented a form of phonograph at the same time Thomas Edison invented his.

10. With the notable exception of Gabriel Lippmann (1845–1921), who invented a direct color photographic process based on the interference of light waves, all attempts in direct color processes were failures.

11. Ralph M. Evans, "Maxwell's Color Photograph," *Scientific American* 205 (November 1961): 118–120, 122, 125–126, 128.

12. In 1873, German photo chemist Hermann Wilhelm Vogel (1834–1898) discovered the sensitizing effect of certain dyes on photographic emulsions. He noticed that some of his photographic plates that had been dyed to reduce the back scattering of light in the camera were unusually sensitive to green. Pursuing his investigation, he dyed his photographic plates with the newly invented magenta dye coralline and obtained a very strong response to solar radiation in the green (magenta absorbs all colors but green). He rightly foresaw that photographic plates could be made sensitive to any desired color by mixing certain dyes into the emulsion.

13. Besides being credited with the invention of the first practical color photographic process, Auguste Lumière (1862–1954) and Louis Lumière (1864–1948) are also well-known for their contribution to cinema. Their 1895 public screening of a film showing several short mundane scenes, including the workers leaving

the factory Lumière, was a sensation. The forty-six-second movie has become an icon of early motion picture.

14. Such ruled screens were commercialized in the 1890s by John Joly (1857–1933) in Ireland and James William McDonough (1845–1897) in the United States. Both products disappeared from the market around 1900.

15. The Autochrome's later versions on film were introduced in the 1930s and remained commercially available well into the 1950s. Many other screen-plate products were introduced after 1907, but none met with comparable success.

16. This was an important shortcoming for photographers of the Pictorialist movement, who favored extensive manipulation of their images and rejected the mechanical aspects of straight photography. Initially acclaimed in artistic circles that quickly abandoned them, Autochromes remained extremely popular with wealthy amateurs and photojournalists.

17. Carbro has been adopted as a general term to designate all products that use the same process.

18. George Eastman (1854–1932) founded the Eastman Kodak Company in 1892 in Rochester, New York.

19. Charles Edward Kenneth Mees (1882–1960) was a British-born physicist who started his career in photographic research at Wratten and Wainwright, Ltd. The company specialized in the manufacture of glass-plate negatives and filters. When Eastman Kodak purchased the company in 1912, Mees moved to the United States and became the first director of Kodak Research Laboratories. He worked at Kodak until his retirement in 1955.

20. 35mm cameras were initially called miniature cameras. Bantam was a camera introduced by Kodak in 1935; it used 828 film format.

21. Leopold Mannes (1899–1964) and Leopold Godowsky Jr. (1902–1983) were professional musicians; Mannes played piano and Godowsky played violin. They began their experimentation with color in 1917. They returned to their musical careers a few years after they invented Kodachrome. They were inducted into the National Inventors Hall of Fame in 2005. Benno Homolka (1877–1949) and Rudolf Fischer (1881–1957) were German chemists. Fischer coined the terms "color development" and "color formers" (dye couplers). He patented the chromogenic development in 1913.

22. Kodak used a slightly different type of dye coupler than Agfa. In Germany, Agfa had also been making good progress toward its own negative-positive system, but marketing of the new materials was impaired by the war raging in Europe.

23. Gevaert in Belgium, Ferrania in Italy, Tellko in Switzerland, UCI in England, Valca in Spain, Fuji, Konishiroku (later called Konica), and Oriental in Japan took full advantage of Agfa technology and entered the color market after the war. Jack H. Coote, *The Illustrated History of Colour Photography* (Surbiton, England: Fountain Press Limited, 1993).

24. When introduced in 1936, Eastman Wash-Off Relief represented great progress in imbibition printing, as it was easier to obtain consistent results.

25. Besides instant photography, Edwin Herbert Land (1909–1991) also invented the first inexpensive filters capable of polarizing light, called Polaroid film. He held more than 500 patents. In 1977, he was inducted into the National Inventors Hall of Fame.

26. Howard G. Rogers (1915–1995).

27. Geoffrey Crawley, "Polacolor," *British Journal of Photography* 110 (February 25, 1963): 76.

28. Silver dye-bleach was invented in the early 1900s. The first commercial silver dye-bleach product was Bela Gaspar's (1878–1973) Gasparcolor, which was used to produce motion picture films. Later, in the 1940s, Gaspar launched a printing material called Gasparcolor Opaque to limited commercial success. Ilford Limited of London also manufactured a silver-dye bleach paper for its mail-order printing service, Ilford Colour Print, between 1953 and 1963.

29. Henry Wilhelm and Carol Brower, *The Permanence and Care of Color Photographs* (Grinnell, IA: Preservation Publishing Company, 1993), 267–292.

30. Traditionally, silver-halide grains have an octahedron shape (eight-plane pebbles); the flat tabular shape offered more reactive surface (more sensitivity to light) without adding granularity. L-couplers are approximately half the size of more conventional coupler particles; because they can be packed in higher concentration in thinner emulsions, films with L-couplers provide a sharper image.

31. It is ironic that notoriously unstable chromogenic prints became the canon against which the permanence of digital prints has been measured.

32. Art Russell, "Inkjet Printing Lessons from Joel Meyerowitz," *Popular Photography* (May/June 2006), http://www.popphoto.com/how-to/2008/12/inkjet-printing-lessons-joel-meyerowitz?page=0,0. Accessed March 8, 2013.

List of Plates

1.11. Frederic E. Ives (1856–1937). *Untitled*, ca. 1915–1920. Hicrome print, 4 × 6 inches. Photographic History Collection, Division of Information and Technology and Communications, National Museum of American History, Smithsonian Institution, Washington DC. 3843.8.

1.12. Nickolas Muray (1892–1965). *Bathing Pool Scene, Ladies' Home Journal, Swimsuit Layout*, 1931. Tricolor carbro prints (diptych), 9½ × 22½ inches. George Eastman House, International Museum of Photography and Film, Rochester, New York. 71:0050:0045 and 71:0050:0046. © Nickolas Muray Photo Archives.

1.13. James N. Doolittle (1889–1954). *Ann Harding*, ca. 1932. Tricolor carbro print, 13 × 10½ inches. The Nelson-Atkins Museum of Art, Kansas City, MO. Gift of Hallmark Cards, Inc. Photograph by Joshua Ferdinand. 2005.27.2631.

1.14. Paul Outerbridge (1896–1958). *Avocado Pears*, 1936. Tricolor carbro print, 10 × 15⅝ inches. The Museum of Modern Art, New York. Gift of Mrs. Ralph Seward Allen. 173.1942. Paul Outerbridge Jr. © 2012 G. Ray Hawkins Gallery, Beverly Hills, California. Digital image © The Museum of Modern Art/Licensed by SCALA/Art Resource, NY.

1.15. John F. Collins (1888–1991). *Tire*, 1938. Silver dye-bleach print, 1988, 11 × 14 inches. Courtesy Howard Greenberg Gallery.

CHAPTER 2

2.1. Jack Delano (1914–1997). *Chopping cotton on rented land near White Plains, Greene County, GA*, June 1941. Kodachrome transparency, 35mm. Library of Congress, Prints and Photographs Division, Washington DC. LC-USF35-599.

2.2. Harry Callahan (1912–1999). *Detroit*, ca. 1941. Dye imbibition print, 1980, 11 × 14 inches. © The Estate of Harry Callahan, courtesy Pace/MacGill Gallery, New York.

2.3. Arthur Siegel (1913–1978). [Untitled, window reflection, Chicago], ca. 1950. Dye imbibition print, 7⅛ × 10⁵⁄₁₆ inches. Amon Carter Museum of American Art, Fort Worth, TX. Purchased with funds provided by the Council of the Amon Carter Museum. P2003.14. Courtesy the Estate of Arthur Siegel.

2.4. Anton Bruehl (1900–1982). *Harlem Number, at the Versailles Café*, 1943. Dye imbibition print, 13⅞ × 11 inches.

Amon Carter Museum of American Art, Fort Worth, TX. Purchased with funds provided by Stephen L. Tatum in honor of Nenetta C. Tatum. P2006.3. © Anton Bruehl.

2.5. Erwin Blumenfeld (1897–1969). *Red Cross*, 1945. Inkjet print, 2009, 12 × 10 inches. Collection of Nadia Blumenfeld Charbit. Variant of *Vogue*, U.S. cover, March 15, 1945, "Do Your Part for the Red Cross." © The Estate of Erwin Blumenfeld.

2.6. Henry Holmes Smith (1909–1986). *Tricolor Collage on Black*, 1946. Dye imbibition print over gelatin silver print, 9⁵⁄₁₆ × 7⁷⁄₁₆ inches. Henry Holmes Smith Archive, Indiana University, Bloomington. 200.II.25. Permission granted by the Smith Family Trust.

2.7. Jeanette Klute (1918–2009). *Derivation—Plantain Lily*, ca. 1950. Dye imbibition print, 12⅞ × 10⅛ inches. Amon Carter Museum of American Art, Fort Worth, TX. P1997.1. © 1950 Jeannette Klute.

2.8. Ferenc Berko (1916–2000). *Monterey, California*, 1954. Dye imbibition print, 9⅞ × 13⅞ inches. Photography Collection, Harry Ransom Center, University of Texas at Austin. 979:0013:063.

2.9. Saul Leiter (b. 1923). *Rain*, ca. 1953. Silver dye-bleach print, ca. 1995, 13½ × 9 inches. Amon Carter Museum of American Art, Fort Worth, TX. Gift of the artist and Howard Greenberg Gallery. P2006.8. © Saul Leiter/Howard Greenberg Gallery, NY.

2.10. Irving Penn (1917–2009). *After Dinner Games, New York*, 1947. Dye imbibition print, 1985, 22 × 18 inches. © Condé Nast Publications, Inc.

2.11. Ernst Haas (1921–1986). *Cowboy and Bronco, New York*, 1958. Dye imbibition print, ca. 1962, 14¹¹⁄₁₆ × 22⅛ inches. Amon Carter Museum of American Art, Fort Worth, TX. Purchased with assistance from David H. Gibson. P2007.4. © Estate of Ernst Haas.

2.12. Nickolas Muray (1892–1965). *Santa's Coffee*, 1958. Dye imbibition print, 11 × 9 inches. George Eastman House, International Museum of Photography and Film, Rochester, NY. 71.0049.0027. © Nickolas Muray Photo Archives.

2.13. Gordon Parks (1912–2006). *Crime Suspect with Gun*, 1957. Dye coupler print, 2006, 19⅜ × 13⅜ inches. © The Gordon Parks Foundation, courtesy the Gordon Parks Foundation.

2.14. William Klein (b. 1928). *Antonia + Yellow Cab, Tuffeau & Bush,* New York, 1962. Dye coupler print, 2012, 20 × 16 inches. © William Klein. Courtesy Howard Greenberg Gallery, NY.

2.15. Pete Turner (b. 1934). *Dyer's Hand*, 1963. Dye imbibition print, 40 × 30 inches. Courtesy the artist.

2.16. Wynn Bullock (1902–1975). *Color Light Abstraction 1185*, 1964. Dye coupler print, 9¾ × 6¾ inches. Amon Carter Museum of American Art, Fort Worth, TX. P2012.8. © 1964/2012 Bullock Family Photography LLC. All rights reserved.

2.17. Eliot Porter (1901–1990). *Pond Brook, Whiteface Intervale, New Hampshire, October 5, 1956*. Dye imbibition print, 8¼ × 10¾ inches. Amon Carter Museum of American Art, Fort Worth, TX. Bequest of the artist. P1990.51.4075. © 1990 Amon Carter Museum of American Art.

2.18. Marie Cosindas (b. 1925). *Floral with Painting*, 1965. Dye diffusion print (Polaroid), 4 × 5 inches. Courtesy the artist. © Marie Cosindas.

2.19. Dan Graham (b. 1942). *Homes for America* [Top: Family group in New Highway Restaurant, Jersey City, NJ; bottom: Trucks, New York City], 1966–1967. Two chromogenic prints mounted on board, top: 9¹⁄₁₆ × 13⅜ inches, bottom: 10¹⁵⁄₁₆ × 13⅜ inches. National Gallery of Art, Washington DC. Glenstone in honor of Eileen and Michael Cohen. 2008.30.20. Courtesy the artist and Marian Goodman Gallery, New York.

CHAPTER 3

3.1. Todd Walker (1917–1999). *Sheila, Four Times*, 1971. Silkscreen, 15½ × 19¾ inches. Private collection. The Walker Image Trust.

3.2. William Christenberry (b. 1936). *Abandoned House in Field, near Montgomery, Alabama, 1971*. Dye coupler print, 1988, 3¼ × 4⅞ inches. Amon Carter Museum of American Art, Fort Worth, TX. P1991.27.1. © 1971 William Christenberry.

3.3. Lucas Samaras (b. 1936). *Photo-Transformation, November 22, 1973*. Dye diffusion print (Polaroid SX-70), 3 × 3 inches. The J. Paul Getty Museum, Los Angeles, CA. © Lucas Samaras, Pace/MacGill Gallery, New York.

3.4. Helen Levitt (1913–2009). *New York*, 1972. Dye imbibition print, 9⅜ × 14⁵⁄₁₆ inches. Amon Carter Museum of American Art, Fort Worth, TX. P2008.20. © Estate of Helen Levitt.

3.5. William Eggleston (b. 1939). *Memphis*, ca. 1971. Dye imbibition print, 18⅛ × 12³⁄₁₆ inches. J. Paul Getty Museum, Los Angeles. Gift of Caldecot Chubb. © Eggleston Artistic Trust. 98.XM.232.2.

3.6. Stephen Shore (b. 1947). *West 9th Avenue, Amarillo, Texas, October 2, 1974*. Dye coupler print, 8 × 10 inches. Amon Carter Museum of American Art, Fort Worth, TX. Purchased with funds provided by an anonymous donor. P2010.5. Courtesy the artist and 303 Gallery, New York.

3.7. Joel Meyerowitz (b. 1938). *Hartwig House, Truro, 1976*. Dye imbibition print, 1980, 14½ × 18¾ inches. Amon Carter Museum of American Art, Fort Worth, TX. P2003.16. © 1976/2004 Joel Meyerowitz.

3.8. John Divola (b. 1949). *Zuma #25*, 1977. Dye coupler print, 9¹¹⁄₁₆ × 12 inches. Amon Carter Museum of American Art, Fort Worth, TX. P2009.5. © John Divola.

3.9. Jan Groover (1943–2012). *Untitled*, 1978. From the Kitchen Still Lifes series. Dye coupler print, 14¾ × 19 inches. Amon Carter Museum of American Art, Fort Worth, TX. Purchased with funds provided by the Stieglitz Circle of the Amon Carter Museum. P2006.9. © 1978 Jan Groover, courtesy Janet Borden, Inc., New York.

3.10. Mark Cohen (b. 1943). *Boy in Yellow Shirt Smoking*, 1977. Dye coupler print, 16 × 20 inches. George Eastman House, International Museum of Photography and Film, Rochester, NY. 78:641:34. © Mark Cohen, 1977.

3.11. Joel Sternfeld (b. 1944). *McLean, Virginia, December 1978*. Dye coupler print, 2003, 16 × 20 inches. Courtesy of the artist and Luhring Augustine, New York.

3.12. Jim Dow (b. 1942). *Interior, Argeson's Shoe and Hat Repair Shop, Allentown, Pennsylvania, September 1979*. Dye coupler print, 2013, 16 × 20 inches. Courtesy Jim Dow and Janet Borden Inc., New York. © Jim Dow, 1999.

3.13. Robert Glenn Ketchum (b. 1947). *Brewster Boogie Woogie, 27*, 1979. Silver dye-bleach print, 29⁵⁄₁₆ × 37⁵⁄₁₆ inches. Amon Carter Museum of American Art, Fort Worth, TX. Gift of Advocacy Arts Foundation. P2002.10. © 1979 Robert Glenn Ketchum.

3.14. Barbara Kasten (b. 1936). *Construct XXI*, 1983. Dye diffusion print, 30¼ × 22 inches. Amon Carter Museum of American Art, Fort Worth, TX. P2008.4. © 1983 Barbara Kasten.

3.15. Laurie Simmons (b. 1949). *Woman/Red Couch/ Newspaper*, 1978. Silver dye-bleach print, 3 × 5 inches. Los Angeles County Museum of Art, CA. Digital Image © 2013 Museum Associates/LACMA. Licensed by Art Resource. © Laurie Simmons. Courtesy the artist and Salon 94, New York.

3.16. Nan Goldin (b. 1953). *The Hug, New York City*, 1980. Silver dye-bleach print, 2008, 23⅛ × 15½ inches. The Museum of Modern Art, New York. Digital image © The Museum of Modern Art/Licensed by SCALA/Art Resource, NY. © Nan Goldin, courtesy Matthew Marks Gallery, New York.

3.17. Tina Barney (b. 1945). *Beverly, Jill, and Polly, New York City*, 1982. Dye imbibition print, 47½ × 60⅞ inches. George Eastman House, International Museum of Photography and Film, Rochester, NY. 84:003:01. © Tina Barney, courtesy Janet Borden, Inc., New York.

3.18. Cindy Sherman (b. 1954). *Untitled #85*, 1981. Dye coupler print, 30 × 54 inches. Courtesy the artist and Metro Pictures, New York.

3.19. Sandy Skoglund (b. 1946). *Revenge of the Goldfish*, 1981. Silver dye-bleach print, 27 × 35 inches. Courtesy the artist. *Revenge of the Goldfish* © 1981 Sandy Skoglund.

3.20. Patrick Nagatani (b. 1945) and Andrée Tracey (b. 1948). *Alamogordo Blues*, 1986. Dye diffusion prints (diptych), 24 × 40 inches. Center for Creative Photography, University of Arizona Libraries, Tucson. 2000:074:036. Courtesy the artists.

3.21. Andres Serrano (b. 1950). *Madonna and Child II*, 1989. Silver dye-bleach print, 60 × 40 inches. Spencer Museum, University of Kansas. 1994.0053. Courtesy the artist and Edward Tyler Nahem Fine Art, NY.

3.22. Carrie Mae Weems (b. 1948). *Blue Black Boy*, 1990 From the Colored People series. Gelatin silver prints toned blue (triptych), each 16⅞ × 16⅞ inches. Virginia Museum of Fine Arts, Richmond, purchased with funds from the Polaroid Foundation. © Virginia Museum of Fine Arts; Digital photo by Katherine Wetzel. Courtesy the artist and Jack Shainman Gallery, New York.

4.1. Neil Winokur (b. 1945). *Glass of Water*, 1990. Silver dye-bleach print, 40 × 30 inches. The Museum of Modern Art, New York. Horace W. Goldsmith Fund through Robert B. Menschel. 521.1994. Digital image © The Museum of Modern Art/Licensed by SCALA/Art Resource, NY. © Neil Winokur, courtesy Janet Borden, Inc.

4.2. Robert Bergman (b. 1944). [untitled], 1990. Inkjet print, 2004, 23¹¹⁄₁₆ × 15⅞ inches. National Gallery of Art, Washington DC. Anonymous gift. 2005.158.37. © Robert Bergman, 1990. Originally published in *A Kind of Rapture*. Courtesy the artist and Yossi Milo Gallery, New York.

4.3. Dawoud Bey (b. 1953). *Nikki and Manting*, 1992. Dye diffusion print (Polacolor ER), 30 × 44 inches. Courtesy Stephen Daiter Gallery. © Dawoud Bey.

4.4. Anthony Hernandez (b. 1947). *Waiting in Line (#21)*, 1996. Dye coupler print, 40 × 40 inches. Courtesy the artist.

4.5. Richard Misrach (b. 1949). *Paradise Valley [Arizona], 3.22.95, 7:05 P.M.* Dye coupler print, 60 × 74 inches. © Richard Misrach, courtesy Fraenkel Gallery, San Francisco, Marc Selwyn Fine Art, Los Angeles, and Pace/MacGill Gallery, New York.

4.6. Todd Hido (b. 1968). *Untitled #2431*, 1999. Dye coupler print, 2006, 20 × 24 inches. Amon Carter Museum of American Art, Fort Worth, TX. Purchase with anonymous donation to the Stieglitz Circle of the Amon Carter Museum. P2006.13. © 1999 Todd Hido.

4.7. Mitch Epstein (b. 1952). *Flag*, 2000. Dye coupler print, 40 × 30 inches. Courtesy Mitch Epstein/Black River Productions, Ltd.

4.8. Alec Soth (b. 1969). *Adelyn, Ash Wednesday, New Orleans, Louisiana*, 2000. Dye coupler print, 16 × 20 inches. Private collection. Courtesy Alec Soth and Magnum Photos.

4.9. Alex Webb (b. 1952). *Istanbul* [View from a barbershop near Taksim Square], 2001. Dye coupler print, 20 × 30 inches. George Eastman House, International Museum of Photography and Film, Rochester, NY. 2007:332:1. Courtesy Alex Webb and Magnum Photos.

4.10. Laura Letinsky (b. 1962). *Untitled #52*, 2002. Dye coupler print, 2007, 24 × 33½ inches. Amon Carter Museum of American Art, Fort Worth, TX. Purchase with funds

provided by Stephen and Suzan Hudgens, Jeanne Gulner, and Kenneth E. Rees. P2007.3. © 2002 Laura Letinsky.

4.11. Gregory Crewdson (b. 1962). *Untitled (Dylan on the Floor)*. From the Twilight series, 1998–2002. Dye coupler print, 48 × 60 inches. © Gregory Crewdson, courtesy Gagosian Gallery.

4.12. Joaquin Trujillo (b. 1976). *Jacky*, 2003. From the Los Niños series. Inkjet print, 2011, 40 × 32 inches. Amon Carter Museum of American Art, Fort Worth, TX. Purchased with funds provided by the Stieglitz Circle of the Amon Carter Museum. P2012.2. © Joaquin Trujillo.

4.13. Simon Norfolk (b. 1963). *Fantasma en la Ciudad, Nogales, Arizona/Nogales, Sonora, Mexico, 2006*. Dye coupler print, 40 × 50 inches. Amon Carter Museum of American Art, Fort Worth, TX. Purchase with funds provided by Nenetta C. Tatum and Stephen L. Tatum. P2007.17. © 2007 Simon Norfolk.

4.14. Sharon Core (b. 1965). *Peaches and Blackberries*, 2008. Dye coupler print, 12½ × 16½ inches. Amon Carter Museum of American Art, Fort Worth, TX. Purchase with funds provided by Nenetta C. Tatum and Stephen L. Tatum. P2008.27. © Sharon Core, courtesy the artist and Yancey Richardson Gallery.

4.15. Alex Prager (b. 1979). *Crowd #1 (Stan Douglas)*, 2010. Dye coupler print, 36 × 60½ inches. © Alex Prager, courtesy the artist and Yancey Richardson Gallery.

4.16. Cory Arcangel (b. 1978). *Photoshop CS, 300 DPI, RGB, square pixels, default gradient "Spectrum," mousedown y=1416 x=1000, mouseup y=208 x=42*, 2009. From the Photoshop Gradient Demonstrations series. Dye coupler print, 72 × 110 inches. Private collection, Fort Worth. Courtesy the artist and Team Gallery, New York.

4.17. Katy Grannan (b. 1969). *Anonymous, San Francisco*, 2010. Inkjet print, 39 × 29 inches. From the collection of Jeffrey Fraenkel and Alan Mark. © Katy Grannan, courtesy Fraenkel Gallery, San Francisco and Salon 94, New York.

4.18. Trevor Paglen (b. 1974). *The Fence (Lake Kickapoo, Texas)*, 2010. Dye coupler print, 2011, 50 × 40 inches. Amon Carter Museum of American Art, Fort Worth, TX. Purchase with funds provided by Finis Welch, Jeanne Gulner, and Kenneth E. Rees. P2012.1. Courtesy the artist and Altman Siegel, San Francisco; Metro Pictures, New York; Thomas Zander, Cologne.

4.19. Marco Breuer (b. 1966). *Spin (C-856)*, 2008. Dye coupler paper, embossed/scratched, 14⅛ × 10½ inches, unique. Courtesy the artist and Von Lintel Gallery, New York.

Bibliography

Abbott, Berenice. *Guide to Better Photography*. New York: Crown, 1941.

Adams, Ansel. "Ansel Adams on Color." *Popular Photography* 61, no. 1 (July 1967): 82–83.

——. "Color Photography as a Creative Medium." *Image: Journal of Photography and Motion Pictures of the International Museum of Photography at George Eastman House* 6, no. 9 (November 1957): 210–217.

——. *A Pageant of Photography, Golden Gate International Exhibition*. San Francisco: Crocker-Union, 1940.

——. "Some Thoughts on Color Photography." *Photo Notes* (Spring 1949): 10–11.

——. "Some Thoughts on Color Photography." *Photo Notes* (Spring 1950): 14–15.

Adams, W. I. Lincoln. "The Heliochromoscope." *The American Annual of Photography and Photographic Times Almanac for 1893* 7 (1892): 165–166.

Akron Art Institute. *Into the 70's: Photographic Images by Sixteen Artists/Photographers*. Akron, OH: Akron Art Institute, 1970.

Albers, Josef. *Interaction of Color*. New Haven, CT: Yale University Press, 1963.

Alexander, Darsie. *Slide Show: Projected Images in Contemporary Art*. Baltimore: Baltimore Museum of Art and State College, PA: The Penn State University Press, 2005.

Alinder, James, ed. *9 Critics, 9 Photographs*. Untitled 23. Carmel, CA: The Friends of Photography, 1980.

——, ed. *New Landscapes*. Untitled 24. Carmel, CA: The Friends of Photography, 1981.

——, ed. *Todd Walker Photographs*. Untitled 38. Carmel, CA: The Friends of Photography, 1985.

Alison, Jane, ed. *Colour After Klein: Re-Thinking Colour in Modern and Contemporary Art*. New York: Black Dog Publishing, 2005.

Allen, Casey. "Bruehl." *Camera 35* 23, no. 9 (October 1978): 20–21, 75–77.

Allshouse, Robert H., ed. *Photographs for the Tsar: The Pioneering Color Photography of Sergei Mikhailovich Prokudin-Gorskii, Commissioned by Tsar Nicholas II*. New York: The Dial Press, 1980.

Alschuler, William I. "The Source and Nature of Inherent Colour in Early Photographic Processes: Niépce's Heliochrome to Burder's Colour Daguerreotypes, and Their Relation to Lippmann Process Images. A Comparative Analysis of the Optical Phenomena That Might Explain the Colour." *Photo-Historian: The Quarterly of the Historical Group of the Royal Photographic Society* 152 (August 2007): 9–19.

Anderson, Paul L. "The Hess-Ives Process of Color Photography." *The American Annual of Photography 1918* 32 (1917): 56–63.

Arago, François. "Communication sur la découverte de M. Daguerre concernant la fixation des images qui se forment au foyer de la chambre obscure" (Communication on Mr. Daguerre's discovery concerning the capture of images formed in the camera obscura). *Comptes Rendus Hebdomadaire des Séances de l'Académie des Sciences* 8 (1839): 4.

Association of Heliographers. *Heliography: Paul Caponigro, Walter Chappell, Carl Chiarenza, William Clift, Marie Cosindas, Nicholas Dean, Paul Petricone*. New York: Gallery Archive of Heliography, 1963.

Auping, Michael. *Stephen Shore Photographs*. Sarasota, FL: John and Mable Ringling Museum of Art, 1981.

Baier, Lesley K. *Walker Evans at Fortune 1945–1965*. Wellesley, MA: Wellesley College Museum, 1977.

Baker, George. "Primal Siblings, George Baker in conversation with Kaja Silverman." *Artforum* 48, no. 6 (February 2010): 176–183.

Ball, Philip. *Bright Earth, Art, and the Invention of Color*. New York: Farrar, Straus and Giroux, 2001.

Baltz, Lewis. "American Photography in the 1970s." In *American Images: Photography 1945–1980*, edited by Peter Turner. London: Barbicon Art Gallery, 1985.

——, ed. *Contemporary American Photographic Works*. Houston: Museum of Fine Arts, 1977.

Banks, Tony. "The Life and Work of Frederick [*sic*] Eugene Ives." Unpublished manuscript, August 10, 2008: 2–20.

Barth, Miles, ed. *Master Photographs from 'Photography in the Fine Arts' Exhibitions, 1959–1967*. New York: International Center of Photography, 1988.

Barthes, Roland. *Camera Lucida: Reflections on Photography*. New York: Hill and Wang, 1981.

——. *Elements of Semiology*. New York: Hill and Wang, 1968.

——. *Mythologies*. New York: Hill and Wang, 1972.

Barney, Tina. *Friends and Relations: Photographs by Tina Barney*. Washington DC and London: Smithsonian Institution Press, 1991.

——. *Photographs: Theater of Manners*. Zurich and New York: Scalo, 1997.

Batchelor, David. *Chromophobia*. London: Reaktion Books, 2000.

——, ed. *Colour*. London: Whitechapel and MIT Press, 2008.

Bauret, Gabriel. *Color Photography*. New York: Assouline Publishing, 2001.

Bayley, R. Child. "An Interview with Mr. Edouard J. Steichen." *Photography* 24, no. 975 (July 16, 1907): 45–47.

——. "The Pictorial Aspect of Photography in Colors." *Camera Work* 2 (April 1903): 42–46.

Becker, William B. "Are These the World's First Colour Photographs?" *American Heritage* 3, no. 4 (June/July 1980): 4–7.

Belo, Hobson J. "Color Negative and Positive Silver Halide Systems." In *Neblette's Handbook of Photography and Reprography: Materials, Processes, and Systems*, edited by John M. Sturge, 333–396. 7th ed. New York: Van Nostrand Reinhold, 1977.

Berg, Stephan, ed. *Gregory Crewdson 1985–2005*. Ostfildern-Ruit, Germany: Hatje Cantz, 2005.

Berger, John. *The Look of Things: Selected Essays and Articles*. New York: Penguin, 1972.

——. *Ways of Seeing*. London: British Broadcasting Corp., 1972.

Bergman, Robert. *A Kind of Rapture*. New York: Pantheon Books, 1998.

Bey, Dawoud. *Dawoud Bey: Portraits, 1975–1995*. Minneapolis: Walker Art Center, 1995.

Birren, Faber. "Color Perception in Art: Beyond the Eye into the Brain." *Leonardo* 9, no. 2 (Spring 1976): 105–110.

——. *Color Psychology and Color Theory: A Factual Study of the Influence of Color on Human Life*. Whitefish, MT: Kensington Publications, 2006.

Bolas, Thomas, Alexander A. K. Tallent, and Edgar Senior. *A Handbook of Photography in Colors*. New York and Chicago: E. and H. T. Anthony & Co., 1900.

Bond, Howard. *Kodachrome and Kodacolor From All Angles*. San Francisco: Camera Craft Publishing Company, 1942.

Boudreau, Joseph. "Color Daguerreotypes: Hillotypes Recreated." In *Pioneers of Photography*, edited by Eugene Ostroff, 168, 189–199. Springfield, VA: The Society for Imaging Science and Technology, 1987.

Boulouch, Nathalie. *Le Ciel est Bleu, Une Histoire de la Photographie Couleur*. Paris: Éditions Textuel, 2011.

Bowles, J. M. "In Praise of Photography." *Camera Work* 20 (October 1907): 17–19.

Brandow, Todd, and William A. Ewing. *Edward Steichen: Lives in Photography*. Minneapolis: Foundation for the Exhibition of Photography and Musée de l'Elysée in association with W. W. Norton & Company, 2008.

Brayer, Elizabeth. *George Eastman: A Biography*. Baltimore: The Johns Hopkins University Press, 1996.

Breuer, Marco. *Marco Breuer, Early Recordings*. New York: Aperture, 2007.

Breuer, Marco, and Carter Foster. *Conversations 7*. Dallas: Pollock Gallery and Southern Methodist University, 2008.

Bright, Susan. *Art Photography Now*. New York: Aperture Foundation Inc., 2005.

Brower, David. *For Earth's Sake: The Life and Times of David Brower*. Salt Lake City, UT: Gibbs Smith Books, 1990.

———. "Foreword." In *"In Wildness Is the Preservation of the World,"* by Eliot Porter. San Francisco: The Sierra Club, 1962.

Brown, Milton W. "Badly Out of Focus." *Photo Notes* (June 1948): 5–6.

Brownlee, Peter John. "Color Theory and the Perception of Art." *American Art* 23, no. 2 (Summer 2009): 21–24.

Bruehl, Anton, and Fernand Bourges. *Color Sells: Showing Examples of Color Photography by Bruehl-Borges*. New York: Condé Nast Publications, Inc., 1935.

Brutvan, Cheryl. *A Distanced Land: The Photographs of John Pfahl*. Albuquerque: University of New Mexico Press in association with Albright-Knox Art Gallery, 1990.

Bry, Michael. "Gallery Snooping." *Modern Photography* 34 (October 1970): 34.

Bullock-Wilson, Barbara, ed. *Wynn Bullock: Color Light Abstractions*. Carmel, CA: Bullock Family Photography LLC, 2010.

Burgin, Victor. *Thinking Photography*. New York: Macmillan, 1982.

Burns, Stanley B. *Forgotten Marriage: The Painted Tintype and the Decorative Frame, 1860–1910: A Lost Chapter in American Portraiture*. New York: Burns Collection, Ltd., 1995.

Burrows, Larry. *Vietnam*. New York: Alfred A. Knopf, 2002.

Burton, Johanna. "Primary Sources, Johanna Burton talks to Ann Temkin about *Color Chart: Reinventing Color, 1950 to Today*." *Artforum* (April 2008): 340–347.

Bussard, Katherine A. *So the Story Goes: Photographs by Tina Barney, Philip-Lorca DiCorcia, Nan Goldin, Sally Mann, Larry Sultan*. Chicago: Art Institute of Chicago and Yale University Press, 2006.

Caffin, Charles H. "Progress in Photography, with special reference to the work of Eduard J. Steichen." *The Century Magazine* 75, no. 4 (February 1908): 483–498.

Callahan, Harry M., ed. *Ansel Adams in Color*. New York: Little, Brown and Company, 1993.

Callahan, Sean. "MoMA Lowers the Color Bar." *New York Magazine* 9, no. 26 (June 28, 1976): 74–75.

Carey, Marty. *John F. Collins: Master Photographer*. New York: Photofind Gallery, 1987.

Cartier-Bresson, Henri. *The Decisive Moment*. New York: Simon and Schuster, 1952.

Charbit, Nadia Blumenfeld, Françoise Cheval, and Ute Eskildsen. *Erwin Blumenfeld, Studio Blumenfeld, Couleur, New York, 1941–1960*. Göttingen, Germany: Steidl, 2012.

Cheskin, Louis. *Color Guide for Marketing Media*. New York: The Macmillan Company, 1954.

Chevrier, Jean-François, Allan Sekula, Benjamin H. D. Buchloh. *Walker Evans & Dan Graham*. Rotterdam: Witte de Withand and the Whitney Museum of American Art, 1992.

Christenberry, William. *Southern Photographs*. Millerton, NY: Aperture, Inc. 1983.

Christenberry, William, and Susanne Lange. *William Christenberry: Working from Memory*. Göttingen, Germany: Steidl, 2008.

Clark, Walter. "The Path of Progress: A Review of Developments in 1954." *Popular Photography* 36 (April 1955): 87.

Coe, Brian. *Colour Photography: The First Hundred Years, 1840–1940*. London: Ash and Grant, 1978.

Cohen, Mark. *Mark Cohen: True Color*. Brooklyn, NY: powerHouse Books, 2007.

Coke, Van Deren. "60's Continuum." *Image: Journal of Photography and Motion Pictures of the International Museum of Photography at George Eastman House* 15, no. 1 (March 1972): 1–6.

———. *Fabricated to Be Photographed*. San Francisco: San Francisco Museum of Modern Art, 1979.

———. *The Painter and the Photograph: From Delacroix to Warhol*. Albuquerque: University of New Mexico Press, 1972.

Coleman, A. D. *Dawoud Bey: Portraits 1975–1995*. Minneapolis: Walker Art Center, 1995.

———. "The Directorial Mode: Notes toward a Definition." *Artforum* 15, no. 1 (September 1976): 55–61.

———. "Is Criticism of Color Photography Possible?" *Camera Lucida* 5 (June 1982): 24–29.

———. *Lee/Model/Parks/Samaras/Turner: Five Interviews Before the Fact*. Boston: Photographic Resource Center, 1979.

———. *Light Readings: A Photography Critic's Writings, 1968–1978*. New York: Oxford University Press, 1979.

———. "Mama Don't Take Our Kodachrome Away." *C: The Speed of Light*. http://www.nearbycafe.com/artandphoto/cspeed/essays/kodachrome.html.

Colombo, Attillio. *The Great Photographers: Pete Turner*. London: William Collins Sons & Co. Ltd., 1984.

"Color." *Popular Photography* 36, no. 5 (May 1955): 71.

"Color Photographs Easily Made by New Process." *Science News Letter* (July 9, 1932): 17.

"Color Photographs: Must They Always Fade?" *Afterimage* 3, no. 5 (November 1975): 16.

"Color Photography Today: A Symposium." *Popular Photography Annual 1955* (1954): 144–170, 235–236.

"Colour Photography." *Photography* 24, no. 976 (July 23, 1907): 65.

Coote, Jack H. *The Illustrated History of Colour Photography*. Surbiton, England: Fountain Press, 1993.

——. *Making Colour Prints*. London: Focal Press, 1945.

Coplans, John. *Serial Imagery*. Pasadena, CA: Pasadena Art Museum, 1968.

Cosindas, Marie. *Marie Cosindas: Color Photographs*. Boston: New York Graphic Society, 1978.

——. *Marie Cosindas: Polaroid Color Photographs*. New York: The Museum of Modern Art, 1966.

Crawley, Geoffrey. "Polacolor." *British Journal of Photography* 110 (February 25, 1963): 76–80.

Crewdson, Gregory. *Beneath the Roses*. New York: Harry N. Abrams, Inc., 2008.

——. *Twilight: Photographs by Gregory Crewdson*. New York: Harry N. Abrams, Inc., 2002.

Crimp, Douglas. "The Photographic Activity of Postmodernism." *October* 15 (Winter 1980): 91–101.

Crist, Steve, ed. *The Polaroid Book: Selections from the Polaroid Collections of Photography*. Köln, Germany: Taschen GmbH, 2005.

Danese, Renato, ed. *American Images: New Works by Twenty Contemporary Photographers*. New York: McGraw-Hill, 1979.

Davis, Douglas. "Color Shock." *House and Garden* (September 1976): 68, 114, 191.

——. "New Frontiers in Color." *Newsweek* (April 19, 1976): 56–61.

——. "Photography." *Newsweek* (October 21, 1974): 63–70.

Davis, Keith F. *An American Century of Photography, From Dry-Plate to Digital: The Hallmark Photographic Collection*. Kansas City: Hallmark Cards, Inc. in association with Harry N. Abrams, Inc., 1999.

Deal, Joe. "Anton Bruehl." *Image: Journal of Photography and Motion Pictures of the International Museum of Photography at George Eastman House* 19, no. 2 (June 1976): 1–9.

Dearstyne, Howard. "The Photographer's Eye." *Aperture* 3, no. 4 (1955): 25–29.

Dexter, Emma, and Thomas Weski, eds. *Cruel and Tender: The Real in the Twentieth-Century Photograph*. London: Tate Publishing, 2003.

Divola, John. *John Divola, Three Acts: Vandalism, Los Angeles International Airport Noise Abatement Zone (LAX NAZ), Zuma*. New York: Aperture Foundation, 2006.

Dmitri, Ivan [Levon West]. *Color in Photography*. Chicago: Ziff-Davis Publishing Company, 1939.

——. *Kodachrome and How to Use It*. New York: Simon and Schuster, 1940.

Dobell, Byron. "Ernst Haas: Master of Color." *Popular Photography Color Annual 1957* (1956): 27–29.

D'Oench, Ellen. *Robert Sheehan: Color Photography, 1948–1958*. Middletown, CT: Davison Art Center, Wesleyan University, 1987.

Douglas, David. "A Call to Colors." *Newsweek* (November 23, 1981): 115.

Dow, Jim. *American Studies: Photographs by Jim Dow*. Brooklyn, NY: powerHouse Books, 2011.

Downes, Bruce. "Let's Talk Photography." *Popular Photography* 25, no. 6 (December 1949): 24–25.

——. "Color's Frustrations." *Color Photography 1960*. In *Popular Photography* (1960): 20–25.

Ducos du Hauron, Louis. *Les Couleurs en Photographie: Solution du Problème*. Paris: A. Marion, 1869.

Ducos du Hauron, Louis, and Alcide Ducos du Hauron. *Traité Pratique de Photographie: Système d'Héliochromie Louis Ducos du Hauron: Description Détaillée des Moyens Perfectionnés d'Exécution Récemment Découverts*. Paris: Librairie Gauthier-Villars, 1878.

Dunn, Carleton E. *Natural Color Processes*. Boston: American Photographic Publishing Company, 1936.

Dunne, Corinne. "The Hillotypes." Advanced Residence Program in Photographic Conservation, August 10, 2005. Curatorial Research Files, Amon Carter Museum of American Art, Fort Worth, TX.

Eastman Kodak Company. *The Photography of Colored Objects*. 14th ed. Rochester, NY: Eastman Kodak Company, 1938.

Euclaire, Sally. *American Independents: Eighteen Color Photographers*. New York: Abbeville Press, 1987.

——. *New Color/New Work*. New York: Abbeville Press, 1984.

——. *The New Color Photography*. New York: Abbeville Press, 1981.

Edelson, Michael. "MoMA Shows Her Colors." *Camera 35* (October 1976): 10–11.

Eder, Josef Maria. *History of Photography*. Translated by Edward Epstein. New York: Columbia University Press, 1945.

"Edward Weston's First Serious Work in Color." *Minicam Photography* 10, no. 8 (May 1947): 51–53.

Eggleston, William. *14 Pictures*. Washington DC: Harry Lunn, 1974.

——. *Ancient and Modern*. New York: Random House, 1992.

Ehrenberg, Rachel. "Digital Image Founder Smooths Out the Pixels." *Discovery News*, June 26, 2010. http://news.discovery.com/tech/digitl-image-pixel.html.

Eiseman, Leatrice, and Keith Recker. *Pantone: The 20th Century in Color*. San Francisco: Chronicle Books, 2011.

"EK Creates Art with Color." *Kodakery* 8, no. 18 (May 4, 1950): 1, 4.

Eklund, Douglas. *The Pictures Generation, 1974–1984*. New York: The Metropolitan Museum of Art and Yale University Press, 2009.

Elisofon, Eliot. *Color Photography*. New York: The Viking Press, 1961.

Enyeart, James L. "Recent Color." *Archive 14*. Tucson: Center for Creative Photography, University of Arizona, December 1981.

Epstein, Mitch. *The City*. New York: powerHouse Books, 2001.

———. *Family Business*. Göttingen, Germany: Steidl, 2003.

———. *Mitch Epstein: Work*. Göttingen, Germany: Steidl, 2006.

———. *Recreation: American Photographs, 1973–1988*. Göttingen, Germany: Steidl, 2005.

Evans, Frederick H. "Personality in Photography—With a Word on Colour." *Camera Work* 25 (January 1909): 37–38.

Evans, Ralph M. *Eye, Film, and Camera in Color Photography*. New York: John Wiley and Sons, Inc., 1959.

———. *An Introduction to Color*. New York: John Wiley and Sons, Inc., 1948.

———. "Maxwell's Color Photograph." *Scientific American* 205, no. 5 (November 1961): 118–120, 122, 125–126, 128.

———. *The Perception of Color*. New York: John Wiley and Sons, Inc., 1974.

———. *Principles of Color Photography*. New York: John Wiley and Sons, Inc., 1953.

Evans, Walker. *American Photographs*. New York: MoMA, 1938.

———. "Color Accidents." *Architectural Forum: The Magazine of Building* (January 1958): 110–115.

———. "Photography." In *Quality: Its Image in the Arts*, edited by Louis Kronenbeger. New York: Atheneum, 1969.

Ewing, William A., ed. *Ernst Haas: Color Correction*. Göttingen, Germany: Steidl, 2011.

Ewing, William A., and Marina Schinz. *Blumenfeld: Photographs, A Passion for Beauty*. New York: Harry N. Abrams, Inc., 1996.

Faber, Monika, and Astrid Mahler. *Heinrich Kühn, The Perfect Photograph*. Ostfildern, Germany: Hatje Cantz, 2010.

Falke, Terry. *Observations in an Occupied Wilderness: Photographs by Terry Falke*. San Francisco: Chronicle Books, 2006.

Farber, Paul. "1-2-3-4-5-6: Color Printing Papers Compared." *Camera 35* 16, no. 1 (January–February 1972): 38–41, 75–77.

Feininger, Andreas. *The Color Photo Book*. Englewood Cliffs, NJ: Prentice-Hall, 1969.

———. *The Creative Photographer*. Englewood Cliffs, NJ: Prentice-Hall, 1955.

———. *Successful Color Photography*. Englewood Cliffs, NJ: Prentice-Hall, 1955.

Feinstein, Roni. *Circa 1958: Breaking Ground in American Art*. Chapel Hill: Ackland Art Museum and the University of North Carolina Press, 2008.

Fiedler, Jeannine, and Hattula Moholy-Nagy, eds. *László Moholy-Nagy: Color in Transparency, Photographic Experiments in Color, 1934–1946*. Göttingen, Germany: Steidl and Bauhaus-Archiv, Berlin, 2006.

Finlay, Victoria. *Color*. New York: Ballantine Books, 2002.

Fishwick, Marshall W. "Michael Miley: Southern Artist in the Brown Decades." *American Quarterly* 3, no. 3 (Fall 1951): 221–231.

Flukinger, Roy. *"To Help the World to See": An Eliot Elisofon Retrospective*. Austin: Harry Ransom Humanities Research Center, 2000.

Fogle, Douglas. *The Last Picture Show: Artists Using Photography 1960–1982*. Minneapolis: Walker Art Center, 2003.

Fondillier, Harvey. "Shows We've Seen." *Popular Photography* (October 1976): 31, 228.

Foresta, Merry A., and John Wood. *Secrets of the Dark Chamber: The Art of the American Daguerreotype*. Washington DC: National Museum of American Art, Smithsonian Institution Press, 1995.

Foster, Hal. *The First Pop Age*. Princeton and Oxford: Princeton University Press, 2012.

Frank, Robert. *The Americans*. New York: Grove Press, 1959.

Fried, Michael. *Why Photography Matters as Art as Never Before*. New Haven, CT: Yale University Press, 2008.

Friedman, Joseph S. *History of Color Photography*. Boston: American Photographic Publishing Company, 1944.

Frizot, Michel. "A Natural Strangeness: The Hypothesis of Color." In *A New History of Photography*, edited by Michel Frizot, 411–422. Cologne, Germany: Könemann, 1998.

Gage, John. *Color and Culture: Practice and Meaning from Antiquity to Abstraction*. Berkeley and Los Angeles: University of California Press, 1993.

——. "Color in Western Art: An Issue?" *Art Bulletin* 72 (December 1990): 518–41.

Galassi, Peter. *Andreas Gursky*. New York: The Museum of Modern Art, 2001.

——. *Jeff Wall*. New York: The Museum of Modern Art, 2007.

——. *Pleasures and Terrors of Domestic Comfort*. New York: The Museum of Modern Art, 1991.

Gasson, Arnold. "Janet Malcom [*sic*] and the *New Yorker* criticism." *exposure* 14, no. 4 (1976): 22–23.

Gernsheim, Helmut. "A Pioneer of Modern Color Photography." In *Ferenc Berko: 60 Years of Photography—The Discovering Eye*, edited by Karl Steinorth. Zürich: Edition Stemmle, 1994.

Goethe, Johann Wolfgang von. *Theory of Colors*. Translated by Charles Lock Eastlake. Cambridge, MA: MIT Press, 1982.

Goldberg, Vicki. "Paul Outerbridge." *American Photographer* 4, no. 3 (March 1980): 36–47.

Goldin, Nan. *The Ballad of Sexual Dependency*. New York: Aperture Foundation, Inc. 1986.

Gomez-Rhine, Traude. "In Living Color: A Conversation with the Dibner Senior Curator of the History of Science and Technology." *Huntington Frontiers* 4, no. 2 (Fall/Winter 2008): 6–10.

Graham, Dan. "Homes for America." *Arts Magazine* 41, no. 3 (December 1966–January 1967): 21–22.

Graham, Paul. *Films*. London: Mack Books, 2011.

Grannan, Katy. *Boulevard*. San Francisco: Fraenkel Gallery, 2011.

——. *Model American*. New York: Aperture, 2005.

Graves, Maitland E. *The Art of Color and Design*. New York: McGraw-Hill, 1951.

Green, Jonathan. *American Photography: A Critical History, 1945 to the Present*. New York: Harry N. Abrams, Inc., 1984.

Greenough, Sarah. *Alfred Stieglitz: The Key Set*. Washington DC: National Gallery of Art and Harry N. Abrams, Inc., 2002.

Grimes, John. *Arthur Siegel: Retrospective*. Chicago: Edwynn Houk Gallery, 1982.

Groover, Jan. *Photographs*. Boston: Little, Brown and Company, 1993.

——. *Pure Invention: The Tabletop Still Life*. Washington DC: Smithsonian Institution Press, 1990.

Grundberg, Andy. "FSA Color Photography: A Forgotten Experiment." *Portfolio* (July/August 1983): 53–57.

Grundberg, Andy, and Julia Scully. "Currents: American Photography Today." *Modern Photography* 44 (October 1980): 94–97, 160–161, 166, 168, 170, 173.

Gustavson, Todd. *Camera: A History of Photography from Daguerreotype to Digital*. New York and London: Sterling Publishing Company, Inc., 2009.

Guthrie, Danny, and Monte H. Gerlach. *Light/Color: An Exhibition of Contemporary Color Photography Comparing the Use of Object and Atmospheric Color*. Ithaca, NY: Ithaca College, 1981.

Haas, Ernst. "Beauty in a Brutal Art: Great Cameraman Shows Bullfight's 'Perfect Flow of Motion.'" *LIFE* 43, no. 5 (July 29, 1957): 56–65.

——. *The Creation*. New York: The Viking Press, 1971.

——. "Images of a Magic City: Austrian Photographer Finds Fresh Wonder in New York's Familiar Sights." *LIFE* 35, no. 11 (September 14, 1953): 108–120.

——. "Images of a Magic City: Part II." *LIFE* 35, no. 12 (September 21, 1953): 116–126.

Hagen, Charles. "An Interview with William Eggleston." *Aperture* 115 (Summer 1989): 40–45.

——. "The Triumph of Photography." *American Photo* 3, no. 1 (January–February 1992): 50–51.

Hammes, Lynda. "Reviews: Andreas Gursky." *Aperture* 165 (Winter 2001): 72–75.

Hammond, Anne. "Impressionist Theory and the Autochrome." *History of Photography* 15, no. 2 (Summer 1991): 96–100.

Hanson, W. T., Jr. "Color Photography: From Dream, to Reality, to Commonplace." In *Pioneers of Photography: Their Achievements in Science and Technology*, edited by Eugene Ostroff, 200–207. Springfield, VA: Society of Photographic Scientists and Engineers, 1987.

——. "Forty Years of Color Photography." *Photographic Science and Engineering* 21, no. 6 (November/December 1977).

Harrison, Helen A. *Dawn of a New Day: The New York World's Fair, 1939/40*. Flushing, NY: Queens Museum, 1980.

Harrison, Marvin. *Appearances: Fashion Photography Since 1945*. New York: Rizzoli, 1991.

Hartmann, Sadakichi. "Color and Texture in Photography." *Camera Notes* 4, no. 1 (July 1900): 9–14.

——. "Frank Eugene, Painter-Photographers." *The Photographic Times* 31, no. 12 (December 1899): 555–561.

Haworth-Booth, Mark. "Amarillo—'Tall in Texas': A Project by Stephen Shore, 1971." *Art on Paper* (September–October 2000): 44–47.

——. "Meetings: 10 Years: From Analog to Digital: *Zone Zero*." *Aperture* 175 (Summer 2004): 76–79.

——. "William Eggleston: An Interview." *History of Photography* (Spring 1993): 49–53.

Heidke, Ronald L., Larry H. Feldman, and Charleton C. Bard. "Evolution of Kodak Photographic Color Negative Print Papers." *Journal of Imaging Technology* 11, no. 3 (June 1985): 93–97.

Heiferman, Marvin. "Paul Outerbridge: Selling the Sizzle." *Art in America* 97, no. 9 (October 2009): 146–151.

Heinecken, Robert. *Recto/Verso*. Portland, OR: Nazraeli Press, 2006.

Heiting, Manfred, ed. *50 Years: Modern Color Photography, 1936–1986*. Cologne: Messe- und Ausstellungs-Ges.m.b.H, 1986.

"The Heliochromoscope." *American Amateur Photographer* 4, no. 10 (October 1892): 447–448.

Henderson, Linda Dalrymple. *Reimagining Space: The Park Place Gallery Group in 1960s New York*. Austin: Blanton Museum of Art, 2008.

Hendrickson, Paul. *Bound for Glory: America in Color, 1939–1943*. New York: Harry N. Abrams, Inc. in association with the Library of Congress, 2004.

Henisch, Heinz K., and Bridget A. Henisch. *The Painted Photograph, 1839–1914: Origins, Techniques, Aspirations*. University Park, PA: The Penn State University Press, 1996.

Herbert F. Johnson Museum of Art. *Translations: Photographic Images With New Forms*. Ithaca, NY: Office of University Publications, Cornell University, 1979.

Hernandez, Anthony. "Rodeo Drive." *Aperture* 101 (Winter 1985): 16–23.

———. *Waiting for Los Angeles*. Tucson, AZ: Nazraeli Press, 2002.

Hido, Todd. *House Hunting*. Tucson, AZ: Nazraeli Press, 2001.

———. *Outskirts*. Tucson, AZ: Nazraeli Press, 2002.

———. *Roaming: Landscape Photographs, 1994–2004*. Tucson, AZ: Nazraeli Press, 2004.

Higgins, Scott. *Harnessing the Technicolor Rainbow: Color Design in the 1930s*. Austin: University of Texas Press, 2007.

Hill, Ed, and Suzanne Bloom. *Manual: Errant Arcadia*. New York: International Center of Photography and the Houston Artists Fund, 2002.

Hill, Levi L. *The Magic Buff: Part 4 of A Treatise on Photography*. Lexington, NY: 1850.

———. *A Treatise on Heliochromy; or, the Production of Pictures, by Means of Light, in Natural Colors*. New York: Robinson and Caswell, 1856; facsimile edition, State College, PA: The Carnation Press, 1972.

Hill, Levi L., and W. McCartey. *A Treatise on Daguerreotype: The Whole Art Made Easy and All the Recent Improvements Revealed*. Lexington, NY: Holman and Gray, 1850.

Hill, Paul, and Thomas Joshua Cooper. *Dialogue with Photography*. New York: Farrar, Straus and Giroux, 1979.

Hirsch, Robert J. *Exploring Color Photography: A Complete Guide*. Madison, WI: Brown & Benchmark, 1997.

Hiss, Tony. "The Framing of Stephen Shore." *American Photographer* 2, no. 2 (February 1979): 26–37.

Hochdörfer, Achim. "A Hidden Reserve: Painting from 1958–1965." *Artforum* (February 2009): 152–159, 215.

Hoehn, Thomas. "Color Motion Pictures—The Earliest Days: 1922." *Kodak: A Thousand Words*. http://1000words.kodak.com/post/?ID=2982503.

Holborn, Mark. "Color Codes." *Aperture* 96 (Fall 1984): 8–15.

Holme, Charles, ed. *Colour Photography and Other Recent Developments of the Art of the Camera* (Special Supplement Number of *Studio*). London: The Studio, 1908.

Hostetler, Lisa. *In Living Color: Photographs by Saul Leiter*. Milwaukee, WI: Milwaukee Art Museum, 2006.

———. *Street Seen: The Psychological Gesture in American Photography*. Milwaukee, WI: Milwaukee Art Museum and DelMonico Books/Prestel, 2009.

"How Creative Is Color Photography?" *Popular Photography Color Annual 1957* (1956): 12–25, 169–170.

Howard, April. "Autochromes: The First Color Photography." *Darkroom Photography* (July 1989): 42–48, 57–58.

Howe, Graham, and Jacqueline Markham. *Paul Outerbridge Jr.: Photographs*. New York: Rizzoli, 1980.

Hughes, Jim. *The Birth of a Century: Early Color Photographs of America*. London: Tauris Parke Books, 1994.

Hsu, Leo. "Is Photography Over?" Accessed April 22, 2010. http://www.foto8.com/new/online/blog/1166-is-photography-over.

"An Important Development in Color Photography: The Kodachrome Process of Color Portraiture." *Scientific American* 112 (April 10, 1915): 341.

Ives, Frederic E. *The Autobiography of an Amateur Inventor*. Reprinted from the *Journal of the Franklin Institute*, June 1906. Philadelphia: Press of Innes & Sons, 1928.

———. "The Heliochromoscope." *American Journal of Photography* 13, no. 155 (November 1892): 515.

———. "Photographs in Natural Colors." *American Journal of Photography* 9, no. 3 (March 1888): 56–58.

Ives, Herbert E. "Improvements in the Diffraction Process of Color Photography." *The Scientific Shop* 348 (May 1907): 1–3.

Jacob, John P., ed. *Inge Morath: First Color*. Göttingen, Germany: Steidl, 2009.

Jacob, Michael G. "Color and the Daguerreotype: The Great Problem Is Fairly Solved . . ." *The Daguerreian Annual 1997* (1998): 174–208.

Jacobson, Egbert. *Color Harmony Manual: 949 Different Color Chips in Removable Form Arranged and Notated According to the Original System of Wilhelm Ostwald.* 4th ed. Chicago: Container Corporation of America, 1958.

Janis, Eugenia Parry. *One of a Kind.* Boston: D. R. Godine, 1978.

Jenkins, William. *New Topographics: Photographs of a Man-altered Landscape.* Rochester, NY: International Museum of Photography at George Eastman House, 1975.

——. "Some Thoughts on 60's Continuum." *Image: Journal of Photography and Motion Pictures of the International Museum of Photography at the George Eastman House* 15, no. 1 (January 1972): 15–18.

Johnston, Patricia. "The Modernist Fashion: Steichen's Commercial Photography between the Wars." In *Edward Steichen: Lives in Photography*, edited by Todd Brandow and William A. Ewing. Minneapolis: Foundation for the Exhibition of Photography and Musée de l'Elysée in association with W. W. Norton & Company, 2008.

——. *Real Fantasies: Edward Steichen's Advertising Photography.* Berkeley: University of California Press, 1997.

Jones, Malcolm. "Translating Ideas Into Color." *Newsweek* (January 1, 1990): 59.

Jordon, Bill. "Three Wizards at Odds: New York Color." *Afterimage* (February 1978).

Julie Saul Gallery. *When Color Was New: Vintage Photographs from Around the 1970s.* New York: Julie Saul Gallery, 2008.

Kane, Art. "Color is a Liar." In *Photographic Communication: Principles, Problems, and Challenges of Photojournalism*, edited by R. Smith Schuneman. New York: Hastings House, 1972.

Kao, Deborah Martin. *Innovation/Imagination: 50 Years of Polaroid Photography.* New York: Harry N. Abrams, Inc., and the Friends of Photography, 1999.

Karmel, Pepe. "Photography: Raising a Hue: The New Color." *Art in America* (January 1982): 27–29, 31.

Kasten, Barbara. *Constructs.* Boston: New York Graphic Society Books, 1985.

Katz, Vincent. "Wild Irises." *Aperture* 136 (Summer 1994): 38–45.

Kazanjian, Dodie. *Vogue: The Covers.* New York: Harry N. Abrams, Inc., 2011.

Kennedy, Nora, and Peter Mustardo. "Changing Perspectives on Color Photography." *Diversity in Heritage Conservation: Tradition, Innovation, and Participation, 15th Triennial Conference 22–26 September 2008, New Delhi* 2 (ICOM/CC, 2008): 689–694.

Keller, Judith. *Jo Ann Callis: Woman Twirling.* Los Angeles: J. Paul Getty Museum, 2009.

Keller, Judith, and Anne Lacoste. *Where We Live: Photographs of America from the Berman Collection.* Los Angeles: J. Paul Getty Museum, 2006.

Keppler, Herbert. "The Horrible Fate of Levi Hill: Inventor of Color Photography." *Popular Photography* 58, no. 7 (July 1994): 42–43, 140.

Keppler, Victor. *The Eighth Art: A Life in Color Photography.* New York: William Morrow & Company, 1938.

Ketchum, Robert Glenn. *The Hudson River & the Highlands.* New York: Aperture, 1985.

Kirsh, Andrea, Susan Fisher Sterling, and Carrie Mae Weems. *Carrie Mae Weems.* Washington DC: National Museum of Women in the Arts, 1993.

Klein, William. *In and Out of Fashion.* New York: Random House, 1994.

Kobal, John. *Hollywood Color Portraits.* New York: William Morrow & Company, 1981.

Kodak Color Handbook: Materials, Processes, Techniques. Rochester, NY: Eastman Kodak Company, 1950.

Köhler, Michael. *Constructed Realities: The Art of Staged Photography.* Kilchberg/Zurich: Edition Stemmle, 1995.

Kozloff, Max. "How to Mystify Color Photography." *Artforum* 15, no. 3 (November 1976): 50–51.

——. *Photography and Fascination.* Danbury, NH: Addison House, 1979.

——. "Photography: The Coming of Age of Color." *Artforum* 13, no. 5 (January 1975): 30–35.

Krauss, Rosalind. *Cindy Sherman, 1975–1993.* New York: Rizzoli, 1993.

——. "Notes on the Index: Seventies Art in America." *October* 3 (Spring 1977): 68–81.

——. "Notes on the Index: Seventies Art in America." *October* 4 (Autumn 1977): 56–67.

Krims, Les. *Fictcryptokrimsographs.* Buffalo, NY: Humpy Press, 1975.

Kroes, Rob. *Photographic Memories: Private Pictures, Public Images, and American History.* Hanover, NH: Dartmouth College Press, 2007.

Kronenberger, Louis, ed. *Quality: Its Image in the Arts.* New York: Athenaeum, 1969.

Labrot, Syl. *Pleasure Beach.* New York: Eclipse, 1976.

——. "Syl Labrot: Work in Progress, The Invention of Color Photography." *Afterimage* 2, no. 3 (September 1974): 7–10.

Lamb, Charles, and Mary Ellen McGoldrick. *Henry Holmes Smith Papers.* Tucson: Center for Creative Photography, University of Arizona, 1983.

Lange, Susanne, ed. *William Christenberry: Working from Memory: Collected Stories*. Göttingen, Germany: Steidl, 2008.

Laurvik, J. Nilsen. "The New Color Photography." *Century Magazine* 75, no. 3 (January 1908): 322–330.

Leadley, Jerome H., and Werner Stegemeyer. *Making Color Prints*. Chicago: Ziff-Davis Publishing Company, 1941.

Lee, Pamela M. "Open Secret: Pamela M. Lee on the Work of Art Between Disclosure and Redaction." *Artforum* 49, no. 9 (May 2011): 220–229.

Leiter, Saul. *Saul Leiter*. Göttingen, Germany: Steidl, 2008.

Letinsky, Laura. *Hardly More Than Ever: Photographs, 1997–2004*. Chicago: The Renaissance Society at the University of Chicago, 2004.

Lewishon, John. "A Phantasy About Color—Photography and Colors." *American Annual of Photography 1917* 31 (1916): 182–187.

Libby, William Charles. *Color and Structural Sense*. Englewood Cliffs, NJ: Prentice-Hall, 1974.

Liberman, Alexander, ed. *The Art and Technique of Color Photography*. New York: Simon and Schuster, 1951.

Lifson, Ben, and Abigail Solomon-Godeau. "Photophilia: A Conversation about the Photography Scene." *October* 16 (Spring 1981): 102–118.

The Light in the Dark. Directed by Clarence Brown. New York: Vitagraph Company of America, 1922.

"Lighting for Color Shots." *Popular Photography* 1, no. 1 (1937): 32.

Lowe, Sue Davidson. *Stieglitz: A Memoir/Biography*. New York: Farrar, Straus and Giroux, 1983.

"The Lumière Autochrome Process." *Wilson's Photographic Magazine* 44 (October 1907): 433.

Lyons, Nathan. *Toward a Social Landscape*. New York: Horizon Press in association with George Eastman House, 1966.

Lyons, Nathan, Syl Labrot, and Walter Chappell. *Under the Sun: The Abstract Art of Camera Vision*. New York: G. Braziller, 1960.

Madame Yevonde [Yevonde Cumbersmiddleton]. "Why Colour?" Address delivered to the Royal Photographic Society on December 6, 1932. *The Photographic Journal* 73 (March 1933): 116–120.

Mah, Sergio, et al. *70s: Photography and Everyday Life*. Madrid, Spain: La Fábrica Editorial, 2009.

Malcolm, Janet. *Diana & Nikon: Essays on Photography*. New York: Aperture, 1997.

——. "Photography: Color." *The New Yorker* (October 10, 1977): 107–111.

——. "Photography: Two Roads." *The New Yorker* (December 4, 1978): 221–234.

Maloney, Tom, ed. "Color Photography in Current Advertising." *U.S. Camera Annual 1942* (1941): 40.

——, ed. "Color Photography in Current Magazine Illustration." *U.S. Camera Annual 1942* (1941): 15–16.

——, ed. *A Pageant of Photography*. San Francisco: San Francisco Bay Exposition Co., 1940.

——, ed. *U.S. Camera 1946: Victory Volume*. New York: U.S. Camera Publishers, 1945.

——, ed. *U.S. Camera 1949*. New York: U.S. Camera Publishing Corp., 1948.

Mandel, Mike, and Larry Sultan. *Evidence*. Greenbrae, CA: Clatworthy Colorvues, 1977.

Mannheim, L. A. "Color Photo History Synopsis." *Camera* 7 (July 1977): 9–10.

Mante, Harold. *Color Design in Photography*. New York: Van Nostrand Reinhold Company, 1971.

Marden, Luis. *Color Photography with the Miniature Camera*. Canton, OH: The Fomo Publishing Company, 1934.

"Martin Parr's Photobiography." *World Press Photo Review* (June 2008): 9–11.

Martineau, Paul. *Paul Outerbridge: Command Performance*. Los Angeles: J. Paul Getty Museum, 2009.

Martinson, Dorothy. *Recent Color*. San Francisco: San Francisco Museum of Modern Art, 1982.

Matthews, Glenn E. "Leopold Godowsky, Jr. and Leopold Mannes." *PSA Journal* 21 (October 1955): 33–34.

McCandless, Barbara, Bonnie Yochelson, and Richard Koszarski. *New York to Hollywood: The Photography of Karl Struss*. Fort Worth, TX: Amon Carter Museum and the University of New Mexico Press, 1995.

McCarthy, Jane Baum. "The Two-color Kodachrome Collection at the George Eastman House." *Image: Journal of Photography and Motion Pictures of the International Museum of Photography at George Eastman House* 30, no. 1 (September 1987): 1–12.

McCray, Marilyn. *Electroworks*. Rochester, NY: International Museum of Photography at George Eastman House, 1979.

McCusker, Carol. "Desiring Veracity: The History of Color Photography." *Color* no. 1 (April 2009): 24–33.

——. "An Eruption of Color: The History of Color Photography from WWII to the Dawn of Digital." *Color Magazine* no. 2 (July 2009): 26–45.

McCusker, Carol, and Mark Berndt. "The Digital Age: Color Fully Realized." *Color* no. 3 (September 2009): 20–33.

McElheny, Josiah. "Spectrum of Possibility." *Artforum* (April 2010): 55.

Mees, C. E. Kenneth. *From Dry Plates to Ektachrome Film: A Story of Photographic Research*. New York: Ziff-Davis Publishing Company, 1961.

——. "The Kodachrome Process of Color Portraiture." *American Annual of Photography 1916* 30 (1915) 9–21.

Meinwald, Dan. "Reviews: Color Me MOMA." *Afterimage* 4, no. 3 (September 1976): 18.

Meyerowitz, Joel. *Cape Light: Color Photographs by Joel Meyerowitz*. Boston: New York Graphic Society, 1978.

Milanwoski, Stephen R. "The Biases Against Color in Photography." *exposure* 23, no. 2 (Summer 1985): 5–21.

——. "Notes on the Stability of Color Materials." *exposure* 20, no. 3 (Summer 1982): 38–51.

Misrach, Richard. *Desert Cantos*. Albuquerque: University of New Mexico Press, 1987.

——. *The Sky Book*. Santa Fe, NM: Arena Editions, 2000.

Moholy-Nagy, László. "Make a Light Modulator." In *Moholy-Nagy: An Anthology*, edited by Richard Kostelanetz, 99–104. New York: Da Capo Press, Inc., 1991.

——. *The New Vision: From Material to Architecture*. New York: Brewer, Warren & Putnam, Inc., 1932.

——. "Paths to The Unleashed Colour Camera." *The Penrose Annual: A Review of the Graphic Arts* 39 (1937): 25–31.

——. *Vision in Motion*. Chicago: Paul Theobald, 1947.

Moody, Rick. "On Gregory Crewdson." In *Twilight: Photographs by Gregory Crewdson*. New York: Harry N. Abrams, Inc., 2002.

Moore, Kevin. *Starburst: Color Photography in America 1970-1980*. Ostfildern, Germany: Hatje Cantz Verlag, 2010.

Morris, Wayne. "Color-Photography." *American Annual of Photography* (1917): 55–57.

Mortensen, William. "Color in Photography." *Camera Craft* 45, no. 5 (May 1938): 200–207.

——. "Color in Photography, Part II." *Camera Craft* 45, no. 6 (June 1938): 250–257.

——. "Color in Photography, Part III." *Camera Craft* 45, no. 7 (July 1938): 300–307.

——. "Color in Photography, Part IV, Some Ideas on Composition in Color." *Camera Craft* 45, no. 9 (September 1938): 398–406.

Mosar, Christian. *Bloom! Experiments in Color Photography by Edward Steichen*. Luxembourg: Musée d'Art Moderne Grand-Duc Jean, 2007.

Munsell, Albert H. *A Color Notation: A Measured Color System Based on the Three Qualities, Hue, Values and Chroma with Illustrative Models, Charts and a Course of Study Arranged for Teachers*. Boston: George H. Ellis, 1905.

——. *Munsell Book of Color: Defining, Explaining, and Illustrating the Fundamental Characteristics of Color*. Baltimore: Munsell Color Co., 1929.

Museum of Fine Arts, Houston. *Edward Steichen: The Condé Nast Years*. Houston: The Museum of Fine Arts, 1984.

Nakao, Donna. *Spectrum: New Directions in Color Photography*. Honolulu: University of Hawaii Art Gallery, 1979.

Neri, Louise, and Vince Aletti. *Settings & Players: Theatrical Ambiguity in American Photography*. London: White Cube, 2001.

Nettles, Bea. *Breaking the Rules: A Photo Media Cookbook*. Rochester, NY: Inky Press Productions, 1977.

New York Cultural Center. *The Photograph as a Permanent Color Print*. New York: New York Cultural Center in association with Fairleigh Dickinson University, 1970.

Newhall, Beaumont. "An 1877 Color Photograph." *Image: Journal of Photography of the George Eastman House* 3, no. 5 (May 1954): 33–34.

——. "The Aspen Photo Conference" *Aperture* 3, no. 3 (1955): 3–10.

——. *The Daguerreotype in America*. Revised Edition. Greenwich, CT: New York Graphic Society, 1968.

——. *The History of Photography: From 1839 to the Present*. New York: The Museum of Modern Art, 1949.

——. *Photography, 1839-1937*. New York: The Museum of Modern Art, 1937.

——. *Photography: A Short Critical History*. New York: The Museum of Modern Art, 1938.

——. "The Misadventures of L. L. Hill." *Image: Journal of Photography and Motion Pictures of the International Museum of Photography at George Eastman House* 1, no. 5 (May 1952): 2.

Newhall, Nancy. "Painter or Color Photographer?" *U.S. Camera* 1, no. 14 (Spring 1941): 42.

Newman, James. *The Principles and Practice of Harmonious Colouring, in Oil, Water, and Photographic Colours: Especially as Applied to Photographs on Paper, Glass, and Canvas; by an Artist Photographer*. London: J. Newman, 1874, 10th edition.

Newton, Gael, ed. *In the Spotlight: Anton Bruehl Photographs, 1920-1950s*. Canberra, Australia: National Gallery of Australia, 2010.

Nickel, Douglas R. "Autochromes by Clarence H. White." *Record of the Art Museum, Princeton University* 51, no. 2, 1992: 31–37.

——. "History of Photography: The State of Research." *Art Bulletin* 83, no. 3 (September 2001): 548–558.

Niven, Penelope. *Steichen: A Biography*. New York: Clarkson Potter, 1997.

Nordström, Alison, and Peggy Roalf. *Colorama: The World's Largest Photographs, from Kodak and the George Eastman House Collection*. New York: Aperture Foundation, 2004.

Nulty, Peter, and Thomas J. Martin. "The New Look of Photography: The Transition from Film to Electronic Imaging Seems Sure to Excite Consumers and Create Fast-growing Markets. Who Will Win Them? Kodak? Polaroid? Or the Japanese?" *Fortune* (July 1, 1991).

Okuefuna, David. *The Dawn of the Color Photograph: Albert Kahn's Archives of the Planet*. Princeton, NJ: Princeton University Press, 2008.

Opie, Catherine. *Catherine Opie: American Photographer*. New York: Solomon R. Guggenheim Foundation, 2008.

Ostroff, Eugene, ed., *Pioneers of Photography: Their Achievements in Science and Technology*. Springfield, VA: The Society for Imaging Science and Technology, 1987.

Outerbridge, Paul. "Color." *U.S. Camera* 1, no. 10 (June–July 1940): 75–76.

———. "Miniatures in Color." *Minicam Photography* (March 1946): 36–37.

———. *Photographing in Color*. New York: Random House, 1940.

Page, Tim. *Tim Page's Nam*. New York: Alfred A. Knopf, Inc., 1983.

Parker, Fred R. *Attitudes: Photography in the 1970s*. Santa Barbara, CA: Santa Barbara Museum of Art, 1979.

Parks, Gordon. *Half Past Autumn: A Retrospective*. Boston: Little Brown and Company in Association with the Corcoran Gallery of Art, 1997.

Parry, Eugenia. *Vanishing Presence*. Minneapolis: Walker Art Center and Rizzoli, 1989.

Passafiume, Tania. "Photography in Natural Colors: Steichen and the Autochrome Process." In *Coatings on Photographs: Materials, Techniques, and Conservation*, edited by Constance McCabe, 314–321. Washington DC: American Institute of Conservation of Historic and Artistic Works, 2005.

Payne, Carol. "Negotiating Photographic Modernism in *USA: A Quarterly Magazine of the American Scene (1930)*." *Visual Resources: An International Journal of Documentation* 23, no. 4 (December 2007): 337–351.

Penhall, Michelle M., ed. *Desire for Magic: Patrick Nagatani, 1978–2008*. Albuquerque: University of New Mexico Art Museum, 2010.

Penn, Irving. *Still Life*. Boston: Bulfinch Press/Little, Brown and Company, 2001.

Peterson, Christian. "American Arts and Crafts: The Photograph Beautiful, 1895–1915." *History of Photography* 16, no. 3 (Autumn 1992): 189–232.

Phillips, Sandra S. *Exposed, Voyeurism, Surveillance, and the Camera Since 1870*. San Francisco Museum of Modern Art in association with Yale University Press, 2010.

Phillips, Sandra S., and Maria Morris Hambourg. *Helen Levitt*. San Francisco: San Francisco Museum of Modern Art, 1991.

"Photography in Natural Colors." *American Journal of Photography* 9, no. 12 (December 1888): 321–322.

"Photography's 'Hole in the Head.'" *U.S. Camera 1960* (1959): 131–134, 363.

Pietrodangelo, Donato. "Stieglitz and Autochrome: Beginnings of a Color Aesthetic." *exposure* 19, no. 4 (1981): 16–19.

Porter, Albert B. "Krōmskōp Color-Photography, F. E. Ives Patents." *The Scientific Shop* 348 (May 1907): 1–3.

Porter, Allen. "The Second Generation of Colour Photographers." *Camera* 56, no. 7 (July 1977): 3–4, 15, 19.

Porter, Eliot. Eliot Porter Papers, Amon Carter Museum of American Art, Fort Worth, TX.

———. *In Wildness Is the Preservation of the World*. San Francisco: The Sierra Club, 1962.

———. "The Rare Photograph." *U.S. Camera* 19, no. 11, (November 1956): 69–70.

Porter, Fairfield. "The Immediacy of Experience." In *Art in Its Own Terms: Selected Criticism, 1935–1975, by Fairfield Porter*, edited by Rackstraw Downes, 79–81. Cambridge, MA: Zoland Books, 1993.

Potter, Rowland S. "The Chromatone Process." *Journal of the Photographic Society of America* 2, no. 1 (June 1936): 1–2.

Prang, Louis, Mary Dana Hicks, and John S. Clark. *Color Instruction: Suggestions for a Course of Instruction in Color for Public Schools*. Boston: Prang Educational Company, 1893.

Rathbone, Belinda. *One of a Kind: Recent Polaroid Color Photography*. Boston: David R. Godine, 1979.

Rayfield, Stanley, ed. *How LIFE Gets the Story: Behind the Scenes in Photo-Journalism*. Garden City, NY: Doubleday & Company, Inc. 1955.

Redfield, Robert. "The Photographic Society of Philadelphia." *American Journal of Photography* 9, no. 4 (April 1888): 80–83.

Respini, Eva. *Cindy Sherman*. New York: The Museum of Modern Art, 2012.

Rexer, Lyle. *The Edge of Vision: The Rise of Abstraction in Photography*. New York: Aperture, 2009.

Rice, Leland. *Henry Holmes Smith: Photographs, 1931–1986: A Retrospective*. New York: Howard Greenberg Gallery, 1992.

Ridgway, Robert. *Color Standards and Color Nomenclature*. Washington DC: Robert Ridgway, 1912.

Rijper, Els. *Kodachrome: The American Invention of Our World, 1939–1959*. New York: Delano Greenidge Editions, 2002.

Rinhart, Floyd, Marion Rinhart, and Robert W. Wagner. *The American Tintype*. Columbus: Ohio State University Press, 1999.

Rinhart, Marion. "Levi L. Hill." *The Magazine Antiques* 152, no. 4 (April 2003): 122–125.

Roberts, Pamela. *A Century of Colour Photography: From the Autochrome to the Digital Age*. London: André Deutsch, 2007.

——. "Edward Steichen: A Passion for Color." In *Edward Steichen: Lives in Photography*, edited by Todd Brandow and William A. Ewing, 145–153. Minneapolis: Foundation for the Exhibition of Photography and the Musée de l'Elysée in association with W. W. Norton & Company, 2008.

Rohrbach, John. *Eliot Porter: The Color of Wildness*. New York: Aperture Foundation, Inc. 2001.

——. *Regarding the Land: Robert Glenn Ketchum and the Legacy of Eliot Porter*. Fort Worth, TX: Amon Carter Museum, 2006.

Rollins, Rich. *The Role of Color in Documentary Photography*. Tempe: School of Art, Arizona State University, 1985.

Rosenblum, Walter. "Reviews." *Photo Notes* (July 1947): 3–4.

Russell, Art. "Inkjet Printing Lessons from Joel Meyerowitz." *Popular Photography* (May/June 2006).

Salomon, Allyn. *Advertising Photography*. New York: Amphoto Books, 1982.

Saltz, Jerry. "Desolation Row." *New York Magazine* (April 17, 2011).

Samaras, Lucas. *Photo-Transformations*. New York: E. P. Dutton, 1975.

——. *Samaras: The Photographs of Lucas Samaras*. New York: Aperture Foundation Inc., 1987.

——. *Samaras Album: Autointerview, Autobiography, Autopolariod*. New York: Whitney Museum of American Art, 1971.

Samaras, Lucas, and Peter Schjeldahl. *Lucas Samaras*. New York: Pace/MacGill Gallery, 1991.

San Francisco Museum of Modern Art. "Is Photography Over?" *San Francisco Museum of Modern Art Research + Projects*. http://www.sfmoma.org/about/research_projects/research_projects_photography_over.

Sandweiss, Martha A. *Laura Gilpin: An Enduring Grace*. Fort Worth, TX: Amon Carter Museum, 1986.

Saunders, F. Anthony. "50,000 People Saw the Show." *Popular Photography* 2, no. 2 (February 1938): 17–19, 87.

Schrepfer, Susan. *David Brower: Environmental Activist, Publicist, and Prophet: An Interview, 1974–1978*. Berkeley: Regional Oral History Department, Bancroft Library, University of California, 1980.

Schuman, Aaron. "Roaming: An Interview with Todd Hido." *Seesaw: An Online Photography Magazine: Observation Full and Felt* 1 (Winter 2004).

Schuneman, R. Smith. *Photographic Communication: Principles, Problems, and Challenges of Photojournalism*. New York: Hastings House, 1972.

Scott, Andrea K. "Futurism." *The New Yorker* (May 30, 2011): 33.

Scott, Dixon. "Colour Photography." In *Colour Photography and Other Recent Developments of the Art of the Camera*, edited by Charles Holme. London: The Studio, 1908.

——. "The Painter's New Rival: An Interview with Alvin Langdon Coburn." *American Photography* 2, no. 1 (January 1908): 13–19.

Sewell, Trevor George. "The Autochrome Process." *Photoresearcher* no. 11 (April 2008): 5–13.

Shamis, Bob. *New York in Color*. New York: Harry N. Abrams, Inc., 2012.

Sheahan, David. "A Few Words About Autochromes." *American Annual of Photography 17* 31 (1916): 104–105.

Sheridan, Sonia Landy. "Generative Systems." *Afterimage* 1, no. 2 (April 1972): 2–4.

Sherman, Charles L., ed. *Nature's Wonders in Full Color*. Garden City, NJ: Hanover House, 1956.

Shore, Stephen. *American Surfaces*. London: Phaidon Press Limited, 2005.

——. *The Nature of Photographs*. London: Phaidon Press Limited, 2007.

——. *A Road Trip Journal*. London: Phaidon Press Limited, 2008.

——. *Uncommon Places: The Complete Works*. New York: Aperture Foundation, Inc., 2004.

Siegel, Arthur. *Arthur Siegel: Retrospective, Vintage Photographs and Photograms, 1937–1973*. Chicago: Edynn Houk Gallery, 1982.

——. "Modern Art by a Photographer: With a Camera for a Palette, Arthur Siegel Rivals the Work of Contemporary Painters." *LIFE* 29, no. 21 (November 20, 1950): 78–84.

Simmons, Laurie. *In and Around the House: Photographs, 1976–78*. New York: Carolina Nitsch Editions and Hatje Cantz, 2003.

Sipley, Louis Walton. *Frederic E. Ives*. Philadelphia: American Museum of Photography, 1956.

——. *A Half Century of Color*. New York: Macmillian, 1951.

——. *Photography's Great Inventors*. Philadelphia: American Museum of Photography, 1965.

Skoglund, Sandy. *Sandy Skoglund: Reality Under Siege: A Retrospective*. Northampton, MA: Smith College Art Museum in association with Harry N. Abrams, Inc., 1998.

Slavin, Neal. *When Two or More Are Gathered Together*. New York: Farrar, Straus and Giroux, 1976.

Slemmons, Rod. "On Robert Heinecken and Recto/Verso." In *Recto/Verso*, edited by Robert Heinecken. Portland, OR: Nazraeli Press, 2006.

Smith, Henry Holmes. Henry Holmes Smith Papers, Center for Creative Photography, Tucson, AZ.

——. "On Color Photography: A Brief Memoir." *exposure* 12, no. 3 (September 1974): 4–5.

Smith, Joel. *Edward Steichen: The Early Years*. Princeton, NJ: Princeton University Press in association with the Metropolitan Museum of Art, 1999.

Sobieszek, Robert A. *The Art of Persuasion: A History of Advertising Photography*. New York: Harry N. Abrams, Inc., 1988.

——, ed. *Early Experiments with Direct Color Photography*. New York: Arno Press, 1979.

——. *Robert Fichter: Photography and Other Questions*. Albuquerque: University of New Mexico Press, 1983.

Solomon-Godeau, Abigail. "The Great Autochrome Controversy." *Camera 35*, 26 (May 1981): 52–57.

Sontag, Susan. *On Photography*. New York: Farrar, Straus and Giroux, 1978.

Soth, Alec. *Sleeping by the Mississippi*. Göttingen, Germany: Steidl, 2004.

Spector, Nancy. "Art Photography After Photography." In *Moving Pictures: Contemporary Photography and Video from the Guggenheim Museum Collection*, edited by Lisa Dennison, John G. Hanhardt, Nancy Spector, and Joan Young. New York: Solomon R. Guggenheim Museum, 2003.

Spencer, D. A. *Colour Photography in Practice*. New York: Pitman Publishing Corp., 1938.

Squiers, Carol. "Color Photography: The Walker Evans Legacy and the Commercial Tradition." *Artforum* 17, no. 3 (November 1978): 64–67.

Stack, Trudy Wilner. *Christenberry Reconstruction: The Art of William Christenberry*. Jackson: University Press of Mississippi and the Center for Creative Photography, University of Arizona, 1996.

——. *Winogrand 1964: Photographs from the Garry Winogrand Archive, Center for Creative Photography, University of Arizona*. Santa Fe, NM: Arena Editions, 2002.

Stainback, Charles. *Special Collections: The Photographic Order from Pop to Now*. New York: International Center of Photography, 1992.

Staubach, Horst W. "Kodachrome." In *50 Jahre Moderne Farbfotografie 1936–1986 (50 Years Modern Color Photography 1936–1986)*, translated by Manfred Heiting. Cologne, Germany: Messe- und Ausstellungs-Ges.m.b.H., 1986.

——. "Kodak: The History of Kodachrome Film." *Camera* 7 (July 1977): 39–40.

Steichen, Edward. "Artist or Photographer?" *Printer's Ink* 157 (November 26, 1931): 64.

——. "Color Photography." *Camera Work* 22 (April 1908): 13–24.

——. *A Life in Photography*. Garden City, NY: Doubleday & Co. in collaboration with the Museum of Modern Art, 1963.

——. "Painting and Photography." *Camera Work* 23 (July 1908): 3–5.

Steichen, Joanna. *Steichen's Legacy: Photographs, 1895–1973*. New York: Alfred A. Knopf, 2000.

Stein, Sally. "FSA Color: The Forgotten Document." *Modern Photography* 43, no. 1 (January 1979): 90–98, 162–166.

Stein, Sally, and Terence R. Pitts, *Harry Callahan: Photographs in Color / The Years 1946–1978*. Tucson: Center for Creative Photography, University of Arizona, 1980.

Steinorth, Karl, ed. *Ferenc Berko: 60 Years of Photography—The Discovering Eye*. Zürich: Edition Stemmle, 1994.

Sternfeld, Joel. *American Prospects*. New York: Distributed Art Publishers, Inc., 2003.

——. *First Pictures*. Göttingen, Germany: Steidl, 2011.

Stieglitz, Alfred. "The Colour Problem for Practical Work Solved." *Photography* (August 13, 1907): 136.

——. "Frilling and Autochromes." *Camera Work* 23 (July 1908): 49–50.

——. "The New Color Photography—A Bit of History." *Camera Work* 20 (October 1907): 20–25.

Story, Derrick. "From Darkroom to Desktop: How Photoshop Came to Light." *Story Photography*. http://www.storyphoto.com/multimedia/multimedia_photoshop.html.

Strand, Paul. "Photography." *Camera Work* 49/50 (June 1917): 3–4.

Stricherz, Guy. *Americans in Kodachrome*. Santa Fe, NM: Twin Palm, 2002.

"The Success of Color Photography." *The Craftsman* 21, no. 6 (March 1912): 687.

Sussman, Elizabeth, and Thomas Weski. *William Eggleston: Democratic Camera: Photographs and Video,*

1961–2008. New York: Whitney Museum of American Art, 2008.

Swenson, Kirsten. "Be My Mirror: Dan Graham." *Art in America* 97, no. 5 (May 2009): 104–110.

"Symposium on Color." *U.S. Camera* 18, no. 5 (May 1955): 58–63, 98–99.

"Symposium on Color." *U.S. Camera* 18, no. 6 (June 1955): 85–91, 108–109.

Szarkowski, John. *The Face of Minnesota*. Minneapolis: University of Minnesota Press, 1958.

——. *Looking at Photographs: 100 Pictures from the Collection of The Museum of Modern Art*. New York: The Museum of Modern Art, 1973.

——. *The Photographer's Eye*. New York: The Museum of Modern Art, 1966.

——. *Slide Show: The Color Photographs of Helen Levitt*. Brooklyn, NY: powerHouse Books, 2005.

——. *William Eggleston's Guide*. New York: The Museum of Modern Art, 1976.

Taft, Robert. *Photography and the American Scene: A Social History, 1839–1889*. New York: The Macmillan Company, 1938.

Taussig, Michael. *What Color Is the Sacred*. Chicago: University of Chicago Press, 2009.

Temkin, Anne. *Color Chart: Reinventing Color, 1950 to Today*. New York: The Museum of Modern Art, 2008.

Time-Life Books. *Color*. Alexandria, VA: Time-Life Books, 1981.

——. *Photography Year 1976*. New York: Time-Life Books, 1976.

Tow, Robert, and Ricker Winsor, eds. *Harry Callahan: Color, 1941–1980*. Providence, RI: Matrix Publications, 1980.

Towler, John. "Obituary. Rev. Levi L. Hill." *Humphrey's Journal* 16, no. 20 (February 15, 1865): 315–316.

Trotman, Nat, et al. *Catherine Opie: American Photographer*. New York: Solomon R. Guggenheim Museum, 2008.

Tucker, Anne Wilkes. *Crimes and Splendors: The Desert Cantos of Richard Misrach*. Boston: Bulfinch Press in association with the Museum of Fine Arts, Houston, 1996.

Tuggle, Catherine T. "Edouard Steichen and the Autochrome, 1907–1909." *History of Photography* 18, no. 2, (Summer 1994): 145–147.

Turner, Pete. *Pete Turner: Photographs*. New York: Harry N. Abrams, Inc., 1987.

Uhrhane, Jennifer. "Timeline of Color Photography." Photographic Resource Center at Boston University. http://www.bu.edu/prc/GODOWSKY/timeline.htm.

Upton, John. "Book Reviews." *Aperture* 11 no. 2 (1964), 73–85.

——. *Color as Form*. Rochester, NY: International Museum of Photography at George Eastman House, 1982.

Varden, Lloyd E. "The Status of Color Photography for the Mass Market." *American Annual of Photography* (1947): 78–80.

Venturi, Robert. *Signs of Life: Symbols in the American City*. New York: Aperture, Inc., 1976.

Wahl, Paul. "Now Color Prints Almost as Easy as B&W." *Popular Science* 195, no. 2 (August 1969): 184–185.

Walker, Todd. *. . . One Thing Just Sort of Led to Another . . .* Tucson: University of Arizona, 1979.

——. *The Photographs of Todd Walker*. Tucson: Department of Art, University of Arizona, 1979.

Wall, E. J. *The History of Three-Color Photography*. Boston: American Photographic Publishing Company, 1925.

Wallis, Brian, ed. *Andres Serrano: Body and Soul*. New York: Takarajima Books, 1995.

Warren, Lynne, et al. *Robert Heinecken, Photographist: A Thirty-five-year Retrospective*. Chicago: Museum of Contemporary Art, 1999.

Wartburg, R. von. "Cibachrome." *Color* 7 (July 1977): 42–43.

Webb, Alex. *Istanbul: City of a Hundred Names*. New York: Aperture Foundation, Inc., 2007.

——. *The Suffering of Light: Thirty Years of Photographs*. New York: Aperture Foundation, Inc., 2011.

——. *Under a Grudging Sun: Photographs From Haiti Libéré*. New York: Thames and Hudson, Inc., 1989.

Weinberg, Adam D. *On the Line: The New Color Photojournalism*. Minneapolis: Walker Art Center, 1986.

Weinberg, Louis. *Color in Everyday Life: A Manual for Lay Students, Artisans and Artists; On the Principles of Color Combination and Color Arrangement, and Their Applications in Dress, Home, Business, the Theatre and Community Play*. New York: Moffat, Yard and Co., 1918.

Weingart, Brigitte. "Kaleidoscope Eyes." *Artforum* 47, no. 10 (Summer 2009): 85–86.

Welling, James. *Glass House, 2006–2009*. Bologna: Damiani Editore, 2011.

Wennerstrom, Nord. "Robert Bergman: National Gallery of Art." *Artforum* 48, no. 7 (March 2010): 252–253.

Wentzel, Volkmar K. "Gilbert Hovey Grosvenor, Father of Photojournalism." *Cosmos Journal*. www.cosmos-club.org/web/journals/1998/wentzel.html.

Weski, Thomas, ed. *How You Look at It: Photographs of the 20th Century*. Cologne, Germany: Distributed Art Publishers, 2000.

West, Nancy Martha. *Kodak and the Lens of Nostalgia*. Charlottesville: University Press of Virginia, 2000.

Westerbeck, Colin, ed. *Irving Penn: A Career in Photography*. Chicago: Art Institute of Chicago in association with Bulfinch Press/Little, Brown and Company, 1997.

———. *Joel Meyerowitz 55*. London: Phaidon Press Limited, 2001.

Weston, Edward. "Color as Form." *Popular Photography* 33, no. 6 (December 1953).

White, Minor. "The Photographer and the American Landscape." *Aperture* 11, no. 2 (1964): 52–55.

Wilhelm, Henry, and Carol Brower. *The Permanence and Care of Color Photographs*. Grinnell, IA: Preservation Publishing Company, 1993.

Wilkin, Karen. *Color as Field: American Painting, 1950–1975*. New York: American Federation of Arts in association with Yale University Press, 2007.

Williams, William Earle. *Walker Evans in Color: Railroad Photographs*. Haverford, PA: Haverford College, 2011.

Winokur, Neil. *Everyday Things: Photographs by Neil Winokur*. Washington DC: Smithsonian Institution Press in association with Constance Sullivan Editions, 1994.

Witkovsky, Matthew. "Another History." *Artforum* 48, no. 7 (March 2010): 212–221, 274.

———. *Light Years: Conceptual Art and the Photograph, 1964–1977*. New Haven, CT: Yale University Press, 2011.

Wood, John. *The Art of the Autochrome: The Birth of Color Photography*. Iowa City: University of Iowa Press, 1993.

———. *The Photographic Arts*. Iowa City: University of Iowa Press, 1997.

Yates, Steve. *Betty Hahn: Photography or Maybe Not*. Albuquerque: University of New Mexico Press, 1995.

Yochelson, Bonnie. *Anton Bruehl*. New York: Howard Greenberg Gallery, 1998.

Yohannan, Kohle. *John Rawlings: 30 Years in Vogue*. Santa Fe, NM: Arena Editions, 2001.

Zavos, Alison. "Q&A: Alex Prager, Los Angeles." *Feature Shoot*. http://www.featureshoot.com/2008/07/.

Acknowledgments

ANY PROJECT OF THIS SIZE and scope could not have reached completion without the assistance and support of many people, and this book is no exception. At our home institution, directors Dr. Ron Tyler and Dr. Andrew J. Walker provided support early on, as did deputy director of art and research Margi Conrads on her arrival in the later stages of the endeavor. We also are grateful to the National Endowment for the Arts for providing key support to see this book to fruition.

Many individuals and institutions provided important guidance and help at key junctures, generously opening their collections to our review, answering pestering questions, and assisting first with our selection of images and then with image files and rights. Sean Waldron, archive director in the editorial assets and rights office at Condé Nast, was a great help early in the project. Kenda North donated books about the development of color. Barbara and Gene Bullock-Wilson, Philip Condax, Gary Edwards, Danah H. Fayman, G. Ray Hawkins, Mark Jacobs, David Mahoney, Kathleen and Melanie Walker, and Cara Weston induced new insights over the course of sharing their collections, as did Nan Brewer, Seth Circio, David Coleman, Verna Curtis, Malcolm Daniel, Claartje van Dijk, Edward Earle, Matt Heffernan, Barbara Hitchcock, Jan Howard, Miriam Katzeff, Sarah Kennel, Arpi Kovacs, John Lawrence, Dan Leers, Barbara Orbach Natanson, Andrea Nelson, Erin O'Toole, Jennifer Parkinson, Christian A. Peterson, Jeff Rosenheim, Eve Schillo, April Watson, and Del Zogg.

Peter Barbarie, Denise Bethel, Brenda Bernier, Janet Borden, Terry Etherton, Burt and Missy Finger, and Christopher Mahoney shared their advice and assisted with image location. Stuart Alexander, Stephen Daiter, James Danziger, Roy Flukinger, Jeffrey Fraenkel, Stephen H. Goddard, Howard Greenberg, Deborah Klochko, Bertrand Lavédrine, Peter MacGill, Karen Marks, John B. Ravenal, and Yancey Richardson generously helped track down artists and key works. Nadia Blumenfeld Charbit, Katherine Brussard, Karen Haas, Robert Friedus, Manfred Heiting, Robert Jackson, Nancy Martin, Paul Martineau, Richard Oldenberg, and Leland Rice provided helpful input at important junctures.

Leslie Calmes and Tammy Carter at the Center for Creative Photography were of tremendous help, as were Kathy Connor, Taina Meller, Alison Nordström, Joseph R. Struble, and Rachel Stuhlman at the George Eastman House International Museum of Photography and Film. Tony Brooks and Michelle Delaney generously shared their knowledge of the nineteenth-century history of photographic color and the achievements of Levi Hill and Frederic Ives.

The foundation of this project, of course, is composed of the photographers themselves whose remarkable experimentation and play with color has so transformed photography. Many of the artists discussed in this book generously gave their time and thoughts including Marco Breuer, Marie Cosindas, Jim Dow, Anthony Hernandez, Joel Meyerowitz, Richard Misrach, Stephen Shore, and Pete Turner.

At the Amon Carter Museum of American Art, Sam Duncan and Mary Jane Harbison ably assisted with library matters. Katie Siegwarth and Jackie Souryavong aided at key times answering questions and assembling details. Will Gillham has brought his usual expertise to shepherding this book through production on the museum end, with assistance from Ross Auerbach, Stefanie Ball Piwetz, Marci Driggers Caslin, Jon Frembling, and Steve Watson. We will always be grateful to the staff of the University of Texas Press, including our editor Allison Faust and manuscript editor Victoria Davis, who so professionally ushered this book to completion, and director Dave Hamrick, who took an early interest in this project.

John Rohrbach and Sylvie Pénichon
Fort Worth, Texas

Index

Page numbers in *italics* indicate images.